Monkey Beach

2000 Finalist for the Giller Prize

"With its wonderful visitors from the unseen world, stunning evocations of the Northern Pacific coast, hilarious humor and marvelously human characters, Eden Robinson's novel *Monkey Beach* is North America's long awaited answer to *One Hundred Years of Solitude*."
Howard Frank Mosher

"*Monkey Beach* creates a vivid contemporary landscape that draws the reader deep into a traditional world, a hidden universe of premonition, pain and power."
Thomas King

"Not one note rings false…. All the characters [are] stubbornly real, [and] her ruminations on her own past allow Robinson's remarkable flair for family history to glow…. This is a world worth every ounce of remembrance."
The Toronto Star

"*Monkey Beach*…is written with poise, intelligence and playfulness…. In Lisamarie Hill, Robinson has created a memorable character, a young woman who finds a way to survive even as everything around her decays."
National Post

"Robinson's specialty is presenting the day-to-day: no bells, no whistles, no filtered lenses—but a lot of close-ups…. *Traplines* was acclaimed for its startling blend of reality, brutality and humour and *Monkey Beach* carries [this] signature. But it does more. The dark humour is still pure, but the grit and blood is now mixed with meditations on still waters, ancestral voices, ghostly footsteps and beating hearts."
The Vancouver Sun

"Eden Robinson taps her own Haisla-Heiltsuk heritage to hurl [our Native] stereotypes into the West Coast mist …that drift[s] through her story. Her heroine, Lisamarie, is fierce and funny and screwed up, [and] her story, told through her memories of a past both rich and troubled, reveals a woman as strong and intricate as a carved mask."
Chatelaine

Monkey Beach

Eden Robinson

VINTAGE CANADA

A Division of Random House of Canada Limited

for Laura Robinson and Dean Hunt

in dreams I hear you laughing and
know that you are near

≈≈ ≈≈ ≈≈

VINTAGE CANADA EDITION, 2001

Published by Vintage Canada, a division of Random House of Canada Limited,
a Penguin Random House company, in 2001. Originally published in hardcover
by Knopf Canada, a division of Random House of Canada Limited, in 2000.
Distributed in Canada by Random House of Canada Limited, Toronto.

Vintage Canada with colophon is a registered trademark.

www.penguinrandomhouse.ca

Library and Archives Canada Cataloguing in Publication
Robinson, Eden
Monkey beach

ISBN 978-0-676-97322-8
eBook ISBN 978-0-307-36393-0

I.Title.

PS8585.O35143M66 2000 C813'.54 C00-931071-1
PR9199.3.O35143M66 2000

Cover design by Jennifer Lum
Cover image © studio on line/Shutterstock.com

Printed and bound in the United States of America

26 28 29 27 25

VINTAGE CANADA

Penguin
Random
House

CONTENTS

≋ ≋ ≋

≋ ≋ ≋

It is possible to retaliate against an enemy,
But impossible to retaliate against storms.

HAISLA PROVERB

Love Like the Ocean

Six crows sit in our greengage tree. Half-awake, I hear them speak to me in Haisla.

La'es, they say, *La'es, la'es.*

I push myself out of bed and go to the open window, but they launch themselves upward, cawing. Morning light slants over the mountains behind the reserve. A breeze coming down the channel makes my curtains flap limply. Ripples sparkle in the shallows as a seal bobs its dark head.

La'es—Go down to the bottom of the ocean. The word means something else, but I can't remember what. I had too much coffee last night after the Coast

Guard called with the news about Jimmy. People pressed cups and cups of it into my hands. Must have fallen asleep fourish. On the nightstand, the clock-face has a badly painted Elvis caught in mid-gyrate. Jimmy found it at a garage sale and gave it to me last year for my birthday—that and a card that said, "Hap B-day, sis! How does it feel to be almost two decades old? Rock on, Grandma!" The Elvis clock says the time is seven-thirty, but it's always either an hour ahead or an hour behind. We always joke that it's on Indian time.

I go to my dresser and pull out my first cigarette of the day, then return to the window and smoke. An orange cat pauses at the grassy shoreline, alert. It flicks its tail back and forth, then bounds up the beach and into a tangle of bushes near our neighbour's house. The crows are tiny black dots against a faded denim sky. In the distance, I hear a speedboat. For the last week, I have been dreaming about the ocean—lapping softly against the hull of a boat, hissing as it rolls gravel up a beach, ocean swells hammering the shore, lifting off the rocks in an ethereal spray before the waves make a grumbling retreat.

Such a lovely day. Late summer. Warm. Look at the pretty, fluffy clouds. Weather reports are all favourable for the area where his seiner went missing. Jimmy's a good swimmer. Everyone says this like a mantra that will keep him safe. No one's as optimistic about his skipper, Josh, a hefty good-time guy who is very popular for his generosity at bars and parties. He is also heavily in debt and has had a bad fishing season. Earlier this summer two of his crew quit, bitterly

complaining to their relatives that he didn't pay them all they were due. They came by last night to show their support. One of my cousins said they've been spreading rumours that Josh might have sunk his *Queen of the North* for the insurance and that Jimmy's inexperience on the water would make him a perfect scapegoat. They were whispering to other visitors last night, but Aunt Edith glared at them until they took the hint and left.

I stub out the cigarette and take the steps two at a time down to the kitchen. My father's at the table, smoking. His ashtray is overflowing. He glances at me, eyes bloodshot and red-rimmed.

"Did you hear the crows earlier?" I say. When he doesn't answer, I find myself babbling. "They were talking to me. They said *la'es*. It's probably—"

"Clearly a sign, Lisa," my mother has come up behind me and grips my shoulders, "that you need Prozac." She steers me to a chair and pushes me down.

Dad's old VHF is tuned to the emergency channel. Normally, we have the radio tuned to CFTK. He likes it loud, and the morning soft rock usually rackets through the house. As we sit in silence, I watch his cigarette burn down in the ashtray. Mom smoothes her hair. She keeps touching it. They both have that glazed, drawn look of people who haven't slept. I have this urge to turn on some music. If they had found the seiner, someone would phone us.

"Pan, pan, pan," a woman's voice crackles over the VHF. "All stations, this is the Prince Rupert Coast Guard." She repeats everything three times, I don't know why. "We have an overdue vessel." She goes on to

describe a gillnetter that should have been in Rupert four days ago. Mom and Dad tense expectantly even though this has nothing to do with Jimmy.

At any given moment, there are two thousand storms at sea.

≈≈≈

Find a map of British Columbia. Point to the middle of the coast. Beneath Alaska, find the Queen Charlotte Islands. Drag your finger across the map, across the Hecate Strait to the coast and you should be able to see a large island hugging the coast. This is Princess Royal Island, and it is famous for its kermode bears, which are black bears that are usually white. Princess Royal Island is the western edge of traditional Haisla territory. *Ka-tee-doux Gitk'a'ata*, the Tsimshians of Hartley Bay, live at the mouth of the Douglas Channel and surrounding areas just north of the island. During land claims talks, some of this territory is claimed by both the Haisla and the Tsimshian nations—this is called an overlap and is a sticky topic of discussion. But once you pass the head of the Douglas Channel, you are firmly in Haisla territory.

Early in the nineteenth century, Hudson's Bay traders used Tsimshian guides to show them around, which is when the names began to get confusing. "Kitamaat" is a Tsimshian word that means people of the falling snow, and that was their name for the main Haisla village. So when the Hudson's Bay traders asked their guides, "Hey, what's that village called?" and the Tsimshian guides said, "Oh, that's Kitamaat." The

name got stuck on the official records and the village has been called Kitamaat ever since, even though it really should be called Haisla. There are about four or five different spellings of Kitamaat in the historical writings, but the Haisla decided on Kitamaat. To add to the confusion, when Alcan Aluminum moved into the area in the 1950s, it built a "city of the future" for its workers and named it Kitimat too, but spelled it differently.

If your finger is on Prince Rupert or Terrace, you are too far north. If you are pointing to Bella Coola or Ocean Falls, you are too far south. If you are pointing in the right place, you should have your finger on the western shore of Princess Royal Island. To get to Kitamaat, run your finger northeast, right up to the Douglas Channel, a 140-kilometre-long deep-sea channel, to its mouth. You should pass Gil Island, Princess Royal Island, Gribbell Island, Hawkesbury Island, Maitland Island and finally Costi Island. Near the head of the Douglas, you'll find Kitamaat Village, with its seven hundred Haisla people tucked in between the mountains and the ocean. At the end of the village is our house. Our kitchen looks out onto the water. Somewhere in the seas between here and Namu—a six-hour boat ride south of Kitamaat—my brother is lost.

My mother answered the phone when the Coast Guard called. I took the phone from her hands when she started crying. A man told me there had been no radio contact since Saturday, two days earlier. The man said he'd like to ask me a few questions. I gave him all the information I could—that Jimmy had phoned

us from Bella Bella on Friday. He told us that 36 hours' notice had been given for a Sunday opening for sockeye salmon in Area 8. Josh had been planning to move the seiner closer to his favourite Area 8 fishing point. No, I didn't know where the point was. Jimmy had said that since it was a boring sit-and-wait kind of job, the crew was splitting up. The three senior fishermen in Josh's crew were staying in Bella Bella and taking a speedboat to join the *Queen* early Sunday. Jimmy had the least seniority so he had to go with Josh.

The man told me that Josh had called his crew in Bella Bella to say the engine was acting up so he was stopping over in Namu. When the crew arrived at the Area 8 fishing site, they couldn't find the *Queen of the North*. They searched all afternoon. No one in the fishing fleet reported seeing the *Queen*. No one knew if she'd gone down or if she'd just broken down and was holed up somewhere. Area 8 was large, the man said. There had been no mayday, but he didn't say if this was a good or a bad thing. Did I know of anything else that could be helpful? No, I said. It wasn't really a lie. What I knew wouldn't be particularly useful now.

≈

There are no direct flights to Namu from the Terrace-Kitimat Airport, so Mom and Dad are traveling to Vancouver on the morning flight. From there, they're flying into Bella Bella and then going by boat to Namu to be closer to the search. I shouldn't have told them about the crows. At least I didn't tell them about the dream: the night the *Queen of the North* disappeared, I

saw Jimmy at Monkey Beach. He stood at the edge of the sand, where the beach disappeared into the trees. The fog and clouds smeared the lines between land and sea and sky. He faded in and out of view as the fog rolled by. He wore the same clothes he'd had on the day he left, a red plaid shirt, black jeans and the John Deere baseball cap Dad had given him. I must have been on a boat, because he was far away and small. I couldn't see his face.

When we were kids, Dad would tell us about B'gwus, the wild man of the woods. They were stories that Ba-ba-oo had told him. Jimmy's favourite was the one where these two trappers go up into the mountains near Monkey Beach. At one point, they had to separate because the trail split. They put a Y-shaped stick at the crossroads. The trapper who finished his line first would point the stick in the direction of their camp.

The first guy who finished checking the traps heard something big moving in the bushes ahead of him. He caught a glimpse of light brown fur through the leaves and thought it was a grizzly. Keeping his gun pointed in the direction of the shaking bushes, he left the trail, moving backwards as quietly and quickly as he could, thinking that if he stayed downwind, it wouldn't notice him.

So he wasn't paying attention to what was behind him when he broke into a clearing. He heard a grunt. He spun around. In front of him were more than twenty very hairy men. They looked as surprised as he was. They were tall, with thick brown hair on their chests, arms and legs. Their heads were shaped oddly, very large and slanted back sharply from the brow.

One of them growled and started towards him. He panicked and bolted back into the bushes, and they began to chase him.

They were fast. He was quickly cornered at the foot of a cliff. He climbed up. They gathered at the bottom in a semicircle and roared. When they followed him up, he raised his gun and, knowing he'd probably have only one shot, picked the leader. The trapper shot him in the head, and the creature landed with a heavy thump at the bottom of the cliff. As the other sasquatches let out howls of grief, the trapper ran.

After he reached the beach and realized that no one was following him, he made his way back to camp. His partner wasn't there. The sun was setting, and the trapper knew that he was going to have to wait until morning before he could go after him.

He broke camp, put all the stuff into their boat, anchored out in the bay and spent the night wide awake. At first light, he headed up the mountain. When he got to the crossroads, he saw his partner, battered, bloody and most definitely dead. Before he could get to him, the howling started all around, and he turned and ran.

"You're telling it wrong," Ma-ma-oo had said once when she was over for Christmas dinner. Every time Dad launched into his version, she punctuated his gory descriptions with, "That's not how it happened."

"Oh, Mother," he'd protested finally. "It's just a story."

Her lips had pressed together until they were bloodless. She'd left a few minutes later. Mom had kissed Dad's nose and said family was family.

Ma-ma-oo's version was less gruesome, with no one getting shot and the first trapper just seeing the b'gwus crossing a glacier, getting scared and running back to the camp. Me and Jimmy liked Dad's version better, especially when he did the sound effects.

Either way, when the trapper got back to the village, he had an artist carve a sasquatch mask. At the end of the story, Dad would put on a copy that his father had carved and chase us around the living room. Jimmy would squeal in mock terror and pretend to shoot him. If Dad caught us, he'd throw us down and tickle us. Ma-ma-oo frowned on this. She said it would give us nightmares. Sure enough, Jimmy would crawl into my bed late at night when he thought I was asleep and curl into my side. He'd leave before I awoke, tiptoeing out.

Jimmy took the story as if it were from the Bible. He bought himself a cheap little camera one day, and I asked him why he was wasting his money.

"I'm going to make us rich," he said.

I snorted. "How? You going to blackmail some-one?" I'd been watching soaps with Ma-ma-oo and knew all about cheating husbands and wives who were photographed in awkward positions.

Jimmy shook his head and wouldn't tell me. "Want it to be a surprise."

All that week, he begged Dad to take him to Monkey Beach.

"How come?" Dad said, getting annoyed.

"Because that's where the b'gwus are," Jimmy said.

Dad raised an eyebrow.

Jimmy squirmed. "Please, Dad. Please. It's important."

"Jimmy," Dad said. "Sasquatches are make-believe, like fairies. They don't really exist."

"But Ma-ma-oo says they're real," Jimmy said.

"Your grandmother thinks the people on TV are real," Dad said, then glanced at me, rolling his eyes. After a moment, he leaned in close to Jimmy, whispering, "You don't really want to get eaten, do you? They like little boys."

Jimmy went pale. "I know." He looked at me. I rolled my eyes upward.

Only when it looked like Dad wasn't going to give in did Jimmy pull out a copy of the *World Weekly Globe*. He showed us page 2, where it said that the *Globe* would pay up to thirty thousand dollars to anyone who got a picture of a sasquatch.

"We'll be rich!" Jimmy said, so excited he began to hop. "We can go to Disneyland! We can get a new car! I bet we could even get a new house!"

Dad stared at him. He patted Jimmy's shoulder. "If you finish all your chores this week, we'll leave on Friday."

Jimmy whooped and ran to tell Mom. I giggled. He was only a year and a half younger than me and he was still such a baby.

"Well," Dad said with a wry smile, "cockle season's starting anyway."

Dad's uncle Geordie and his wife, Edith, dropped off equipment for the trip that night. Jimmy was furious that they were coming with us until they both promised that he was the only one that would be taking pictures. They were, Uncle Geordie assured him, coming along only for the cockles.

We left early Saturday morning. It took forever to get going. Me and Jimmy watched cartoons while Mom made herself up in the bathroom. She never left the house without at least wearing lipstick, and even though no one was going to see us, she got up extra early to do her hair and makeup. Dad was adamant that when we built our new house, she'd get her own bathroom.

I poured myself some Puffed Wheat and pushed them around my bowl, feeling time crawl slowly across my skin, an agonizing eternity of waiting for Mom to get ready. She finally came downstairs in carefully pressed jeans, a white shirt and jean jacket, and with a blue kerchief over her hair. Dad wiped his hands on his pants before he kissed her good morning and said she looked great.

At the docks we had to wait for Aunt Edith, who was bringing fresh bread. Mom had mortally offended her a few months earlier by buying her a bread machine for Christmas. Dad tried to warn her, said she'd appreciate an electric knife a lot more, but Mom insisted because she knew Aunt Edith's arthritis was getting worse. Just recently, she'd had to cut her long hair into a bob because she couldn't braid it any more. Uncle Geordie conceded that Edith did use the machine for the kneading part, but everything else was still done the old-fashioned way. Her bread was absolutely the best: cotton-ball soft inside, so tender the butter almost made it dissolve, with a crust as flaky and golden brown as a croissant's. Mom later got back in her good books, at Ma-ma-oo's birthday party, by baking a slightly tough, heavy loaf and then casually asking what Aunt Edith thought she'd done wrong.

Uncle Geordie's rattly old truck pulled into the bay, and Mom shooed me and Jimmy inside the cabin, where we fought over the captain's seat. Dad had bought the gillnetter, *Lulu*, for two hundred dollars. *Lulu* was long and heavy and so slow that the only way we'd run into anything was if it was trying to hit us. When we went anywhere, I could count the logs on the beach, the trees on the mountains, the waves in the ocean. Her only saving grace was that she was big enough to give us tons of elbow room. But the smell of the old boat was so strong that we'd have it in our clothes for weeks after we got home.

Uncle Geordie came on board first. He looked fierce, with his eyebrows hanging over his eyes and his hollow cheekbones and his habit of frowning all the time, but whenever he baby-sat me he carved me little seiners and gillnetters out of corks. I told him he should sell them, but he always shook his head. Once we were under way, I sat in his lap while he explained the tides to me and let me steer *Lulu*. The engine was as loud as a jackhammer, and everyone had to yell to be heard. When I got bored of steering, I lay on the lower bunk under the bow and read a *True Stories* I'd filched from Mom's bedroom. She said nine years old was too young to be reading trash, so I hid it behind my comic-book covers.

Only when I was on the boat could I eat Spam. Dad fried it until it was crispy and served it with hash browns and ketchup. Uncle Geordie roasted marsh-mallows for us, and Aunt Edith brought out some canned crabapples.

Mom forced Jimmy to come down for lunch and

snacks, and he'd come scrambling back to use the PortaPotti, but he stayed on the bow most of the time, his camera ready in case any sasquatches appeared on the beach, scanning the shore for anything that looked like a large hairy monkey. Mom wanted him to take pictures of the mountains, but Jimmy wouldn't—he didn't even relent when some porpoises came and played around the bow.

Dad and Uncle Geordie jigged while Mom and Aunt Edith took turns at the wheel. Dad wanted some halibut, and Uncle Geordie said he wanted something fresh so bad he wouldn't even mind a sea cucumber.

The summer had stretched itself into early September. When we finally arrived, the day was sweltering. I loved going to Monkey Beach, because you couldn't take a step without crushing seashells, the crunch of your steps loud and satisfying. The water was so pure that you could see straight down to the bottom. You could watch crabs skittering sideways over discarded clam and cockleshells, and shiners flicking back and forth. Kelp the colour of brown beer bottles rose from the bottom, tall and thin with bulbs on top, each bulb with long strands growing out of it, as flat as noodles, waving in the tide.

Dad and Uncle Geordie shoved the skiff into the water and rowed most of the gear to the beach. We stopped on the north side of Monkey Beach, where the shore is flatter and the beach a little longer than a football field. As they were rowing back to the gill-netter, Uncle Geordie yelled excitedly for Dad to give him the net, then grabbed it and dipped it into the water and brought up a crab.

Aunt Edith clapped, then hollered, "Get me one with eggs!"

Uncle Geordie waved at her.

"Hurry up!" Jimmy yelled across the water, swatting horseflies away from his face. "Jeez, they're taking long."

"Put some bug dope on," Mom said to him.

Jimmy leaned over the railing to dip his hand in the ocean. His legs dangled in the air. "The water's still warm."

"Don't even think about it," Mom said, hauling him back in.

"It's not that far," he said.

"Your camera would get wrecked, dummy," I said.

Dad and Uncle Geordie caught two more crabs before finally rowing the rest of the way back to us. I was anxious to start hunting for cockles, bending down and looking for places where the sand bubbled. Those suckers moved fast. I'd always liked it when they stuck their tongues out, until Mom told me those were really their legs. As soon as we touched shore, Jimmy leaped off the boat and ran for the woods. Years of babysitting instinct kicked in, and I sprinted after him. Mom and Dad were shouting in the background, annoyed. I tackled Jimmy, and we both fell flat in the sand.

Mom caught up to us and pulled Jimmy to his feet by his ears. "What do you think you're doing, young man?"

"Making us rich!" he said. "I—"

"Lisa," Mom said to me, "stay with him and make sure he doesn't get into trouble."

"But—" Jimmy and I said at the same time.

"Don't argue with your mother," Dad said, "or you can both go back on the boat."

Jimmy almost started crying. He was getting older though, less prone to throwing himself on the ground, kicking and screaming. When they started to set up a little camp, I dragged him down the beach to look for shells.

We slept on the beach that night. We roasted more marshmallows and some hot dogs on the fire. Aunt Edith boiled hers, saying her stomach wasn't what it used to be, and Uncle Geordie fell asleep without eating, snoring so loud that he sounded like the gillnetter.

In the morning, Jimmy was gone. Dad and Mom hunted one way up the beach, and Aunt Edith and Uncle Geordie went the other. They shouted Jimmy's name. I was supposed to stay at the camp, but I heard something crack in the trees.

"Jimmy?" I said.

I heard someone start to run.

"I found him!" I shouted. "I found him!"

Without waiting to see if anyone had heard me, I started to run after him. I'd catch glimpses of a brown shirt and hear Jimmy up ahead, but I couldn't catch up to him. I chased him as hard as I could, until my side ached as if I'd been punched and I gasped for air. I could hear him ahead of me. I stopped, leaning over, consoling myself with the spanking Jimmy was going to get when we got back.

Suddenly, every hair on my body prickled. The trees were thick, and beneath them everything was hushed. A raven croaked somewhere above. I couldn't hear anyone calling for Jimmy. I could hear myself

breathing. I could feel someone watching me. "Jimmy?"

The sweat on my body was stinging cuts and scratches I hadn't been aware of before, was drying fast, making my skin cold. I turned very slowly. No one was behind me. I turned back and saw him. Just for a moment, just a glimpse of a tall man, covered in brown fur. He gave me a wide, friendly smile, but he had too many teeth and they were all pointed. He backed into the shadows, then stepped behind a cedar tree and vanished.

I couldn't move. Then I heard myself screaming and I stood there, not moving. Jimmy came running with his camera ready. He broke through the bushes and started snapping pictures wildly, first of me screaming and then of the woods around us. Jimmy was wearing a grey sweatshirt. I stared at him, and he stared out at the bushes.

"Where are they?" he said, excited.

Doubt began to set in: it had happened so fast and had been so brief, I wondered if I'd just imagined the whole thing.

"Did you see them?" Jimmy said. "Which way did they go?"

"Who?" I said.

"The sasquatches!" Jimmy said.

I thought about it, then pointed in the direction of our camp, and Jimmy started running back the way I'd come. I stayed for a moment longer, then turned around and left.

On the way back, Jimmy looked tired and scared. He stayed close to me. I didn't want to spook him, so I

didn't tell him about the man I'd seen disappearing behind the tree.

"Did you follow right behind me?" he said.

I nodded.

He sighed. "I thought you were asleep."

Jimmy got tanned, I got a lecture and we had to sleep on the boat that night instead of on the beach. Jimmy cried and cried, quietly. I knew he thought I was asleep, so I pretended to turn over and flop my arm across him. He didn't move. His breathing steadied, he sniffed a few times, then he curled into me and went to sleep. I watched the stars as the gillnetter bobbed. I cringed when I imagined myself telling people I'd seen a b'gwus. They'd snicker about it the way they did when Ma-ma-oo insisted they were real. But if the *Globe* did pay a lot of money for a picture, I'd probably given up a chance to make us rich.

I sigh. Maybe dreaming about Jimmy standing on Monkey Beach is simply regret at missed opportunities. Maybe it means I'm feeling guilty about withholding secrets. It could be a death sending, but those usually happen when you are awake.

God knows what the crows are trying to say. *La'es*— go down to the bottom of the ocean, to get snagged in the bottom, like a halibut hook stuck on the ocean floor; a boat sinking, coming to rest on the bottom. The seiner sank? Mom and Dad are in danger if they go on a boat? I should go after him? I used to think that if I could talk to the spirit world, I'd get some answers. Ha bloody ha. I wish the dead would just come out and say what they mean instead of being so passive-aggressive about the whole thing.

My mother gets up and pours herself a cup of coffee. She used to kick me out of the house when I smoked, but now she doesn't care. All the same, out of habit, I go out to the back porch even though Dad is smoking in the kitchen. The wind has started up, it's fast and cold, making whitecaps on the channel. It keeps blowing my lighter out, even when I cup the flame carefully. Mom bought me wind chimes last year for my nineteenth birthday, the expensive kind that sound like little gongs, and they're ringing like crazy. For Christmas, she bought me a box of smoker's chewing gum, foul and every kind of vile. I've tried tossing them in the garbage, but she sneaks them back in my desk.

The first puff flows in and I sit back, leaning into the patio chair. In addition to all that coffee, I smoked for hours last night. My throat hurts and is phlegmy. The sun is low and the light is weak, but it makes the water glitter. The ocean looks black where there's no light and dark green where the sun hits. A wave of lovely dizziness hits as the buzz kicks in. I have a moment of dislocation. I can separate myself from my memories and just be here, watching the clouds, ocean and light. I can feel my own nausea, the headache I'm getting, the tightness in my chest.

≋

I stood beside a ditch, looking down at a small, dark brown dog with white spots. I thought it was sleeping and climbed down to pet it. When I was near enough to touch it, I could see that the dog's skin was crisscrossed

by razor-thin cuts that were crusted with blood. It had bits of strange cloth tied to its fur. The dog whimpered and its legs jerked.

Someone tsk-tsked. I looked up, and a little, dark man with bright red hair was crouching beside me.

"Your doggy?" I said.

He shook his head, then pointed towards my house.

"Lisa!" Mom yelled from our front porch. "Lunchtime!"

"Come see doggie!" I yelled back.

"Lisa! Lunch! Now!"

Later, I dragged Mom to the ditch to see the dog. The flies had found it. Their lazy, contented buzz and the ripe smell of rotting flesh filled the air.

≋

Dad opens the back door and I jerk awake, making our rusty patio furniture squeal.

"Wind's picking up. You coming in?" he says.

"I'm going to sit for a while," I say.

"It's getting cold."

"I'm okay."

Dad comes out and sits beside me. He pulls out his own pack of cigarettes and lights up. He holds the pack out for me and I take one. He stopped bugging me about smoking a long time ago. He's like Uncle Mick that way, not one for arguing.

I had my first cigarette about six or seven years ago. Tab and I had snuck behind the gym. She'd carefully pulled a squashed Marlboro out of her lunchbox. Giggling, she'd told me she'd stolen it from her

mother. She'd showed me the elegant way to smoke, the cigarette low between your first two fingers, taking ladylike puffs and blowing the smoke upward. Much later, when Mom found out that I smoked, she'd blamed Uncle Mick for my nasty habit, until I pointed out that Dad smoked too. He'd glared at me. "What?" I'd said.

My Uncle Mick used to smoke a brand called Sago. I tried them and they made me high on the first puff. He liked to roll them himself, a habit Mom found even more disgusting than smoking. When cigarette prices went up, Dad tried to buy loose stuff, but Mom handed him a fifty-dollar bill and said she'd rather buy the damn things herself than have him smoking hippie weeds.

Dad gets up and goes inside. He comes back out with two blankets and hands one to me.

Sometimes I want to share my peculiar dreams with him. But when I bring them up, he looks at me like I've taken off my shirt and danced topless in front of him. The memories are so old that I used to think the little man and the dog in the ditch were a dream. I'm sure that was the first time I saw the little man. That was the day before the tidal wave. The next time was when I was six. I woke up with the eerie feeling that someone was staring at me. I clutched my ratty teddy bear, Mr. Booboo. When I finally got up the courage to peek out of my blankets, I could see by the moonlight that there were no monsters ready to grab me and drag me into dark places and do terrible things to me. My eyelids were pulling closed and my death grip on Mr. Booboo was loosening when my jewellery box

fell off my dresser. I jolted awake, heart thudding so hard I couldn't breathe. My jewellery box's tinkling, tinny music played, but I heard it only somewhere in the distance because I was staring open-mouthed at the red-haired man sitting cross-legged on the top of my dresser.

His crinkling face arranged itself into a grin as he rolled backwards and stood. He tilted a head that was too large for his body, put one stubby finger to his lips and went "Shh." Frozen where I lay, I couldn't have made a sound. His green plaid shirt jingled with tiny bells as he bowed to me, then he straightened until he was standing again and stepped back into the wall.

I didn't move from under the covers until Mom knocked on my door and said it was time to get my lazy bones out of bed. I told her about the little man and she gave me a hug and said everyone had bad dreams and not to be scared of them—they were just dreams and they couldn't hurt me.

"But he was here," I said.

She smoothed my hair. "Some dreams feel very real. Come on, let's get breakfast."

Dad came into the house as I was eating my cereal. He plopped a bulging burlap sack on the kitchen floor beside Mom. He looked very pleased with himself as he said, "Happy birthday, Gladys."

She opened the sack and peered inside. "Albert, you are just too romantic." She pulled out one of the cockles and balanced it on the back of her hand. "Next year, I want a diamond this big."

"I can take them back," he said, his smile growing fainter.

"Don't be silly," she said, standing on tiptoe to kiss his cheek. "I'm just teasing. It was very thoughtful."

He wasn't looking reassured until she kissed him again. When he leaned in for a bigger kiss, I felt it was time to make gagging noises so they wouldn't get too mushy in front of me.

"Go watch cartoons with Jimmy," Mom said.

Jimmy had parked himself two feet from the TV and right in the centre and he yelled out "Mom!" when I shoved him over.

"Lisa!" Mom said.

"He's hogging the TV!"

Later in the morning, while Mom checked the seals on the jars of cockles, the doorbell rang. I jumped up to get it. When I opened the door, I was looking up at a tall, deeply tanned man with black hair pulled back in one long braid.

"Hey, short stuff," he said. "Your mommy home?"

Mom came up behind me, stopping suddenly. I turned in time to see her smile freeze. "Oh my God."

The man held out a single pink salmonberry flower. "Surprise."

She kept staring at his face, mouth opening and closing soundlessly.

"Did I get the day wrong?"

"No, I, I thought you were . . . I mean, we heard the standoff went, um, well, badly and we thought . . . " Mom nervous was a new experience for me. I stared as she blushed and stepped back. "Come in," she said. Then to me, "Go get your dad."

The man had a loping, bowlegged walk that made

the fringe on his buckskin leather jacket sway as he strolled into the house.

"Dad!" I yelled. "Dad! There's a man here!"

"I said go, I didn't say scream," Mom said, turning a darker shade of red. "Now *go* get your dad."

"I'm coming, I'm coming," Dad said as he bounced up the basement steps. "How many times have I told you not to yell—" He stopped at the entrance to the hallway. The man took two steps and bear-hugged Dad so hard he lifted him off the ground.

"Look at you," the man said, thumping him back down and holding him at arm's length. "I heard you had settled down, but I didn't believe it."

"Jesus," Dad said, leaning over like he'd been punched in the stomach. "Jesus."

"You okay, Al? What's the matter? What?" the man said.

Dad put his shaking hands over his face and stayed bent over, shuddering. It took me a moment to realize he was crying.

"Go away!" I shouted at the man. "Get out! Go away!"

"Stop it, Lisa," Mom said.

"Al?" the man said.

Jimmy came running into the hallway. "Daddy?"

Dad wiped his face and said, "It's okay, it's okay."

I pushed myself between them and glared up at the man. "You go away."

The man knelt down and smiled at me. "You know who I am? I'm your uncle Mick."

"No, you're not. Uncle Mick's in jail."

The man burst out laughing. After a minute of silence on everyone else's part, he said as he stood up, "You thought I was in jail? Why the hell'd you think I was in the big house?"

The look Mom gave him was so dark that if she'd given it to me, I'd have been running for my room. Instead, Mick started laughing again. Dad was blinking faster and staring at the floor. I thought Mick was making fun of him and, in an absolute fury, pulled my foot back and gave the man a good, hard kick to the shins. He was howling and hopping so fast that none of my other kicks landed as nicely. Then Dad grabbed me around the waist, picked me up and said, "Enough now." To Mick, he said, "You want some coffee?"

Mom poured three cups of coffee, and we all sat at the kitchen table. Dad sat at one end, Mom at the other and Mick in the middle. Jimmy stood behind Mom's chair and wouldn't come out to say hi. I had a death grip on Dad's neck and wouldn't let go, even when Mom told me to bring Jimmy into the living room.

"No," I said.

"Lisa," Mom said in her warning tone that meant I was going to get a talking-to when we were alone.

"That's what we get for naming her after you," Dad said.

"You named her after me?" Mick said.

"Michael, meet Lisamarie Michelle," Mom said dryly. "It was supposed to be a touching tribute."

Uncle Mick reached to shake my hand and I lunged to bite his arm, but he pulled it back just in time. My

teeth snapped together so hard it hurt, like biting down on aluminum.

"Lisa! That's enough!" Mom said.

"Don't like you," I said to Mick.

"God," Mom said.

"Hey, I'm a good guy, not a bad guy," Mick said, not the least bit mad. "I'm your daddy's brother."

"I was surprised, that's all." Dad said, giving me a squeeze to get my attention. "Come on, say you're sorry for kicking your uncle."

"No," I said.

"You think I'd hurt your daddy?" Mick said. "I'd never hurt him."

"You better not," I said.

Mick started grinning again. "You should have named her Agnes, after Mother." When I scowled at him, he added, "'Cause she's a delicate Haisla flower too."

"Mother," Dad said, almost letting me go. "Jesus."

"What? Is she still mad at me? Man, she can hold a grudge."

"Mick," Mom said, "she thinks you're locked up somewhere."

"Why does everyone think that?"

"They phoned us," Dad said.

"Who?"

"All your friends. They said you were shot and the FBI took you away."

Mick's eyebrows went up. He turned to confirm this with Mom and she nodded.

He sat back in his chair and laughed so hard that the coffee came back up his nose and he started choking. Mom pounded his back. "You could have written.

You could have phoned. But no, that would have been too much trouble—"

"Okay, Gladys, now you're hurting me," Mick said, and she stopped hammering. "Jeez, I been kicked and walloped and yelled at, and I haven't even been home a half-hour. I was safer hiding out in the boonies, for Christ's sake."

"Oh, boohoo," Mom said, sarcastically. "You had us thinking you were being tortured God knows where."

"I didn't do it on purpose."

"You never do it on purpose."

"Enough, enough," Dad said. "Let's just figure out a way to tell Mother without giving her a heart attack."

While Dad and Mick went off to tell Ma-ma-oo the good news, Mom hauled the sack of cockles to the sink and began shucking them, popping cockles into her mouth, humming as she chewed. I was disgusted, imagining the cockles cold and slimy, and said so. Mom laughed, then said the best part was the cockles wiggling in your mouth.

I was afraid to sleep because of the little man's visit the night before. I lay awake with a stranglehold on Mr. Booboo and the lights turned on. Mom came by, and I pretended to sleep and she shut the light off. My bedroom is above the kitchen and when Mick and Dad returned, I could hear the murmur of conversation, but not the actual words. If I had got out of bed and pressed my ear against the register, I could have heard them, but I was too scared to leave the sanctuary of my covers. I heard the front door open and then Aunt Trudy shrieked. She cried and cried until Uncle Mick said she was ruining his second-best shirt. I fell asleep

to the sound of Mick's whooping laughter and the smell of coffee and cockle stew.

Now that I think back, the pattern of the little man's visits seems unwelcomely obvious, but at the time, his arrivals and departures had no meaning. As I grew older, he became a variation of the monster under the bed or the thing in the closet, a nightmare that faded with morning. He liked to sit on the top of my dresser when he came to visit, and he had a shock of bright red hair which stood up in messy, tangled puffs that he sometimes hid under a black top hat. When he was in a mean mood, he did a jerky little dance and pretended to poke at my eyes. The night before the hawks came, he drooped his head and blew me sad kisses that sparkled silver and gold in the dark and fell as soft as confetti.

The morning after Mom's birthday, as she was jarring the last of the cockles and I was using my blanket as a sleigh down the steps, she asked Dad to take me with him when he went for groceries. The road from Kitamaat Village to town is an eleven-kilometre strip of concrete that winds north along the coast and over steep hills like a roller coaster. It was finished in the late sixties and is patched every year when spring and fall floods eat away at the portions near the cliffs. Before the road was built, people went to town by boat. The town docks were across the channel, so even today, when people go to town, they say, "I'm going across."

The town of Kitimat, with its different spelling, has a fluctuating population of about ten to twelve thousand, while the village has between seven and eight hundred people. Most people from the village who

work in town travel this road twice a day and know its hairpin turns so well that they say they can drive it blindfolded. After getting his second speeding ticket in a month, Dad was one of those who pushed to get the speed limit raised from fifty kilometres an hour to sixty. When the safety inspector from the department of highways came out to test the road, he drove back and forth four times in a car laden with instruments, then announced that the road wasn't even safe to drive at fifty kilometres on dry pavement and the speed limit should actually be lowered to forty kilometres an hour.

Dad was driving too fast that day, but I liked the speeds that sent you straining against the seat belt. We stopped at the bank first. "Jesus," he said when he looked at his updated bankbook.

"Is something wrong?" the teller asked.

"I think there's been a mistake. There's a couple more zeros here than there should be."

"Oh," the teller said. "Is your brother Michael Hill?"

"Yes."

"He dropped by this morning. He said he owed you some money. He had your account number."

Dad shook his head. "He doesn't owe me anything. Could you give me the exact amount he put in?"

"You want to take it out?"

"Yes."

"All of it? You're sure?"

"Very."

The teller handed Dad a fat envelope, and instead of driving to the grocery store, we stopped in front of a long, run-down series of town houses.

"Stay in the car," Dad said.

"Don't want to," I said.

"Lisa, once, just once, don't argue with me. Okay? Stay in the car and don't move—"

"Well, howdy stranger!" Uncle Mick's voice boomed. I looked up and he was standing bare-chested in a pair of shorts on the porch.

"Stay," Dad said.

He walked up to Uncle Mick and held out the envelope. Mick shook his head. Dad tried to push the envelope into Mick's hands, but Mick lifted his arms above his head and dodged out of his way. Dad chased him until the door opened and a blonde white woman in a terry-cloth bathrobe started talking to Dad. They shook hands. Mick disappeared inside, came back outside wearing a flannel shirt, kissed the woman on the cheek and passed Dad as if he didn't notice him. He came straight to the car, with Dad following behind him.

"Hey, Lisa M," Mick said, opening the door and sliding into the backseat. His legs folded up almost to his chest, and he had to keep his head at an angle or he'd hit the roof. "You want some ice cream? Your daddy's taking us to Dairy Queen!"

"Yay!" I said, bouncing up and down on the seat. "Ice cream! Ice cream!"

"Hey, Al," Mick said when Dad got to the car. "Maybe we should take my truck. I'm getting claustrophobic back here."

"Ice cream! Ice cream! Ice cream!"

"Settle down, Lisa," Dad said. "We're not getting ice cream."

"Sure we are," Mick said. "You said we should go for coffee and I pick Dairy Queen. Do you want to go to Dairy Queen, Lisa M? Hmm? Ice cream! Banana splits! Strawberry sundaes!"

"Mick," Dad said, turning in his seat to glare at his brother.

"See?" Mick said, punching his shoulder. "You're outvoted." When Dad didn't say anything, Mick leaned back. "Don't worry about it, man. I figure it's the least I owe you."

"You should invest it," Dad said.

"I am," Mick said. "You're my Bank of Al. Come Christmas, I'll be bumming off you and living in your basement, you'll see."

≈

I unpacked the box of extra dishes we had given to Mick as a housewarming present. Mom put groceries in his cupboards while Dad looked through Mick's tax forms. A few days after he started work at the logging camp, Revenue Canada had sent their own welcome-back package—a bundle of forms for each year he'd been missing, with instructions to file immediately or face an audit. Jimmy stayed curled up in Dad's lap, thumb firmly in mouth. Dad gave an exasperated sigh and put down the papers he was holding. "This is a mess. It'll take me a few weeks to figure it out."

"I don't see why we have to file at all," Mick said. "The whole fucking country is on Indian land. We're not supposed to pay any taxes on or off reserves."

"God, don't start again," Dad said.

"This whole country was built on exploiting Indians for—"

"Mick," Dad pleaded.

"Look at this." Mom was shaking her head. "Nothing but Kraft. How does he stay healthy?"

I helped Mom by finding some wieners in the fridge. We began making a macaroni-and-wiener casserole.

"I'll make you a warrior yet," Mick said, punching Dad's shoulder.

"Enough, enough. You'll wake Jimmy."

"Tell your brother about the dishes," Mom said to Dad.

Dad started telling Mick about the tidal wave. I remembered that day very clearly. Late July, a bright, sunny day. Normally, you would still see people playing soccer on the field, or visiting with other people in the village, or picking up their mail—even after the warnings on the radio. You could expect a half-dozen or so tsunami warnings a year, and all they amounted to were some whitecaps. This time the evacuation order was real, and the fire station alarm was jangling in the background as Mom and Dad frantically ran to get clothes, bottled water and camping gear. Me and Jimmy were waiting in the car, with Jimmy screaming because Mom and Dad were upset and hiding it badly. Mom wanted to save her Royal Doulton and Dad said, "That's just dandy. People are going to say hey, aren't those the Hills floating by? They're dead, but damn they have nice dishes."

"If my dishes stay," Mom shot back, "so do your golf clubs."

"Jesus on crutches," Dad said, getting out of the car and heading to the basement. "At least I *use* my golf clubs."

Jimmy continued screaming and Mom came and took him out of his car seat and carried him to the front seat with her, singing him a lullaby.

She'd left the car door open. I knew I wasn't going to get another chance. I snuck out of the car and ran. I was ecstatic. I was finally going to have an adventure! I wasn't completely without an escape plan. I'd brought an umbrella. My idea was to turn it upside down and float away on it, just like in the books Dad read to me. I ran through the bushes at the back of our house and down the front street by the water. It was sheer bad luck that Uncle Geordie was driving to the docks to save his seiner. I saw his beat-up old Ford and I quickly veered off the road, running across the soccer field, but when I looked behind me, Uncle Geordie was pumping his gumboots, his yellow sou'wester flapping. I put everything I had into making it to the beach, then scrambled up a tree.

"Lisa, get down! Now!" he yelled, coming right under me and opening his arms as if he expected me to jump.

"Want see big wave!"

"Don't make me come up there!"

If Mom or Dad had made that threat, I wouldn't have worried because I knew neither of them was any good at climbing. I hadn't even known Uncle Geordie could run, and from the way he was glaring at me, I didn't want to find out if he could climb. He didn't lecture me when I got down, just scooped me up

and ran back to his truck, threw me in and drove me up to the old Hall, where almost everyone else had gathered, including Mom and Jimmy. Dad was driving around the village looking for me. Before he could go to the docks, Uncle Geordie had to go find him and tell him I was safe. They were both furious, but I was already crying, mad at everyone for ruining my big plans.

That night, when everything was over and we were sitting in Uncle Geordie's house, he told us about trying to save his boat. The docks had squealed and moaned, undulating over the water like snakes. One of the boats had swirled like a toy boat caught in the bath-tub's drain. The tide had risen so high, the ocean leaked and slid over the roads. Then the docks went underwater and the boats were floating over them, bumping and grinding their keels against them when the waves dipped down. Uncle Geordie gave up when the gangplank started twisting. Later, he found his seiner on the beach with half its keel scraped off.

≋

That spring was lush, filled with hazy sunlight and long afternoons on the porch with Mom, and we basked like lizards on her newly ordered patio furniture. Dad sat down beside us that afternoon and announced that he was going to grow a vegetable garden. Mom opened one eye, lifted a languid hand and sipped her coffee. "Good. Go do that."

At the garden centre, he poured over the seed packets, enlisting the help of passing clerks and other

customers. He showed me pictures of the plants and asked if I'd want to eat this or that. He spent the next three weeks happily turning ground, fertilizing, balancing pHs and planting seeds in egg cartons on our windowsills. I enthusiastically searched for worms and brought interesting bugs into the house in a Mason jar with the lid punched through with holes. Mom refused to join in, annoyed when Dad asked if she'd mind weeding.

"Look at these," she said, holding up her perfectly manicured fingernails with their stylish red nail polish. "Do you know how long I worked on these?"

Somewhere in our deepest past, in among eons of fishermen, there must have been a farmer. Whatever Dad touched grew like it had been fast-forwarded in a film. The sunflowers in the front yard shot up eight feet, with basketball-sized flowers that stared sullenly at the ground. The pumpkins and zucchini sprawled over potato patches and fought with the strawberry runners for ground space. Bees hummed contentedly in our greenery through the spring and summer, and the kids who raided our garden said there wasn't a better one in the village. In the pictures of the garden that year, Dad posed me and Jimmy for maximum effect, standing us beside the largest sunflowers, having us sit on the most orange pumpkins.

Over the years, he became more ambitious. He made an elaborate archway over the walk that led to our front door and planted trailing roses that everyone knew died in the winter. Ours survived to become thorough nuisances, choking Mom's nasturtiums and displacing carefully laid bricks with their gnarly roots.

Corn flourished for him, attracting hordes of crows and sparrows. Rhubarb spread broad leaves and grew to mutant-like heights, becoming hard and inedible when we refused to pick it, sick of the sweetly sour taste after weeks of eating it. Dad even transplanted a full-grown greengage tree from a house that was going to be demolished, and despite everyone's predictions to the contrary, the tree survived, producing fruit three years after it was plopped in our front yard, attracting kids and birds. The birds squawked and fought over the plums, and at least once a year, some kid would fall out of the tree and break an arm.

"Is a simple lawn so much to ask for?" Mom asked Aunt Edith over the phone. "Why does he always have to go overboard?"

You could always tell when Dad had done something he knew she wasn't going to like. His shoulders hunched, his smile turned up only the corners of his mouth and his eyebrows went halfway up his forehead, as if he couldn't believe what he'd done either.

"Now what?" Mom said, watching him gingerly carry a large cardboard box up our front steps. She opened the door for him, and we could all hear the high, sweet chirping of the chicks that poked their tiny beaks out of the air holes.

Dad smiled his silly smile, and Mom bit down firmly on whatever she was going to say and slammed the door in his face. "Chickens!" I heard her shouting at him later that night. "Chickens! You had to pick the filthiest, ugliest, most—"

Dad said something quiet.

"It's on your head, then," Mom said, sounding

disgusted. "They're your babies, mister. I want noth-ing, *nothing*, to do with them."

Uncle Mick howled when he saw Dad's chicken coop. To Mom's added annoyance, he began to sing the theme from "Green Acres," the TV show that she hated the most. When he teased her long enough, she would give him a good whack to the side of the head, but she had to stand up on tiptoe to do it because she barely scraped five feet and he was nearly six. If he really wanted to bug her, he pretended to stagger around, clutching his head after she hit him, which drove her nuts and made her whack him even more. He never knew when to stop, and he sang "Green Acres" until the day she got out the broom and chased him through the house, and he tripped over the living-room rug and hit his head on the coffee table.

For a few weeks me and Jimmy were the most pop-ular kids around, because all the other kids wanted to hold the chicks and feed them. I ran home every day after school to watch them. Dad defended his latest project by saying that at least it got me away from the TV, but as the chicks grew older and less cute, the kids trickled away.

Some time later, when Uncle Mick was baby-sitting us, we heard a chicken clucking on the roof. We looked at each other, puzzled. Dad had covered the backyard with fishnets so the hawks wouldn't get at the chickens. Mick got a broom to chase it down, and Jimmy and I went out to help him. To our surprise, it was a crow, imitating the chickens, pretending to peck at the roof and then gurgling so it sounded almost like it was laughing. "I'll be damned," Mick said.

The next morning, I awoke when I heard the chickens squawking. I thought they were fighting until I heard the hawks cry. I jumped up and ran to the window. There were large tears in the net over the coop. A chicken ran around and around, spurting blood from its missing head, until it fell over. Another chicken ran through the yard with its guts trailing behind it, flapping its one wing, shrieking. A hawk plunged through the net, squashed the screeching chicken in its grip and pecked its eyes. Mom chased the hawk out of the coop. She grabbed the half-eaten chicken as it ran by her. She picked it up and snapped its neck. Dad pulled me away from the window, and held me until I stopped crying.

Seven of the chickens were killed that morning, and the rest escaped through the hole in the net and were hiding down on the beach. Mick and Dad tried to round them up, but the chickens had been badly spooked. They refused to be herded back. Reserve dogs got most of them, foxes got others, some German tourists ran over one on the highway and the hawks finished off the rest.

≋

"Lisa, we're leaving now," Mom says, shaking my shoulder. "Are you all right?"

Dazed, thinking of Uncle Mick and the chickens, it takes me a moment to wake up from the memories. I have a crick in my neck from the way I've been sitting. Mom stares down at me, frowning, the lines creasing her forehead and her eyebrows exaggerated by the harsh early-morning slant of the light.

"Did you hear me?" she says.

I nod. "Sorry. Daydreaming."

"You should go inside and get some sleep."

"Who's driving you to the airport?" I say, struggling to get out of the patio chair.

"Kate. She brought some lemon meringue pie, if you're feeling hungry."

I shake my head. "Too early. I'll have some later."

"You should eat," she says.

Dad is already loading their luggage into his older sister's car. I wave and she waves back.

"We'll call you from Bella Bella," Mom says, giving me a quick hug.

"Okay," I say.

"Oh," she says casually, "Aunt Edith is staying over with you."

"Mom," I say, exasperated. Lately they've been treating me like I can't tie my own shoelaces. "I'm perfectly capable—"

"Just to keep you company," she says quickly.

"And out of trouble," Dad adds, coming up the steps. He gives me a hug too, squeezing my shoulders. "Don't give her a hard time."

"Would I do that?" I say.

"Behave yourself," Dad says.

"Eat," Mom says.

We say our goodbyes, and they wave as Aunt Kate drives them away. I stay on the front porch for a moment, then turn inside.

≋

I light a cigarette and Aunt Edith pointedly pushes a saucer my way. I nod thanks, but don't look at her. My hands are shaking and I feel like absolute shit. Eyes are closing again. I need coffee but moving from this spot is going to be tough. Aunt Edith probably thinks I have a hangover. She caught me a few minutes ago, asleep in front of the TV, and woke me up to ask if I needed anything. I said no, but she is frying bacon and eggs and the smell makes me nauseous.

Jimmy hates fried food. I tried to tell him that was all he was going to get on a boat. Staring through me, he said, "I'm not going out there for the cuisine."

"Well, why the fuck are you going?" I said.

"To make things right."

"What things?"

He ducked his head and muttered something about the money, and I know he told our parents he was saving up for his wedding. But he didn't even tell his girlfriend he was leaving. "Jimmy?"

He kept watching his feet. "Take care of yourself."

God, let this be an accident. Must have drifted off for a minute again. Or else Aunt Edith can move at superhuman speed. One second standing next to the stove, the next back at the table again. She takes the cigarette from my fingers and crushes it out. I realize I'm resting my face against the table. Can't remember falling over. She shoves breakfast into my hands, murmuring a prayer of thanks. I taste the fuzz in my mouth.

She moves through the kitchen with frenetic energy, wiping, sweeping, rearranging. My mother's kitchen is tidy, but while I stir the eggs into a pale

yellow pulp, Aunt Edith brings this room up to a level
where you could perform open-heart surgery on the
floors. I almost tell her to sit down and have a cup of
coffee, but I decide to let her go. At least her way of
dealing with stress gets the housework done. I force
down some bacon with coffee. After I finish breakfast,
she moves on to the living room. I watch her vacuum-
ing the area rug and curtains and marvel at her sta-
mina. Her fingers are swollen, but if you say anything
about her arthritis, she glowers and tells you to mind
your own beeswax. Dad says she's already given her
daughters her expensive jewellery. Practical yet mor-
bid, she told them that if she made it clear right now
who would get what there'd be fewer squabbles to mar
her funeral.

Jimmy would never hurt anyone. They must have
had an accident. It would be the worst kind of irony if
Jimmy died by drowning. He was never afraid of water.
When we were kids, we spent almost the whole of our
summers swimming.

The village is squashed up against the mountains
and the channel, a stretch of flat plain built up by
Walth Creek. The beach in front of the village is mostly
rocks and logs; you can swim there, but it isn't shel-
tered like the bay, which also has the government docks
and a breakwater made of logs linked together. The bay
marks the end of the reserve, at the other side of the
village from our house. The water there is relatively
calm and shallow. We used to start swimming in late
May, sometimes even in late April if the weather was
hot enough. Jimmy was a drag, but Mom wouldn't let
me go swimming without him.

On typical summer mornings, I would wake up late. Jimmy would already be watching cartoons. I'd change into my bathing suit and make myself some toast. Jimmy's mouth would be smeared red with Jell-O powder, his favourite. I'd nudge him and he'd hand the Jell-O box over. I'd dip my toast in it, then hand it back.

The day I remember most clearly was near the end of summer, the year after Mick came back. It started off the same: me and Jimmy watched cartoons until noon, then packed a lunch—a box of Jell-O and a peanut butter sandwich each, and greengages. We wrapped lunch in our towels and didn't bother to dress, wore our bathing suits and headed to the bay. The pavement was too hot to go barefoot so I wore flip-flops and Jimmy decided to wear his wading boots. He liked the sound they made when he didn't wear socks and his feet started to sweat. Sort of a cross between a burping and a farting sound.

Jimmy clomped behind me all the way to the bay. We claimed our spot on the docks by spreading our towels out. The tide was low and the sun was at just enough of an angle so that you could see the bottom, where there were piles of clamshell and a scattering of beer and pop cans. Minnows flashed near the surface. Jimmy kicked off his boots.

"Bonzai!" he yelled. He hadn't mastered the art of diving yet, so he belly-flopped into a school of minnows. He splashed around, trying to catch them, and I thought that six-year-old boys were possibly the stupidest animals on earth.

Jimmy swam towards the beach where his friends were. I stayed on the docks, listening to my cousin

Tab's radio and suntanning. Tab was always a scrawny
kid. She was born five pounds one ounce, and never
grew past four foot eleven. Her thin hair escaped all
attempts to tame it into ponytails or braids. She had
two of her baby teeth made into earrings and told any-
one who'd listen how she'd pried them out of her
mouth herself. She wasn't popular because people
thought she was weird. I liked playing with her because
she wasn't worried about ruining her clothes and she
taught me how to play poker and crazy eights. Everyone
called her Tab, like the diet pop, but her real name was
Tabitha. I thought her name was cool. I'd never let
anyone call me Tab. When I asked her about it, she said
she didn't give a flying fart what people called her as
long as they left her alone.

Another cousin, Erica, arrived, pausing at the top
of the gangplank leading down to the docks. She
shaded her face with one hand, surveying the territory.
Her distinctive wavy blue-black hair was rolled into a
ballerina's bun. A gang of friends chattered behind
her, wearing almost identical bathing suits. You could
tell they'd gone shopping together and Erica had
approved of this style, shimmering blue with spaghetti
straps. They claimed spaces beside me. Tab shut the
radio off. Erica pouted, artfully pursing her perfect
Cupid's bow lips. When Tab ignored her, Erica
reached over and turned it back on. One of the boys
who followed Erica around tried to get her attention
by dumping a pail of water on her. She pushed him off
the dock, and his friends grabbed her arms and legs
and swung her back and forth like a hammock until
they let her go and she fell shrieking into the water.

Two guys came towards me, and it was either trust them not to drop me when they swung me or dive in myself. I plugged my nose and jumped.

Although the ocean around Kitamaat warms up by August, this means that it's no longer ice water but isn't exactly tropical. Given a choice, I like to move in up to my ankles. Wait until my body adjusts. Up to the knees. Wait. Up to the thighs. Wait. And on and on, slowly, until I am dog-paddling around. Even then, I never enjoyed the first icy shock as much as Jimmy. I always felt panic, felt my heart stutter until I reached the surface. Erica swam up beside me and put her hand on my head when I surfaced. She let me catch a breath, then dunked me. After I struggled away, we went into a splashing fight that ended when Big Timmy did a belly flop beside us.

I got brave and dived, opening my eyes under-water. Colours changed. Dark brown skin looked pale. Bright swimsuits looked dull. I surfaced. The blue of the sky was dark cobalt at its height, but became milky turquoise as it neared the mountains. I floated on my back until horseflies started to buzz around my head. I dived. Sounds changed too. The sounds of boats bumping against the docks and the docks creaking in the waves were magnified, but the yelling and tinny radio music were muted. My ears began to ache, but I felt light. I lifted my arms over my head and kicked my leg out so that I spun like the plastic ballerina in my jewellery box.

When I came up for air, someone hit me on the arm and said, "You're it!"

I played tag until my arms and legs felt dislocated

from the rest of me, then went back to the dock and ate my sandwich. I shared the Jell-O powder with Erica and her gang in return for Oreo cookies and Kool-Aid. "Look," Tab said. She pointed with her chin out to the ocean.

I turned. Jimmy was waving to me from the break-water logs, thirty feet from the dock. I could see him slick and shiny with water, and watched him help pull his friends up. They ran to the end of the breakwater, leaping across the space between the logs, the space that opened and closed with the waves and the length of the chains that held the logs together. Every time they jumped, I imagined Jimmy falling. When they reached the end, they turned around and ran all the way back. Jimmy saw me still watching him. While his friends dived in, he waved to me again. I waved back. He shouted something. Probably "Bonzai!"

He dived in. I waited. He didn't surface. Long after his friends came up, he was still underwater. The skin on my arms and legs goose-pimpled. I didn't move until I saw his head. When Jimmy pulled himself onto the dock, asking me for half of my sandwich. I said if he wanted more he could go home and he glared at me, but I glared right back at him. He was just about to tell me off, when he stopped, mouth open, eyes suddenly not seeing me at all, staring intently at something behind me. The chatter died off, and the other kids turned to stare. I twisted around to see what everyone was ogling.

A new girl was coming down the gangplank. Without smiling or looking shy, she gave us all a flat, assessing glance. She paused, then flipped her waist-length hair

behind her and walked over to sit beside a group of girls I never played with.

"Who's the snot?" I heard Erica whisper.

"Adelaine Jones," Tab whispered back. "Just moved back with her mother."

This girl was not just pretty, she was actual model material. Puppy-dog-eyed boys watched her sunbathing. Erica glared venomously. The new girl ignored us all. I hoped she went to our school, so I could watch her duke it out with Erica.

"Adelaine," I heard Jimmy whisper.

We stayed in the bay until dinner. Jimmy wanted to go with me to Erica's house, but I was tired of babysitting and told him to go home. When he didn't, I told him we were going up the graveyard and we'd be playing there until dark.

"I'm telling," he said.

"Go ahead," I said.

I ate at Erica's, a large house up the steep hill near the band council office. Aunt Kate frowned at our wet bathing suits, made us dry off on the porch, then stuffed us with huge chunks of watermelon, fresh buns and homemade blueberry jam. Then we all trooped outside and played a variation of tag by spitting watermelon seeds at each other until Aunt Kate called Erica in and told me and the rest of Erica's gang that it was time to go home.

Mom was waiting for me in the living room. "You shouldn't have left Jimmy like that. You should know better." I glared at the floor. "He's your brother. He wants to be with you."

"He's a poop-head."

"Lisa—"

"He is! He's a big, stupid poop-head."

"Enough."

Mad at the unfairness of it all, I started crying. I didn't want to, and I didn't raise my head, not wanting it to show.

"Come here," Mom said. When I didn't, she came and stood over me. "He wants to do everything you do. He wants to go where you go. You think he'll want that forever? He's going to go his way and you'll go yours, and this is what you'll miss."

"Won't."

She kissed the top of my head. "Will."

If you stand on your tiptoes and lean out the window, you can see the bay from our house. The bay curves out, and the part that juts into the ocean everyone simply calls the point. Beyond the point, there are the Octopus Beds, rocks that have long, smooth indentations where it looks like giant octopuses sleep. The channel itself is wide and deep, a saltwater sea. As I stand by the window, the channel is dull grey-blue under the clouds. The Greeks ironically called the Black Sea *Euxinos*: friendly to strangers. Those who know the ocean know it doesn't make friends. *Exitio est avidum mare nautis*— the greedy sea is there to be a doom for sailors.

I never understood Jimmy's implicit trust that the water would hold him safely. The first time we were at the Sam Lindsay Memorial Pool, Jimmy got in line for the swing, a thick, knotted rope that hung from the ceiling. The lifeguard asked Jimmy how old he was, and when he admitted he was six, the guard herded him back to the shallow end, where I'd been watching

him. I shook my head, "Told you so." He sat miserably on the side of the pool and kicked the water.

The pool was a novelty. Usually we went down to the docks at the bay and splashed around. Jimmy liked the diving boards and the swing and the balls and other toys. I think he had no sense of smell, otherwise he would have been be as nauseated as I was from the bitter smell of chlorine. But that year in school, all the kids in my class had gone to the pool for swimming lessons. You had to be able to duck underwater twenty times in less than five minutes, stay underwater and blow bubbles through your nose, float on your back and do the deadman's float before the swim instructors would allow you to progress to dog-paddling. I hadn't even managed the bobbing-underwater part. Once underwater, my ears would ache and the water would press against me unpleasantly. I was afraid to open my eyes, afraid of the darkness and of not being able to breathe. I would shoot to the surface, gasping and frantically splashing. At the beginning of the lessons, there had been ten of us in the shallow end. By the last lesson, there was only me and a frustrated instructor, who put her hand on my head and held me under to show me I wouldn't drown. I hit her shin until she let me go. She passed me on condition that I wouldn't tell anyone what she'd done.

I was determined not to be the only kid in the shallow end when we started swimming lessons again in the fall. I had four weeks left before school started; I was going to learn to bob if it killed me. It didn't help that Jimmy copied me effortlessly. As I scrambled for the surface, he would stare up at me from underwater. If

he'd been smug, I could have coped with it. I would have given him a good whack. But he gave me these soft, pitying looks that people give only when you are being truly pathetic.

Jimmy copied everybody. If the kids hurled themselves off the diving board, he was next in line, making a ferocious run for it, bouncing off the end, curling up and cannonballing into the water. If some girls dived underwater for brightly coloured rings, Jimmy had to do it too. I would watch him go into the swimming lane and copy adults doing strokes, afraid that he was going to get hit, but he never did.

That was the summer Jimmy found his calling. Even though he was scared to run home alone in the darkness, and was still pissing his bed because he was too afraid to go to the bathroom in case the monsters hiding underneath grabbed him, he decided what he was going to do for the rest of his life. We were watching a documentary about the Moscow Olympics on TV. A Canadian swimmer came in second doing the butterfly stroke. As the guy was standing on the podium, Jimmy said, "I'm going to get a gold."

I think my reaction was, "Yeah, yeah. Shut up and watch TV."

He pushed some kitchen chairs together later that night and stood on the one in the centre, handing himself foil-wrapped chocolate coins. I booed and made farting noises. Ignoring me, he waved to imaginary fans, sang himself "O Canada," then ate his gold medal.

Jimmy got his first bike three months after me. He turned to me and stuck out his tongue. "You can't even ride yours."

"Can so," I said.

"Can't. Bet you I can ride mine tomorrow."

"Enough," Dad said. They disappeared to the back of the house for Dad to adjust Jimmy's banana seat and oil the chain.

I was so pissed off that I decided to learn how to ride my bike right then and there. I dragged it out of the garage and pushed it out of sight of our house.

When I sat on it and tried to pedal, I tilted over. I couldn't get my balance. The afternoon sped by as I pictured Jimmy circling me on his bike, snickering. I finally got my balance, but I couldn't keep it when I started pedaling. It dawned on me that if I was on a hill, I could balance and roll at the same time. I was going to try it on a small hill first, but then decided that a big hill would be better.

I went to the top of Council Hill, which slants as steep as a roller-coaster ride. I balanced, then pushed myself over. The bike went so fast that the handlebars started to shake. I put on the brakes, hard, and my bike flipped over. I crashed near the big tree that marks the halfway point of the hill. My bike lay with both tires spinning crazily. I got up and felt blood leak down my knee where the skin was scraped open.

Damned if Jimmy was going to lord it over me for the rest of eternity. It was embarrassing enough that he could swim, dive and snorkel while I was still dog-paddling in the shallow end. I picked up my bike and got back on it. I pushed off and flew down the hill. At the bottom of Council Hill there is a four-way stop. The trees blocked my view, so I never saw the truck coming until it honked.

I zipped through the stop, heart thudding as the truck swooshed by me. I tried to pedal, but the bike was going so fast that the chain just ran loose. My hair whipped behind me and my skin tingled. As the bike slowed, I tried to pedal again. The chain caught and I was biking.

The truckdriver turned out to be Uncle Geordie, who drove around until he found me, made me get off my bike, threw it in his truck and drove me home. Dad confiscated my bike and we went to Emergency, even though I kept telling everybody I was fine.

Jimmy got training wheels and didn't learn to bike without them for another four months, but I wasn't allowed to ride my bike for two weeks. I gloated as much as I could, but Jimmy spoiled it by pointing out that half of my face looked like a pizza. The scars are still there, but you can't see them until I get tanned, and then they stand out like freckles.

My wounds were still oozing and raw three days later when Mom said I wasn't grounded any more, and I decided to go spend the day at my cousin Tab's. Her house was only a few years old, but it already looked run-down. The walls had punched-out holes and the carpet was grey and cigarette-burnt. Her room was in an unfinished basement and never seemed to get warm. I liked going over to Tab's house because her mother didn't act like I was going to break something or watch me nervously like Aunt Kate when Erica had the gang over.

No one ever came down to the basement, so we had complete privacy. As a change from playing cards, which I usually lost, I brought Tab *True Stories* and we

read "In Love with a Felon," about a woman who eventually married the burglar that had kidnapped her.

"Holy, what a dummy," Tab said. "Why didn't she just turn him in?"

"She was in love," I said. "Didn't you read that part?"

"She was a horny slut," Tab said.

I sucked in a breath, shocked, thrilled. Mom would never let me get away with swearing the way Tab's did. But Gertrude, Tab's mother, wasn't anything like mine. Dad said that even when they were kids he never called his sister Gertrude, because if you did, she would backslap you into next week. She hadn't officially changed her name to Trudy, but if you were smart you didn't call her anything else. We could hear her vomiting in the upstairs bathroom, then clomping down the stairs to Tab's room, hungover and cranky, she sent me home, saying I could damn well eat out someone else's fridge.

Mick had moved into an apartment near the City Centre Mall. Mom and Dad were going to Terrace for a wedding, and since most of the people in the village were going too, Mick was the only baby-sitter she could find. Mom told me to be on my best behaviour. She didn't tell Jimmy to behave himself, but he sat quietly on Uncle Mick's sofa.

Uncle Mick's apartment was large but almost empty. He had a TV, a battered plaid sofa that smelled mouldy, a kitchen table with some crates in place of a missing leg, a mattress on the floor and a dresser with all the knobs broken off. The only new thing was an eight-track, which would have been great if he'd played

anything but Elvis. Later, Dad told me Mick was very happy I'd been named after the King's daughter, but disappointed that they hadn't named Jimmy Elvis, or at the very least, Presley.

"Elvis Hill," Dad said, rolling his eyes.

Mick was on workman's comp that summer. There'd been an accident out in the logging camp, and he'd been knocked over by a truck. He moved slow, as if he were an old man. He made us Kraft Dinner with wieners and some grape Kool-Aid. Then he retreated to his bedroom, poking his head out once in a while to see what we were up to. Jimmy was happy to have a TV all to himself and he could watch forever. I went and knocked on Mick's door.

"What's up?" he said, pushing himself onto his elbows.

I carefully sat on the edge of his mattress. He winced when it wobbled. I paused for a moment, knowing Mom would say I was being rude.

"What?" he said.

"Did you really get shot?" I said.

He smiled, but only one side of his mouth turned up. "Yeah."

"Did it hurt? Did you cry?"

"You betcha."

"Who shot you? Did you shoot him back? How come you went to jail?"

He closed his eyes and eased himself back down onto his mattress. "Do me a big favour. Go get me a glass of water, okay?"

None of his dishes were clean so I had to rinse out a glass. He thanked me when I handed him the water.

He took out a plastic bottle and shook out two large orange pills with one hand, then popped them into his mouth. "Listen, if I fall asleep, you go and watch Jimmy. If anything happens, you take care of him first, you hear?"

I nodded.

"Good girl," he said. "I owe you one. Why don't you go watch TV? Good girl. Go watch TV."

I waited patiently, but then his eyes started drifting shut. "Uncle Mick?"

He blinked hard and stared at me. "What?"

"Who shot you?"

"It's a long story, all grown-up and silly."

"I like stories."

"You do, huh?" He grimaced as he shifted his pillow under his neck. "Well, about the time you were born, I was on a reserve called Rosebud having tea with a very nice old woman. She was a few years older than your Ma-ma-oo and some people were doing things she didn't like—"

"What people? Were they drug dealers?"

"No, no. They were Goons."

"Why were they called Goons?"

"Guardians of the Oglala Nation. Goons. That's what they were. Big, old goons." He crossed his eyes and let his tongue roll out of his mouth. I laughed. Then he added lightly, "This old lady had told the police about what the Goons were doing and the police had told the Goons what she said, and so the Goons came over to her house while we were having tea and they shot at us."

"Why?"

He shrugged. "Because the world is a fucked-up, amoral—" He paused, scratched his nose. "They were trying to scare her into shutting up."

"Did she shut up?"

"Yes."

"Oh."

"Did you like that story? Kind of a shitty ending, huh?" He sounded tired. I touched his arm. "That's okay. I liked it."

"Yeah?"

"Yeah. Dad puts sound effects in his stories but Ma-ma-oo says you shouldn't put them in just to make it exciting. But if you got guns in your story, and you got shot, maybe you can go *bam! bam!* And go like this—" I clutched my side and hollered, then fell to the floor and rolled around in mock agony.

Mick's bewildered expression stopped me. "I guess that was too exciting," I said meekly. "Mom says I should learn when to be quiet. I'll check on Jimmy now."

I shook Mick awake a half-hour before Dad and Mom came back. He was finishing his first coffee when they walked in. Dad tried to pay Mick for baby-sitting us, but he wouldn't take any money. The next day, Dad bought him a mattress and bedframe. Mick told him to take it back. Dad set it up in the bedroom while his brother stood in the doorway and I told him how many teeth I had left. I counted them for him, and Mick patted my head. "Good, good. Al, come on, man. I have a mattress."

"Now you have a better one," Dad said.

"I don't even know how long I'm going to stay here. Why should I get good furniture if I—"

"Bank of Al, remember?"

≋

One of Dad's cousins had died a year earlier and we
were invited to the settlement feast. The day before
the event, all the women in the family had had to help
do the cooking. We went over to Aunt Kate's because
she had the biggest kitchen. I'd peeled carrots while
Erica had peeled potatoes because she could peel veg-
etables better.

The day of the feast, Dad and Jimmy went to
Terrace for one of Jimmy's first swim meets. I com-
plained about this while I was being physically forced
into a pink dress that was too tight around my chest
and fluffed out like a duster around my legs. As Mom
scraped my hair back into a bun and secured it at the
top of my neck, she said that they wouldn't be getting
out of it either, they'd join us as soon as they got back.
Then she muttered under her breath that she'd kill
Dad if she caught him watching hockey. I had to wear
black patents that pinched. I snuck my Pac-Man game
into my knapsack because anything you had to dress up
for couldn't be fun.

The rec centre was decorated with cedar boughs.
The tables were lined up in rows across the gym. We
sat with Aunt Trudy in the corner, near the basketball
hoops. The invitation said the feast would start at
6 p.m., but everyone knows that these things always
start about a half-hour later than the time specified.
That gives everyone time to mingle and check out what
everyone else is wearing or talk about the people who

didn't show up. Or, if they're far enough out of hear-
ing range, the people who did show up.

"Lordy," Mom said.

I turned in my seat in time to catch Mick swagger-
ing through the front doors.

Mom and Aunt Trudy exchanged glances and
Trudy said, "All he needs is a black hat with a feather."

For work, Uncle Mick wore his plaid shirt and
rubber boots. On hot days, he wore his message
T-shirts: Free Leonard Peltier! or Columbus: 500
Years of Genocide and Counting. Usually, he wore a
Levi jacket with Trail of Broken Treaties embroidered
in bright red thread on the back. For this feast, he'd
changed into his buckskin jacket with fringe, his
A.I.M. Higher—Join the American Indian Move-
ment! T-shirt and his least ratty pair of jeans. He
spotted us and let out a moose call. Mom cringed.
Conversations stopped and people turned to watch my
uncle as he came over to our table. When I sat in his
lap, he let me play with the claw that dangled from his
bone choker. He wore it all the time, along with an
earring of a silver feather.

Mom had her everyday earrings—the ones with two
delicate gold coins, the tiny carved ravens, or the gold
nuggets—and her special jewellery that was kept in a
small safe in the basement. I liked those the best—
a gold brooch of a raven clutching a fiery opal, a neck-
lace of real pearls. For the feast, she was wearing her
two-inch, 22-K gold bracelet, carved by a famous
artist that she was careful not to name unless asked, so
that people wouldn't think she was bragging. She
bought me dainty, dime-sized earrings and elegant

bracelets and brooches. I found them boring. I went for the earrings that dangled to my shoulders, or jingled and sparkled when I walked.

I saw some of my friends and Mom waved me away to play with them, firmly in a conversation with Aunt Trudy about Stanley's open-heart surgery, while Mick flirted with some women I didn't know. Erica didn't leave her table. She sat there the whole time with her hands neatly folded in her lap, waiting patiently. I couldn't believe anybody was buying her goody-two-shoes act. She was the first girl in our age group to smoke and the first to get a hickey.

Ma-ma-oo entered the gym wearing a black sweater. I called to her and ran back to our table and pulled out a chair for her. As soon as she saw Aunt Trudy, Ma-ma-oo's wide smile hardened into falseness. She sat stiffly in her chair. "Trudy," she said.

"Mother," Aunt Trudy said.

"If you get bored, I have a Pac-Man game." I offered it to Ma-ma-oo. "You can use it if you want."

"Lisa," Mom said in a warning tone.

"If someone's speaking, you have to listen," Ma-ma-oo said. "You have to show them respect, even if—"

"Yes, be a good girl, Lisa," Aunt Trudy interrupted. "Be a fucking little lady. See what that gets you."

Mom asked me to get her a coffee, and when I came back no one at our table wanted to talk.

Dad and Jimmy arrived as dinner was winding down. Jimmy barreled towards Mom, wrapping his arms around her waist. He held up the medal he was now wearing around his neck and she kissed the top of his head, telling him how proud she was.

When Dad came in, he waved at Mom, then at me, but he stopped short when he saw Ma-ma-oo and Aunt Trudy sitting side by side. He advanced slowly while Jimmy was excitedly telling Mom how he kicked butt, but Mom was only pretending to listen, was nervously sneaking looks back and forth at Ma-ma-oo and Aunt Trudy.

"Come on, Jimmy-boy," Dad said. "Let's put that medal with the rest. We're going to have to build a trophy case soon."

"Aw, Dad," Jimmy said.

"Let's go."

"See ya later, Ma-ma-oo!"

Ma-ma-oo watched them leave, hands locked around her cup. They stopped to talk to Josh, who laughed at something Jimmy said.

"You be careful, Trudy. Josh isn't right."

Trudy gave an exaggerated sigh. "You think he's not good enough for me? Or is it the other way around?"

Ma-ma-oo's lips thinned to a tight line.

Mick came back to the table as there was a bustle of activity at the head table. He pulled up a chair and wedged himself between Ma-ma-oo and Aunt Trudy, loudly announcing that he wanted to be between the two most beautiful women in the whole of Kitamaat Village.

Jimmy and Dad came back moments before Rick, the master of ceremonies, opened the floor to anyone who wanted to speak. Marty Gable stood up and there was a subdued sigh from the crowd. Marty the Mouth— the man who had never heard the saying "Silence is golden"—began with his birth and worked his way up to his retirement from commercial fishing. Everyone

around me was looking glazed. I couldn't figure out why Ma-ma-oo and Aunt Trudy didn't get along.

Mick came over to our house for coffee. The grown-ups sat around the kitchen table. I listened to them from the front porch while I waited for Aunt Trudy to bring Tab over. Trudy, Mick and Mick's friend Josh were going out to the bars and I could hear Mick trying to talk Dad into going along. Aunt Trudy's green car pulled into our driveway. She waved at me as Tab stepped out. It occurred to me then that if Dad didn't talk much to Ma-ma-oo, Aunt Trudy didn't talk to her at all. I wondered if it was for the same reason.

"Why doesn't your mom talk to Ma-ma-oo?" I asked Tab when we were reading comics in my bedroom.

Tab sighed. "Don't you pay attention?"

"I pay attention," I said, getting indignant.

"No, you don't. Ba-ba-oo was an asshole. He beat Gran. Instead of sending him away, she sent Mick and Mom to residential school."

"And?"

"God, you can be so dense," she said.

≋

If Mick and Dad hadn't been brothers, I wonder if they would have ever spoken to each other. Dad had been to school to become an accountant, but he quit the firm he was with after they passed him up for promotion four times. He spent a few years working at home, but the money wasn't good and he hated the tax-time crunch. He tried working for the village council, but the politics made him crabby and tired. Working at the

potlines in Alcan was steady—he got to leave his job at the end of the day and didn't have to think about it again until the next shift and, he told me once, he made more money. Uncle Mick, on the other hand, hated straight work. After he drifted out of A.I.M., he fished on Josh's seiner, did some logging, beach-combing, trapping, fire fighting, tree planting—whatever paid his rent. He rarely used his apartment because he liked camping better. Dad didn't like to be anywhere you couldn't get cable.

They shared a fishing net, which meant that Dad had bought it and paid for gas for the boat while Mick did most of the actual net-checking. Mick took me out sometimes, when I behaved and managed to stay out of trouble for a few days at a time. Mom bought me a life jacket and said that if she caught me even once without it, she'd tan my butt from here to king-dom come.

Our net was a five-minute ride from the docks. One end of the net was attached to the shore, and the other to a buoy, a few hundred feet out. The net was held up by a series of corks, which was how you could tell if you'd been skunked or not. If a section of the corks was underwater, it meant that the net was hold-ing up some weight. It could fool you, though, and just be driftwood. We would pull up beside the net, and Mick would cut the engine. With one cigarette dan-gling from the corner of his mouth, he would reach down and, beginning from the buoy end, pull the net up section by section, pulling out weeds and gunk as he went. The weight of the net and Mick together would make the speedboat tilt so the bilge shifted and gurgled

under our feet. At first I was afraid, convinced we were going to tip over, but after a few times, I trusted Mick to know if we were in danger. Sometimes, the fish would still be alive, and Mick let me club them on the head. I wanted to prove I wasn't a wussy girl. He'd shake his head and grin, telling me not to turn them into mush.

That summer, the ocean was clouded with jelly-fish—small, translucent ones with an oily rainbow sheen. They got stuck in the net, and when we were pulling it up, they stung my hands. Mick kept smoking and pulling. I swallowed my tears, and that night my hands burned. I smeared them with Noxema. I swore to myself that if Mick didn't say anything, neither would I.

He baby-sat us five more times that summer. If it was hot, we'd make a trip to the corner store and get double-scooped ice cream and candy. Mom protested, but he said it was his job as an uncle to get us hypered up before he sent us home. If it was raining, he'd drive us around to the mall or the library. Once, he took us to Mount Layton Hot Springs and stayed in the hot tub while me and Jimmy tired ourselves out in the big pool.

The last time he was supposed to baby-sit us that summer, Mom dropped us off but stopped outside his door, listening to the sounds of breaking glass and swearing. Neighbours cautiously stood in the hallway, staring at Mick's door. The walls vibrated as things were thrown around inside. Jimmy's eyes went wide and he held my hand. Mom looked down at us. "Go wait in the car."

I took Jimmy back, put his seat belt on him and told him to stay put. I ran back to Mick's apartment. The door was open. Mick was in the living room, pulling apart his eight-track tapes. Mom watched him, hugging herself. Finally, she reached out and tried to stop him. She said something I couldn't hear.

"He's dead!" Mick yelled at her. "Don't you get it? D-E-A-D."

She took a step back. He crumpled and sat with a heavy thud, the pile of broken eight-tracks crunching under him.

She went over to the phone. As she talked in a low voice, Mick's head rolled listlessly, as if he couldn't keep it still. Mom turned around and I ducked out of sight before she could spot me.

Wow, I thought. He's really drunk.

I went back and waited in the car. Jimmy asked if we were still going swimming. He looked so hopeful when he said this, I said maybe.

Mick's drinking buddy, Josh, walked up the apartment building steps. As he headed inside, I slouched in my seat so he wouldn't see me. The times that he came to pick up Mick at our house, he would stagger over, wanting to talk about their glory days on the basketball team when they were teenagers. If he cornered you, he'd go on and on about how hard he'd trained, how good he'd been and what a great team he'd made with Mick. Mom came out of the building a few minutes after Josh went in, frowning, but no longer looking lost.

"Uncle Mick's not feeling too good," she said as she clambered into the car.

"What's wrong?" I said.

She slammed her seat belt in and gave the ignition a yank. "The world has come to an end," she said very dryly. "Elvis is dead."

"Who's Elvis?" Jimmy said.

Mick took off for almost a month and we later learned he'd driven to Graceland. Not knowing this at the time, Dad phoned and phoned, and when Mick didn't answer, Dad banged on his door, yelling at him to let them in. Mom phoned Mick's friends, his ex-girlfriends, his fishing buddies, all the family. By the time he came back, he'd lost his job and his apartment. My parents put him on the missing person's list and had to call the police department to tell them he was okay. When Mick said that if they pushed the panic button every time he took off, they'd be grey-haired by the time they were forty. Dad picked up his brother's eight-track machine and threw it against the TV.

Dad didn't talk to his brother for two weeks. If Mick came over, Dad would go into his bedroom. He hung up if Mick tried to call. But the more he ignored Mick, the more cheerful his brother became. He was staying with Josh, but visited our house almost every night, trying to make Dad say something even though Dad was ignoring him.

Mick came by with an offering of freshly killed deer. As he held the carcass in his arms, covered in a blue tarp, Dad stood in the doorway, not letting him in.

"I'll just leave it here then," Mick said.

His footsteps clunked down the stairs. Before he got to his truck, Dad yelled out, "Do you expect me to carry this in myself?"

Late one afternoon, Erica and I were playing hop-scotch in front of the rec centre. Erica was cheating, but I had to let her, or she'd go home and I'd have no one to play with but dumb old Jimmy. It was getting cold. The streetlight flickered on early, then spasmed and flashed like a strobe light, yellow against the blue sky. Erica was almost finished, balancing on one foot as she bent over to pick up her rock. As she straightened, I saw her freeze, then she was running, her shoes clicking fast against the pavement. I turned just as someone pushed me down.

I put my hands out and managed to scrape only my palms. Three boys about my age circled me on their bikes, laughing. One of them was Frank, who kept trying to run me over. I had to roll fast to keep out of his way. He was bigger than anybody in grade two, and if he decided he didn't like you, you were in trouble. His hair flopped all over his face and his shirt flapped as he drove his bike towards me.

"If you touch me again, I'm telling my mom!" I shouted.

"Mommy!" Frank said, making another run at me.

"Waaa!" the other guys said, pretending to cry. "Waaaa! She wants her mommy."

"Go on and cry!" Frank said. "Wussy baby."

"Wus-sy ba-by, wus-sy ba-by!" the other two sang.

"I'm not!" I said. "You take that back or I'll . . . I'll—"

"Moooommy! Mommy!" Frank said, kicking my arm as he rode by. "Come on, wussy baby, cry."

I stood up, blood leaking through my shirt. My lips trembled, and I felt the first hot tears sliding down my

face. Frank pointed at me and laughed. The others joined in. He was going to tell everybody at school that I was a wussy baby, and that was what they were going to call me forever. Last week, he'd chased Erica around, and when he and his friends caught her, they pulled her dress up. She was wearing pink panties but they told everyone she was wearing diapers. They still called her Pissy-missy.

Rage scorched my face. I balled my fists up, held them in front of me and rammed into Frank. His bike tipped over and he yelped. I landed on top of him. I sank my teeth into the closest part of him, which happened to be his butt. He howled and tried to punch me off, but I dug my teeth in harder, until I could taste his blood through his shorts. I wrapped my arms around his leg and held on with all my might.

He was really screeching now, scrambling to get out from under the bike and away from me. As he dragged me with him, my legs scraped against the chain and the pedal. His friends had jumped off their bikes by now and were kicking any part of me they could get to, sometimes hitting Frank.

Frank punched me in the face. It hurt so bad that my eyes swam in their sockets. I fell back, pulling him with me. We rolled together on the ground, and I made my hands into claws and raked his arms.

Someone was shouting at us to stop fighting, and I saw Erica's brother J.J. above us as he kicked Frank's friends, who hopped on their bikes and rode away. Frank rolled away from me and sprinted after them. I thought of chasing him, but I was too slow so I stomped on his bike. The spokes bent and the chain flew off.

J.J. watched me, grinning. When I got tired and paused, he said, "You done?"

"Oh my God," Mom said when J.J. carried me into our house. I cried so hard that I couldn't tell her what had happened.

J.J. said, "If you think she looks bad, you should see the other kids."

Mom gave him a dark dirty look and took me from him, lowering me slowly to the ground and giving me a gentle hug.

While she was cleaning my cuts, Mick dropped by. He drove us to Emergency. Frank and his mother were already in the waiting room. She pursed her lips and stood. Mom tucked me behind her and glared.

"My Frankie needs shots because of your daughter," she said.

"Oh?" Mom said.

"Look at what she did." She pulled Frank to her, spun him around and pushed his shorts down.

"Mom!" Frank said, pulling his shorts back up.

"If Frankie hadn't been torturing my daughter, he wouldn't have got bit, would he? I'd say he got what he deserved."

"I could sue you."

"Try it. I'll see your juvenile delinquent in foster care faster than you can say court date."

"Ladies, ladies, ladies," an orderly said, jogging into the waiting room to stand between them. The nurse hastily called out Frank's name and ushered them out.

"Wipe that smirk off your face," Mom said to Uncle Mick, who immediately sucked his smile into a pucker.

She paced the waiting room while he cheerfully gave the duty nurse our address and phone number. I sat by the TV, wiggling a loose tooth with my tongue.

While Mom was in the bathroom and Mick was flirting with the nurse, Frank and his mother came back out. She came right up to me and said, "I think you have something to say to my son."

I knew I was supposed to say sorry. But if Frank wasn't going to say it, neither was I. "You taste like poo."

"You are a monster," she said to me. "You are an evil little monster."

"Takes one to know one!" Mick shouted, looking up from his potential date.

She scowled at him. "Apple doesn't fall far from the tree, does it?" She hustled Frank out of there.

Mick came up and knelt beside me. "You okay?"

"I'm not a monster," I said.

He grinned at me. "You're nowhere near as bad as your mom was. Now, she was a holy terror."

"Nobody likes me," I said.

"Kiddo," Mick said, kissing my forehead, "you are my favourite monster in the whole wide world."

Three days later, I answered the front door and Mick's friend Josh stared down at me. He said, in a loud, tipsy stage whisper, that he had taken care of his nephew Frankie for me. "You want me to bring him over to say sorry, I can do that, too."

I shook my head.

Josh leaned over. I turned my face away and held my breath because it smelled like something had died in his mouth.

"He's spoiled, that's what he is. He just needed a good kick in the pants. He'll learn, God love him."

Later that evening, Mom and Dad offered to fix up the basement for Mick, but he decided he was going to live with Josh until he got back on his feet.

"I don't know," Mom said. "Your mother said he isn't right and I think she's on to something."

"He's okay." Mick said.

"He is kind of haywire," Dad said.

"He's a bit fucked up, but, hey, who isn't?"

"But—"

"It's my own mess, Albert Hill. You don't have to clean up after me any more. I'm a big boy." When Dad still looked doubtful, Mick noogied his head. "Stop worrying, will you?"

Mick took me Christmas-tree hunting that winter. We drove along the highway between Terrace and Kitimat and stopped when Mick thought we'd reached a good spot. As we drove, Mick played Elvis and home-made tapes that his friends had sent him, with songs like "FBI Lies," "Fuck the Oppressors" and, my fa-vourite, "I Shot Custer." Despite my pleading that they really were socially conscious, Abba was absolutely forbidden in Mick's cassette deck.

"She's got to know about these things," Mick would say to Dad, who was disturbed by a note from one of my teachers. She had forced us to read a book that said that the Indians on the northwest coast of British Columbia had killed and eaten people as religious sac-rifices. My teacher had made us each read a paragraph out loud. When my turn came, I sat there shaking, absolutely furious.

"Lisa?" she'd said. "Did you hear me? Please read the next paragraph."

"But it's all lies," I'd said.

The teacher stared at me as if I were mutating into a hideous thing from outer space. The class, sensing tension, began to titter and whisper. She slowly turned red, and said I didn't know what I was talking about.

"Ma-ma-oo told me it was just pretend, the eating people, like drinking Christ's blood at Communion."

In a clipped, tight voice, she told me to sit down.

Since I was going to get into trouble anyway, I started singing "Fuck the Oppressors." The class cheered, more because of the swearing than anything else, and I was promptly dragged, still singing, to the principal's office.

Mick went out and had the teacher's note laminated and framed. He hammered a nail into his wall and hung the note in the centre of the living room. He put his arm around me, swallowed hard a few times and looked misty. "My little warrior."

Dad was not impressed with Mick's influence on me. He gave his older brother a hard slap to the side of his head. Mick got him in a headlock, then wrestled him to the ground. Once he got Dad pinned, he held him there until Dad called him the most handsome, bravest and smartest warrior in the world. He let Mick get away with "brainwashing" me because my uncle was one of the only people willing to be my baby-sitter.

Our Christmas-tree hunt was something Dad didn't mind. Their father used to take them on the same yearly trek. "I had to go even when I told him I hated it," he said to me as we put the dishes away.

"Dumb idea anyway. Who sat around and decided a dead tree in the house would make the winter that much more festive?" And Mom agreed, then grumbled about the dried needles in her carpet and said that she was the only one who watered the stupid thing. Mick invited Jimmy, who looked up from his homework with a puzzled expression.

"Outside? In the cold?"

"It'll be fun," Mick said.

"Why don't we just buy a tree from Overwaitea?" Jimmy said.

"Come on," Mick said, lifting him out of his chair, "stop being an old man."

"Oh, leave him alone," Dad said. "If he doesn't want to go, he doesn't have to."

I loved the long slog through the bush in snowshoes, walking as awkwardly as an astronaut in zero g. I loved the wind's sting on my face. I loved the steady hiss of our breath, the crunch of our snowshoes and the tinkle of snow blown from the trees. Mick loved the exercise; Mom loved it that I was so tired when I got back that I collapsed into bed; Dad loved the free tree.

Mick and I would examine the trees carefully, discussing the balance of the branches, the plump or dry feel of the needles, the thickness of the trunk. I preferred spruce, for its harmonious triangular slope; Uncle Mick leaned towards pine, for the squirt of scent it gave off when you crushed the needles between your fingers, the aroma that filled a room like the heavy smell of oranges. Inevitably, Mick picked for himself only the scrawny, half-dead trees we came across. Mom called them his Charlie Brown trees and

said God only knew why he liked them. I figured Mick always went for the underdogs. Which was fine for Mick, because no one saw his tree but him. Mom would kill me if I brought home a tree that butt-ugly.

We ended the day of the first Christmas-tree hunt with hot chocolate and sugar cookies for me, and a beer and a slice of mincemeat pie for Mick. Jimmy, Mom and Dad argued over where the decorations would go, while Mick sat at the kitchen table and ignored them. We had done our work. After I finished my cookies, I fell asleep at the table. Later, as I got older, we'd end the hunt by sitting in a comfortable, satisfied silence until Mick decided it was time to go. He would lean over me, kiss the top of my head, then leave without saying goodbye.

A week before Christmas, while my parents were doing last-minute shopping, Dad dropped us off at Mick's new apartment. Some people were roaring so hard, we could hear them all the way from the lobby. His visitor was a man with two long braids, high pock-marked cheekbones and a crooked nose. He seemed familiar, even though I'd never met him before, and then I realized he smelled like Mick. He was sur-rounded by the strong odour of cigarettes, the same brand that Mick smoked.

"Al!" Mick said. "Come meet Barry. Barry, this is my brother, Al. That's Jimmy, the future Olympic star, and this," he grabbed me and noogied my head, "is our little warrior, Monster."

"Heya," Barry said in a deep, raspy voice. He shook Dad's hand.

"I didn't know you had a guest," Dad said.

"Guest?" Barry said. "You didn't tell them about me? And me, your family, you ungrateful bastard!"

Mick grinned. "We were in Washington together, at the BIA building—"

"Are you still trying to sell that load of crap about being a warrior?" Barry said, elbowing Mick in the ribs. "Ah, tell the truth. You just joined A.I.M. to get in my sister's pants."

Dad frowned. "I can ask Edith to look after the kids if you want to visit—"

"No, no, stay," Mick said.

"I—"

"Al, this is your brother-in-law," Mick said, sitting back, waiting for Dad's reaction.

"Yeah?" Dad said, looking skeptical. "Was the invitation in the mail?"

"Nah, it was an Indian marriage," Barry said. "Medicine man and everything. How long'd you stay together, Fly-by? Two, three days?"

"Screw you," Mick said, shoving Barry, who shoved him back.

"Hey, you're not my type," he said.

"Kids are present," Dad said.

"I got to get going," Barry said, standing. He towered over Dad, but slouched so he was Mick's height. "Think about it, Mick."

He shook his head. "I'm retired. Good to see you, though. Stay out of trouble, you crazy bastard."

Barry slapped his shoulder. "Take your own advice."

They laughed again and his friend nodded to us, then left.

"What was that about?" Dad said.

"Barry? He's getting together support for another hopeless cause. Some caribou thing up north."

Dad asked if we could stay until ten or so, and Mick said that was no problem. Jimmy settled down in front of the TV and I waited until Dad was gone before I asked Mick if he was really married.

"Another life," he said. "Long, long ago. Who wants ice cream?"

≋

Mick took me $q^o alh'm$ picking in the spring. We wandered through the bushes, stopping to examine interesting trees or listen to birds or throw rocks in rivers. We scanned the ground for the serrated, broad leaves of thimbleberry and salmonberry shoots, $q^o alh'm$. You had to be careful not to pick the ones higher than your knees, because once they were that tall the stalks became woody and no amount of chewing would make them soft.

Winter in Kitamaat meant a whole season of flaccid, expensive vegetables from town. $Q^o alh'm$ was the first taste of spring. The skin of the shoots had a texture similar to kiwi skin, prickly soft. Once you peeled them, the shoots were translucent green, had a light crunch and a taste close to fresh snow peas. $Q^o alh'm$ picking lasts a few weeks at best.

Mick had two large bundles of $q^o alh'm$ under his arms. I had a smaller one that I had reduced to two shoots by the time Mick was ready to go back to his truck.

"Let's drop this one off at Mother's," Mick said, holding up a bundle.

Ma-ma-oo's house was one of the oldest in the village, a box with a low-ceiling basement and a steeple-like roof. It was painted a plain, flat brown, which was peeling back to reveal grey wood. The glass in the windows was so warped that the world outside looked like it was being reflected through a fun-house mirror. She never liked gardening, so the lawn was wild, with tree-high elderberry bushes and a tangle of untrimmed grass.

Mick opened the door and stepped inside, then said, "Yowtz!"

"Mick!" Ma-ma-oo said. She was brushing her hands against her apron as she came out of the kitchen.

"Here," Mick said, handing her the bundles of $q^o alh'm$.

"Oh, I was wanting her," she said. "Come in, sit, have tea."

We followed her into the kitchen where freshly baked biscuits were cooling on the countertops. Once I was eating and quiet she turned to Mick and they talked while I watched everything around me. Inside, she kept the house tidy, but she didn't bother to decorate like other grandmas I knew. There was nothing on the walls, no doilies on the chairs, no knickknacks on her coffee table. Her saggy, orange sofa never moved from its spot by the front window. I was afraid to touch the curtains because they were so threadbare. If you breathed hard, they whispered against her cracking linoleum, which still had a few sparkles not worn out of its yellowing surface. She had a heavy, black rotary phone that rang like a fire alarm. On the phone stand,

she kept a picture of her husband, Sherman, who had died before I was born; another picture of Uncle Mick holding a giant halibut; and a popsicle-stick house I'd made for her in kindergarten and painted hearts all over. Even when the glue wore out and the popsicle sticks fell off one by one, she didn't throw it out.

Ma-ma-oo wore Salvation Army thrift-shop clothes. Shirts and dresses she turned into aprons when they got too thin. When the aprons wore out, she made them into wash rags, and when the rags disintegrated, she used them for stuffing in her pillows. This habit of wearing things until they fell off her body annoyed Mom to no end. She would regularly buy Ma-ma-oo stylishly cut dresses, slacks and shirts. Ma-ma-oo would carefully put them in her storeroom and say she'd wear them when she was trying to impress someone.

Her fishing nets, on the other hand, she kept immaculate, so they looked brand spanking new. Much later, I suggested that since she was so good at fixing nets, she'd probably be good at crocheting. She threw her head back and roared, laughing so hard she had to sit down.

Ma-ma-oo never locked her doors, reasoning that she had nothing anyone would really want. I think it was because no one she knew had ever locked their doors and doing it seemed rude. We always locked our doors because once someone had broken into our house and taken our videos, video player and TV.

Mom and Dad had shaken their heads at the state of things in the village.

"It's one of those druggies," Mom had said.

"Well," Dad had replied, "now we can buy a VHS."
We'd got Beta because he claimed the quality was way
better, but now it looked like everyone was going VHS.
Because it was vaguely embarrassing to admit we'd
picked the wrong machine, we'd never made the switch.

Ma-ma-oo didn't even have a Beta. Her TV was a
relic from the black-and-white era, with foil wrapped
around its rabbit ears. Sometimes it picked up truckers
on their CBs or a radio station out of Vancouver. We'd
be watching some soap and suddenly the characters
would be interrupted by a voice saying that 16 was slick
today, good buddy. The steep roof, the creaky, dark
wood, the crooked steps, the smell of age and mildew
would have been enough to keep all but the desperate
away, but the truth was that no one broke into her
house because everyone thought it was haunted.

Mick liked to bring her things. When the salmon-
berries came out, we picked two buckets. I liked to pick
out the red ones because the sweetness depends on the
colour of the berry, with red being the sweetest, orange
less sweet, and yellow the mildest. Ripe berries can be
as long as the tip of your thumb, and are best picked
before they become mushy. People who haven't grown
up with salmonberries call the taste watery and seedy. I
think of the taste as a soft sweetness, a gentle flavour.

Hand-high salmonberry shoots unfolded from
tight fronds. Serrated, raspberry-like leaves unfurled
as the shoots became stalks, then bushes. Hard, nubby
buds opened into five-petaled hot-pink flowers about
the diameter of a quarter. The petals formed a deep
cup with a fuzzy yellow centre where the heavy, zingy
nectar sparkled. As the petals fell, salmonberries

poked through. They started off green and hard, look-ing like unripe blackberries. They plumped up and softened with the rain and ripened in the sun, suffus-ing jewel-bright red, orange or yellow, glowing against the green of the bush.

Thimbleberries are completely different from salmonberries and come out just a bit later. The flat, white flowers don't have the easily lickable nectar that salmonberries have, but their smell is sharper. The berries themselves are intensely sweet, like strong, fresh raspberries, but drier. I used to crush the berries against my lips because they left behind a stain the colour of the matte red lipsticks that Ma-ma-oo wore in the pictures of her youth.

We picked berries for Ma-ma-oo, and then she made salmonberry stew. When we had a big bucketful of salmonberries and thimbleberries, we'd bring them to her and she'd soak them in a large pot with cold water and a bit of salt to chase the bugs out. She'd open her jars of blueberries and huckleberries then leave them on the table. We'd sit in her living room while the fresh berries were soaking and watch "The Young and the Restless," "All My Children" or in the evening, "Dynasty."

"Lauren," she'd shout at the TV, "leave him, he's no good for you! *Na'*. What a crazy woman."

"Mother," Mick would say. "It's only TV. Everyone's stupid on TV."

"I know, I know. *Wah*. She's taking him back." She shook her head sadly.

After picking out the bugs, leaves and twigs, Ma-ma-oo would transfer all the berries to a clean bowl

and mulch them all together. She added a few table-spoons of oolichan grease, stirring all the time, then added a sprinkling of sugar. She'd leave the bowl in the fridge for another hour to let the flavours meld and we'd watch some more TV until the salmonberry stew was ready, then we'd go into the kitchen and Ma-ma-oo would give me a little dessert bowl. We'd eat in respectful silence, Ma-ma-oo closing her eyes in ecstasy as she ate. The grease makes the berries sinfully rich, as thick as cheesecake. We'd split the stew, and I'd take my half home, so full I felt sleepy.

Late in the spring, on Ba-ba-oo's birthday, Ma-ma-oo took me down to the Octopus Beds. She brought a bottle of Johnnie Walker and a pack of Player's cigarettes. She made me carry the box of Twinkies, with a stern warning that she knew exactly how many were left.

"Go get wood," she said, her face pinched.

I ran along the beach and up into the bushes, pick-ing up all the dry driftwood that I could carry, running back to her and laying it at her feet. The wind shook the trees. Down the Douglas Channel, I could see the white curtain of rain advancing towards us. The pre-rain air, muggy and thick around us, made it hard for her to light the fire.

"Sherman," she said to the air. "Happy birthday, you crazy old bugger. I brought you some things."

Ma-ma-oo brushed her hair back and opened the bottle of Johnnie Walker. She said some words in Haisla that I didn't understand. She passed the bottle over the fire, which popped and sizzled.

"This is for Sherman," she said, placing it carefully

near the centre of the flames. "You'd better appreciate that. Say hi to your ba-ba-oo, Lisa."

"But he's not here," I said.

"Yes, he is," she said. "You just can't see him, because he's dead."

I frowned. "Can you see him?"

"She gets it from you," Ma-ma-oo said to the air again. "No, I can't see him. He's dead. He can come to you only in dreams. Be polite and say hello when you give him food." She handed me a Twinkie and told me to throw it in the fire.

"Hello," I said. I looked at the Twinkie thoughtfully. "Will he share?"

"Say his name. If you don't say his name, another ghost will snatch it up."

"Hello, Ba-ba-oo. I can count to ten in Haisla," I said. I'd been telling everyone that all day, but no one would listen. "Want to hear?"

"Go ahead. He's listening."

I counted to ten in Haisla, then told Ba-ba-oo about what I did in school as I fed four Twinkies into the fire. Ma-ma-oo fed another four into the fire and I eyed the last two.

"Isn't he full yet?" I said.

"Sherman's a big hog," she said.

"Can't we give him something else?"

She shook her head. "Sherman doesn't like anything else. You never did, did you?" She talked to him for a while and soon I felt left out and bored.

The rain hit, fat drops that spat up dirt and hissed on the choppy ocean. Ma-ma-oo said goodbye and kicked the fire out, took my hand, stopped one last

time to look out at the water, to the place where Uncle Mick always put his net.

Ma-ma-oo said that Ba-ba-oo used to paddle out with the tide in the morning and come back on it at the end of the day. When he was a teenager, he had such massive arms that he was always a sports-day favourite in the canoe races. Everyone wanted him on their team. One day, he slipped getting into the bathtub, hit his head, was knocked out and drowned. The water overflowed and ran under the door. Uncle Mick had to kick in the door when Ma-ma-oo got worried. He wouldn't let Ma-ma-oo into the bathroom until he'd checked that Ba-ba-oo wasn't alive, turned the water off and put a towel over him.

As I was getting ready for school that night, Mom asked me what I did and I told her about everything except Ma-ma-oo and the Octopus Beds. I was uncomfortable sharing it with her. It felt like it was something private.

≋

When the weather was good, Tab and I would bike to the top of Suicide Hill. We didn't go to my house much. Mom was always poking her head in my bedroom to see what we were up to. She watched Tab as if she expected her to tuck something into her pocket, which she had done once. As Tab was leaving, one of Mom's earrings dropped on the floor. Mom held out her hand. Tab picked it up and, looking sheepish, gave the pair back to Mom.

Instead of biking up Suicide Hill, Tab said we

should go to the graveyard and smoke. We stopped near Ba-ba-oo's grave. He had a white, stone headstone that read, "Sherman Hill: March 30, 1923—February 7, 1970. Beloved Husband." Ma-ma-oo kept an ashtray at the foot of the headstone. Ba-ba-oo had lost his arm in the Second World War, at Verrières Ridge. When he came home, he couldn't get a job or get the money he thought he should get from Veterans Affairs because they said Indian Affairs was taking care of him. Indian Affairs said if he wanted the same benefits as a white vet, he should move off reserve and give up his status. If he did that, they'd lose their house and by this time, they had three children and my dad, Albert, was on the way.

"Geordie and Edith helped as much as they could," Mick had told me, squeezing my hand. "But they had their own family. My father worked hard all his life, and now he would say things like, 'Agnes, I'm useless.' She didn't know what to do."

I hadn't seen Ma-ma-oo for a few weeks now. She'd been cranky ever since the feast. Tab broke open a pack of cigarettes and handed one to me. She managed to make it look cool, but I still hacked and had to hold the headstone when the buzz hit. My throat itched and the sour taste of stale cigarettes lingered on my tongue. Tab's lighter clicked and the hiss of the flame was followed by the smell of her lighting up another cigarette. "You ever think of just leaving?"

"Do you?"

"Yeah." She rubbed her arms. "As soon as I'm sixteen, I'm going to go work in the cannery in Rupert and save all my money. Then I'm going to buy a house.

It'll be small, and I'll have to do a lot of work on it, but it'll be mine."

She said it with such seriousness, I was convinced it would have to happen that way.

≈

At Kemano, there is a graveyard. Leave our house with its large, black-eyed windows staring out at the channel. Follow the path down to the beach. Follow the beach to the point, about a three-minute walk. Enter the trees, step over the fallen logs and watch out for the prickly, waist-high devil's club.

All graveyards should have moss-covered trees creaking in the wind and the sound of the waves grating the round stones on the beach. The trees are so high and large here that under this canopy, even the brightest day is pale. Wander slowly, careful where you step. No neat row of crosses, no meticulous lawn, no carefully tended flowers will guide you. Too sterile, antiseptic. Headstones carved into eagles, blackfish, ravens, beavers appear seemingly at random. In the time of the great dying, whole families were buried in one plot. Pick wild blueberries when you're hungry, let the tart taste sink into your tongue, followed by that sharp sweetness that store-bought berries lack. Realize that the plumpest berries are over the graves.

≈

Night and everything is quiet again. Aunt Edith's voice is low and sad somewhere inside. Tupperware is

piled and squashed in the fridge, all loaded down with my favourite foods. Tradition. A human need to express sympathy with tangibles. Cards. Brownies. Our living room is crowded with flowers. Jimmy has a lot of friends.

I stand up. Stretch my neck, my arms, then shake out my legs. I ended up napping on the porch again. Staying inside is out of the question. Feel antsy. Must move. Must do something. Aunt Edith has probably scrubbed the house right down to the foundations. The clouds have blocked the stars and moon. The lights from the village twinkle in the high tide, but much farther down the channel only the red beacon flashing against the black shows that there's anything out there. I lean against the railing, get the chills as the dream comes back in snippets, flashes of bright Technicolor.

Aunt Edith speaks urgently into the phone, but when I walk into the living room, she smiles at me. "It's your mom."

I take the phone. "Any news?"

"No," Mom says. "We're going out to Namu tomorrow morning. Edith said you were sleeping. Sorry to wake you."

"That's okay," I say. "Good to hear you made it down in one piece."

It must have come out odd, because there is a long silence from Mom's end. "We had a good flight."

"Good, good. That's good." As the awkward pausing goes on and on, I think, if you say a word long enough, it loses meaning. What's "good"? What the hell am I trying to say? Fuzzy thinking. Need a hit of coffee. I say this and she laughs.

"No more coffee. Just get some sleep, Lisa," she says. "Your dad wants to say hi."

"Okay."

The phone clunks down. Mom says something I can't quite catch, and Dad comes on, breathless. "Hi, how ya doing?" Overly cheerful, in full and complete "nothing's wrong" mode.

"Tired," I say.

"Just got out of the shower," Dad says. "Everyone's being friendly. They say there's a good chance we can pick him up on one of the islands. He's such a strong swimmer, they think he made it even if"—a couple of words from Mom that sound like For Christ's sake—"even if we can't find anyone else," he finishes quietly.

"I know you'll find him," I say.

"You be good," he says.

"You too," I say.

We mumble goodbyes, and as I'm hanging up the phone, Aunt Edith hands me a mug of chamomile tea. It's got at least a half-cup of honey and a sprig of mint. She sits beside me. "Why don't you just go to bed?"

I nod. "In a minute."

"Are you hungry?"

"I just ate."

Aunt Edith lowers her head and gives me a stern look over her glasses. "You missed lunch."

Caught, I don't bother to deny it. My stomach growls.

"How about some half-smoked?" she says.

"Sounds good." I say this mostly to stop her from hovering over me. I know she's being considerate, but it gets on my nerves.

She opens a jar of half-smoked salmon and boils it. She peels some potatoes, puts oolichan grease on a saucer, cleans some green onions, then we wait for the potatoes and fish to be done.

"Lisa," Aunt Edith says, squeezing my shoulder. "God is with them."

I nod. After Aunt Edith says grace, I eat all of the salmon on my plate. Mom jarred this fish earlier this summer. Sockeye. She did a good job on the smoking. Aunt Edith and Uncle Geordie went out to the Kemano to catch oolichans and make grease. Mom couldn't make it this year and I didn't have the heart to do it. I know Mom was disappointed. She wanted someone in our family to learn to make grease. The grease I'm spreading over the fish we traded with Aunt Edith, her grease for a box of our half-smoked.

Oolichan grease is a delicacy that you have to grow up eating to love. Silvery, slender oolichans are about as long as your hand and a little thicker than your thumb. They are part of the smelt family and are one of the tastiest fish on the planet. Cooking oolichans can be as simple as broiling them in the oven until they're singed—which is heavenly but very smelly, and hard on your ears if you have a noisy smoke alarm—or as touchy and complicated as rendering oil from them to make a concoction called grease. Oolichans can also be dried, smoked, sun-dried, salted, boiled, canned, frozen, but they are tastiest fresh. The best way to eat fresh oolichans is to run them through with a stick and roast them over an open fire like wieners, then eat them while they're sizzling hot and dripping down your fingers.

Because of their high oil content, oolichans go rancid easily and don't last in the fridge or freezer. If you want the taste of oolichan all year round, you have to make them into grease. To do this, you have to catch a suitable number of fat, juicy oolichans. Then the fish must be aged properly, for one to two weeks, in a large pit. Two things must be kept in mind when aging the fish: first, the longer the fish is aged, the stronger the taste of the grease, and secondly, weather conditions affect the ripening process. Only the most experienced grease makers should decide when the oolichans are ripe enough to be transformed into grease.

Fill a large metal boiler with water. Light the fire pit beneath the boiler and bring the water to a boil. Then add the ripened oolichans and stir slowly until cooked (they will float slightly off the bottom). Bring the water to a boil again and mash the fish into small pieces to release the oil from the flesh. A layer of clear oil will form on the surface. Scrape out the fire pit and keep the boiler covered. Let simmer, but, before the water cools completely, use a wooden board to gently push the layer of oil to one end of the boiler and scoop it into another vat. With a quick, spiraling motion, add two or three red-hot rocks from an open fire to the vat of oil, which will catch fire and boil. Once the oil has cooled, do a final straining to remove small twigs, water and scales. Put oil in jars. Keep your fresh oolichan grease refrigerated to prevent it from going bad.

Oolichan grease is versatile. Most people use it as a sauce—a tablespoon or two is drizzled over cooked fish or added to stews or soups for instant flavour. Some people prefer to use grease to combat cold symptoms

and to boost their general health. A mere teaspoon a day is enough to keep you regular and in top physical condition. When spread on the skin, grease is an expensive, fragrant and highly effective moisturizer. In olden days, grease was also used to preserve berries, fruit or meat.

"Are you going to finish that?" Aunt Edith says.

"Oh," I say. I stop stirring my potatoes. They're a fine mush now. "No, thanks."

"Lisa," she says. "Go to bed."

"Hmm."

"I'll pray for you and for your brother."

"Thanks," I say. "For everything."

I scrape the leftovers into the garbage, put the plate into the sink and go upstairs to my bedroom. I stop at my door and stare down the hallway. Jimmy's door is closed. I know he hates people to go in there without his permission, but I can't help myself. The door squeaks a bit, the hinge needs adjusting and a little oil.

His room is compulsively neat. From the size-organized paper clips on his desk to the colour-arranged clothes in his closet, you can tell he knows where every single thing in this room is. I touch the picture of Karaoke. He took it when she wasn't looking, as she examined a bouquet of magenta fireweed.

"Why'd you put that picture up?" she'd said, frowning.

"I like it," he'd said.

"I don't. If you want to remember me looking for bugs, go right ahead," she'd said.

She's like me, not much of a romantic. I'm surprised at Jimmy. I would never have pegged him for a

sentimentalist. Everything in his life has been so
... utilitarian. Is that the right word? I don't know.
His life has been focused so tightly that I made the
unflattering assumption that Karaoke was a substitute
for swimming. She didn't seem his type. Even the most
aggressive of his girlfriends up to that point had been
bunny rabbits compared with Karaoke. As Uncle Mick
would ironically have said, she is a delicate Haisla
flower. I wonder what they said to each other when they
first met. From what I can squeeze out of Jimmy, I take
it they were introduced by Jack Daniel's.

Karaoke's picture is over the place where one of his
first national awards rested. In the morning light, you
can see the slightly darker outlines on the walls of his
swimming medals and trophies, the ghostly imprints
of his accomplishments. He took them down in early
summer. They're packed in four boxes and tucked
somewhere in the attic.

Dinner's resting uneasily in my stomach. Or I've
had too many cigarettes. Either way, I have to stay sit-
ting up because when I try to lie down, acid burns up
my throat. From his bed, I can see Canoe Mountain.
Jimmy's room is on the other end of the house from
mine, and you can't see down the channel as well
because the greengage tree is nearer to his window. He
has a wonderful view of the Alcan docks, though. And
the place Ma-ma-oo pointed out, the canoe shape in
the mountain across the channel. She said that when
the sun touched the bow, you knew the oolichans
would be here. Bears woke up and eagles gathered with
seagulls and crows and ravens, waiting anxiously at the
rivers. Seals bobbed hopefully in the water and killer

whales followed the seals. The people who still made grease started building wooden fermenting boxes and tuning in to the weather network, watching for gales and storm warnings that might delay the start of oolichan fishing.

The day Mick and I left for Kemano, the sky was low and grey, snow compressed into ice and covered by knee-deep puddles and slush. Ma-ma-oo used to say winter loved Kitamaat so much that he didn't want to leave. He gave up only when the oolichans came, and then he packed reluctantly, grumbling and cranky. On *wa-mux-a*, the day winter shook out his cape, the snow fell in big flakes, but later the sun came out and melted them all away; that was winter going home.

I had kept Mom and Dad up almost all night. I was so excited at the idea of having an adventure with Uncle Mick that I couldn't sit still. I packed and repacked and hunted through the whole house for things I thought I might need on our trip to Kemano. We were going to make grease with Uncle Geordie and Aunt Edith, who would be following later in the day in Geordie's troller. Mom was catching a ride with them and when Mick asked if they needed help, Mom gratefully said he could get me out of her hair while they were getting ready. Dad and Jimmy were going to Terrace for a swim meet. I thought they were nuts to give up a fishing trip just to go splash around some dumb swimming pool.

I bounced out of bed at exactly 4 a.m., raced down the hallway to the master bedroom and shook Mom until she blearily told me that she still had a half-hour left before she had to get up.

"You are out of my will," Mom muttered, slowly rolling out of bed.

She drove me to the docks, where the water was as flat as paper and the first light made the sky a receding grey. Even through the layers of clothes Mom had stuffed me in, the morning air had a keen, curt bite. We waited five minutes for Mick to show up. Mom spent the time smearing my face with sunscreen and threatening me with untimely death if I took off my baseball cap.

"I'm not going to spend the week listening to you gripe about your sunburn," she said.

When Mick finally appeared, he clunked along the gangplank carrying his backpack. The feeling of everything moving too slowly became overwhelming, and I had to bounce. Mom hauled me back by the collar and said that if I didn't behave, I wouldn't go at all.

"Come on, Monster," Mick said as he threw the backpack in the middle of the speedboat. "Here," he said, picking me up, grinning. "You gonna be a good girl?"

"Yes."

"Ah, go ahead. Be my monster." He noogied my head.

"Mick," Mom said in a warning tone. "Don't encourage her."

"Can you do a moose call for me?" Mick said, eyes sparkling.

I closed my left nostril with a finger and trumpeted as loudly as I could. When he'd taught me, he'd said that female moose made the sound so that they could have other moose to play with. He laughed and Mom said, "Put Her Royal Highness down and get going."

He smiled at me. "We used to call her Miss Bossy Pants when she was a kid."

I giggled.

"Less cute remarks," Mom said. "More attention to details—like the tide, Mr. Smarty-Pants."

Mick tossed me up over his head. The world spun, blurred as I twirled, then Mick caught me by the waist and, in one dizzying, swooping movement, lowered me from the dock so I landed in the speedboat with a thump.

He cast off and hopped in the boat, rocking it alarmingly. After he started the motor, he raised one hand and flapped it a few times at Mom, then saluted and yelled, "Red power!"

"Get out of here, you nut," she said.

Mick pushed us off, as she stood on the docks and watched us. He fired off the engine. We started off sedately, but once we rounded the breakwater and the point, and were firmly out of her view, he gunned the motor, the bow lifted like a ramp, spray kicked up three feet high behind us and we tore across the water.

Behind us, the village, the road to town, the hazy plumes of smoke and the bright orange lights of Alcan shrank away. Ahead of us, the mountains stretched along the sides of the channel. As we rode near the Kildala Valley, I felt a sudden chill. A white man and his son, in matching neon green and black scuba gear, stood on a point, waving to us. I stood up and waved back wildly.

"Who are you waving at?" Mick shouted over the engine. He was looking at me like I was nuts.

"You can't see them?" I said, lowering my arm.

"Who?" He looked back at the shoreline.

"They're right there," I said, pointing. "On the beach."

Mick craned his head and squinted. "I don't see anyone."

The man turned and walked into the woods. The son—I don't know how I knew he was the son—stopped waving too, but stayed and watched us. He seemed so lonely that I took off my cap and waved it in the air to make him smile. He stayed on the beach until we were out of sight.

The Kemano was a half-day away on a fast speed-boat. About three of the rivers in Kitamaat territory have reliable oolichan runs—the Kitimat, Kitlope and Kemano rivers. Like salmon, oolichans spawn in rivers and their fry migrate to the ocean, where they live for about three years. They return to their home rivers along the British Columbian coast in early spring, usually between mid-February and early April. The Kitimat River used to be the best one, but it has been polluted by all the industry in town, so you'd have to be pretty dense or desperate to eat anything from that river. Mom said the runs used to be so thick, you could walk across the river and not touch water. You didn't even need a net; you could just scoop them up with your hat. Most people go out to the Kemano and the Kitlope these days, but you have to pay for gas, and you need a decent boat and have to be able to spend a few weeks out there if you want to make grease. If you have a job, it's hard to get enough time off work. Oolichans spawn in only a small num-ber of rivers in B.C., so the Haisla used to trade them

with other villages for things that were rare in our area, like soapberries. In the past, most of the groups spoke different languages, so a trade language called Chinook was created, which combined the easiest-to-pronounce words in the languages into a pidgin, a patois. Oolichan is the Chinook word for the fish, but in Haisla they're called *jak'un*.

Oolichans spawn in other rivers on the northwest coast like the Chilcat, Nass, Skeena, Kimsquit, Bella Coola, Oweekeno, Kingcome and Fraser rivers. Each place has its own way of spelling and pronouncing "oolichans," so the fish are also known as eulachons, ooligans, ulicans, hollikans and oulachens. Other people on the coast make oolichan grease too, but Mom always said, "Ours is the Dom Perignon of grease."

When I was a kid, I assumed Dom Perignon was another kind of fish oil. I was very disappointed when I found out that it was just a champagne, like Baby Duck, which I'd snuck a sip of one New Year's Eve and hated. I coughed, spitting and sneezing as the bubbles tingled sharply up my nose.

We drove past Costi Island, which splits the channel in two. We took the north side. Behind Costi Island are the Costi Rocks, a small chain of bare rocks. All except the highest are covered by the high tide. Light brown seals lay like fat cigars, crowded together, barking.

"You want some seal?" Mick yelled.

I made a disgusted face.

He laughed. "You don't know what you're missing." He paused, slowed the boat down, then let the motor idle. "You want to drive?"

"Really?" I said as we drifted in the tide. "Really?"

"Come on, hop over," he said, sliding out of the captain's chair. I was too short to see over the bow, so Mick let me sit on his duffel bag. He gave me a brief lesson on the steering wheel and the stickshift. The outboard motor, he explained, could be sped up or slowed down, but reversing was tricky because the engine tended to stall.

"I'll get it fixed sooner or later. Keep the bow towards a sightline," Mick said. "See that point way down there?" I nodded. He continued, "Drive straight towards it and you'll be okay. When we get there, I'll take over. Whoa, gently, gently," Mick said as I cranked the engine. "Start off slow and work your way up or you'll burn our motor out. And watch ahead of us for deadheads. Do you know what deadheads are?"

"Old logs sunk underwater but floating near the surface."

"Good. Avoid kelp too. If it gets tangled in the blades, we're going to have to stop and take it out, and that'll waste good fishing time. Okay?"

"Can I speed up now?"

"Yeah, yeah. Go ahead." Mick sat back, smoking, as I pushed the engine as fast as it would go. It felt as if we were barely touching the water. I saw a flock of black ducks bobbing on the surface and swerved to go through them. Mick swore, but didn't tell me to stop. The ducks rose up and, for a moment, flapped alongside us. Mick lifted his arms like he was flying, cigarette dangling from his mouth, and honked. They honked back, sounding aggravated, then climbed into the sky and flew north. Mick grinned at me.

He took over near Wee-wah, a small cove about a half-hour from the village. A forestry camp is there now. They built their base over one of the best crab beds on the channel, but back then, the crabs caught there were large and fat. We set our traps. Mick let me bait them and toss them into the water. We drifted on the ocean for a while, bobbing with the waves. Mick turned his face to the sun. I played my cassettes, but quietly, because Mick hated Air Supply. If I played it too loudly, he'd reach into his bag and pull out Elvis and we wouldn't be able to listen to anything else for the whole trip.

"It'll take a while. You want to wait at the hot springs?" he said.

"Hot springs!"

"Get your swimsuit, then."

I dug around until I found it. The hot spring was a squat little hut tucked fifty feet up from the shore and surrounded by high, creaky trees and squishy moss-covered ground. But the water, when I dipped my toes in, was silky and warm. Mick went up into the bushes to change into his shorts and let me use the hut. The air was cold, so I sat down fast after I changed. The concrete tub was slick and my feet slid so I landed on my rump.

"Knock, knock," he shouted.

"I'm decent," I said.

He came in, dropped his stuff by the door and sighed as he sank down. His face went red with the heat. His hair flopped over his shoulder, frizzing where it was loose from his braid. Staying in the water, he half-swam, half-bobbed towards me. He leaned against the rocks. "Pretty cool, huh?"

I nodded. "I wish I could live with you."

"No, you don't."

"You're fun. They never let me have any fun."

Mick sucked in a deep breath. He swam over to his clothes and shook out a cigarette. He came back dog-paddling with his head tilted out of the water, cigarette in his mouth, his braid trailing behind him.

"Your mom and dad are fun too," Mick said.

I gave him a doubtful look.

"They are. But with you, they have to do parent things. They have to keep you fed and clothed and pay the bills and watch out for you. That kind of stuff. We can just hang out like this. You understand?"

"Yeah. You don't want me either."

He flicked some water at me. "*Na'*. What a mood."

I wiped the water from my face. My hands were going all white and wrinkly. "I want to be like you. I don't want to stay here and be all boring."

"Mmm. You might want to think that over."

"I want to be a warrior."

"A warrior, huh?"

"I do! I don't care what you think."

His smile faded. "Fighting didn't get me anything but lots of scars."

"But you did things!"

"For all the good it did," he said, poking me in the side. He finished the cigarette, let it hiss to death in the water, then flicked it out one of the small windows. "Okay, let me tell you a secret. You want to hear a secret?"

I shrugged, disappointed that he hadn't reacted more enthusiastically to my revelation.

"When your mom and dad went on their first real date, he invited her over for a few drinks. He had to go across to get some beer and got stuck in a snowstorm in town. He had to wait for the snowplow to go back to the village, and meanwhile, your mom was so nervous that she bummed some booze off her friends and was waiting for him at his house, getting royally pissed."

"Bullshit," I said, having never seen Mom even tipsy.

"Cross my heart," Mick said. "But she got tired of waiting for him and went home. He tried to phone her when he got back, but she said she was beat and wet and wanted to go to sleep. The next morning, your mama-oo came home and asked him who made the snow angels. Your dad went to the window, and the whole front yard was covered with them. Your mom doesn't even remember making them, that's how toasted she was. 'That's when I knew I was going to marry her,' your dad told me."

It didn't sound like them at all. I thought Mick was mixing them up with two completely different people, and I said so.

"You can ask them," Mick said. "Go ahead."

"No way. They'd kill me."

"Blackmail material," Mick said with a wink.

We had a lot of time on our hands. Mom had said that she wanted to reach Kemano before us, so we hung out at the springs. Mick got out first, sitting on the edge of the tub, lighting another cigarette. He chain-smoked. I don't think there was a moment when I saw him without a cigarette hanging out of the corner of his mouth. When he lifted his arm, I could

see the pale scar along his side where the bullet had grazed his ribs.

After hanging out at the hot springs, we toweled off and Mick had another smoke. I hunted between the logs on the beach for shells, but didn't find any. About noon, we went back to the crab traps. When he pulled up the first crab trap, he whooped, delighted. It was so full, there were crabs clinging to the outside. "Ready to jump in our pot!"

The crabs skittered on the bottom of the boat. We put them in buckets. I hated the sound of their claws rasping on the plastic. I hated the way Mom and Dad cooked them, the way they rattled against the pot as they were boiled to death. I liked it best when Mick cooked them because he stuck a knife through their bodies first, one quick thrust.

The next crab pot and the next were full too. Mick began to throw crabs back in the water. His whole face glowed with satisfaction. The last pot was so heavy, his arms were bulging with effort. The boat tipped, and I thought we'd flip. As the pot came over the rim of the boat, a halibut inside began to flap. There were three crabs clinging to it.

"Far out," Mick said, panting.

"How'd it get through such a tiny hole?" I said.

Mick shrugged. "Don't touch it. It means either really good luck or really bad luck, I think. We'll have to ask someone. But meanwhile, there you go, big fella." Mick opened the pot and dumped the halibut back in the water. It spiraled into the darkness, its pale white belly flashing as it sank.

"What'd you do that for?" I said.

"It's a magical thing," Mick said. "You aren't sup-
posed to touch them if you don't know how to han-
dle them."

"It's just a halibut."

"Do you know how it got in the pot?"

I shook my head.

"Then leave it alone. We got enough crabs anyway.
Let's get going."

He wouldn't let me drive any more because I didn't
know the area. The mountains stretched on and
blurred together. As the previous night of sleepless-
ness began to take its toll, my eyes drifted shut.

"Afternoon, sleepyhead," Mick said, shaking my
shoulder. "Day's almost finished."

The air had changed, was sharp and made me
shiver. He'd put a sleeping bag over me while I napped
and I pushed it aside, stretching. Mountains un-
touched by clear-cuts, roads or houses rose fiercely
high. The bald rocks, scraped by the Ice Ages, were
topped by glaciers that melted in the sunshine, the
water glittering down the grey cliffs. A sparse treeline
started halfway down, thickened into forest, then
ended in lush green carpets that fell into the ocean.

"We're near Kemano," Mick said. "Look up there.
That's your ba-ba-oo's trapline on that mountain. I
think Al has it now."

At the base of the mountain, there was a stretch of
flat space that ended in a point. A square patch glinted
like mica in the sunlight, a bright glowing spot swal-
lowed by the surrounding dark green of the trees.

"Can you see it?" Mick said. "That's where we're
staying."

I picked up the binoculars. The house was still just a fuzzy patch. I searched up and down the beach. A tiny figure waited on the beach. I caught glimpses of buildings through the trees. The figure raised its arm and waved. As we got closer, I could see it was Mom in a kerchief. They must have passed us while we were at the hot springs, I thought. Mom waited until Mick landed the speedboat against the shore before she asked, "Did she give you any trouble?"

"Nope," Mick said. "Look, we brought crabs."

"I saw seals and ducks too," I butted in after I jumped out of the boat. The beach at Kemano was all gravel, large round stones that sucked at your feet and made every step slow. "And we caught a halibut, but we had to throw it in the water."

"I don't believe you," Mom said to Mick. She turned to me, "Go run up and down the beach a few times."

"Is there a village here?"

Mom shook her head. "Used to be."

"What happened?"

She looked down at me. "Most of the people died."

"How?"

"They just died," she said, her lips thinning.

Which meant that she wanted me to stop asking what she called my nosy questions. I wanted to go into the little town that Alcan had set up for the Kemano workers. Dad worked there for a month when me and Jimmy were little, and he said the money had been great but he hated being away from civilization.

Even though it was just around the corner from the old fishing village where we were going to be staying,

when I asked if we could go, Mom looked down at me and gave an exasperated sigh. "Later, Lisa."

I put my finger on the side of my nose and let out the loudest moose call I could. The sound echoed off the mountains, coming back faint and shaky. Uncle Geordie came down to help Uncle Mick unload fishing gear. Aunt Edith stood at the base of a path that led to a white house with a tin roof and gestured at me to follow.

"Here's my crazy girl," she said.

"I want to go to the townsite."

"Hear that? Just like Gladys."

Mick and Geordie laughed, passing each other bags and boxes.

I raced up the path but paused at the bottom of the steps that led to the front door. I felt a heaviness, like you feel emerging from water after swimming, pressing against me, making my skin tingle. I turned around, fast, to catch anyone who happened to be staring at me. The bushes near the house were still bare, the buds barely breaking from the cases, and the grass wasn't even poking out of the ground yet. I looked back to the beach. Mom was helping out the others, and their laughter carried clearly across the beach.

I heard it then and thought it was an echo. But long after Mom, Mick and Uncle Geordie had stopped laughing, the distant, tinkling laughter came again from somewhere past the house, in the trees.

I ducked inside. The house was deliciously old, and each step I took was rewarded with loud, reverberating groans. It had to be haunted, I thought as I darted through the musty rooms with the saggy mattresses and

skittering mice. I had been transported somewhere
magical, full of endless opportunities for adventure.

"Lisa!" Mom yelled from downstairs. "Stop bang-
ing around!"

"She's excited," Mick said. "Let her be."

"She's going to get hurt. Lisamarie Michelle Hill,
where are your ears?"

I stopped, dropped my bags and waited for the
laughing ghosts to appear. The upstairs rooms were
silent, but not ominous, just empty. I swallowed a
heavy lump of disappointment and slumped onto one
of the beds. Maybe, I consoled myself, they showed
themselves only at night, which wasn't too far away.

"Want to help me get the water?" Mick said, pop-
ping his head around a corner.

"What water?" I said as I came back downstairs.

"Our drinking water, silly," Mom said, busily
turning bacon in the frying pan. The smell reminded
me that the last time I'd eaten was hours earlier.

"No running water here," Mick said. "We do it the
old-fashioned way. We go and get it."

He gave me a small bucket and took two large white
pails. We went down the steps, Mick whistling. The air
was cold and my arms goose-pimpled, the breeze bit-
ing through my sweater. I shivered but followed him
along the beach. Mist crawled through the mountains,
sluglike and pale against the darkness of the forest.
Mick walked close to the waves, which surged and
hissed listlessly.

He nudged my arm. I turned my head to see what
he was staring at and glimpsed a black head bobbing in
the waves. I stopped to watch the seal, but Mick kept

walking and I had to run to catch up, my feet sinking in the stones and then slipping, so I had to concentrate on each step or fall. He swung his arms and made the pails clunk together. I stayed beside him, panting with the effort of keeping up to his long strides. Near the end of the beach, we turned up into the trees and followed a trail to a small stream and then up to a clear, dark pool.

He sat down on a log that was green with moss and lichen. As he set his pails down, I sat beside him, the log squishing underneath me, soft with rot. Mick leaned over, hand on his knees. I kicked my feet back and forth, letting them thump against the log and bounce off. The stream was quiet, making whispery sounds.

Mick finally stood up and dipped his pails into the pool. I handed him mine, and he filled it halfway. The water was clear, but littered with twigs.

"Taste it," Mick said.

I shook my head.

"It's good." As if to prove it, he leaned over the pool, and dipped his hand in the water. "Ahhh."

He moved aside, and I cautiously copied him. It was burning cold and sweet with the taste of trees. He grinned. I drank a few more handfuls. Mick lifted his pails. They sloshed over and splashed his legs.

My pail was so heavy that I carried it with two hands. We walked along the beach closer to the trees, following hard-packed sand until it disappeared into the stones. Mick paused to let me catch up to him. My hands hurt where the metal handle bit into the flesh of my palms.

"Smoke break," he said, putting his pails down.

I let my bucket fall and sank into the beach, yawning, suddenly tired. Mick crouched down and cupped his lighter. He sighed as he let go his first puff. Sweat cooled on my face. I yawned again, aching for bed.

"Me and your dad used to do this all the time," he said. "We used to have contests."

"Like what?"

"Kid stuff. Who could carry the most. Who could get it back the fastest."

I closed my eyes and tried to picture Dad running around with pails. An owl hooted. When I opened my eyes, Mick was staring at nothing, looking sad. The breeze stopped blowing and everything became still. The water went black and glassy.

"Dinner's probably ready," Mick said, stubbing out his cigarette on a rock and standing up.

"You want to race?" I said.

He grinned. "I'll give you a head start."

Most of the water ended up on my pants, and Mom made me go upstairs to change. The house was lit with kerosene lamps that buzzed like the electric bug killer Dad had bought at a garage sale. Mom had made fried eggs and set them with the bacon on the long wooden table in the front room. It was surrounded by old squeaky chairs. Uncle Geordie and Aunt Edith were already there, concentrating on eating. "Bannock's in the kitchen," Aunt Edith said. "Hurry, while it's hot."

Now that it was dark, the idea of sleeping in a haunted house wasn't as thrilling. I changed into my sweats in record time and raced back downstairs. I was so hungry, I didn't even mind that we were having eggs

and gobbled some straight out of the frying pan on the table. Aunt Edith watched me with a sour expression.

While Mom and Mick ate, Aunt Edith opened her knitting bag and pulled out pieces of a sweater. Uncle Geordie tilted his chair back and filled his pipe. I hoped everyone was as tired as I was, so I wouldn't have to go upstairs alone. I picked at a last piece of egg, squashing it with my fork.

Mick leaned over and whispered, "I think it's dead."

"Don't play with your food," Mom said automatically, not even looking at me.

"Remember the last time Al came up to the lake?" Mick was saying to Aunt Edith.

Everybody laughed.

"What happened?" I said.

Uncle Geordie chuckled. "Two years ago, wasn't it?"

"Three, I think," Mom said. "Jimmy was still in kindergar—"

"What *happened?*"

"We went up the Kitlope, me and your dad. Why'd he come with me? I can't remember. . . . Oh, yeah. We were bear hunting. Well, we spent the night on the beach. It was warm that night, so we didn't bother putting up the tent, just spread our sleeping bags on the sand. Woke up the next morning and the whole beach was just covered in seals. One was sleeping on the zipper side of your dad's bag, so he couldn't move—big one too, almost a ton—and he kept yelling, 'Mick! Shoot it! Shoot it!' Another seal was sleeping on my gun. Then Al starts hooting and making these moaning sounds and I thought he was being crushed. . . . "

I waited for Mick to stop laughing.

"He was making whale calls," Mom explained. "It worked. The seals left."

Uncle Geordie made a whiny, fluty sound, and they cracked up again.

Mick put his arm around my shoulder. "'Didn't you notice a seal snuggling up to you?' I asked him. 'I thought it was Gladys,' your dad said. 'She always hogs the blankets.'"

"Ha ha ha," Mom said, cuffing the back of his head.

After dinner, I had to pee badly, but I didn't want to go to the outhouse. It was only about twenty feet from the house, but I'd held my pee for what felt like hours so I wouldn't have to go in the darkness. Mick said we were lucky it wasn't summer, because the cold kept it smelling fresh.

"Mick," I whispered. "Can you come with me to the outhouse?"

"Don't baby her, Mick. You're old enough to go to the outhouse alone."

I gave Mick my most desperate look.

"Gladys—" Mick started to say.

"You're spoiling her. There's nothing out there but you and the mice, young lady."

I got up slowly. Mick stood up too. "I'll watch you from the porch."

Mom gave a heavy, dramatic sigh.

"Thanks," I whispered to him as we went through the kitchen and I dashed down the steps. I flung open the outhouse door, peed and didn't even bother to wipe. When I got back to the porch, Mick was grinning at me, puffing away.

"I'm not a chicken," I said.

"I know."

"I'm not a baby either."

"Didn't say you were."

"I just don't like the ghosts."

"Ghosts, huh?"

"Don't you believe in ghosts?"

"Did you see them?"

I shook my head. "I just heard them laughing."

Mick grunted.

Aunt Edith had left for bed by the time we went back inside. Mom had cleared off the table and was scraping the leftovers into a bag.

"She says she heard ghosts," Mick said to Mom.

"Mick," I said, glaring at him.

"Ghosts?" Mom said. "Dammit, what have you been telling her now?"

"Nothing!" Mick said, indignant.

"Right. Did you tell her about Ba-ba-oo?"

"No. Did you?"

"No. Lisa, has your dad been telling you stories?"

I sat in my chair and glared at my feet. No one ever believed me.

"Best way to keep ghosts away is to fart," Uncle Geordie said.

"*Na*', don't tell her that," Mom said, suddenly smiling.

"It's true," Uncle Geordie insisted.

I looked at him hard to see if he was teasing me. He crossed his heart.

Mick started telling me about the time Ba-ba-oo went hunting mountain goats up the Kitlope but Mom shushed him.

"She'll have nightmares," she said. "If you tell her about Ba-ba-oo seeing ghosts, I'll have to take her to the outhouse every time she wants to pee."

"Ghosts, my ass," Uncle Geordie said. "Old bugger was probably drunk as a skunk."

"Bedtime," Mom said.

Late that night, I dreamed I was at the docks watching Jimmy dive off the breakwater logs. I waited and waited for him to surface but the water was still and dark. I woke, heart hammering. I heard groans. I pulled the blankets tighter. The moaning was soft at first, then got louder.

"Mom," I whispered. "Mom. Wake up."

Mom is a heavy sleeper. I knew that if I wanted to wake her up, I'd have to get out of bed and take two steps, then hop into her bunk. I couldn't do it. My muscles felt all soft and shivery. Even if the house caught fire, there was no way I could move.

"Cookie." I recognized Mick's voice. The wash of relief made me giggle. Mick was having a bad dream about cookies. He was moving around, thrashing.

"Cookie!" he shouted. "Cookie!"

I poked my head out from under my blanket, worried now. I'd never heard Uncle Mick sound afraid before. I went over and shook Mom's shoulder. She was about to say something when Mick started shouting again. I heard Aunt Edith whispering to Uncle Geordie. Mom wrapped the blanket around her shoulders as she shuffled out of the room and went down the hall.

"Stay here," she said. "Don't say anything."

Mom's footsteps creaked across the floor, and I

heard her waking Mick up. Someone started to sob, deep, achy sounds that couldn't be Mick because nothing made him cry. No one said anything, and when the light started to make the room grey, Mom came back. She bent over me.

"What's wrong?" I said.

She put her finger to my lips. "Shh."

"Wha—"

"Lisa, hush," she whispered sternly. "This is grown-up stuff. Don't ask him anything tomorrow. You hear?"

I nodded.

"Good girl," she said, kissing my forehead. "Good girl."

I woke to the sound of rain against the roof, and Mick yelling. I slipped my shoes on and took the steps downstairs two at a time. Mick was in the front room, with Aunt Edith and Uncle Geordie staring at him, looking shocked.

"How?" Mick was shouting. "They were after numbers! That's all they wanted! How many converts they could say they had. How many heathens they—"

"Mick," Mom said, running in from the porch. "What's wrong?"

"Wrong? What's right?"

"He's gone crazy," Uncle Geordie said.

"Crazy? I'm crazy? You look at your precious church. You look at what they did. You never went to residential school. You can't tell me what I fucking went through and what I didn't."

"I wasn't telling you anything!" Aunt Edith said. "I was saying grace!"

"You don't get it. You really don't get it. You're buying into a religion that thought the best way to make us white was to fucking torture children—"

"Enough," Mom said, standing in front of Mick. "We're going to look for oolichans now. Go get your things, Mick." Mom stared at him until he pushed past her. I stepped out of his way and he walked by me as if I wasn't there.

"He started screaming at us for no reason," Aunt Edith said when he was upstairs.

"It's got nothing to do with you," Mom said quietly. "Don't take it to heart." She smoothed her hair, then noticed me and smiled. "Come here, sweetheart."

I went to her and she put an arm around me.

"You okay?"

I nodded.

"I'm going to take Mick up the lake to cool off. He's going to be pretty grumpy today. You want to stay with Edith and Geordie?"

I shook my head.

"You sure?"

"Yes," I said.

"Then let's go get our things."

"Can we camp out there tonight?"

Mom brushed back her hair, frowning thoughtfully. "That's not a bad idea."

At the beach, Mick announced he was going back to the village. Mom said that was fine, but we were going in the punt up to Kitlope Lake. Mick glared at her. She crossed her arms over her chest.

"I know what you're doing," he said.

"You go where you please. You always do."

"That's right, use a little more guilt, why don't you?"

"I'm a mom. That's what we do best."

Mick growled, but hurled his things into the punt and we were off.

I spent most of the boat trip sitting on an over-turned bucket, wishing I was anywhere but there, getting soaked to the bone, staring at mountain after mountain, the clouds getting lower and darker. Every once in a while, Mom would yell at me to bail and I would, feeling the bilge seep through a hole in my rubber boots. I tried talking to Mick to relieve my boredom, asking him questions, just wanting to chat, but he frowned and said sometimes people should just be quiet.

Mom slowed the punt to a crawl, pointing towards the shore. I didn't see anything for a few moments, and then movement caught my eye. A black bear was on the shore, its head bent down. From this distance, it was tiny, no bigger than my hand. It swung its head back and forth, and pawed at the ground.

"What's it doing?" I whispered.

She shrugged. "Uncle Geordie said every time he goes up the lake, it's on that point."

"Probably eating seaweed," Mick said.

"Bears eat seaweed?" I said.

"Too early for seaweed," Mom said.

"Not if you're hungry enough."

The bear raised its head. It spotted us, turned and sauntered up to the tree line and out of sight.

You can tell when you're getting close to the Kitlope watershed because the water changes colour. At Kemano, the water is still a normal dark green, but

the closer you get to the Kitlope, the milkier the water becomes, until all around you the water is the colour of pale jade. Most of the mountains are rounded bald heads, scraped smooth by passing glaciers. Some of the bays still have icefields, and Mom said that when she was a kid they used to go bum-sliding on them.

The rain let up just as we got to the mouth of the Kitlope River. Mom leaned over and dipped her hand in the water, then washed her face. After stubbing out his cigarette, Mick did the same.

"When you go up the Kitlope," Mom said, "you be polite and introduce yourself to the water."

I didn't see the point and said so.

"It's so you can see it with fresh eyes," Mick said.

"Over there," Mom said, pointing to the left bank, "somewhere up in that part of the forest, there's a village that was buried under a landslide about five hundred years ago."

"Yeah?" I said, perking up. "Can we go see it?"

"No one knows where it is."

The forest looked like all the other forests around. "Far-out."

Most parts of the Kitlope River are as wide as a channel, but when you look over the edge of the boat, the riverbed is a few feet beneath you. Old logs stick out of the water like great, bleached finger bones. The ones you can see aren't as dangerous as the ones submerged just below the surface, the deadheads, which can puncture your keel. Mick took over steering the punt, since he had more experience with the river. Mom went up to the bow to spot deadheads, but she wouldn't let me join her because she said I'd be too

distracting. We started up the river, hugging the shore. The banks were covered in yellow, dry grass. I looked out for kermode bears, which are black bears that are cream-coloured, white or very pale brown. But I didn't see any, just a pair of eagles that circled high above us, then lost interest and flew towards the ocean. The water was furiously foaming and surging, so we virtually crawled up the river. Mom would shout out if she saw a log or a deadhead in front of us, and use her hand to point which direction Mick should go.

We stopped just before we reached the lake, and Mom pointed out some indentations in the rock on the beach that she said were the footsteps of the Stone Man. They were in granite. They looked like real footsteps.

"Can we go up?"

Mick shook his head. "The Stone Man isn't in the mood for company today." He steered us into the lake. "That's where we'll be staying tonight."

"Where's the Stone Man?" I said. On the north side, I could see a pale strip of sand. Kitlope Lake was wide enough that the shores on the opposite side were a thin line. Ringed with mountains, the lake was choppy because the winds were funneled straight down from the glaciers towards the ocean.

Mom pointed to the mountain behind the sandy beach. The clouds hadn't lifted high enough for us to see him. When I was little, she told me that the Stone Man was once a young hunter with a big attitude. He thought he knew everything, so when the elders warned him not to go up the mountain one day, he laughed at them and went up anyways. Near the top, he sat down to rest and wait for his dogs. A cloud came

down and turned him to stone. Sometimes, when the wind blows right, she said, you can hear him whistling for his dogs.

Mick unloaded our things while Mom took out some kindling and got enough wood together to start a fire. I unpacked the tent for Mick, who took over and left me with nothing to do but watch.

I asked Mom how we were supposed to see oolichans and she said to look for the sea gulls. Wherever the oolichans go, the sea gulls follow. She said that a long time ago, people were afraid to go up the Douglas Channel because this great big monster guarded the entrance. It was white and opened its huge mouth, making a roaring cry. The monster turned out to be just a huge flock of sea gulls feeding on herring. The flock would rise into the air and the monster's mouth would open, then it would settle back on the water and the mouth would close.

She also told me about the time she was on this very beach and she saw a pod of killer whales chasing seals. The river leading up to the lake is shallow and tidal. It was high tide, and she had a clear view of the whales and the seals—she said it sure was something to see them chasing the seals, snapping out of the water and dragging the seals down.

"Cool," I said.

"Don't go wandering off," Mom said. "There's lots of sasquatches around here."

Mick snorted.

"Your uncle saw one. Didn't you, Mick?"

He grudgingly told me about the time he was checking his trapline up Kitlope Lake and he thought

he saw a sasquatch. Its fur was pale brown, and it was standing, looking the other way, when Mick tried to sneak up on it, getting excited, thinking he was going to get rich, wondering how he was going to get the body back to his boat. The sasquatch turned out to be a grizzly that was, luckily, paying attention to something in the distance.

The sun set in the late afternoon, just as we were finishing our Kraft Dinner and bologna. It wasn't so much a sunset as a fading, with the light leaking away. Our fire was a tiny orange dot against the deep black that reached right up to the thick splatter of stars. The Milky Way arched from horizon to horizon, a dusty, glowing path. The wind pushed hissing waves against the sand, and the fire spat sparks and sent smoke spinning upward. I don't remember falling asleep, but when I woke up, Mick was carrying me into the tent. He put me down and covered me with a sleeping bag.

"Is she asleep?" I heard Mom say softly as Mick settled near her.

"Out like a light," Mick said.

There was rustling and popping and I guessed one of them was putting wood on the fire. I yawned. The sleeping bag was cold so I tucked my knees up until it started to warm.

"So where will you go?" Mom said.

"I don't know. Does it matter?"

"You've got to settle down some time."

"And do what?"

"Why does it have to be so complicated? You find a woman, you marry her, you have kids."

"That's it? That's your advice? Pump out some kids and die?"

"Well, excuse me for not wanting to run around saving the world."

He laughed bitterly. "Ouch."

"Michael," Mom said, her tone becoming gentle. "You did your part. You said yourself it wasn't worth it. Why get yourself beat up again?"

"I didn't say I was going back."

"So you're just going to wander around. That's your plan."

He sighed. "No. I don't know. I thought I'd find something here. Get my head together. But I haven't had any stunning revelations so far."

"You want some more coffee?" I heard the coffeepot clanking against something metal, and then she said, "What was she like?"

"She was a lot like you."

The silence was so long, I thought they had stopped talking until Mom said, "You're a great uncle. You'd make a great dad."

"Admit it, you just like the free baby-sitting."

Mom laughed and they started talking about the oolichan run being late. My hands unclenched. I caught my breath and my heart began to calm. Life would become unbearably dull without Uncle Mick.

I listened as Mom complained about Dad's new plan to tear up the front fence and put in shrubs, as Mick told her about his last fishing trip and worried over how short the openings were becoming. They debated about bringing Jimmy oolichan fishing next year. Mick said it wasn't healthy for a boy to be such a

housecat. Mom laughed and said Jimmy took after his father. I was afraid to fall asleep in case I missed over-hearing something important, but I began to drift.

I woke when Mick started snoring. Not loud, but he was right beside me, and his wheezy breath in and whistling breath out kept me from sleep almost as much as Mom's twitchy arm across my waist. Our combined heat made the air clammy and stifling. I pushed my part of the sleeping bag down. Mom shiv-ered and pulled it back up. I tried wiggling farther up, out of the blanket, but she cuddled into me. When I untangled myself, she lifted her head, blinked at me and asked where I was going.

"I have to pee."

"Don't go running around," she murmured.

I stumbled out of the tent and went first to wash my face in the lake to get the grit out of my eyes. I paused a few feet away from the tent. I felt small as I looked up at the mountains, royal blue against the grey sky, ten-drils of mist lifting through the trees like ghosts. In this soft light, the lake was dark and still.

A log, white with age, jutted out of the water. Balanced on top of the log was a long-legged bird star-ing out at the lake. At first, I thought it was a crane, but I couldn't remember cranes being blue. The bird's long thin beak pointed towards me as it rolled one yellow eye then the other, checking me out. I stayed very still—the bird was almost as high as my waist and looked cranky. I thought it ugly, but as we watched each other, I decided it had a Charles Bronson-type appeal. The back feathers looked like light blue fur, the wings and the stubby tail were smooth blue-grey,

and it had a distinguished white streak on top of its head. I moved, wanting to run back to wake Mom and Mick but, startled, the bird launched itself over the lake, croaking, wings spread open, its neck bent back into a tight S. Later, when I looked it up in the library, I discovered it was a great blue heron, but while I watched it disappear in the distance I thought I was watching a pterodactyl straight from the Dinosaur Age.

Mick woke up not long after that. I heard him unzip the tent and start chopping kindling for the fire. I stayed by the edge of the beach, watching the lake. The fire crackled to life, the smoke rising in a straight, pale grey column. He made himself coffee, then came to stand beside me.

"You okay?" he said.

I nodded. "It's just so pretty."

"Sometimes," he said, "when there's a storm, you can hear voices singing on the lake."

I reached out my hand and he took it. His hand was warm and solid. Mick sniffed. "Now I know I'm awake. You stink."

I punched his arm. "I do not!"

"You up for a dip in the lake?"

"You're kidding."

He glanced at me sideways. "They used to do it in the old days. Cleans your soul."

"No way. It's freezing."

"Suit yourself," Mick said, handing me his coffee cup. He peeled off his thermal top and slapped his chest. "Last one in's a rotten egg." He kicked off his socks and stripped down to his underwear. With a loud

hoot, he made a dash down the beach, waded up to his knees, yelping with the cold, then he dived. He cut the water with a sharp splash that echoed back to us, then he slipped underwater. The ripples spread, the mountain's reflections jiggling like a blurry TV reception. He was still visible under the water, a pale shape slowly rising to the surface. His head broke the surface and he spat and shook his hair out of his face.

"You nut!" Mom scolded him, poking her head out of the tent. "Get out of there before you catch pneumonia."

"Come on in, Gladys. The water's just fine."

"Get your butt out of there!"

He swam to shore, stood up and made a dash for the tent. She threw his sleeping bag at him, and he wrapped it around his shoulders, laughing as she told him what an idiot he was.

The water kept rippling, even after he had had his second cup of coffee, but nothing surfaced.

"What you looking for, Monster?" he said, coming up and dripping on me.

I couldn't explain the feeling I had and didn't want to ruin his newly restored good mood. "Seals."

"They'll come when the oolichans get here."

He said he wanted to give Mom a rest, so made breakfast. It was just scrambled eggs, but she pinched his cheek and said it was the best breakfast she'd had in ages. He looked annoyed and said he didn't need to be babied any more.

"What oo say?" Mom said, in a high, sweet singsong. "Oo don't wike me tawk—"

Mick lifted her up and ran down to the beach.

Mom squawked and hit him. "You do and you're dead, mister! You hear me?"

He dropped her and staggered around the beach, barely suppressing a smile, clutching his ear where she'd clipped him. She smacked his back.

"*Na'*. Enough."

When we left to go back to Kemano, Mom said we'd try one last time to see the Stone Man. We loaded everything back into the speedboat and drove to the middle of the lake. She stopped the engine, and we just sat there.

"That's the Stone Man," she said.

A large, black, hunched-over figure sat on the side of the mountain staring down at the lake. It felt like he was watching me, like one of those trick pictures that has eyes that follow you.

By the time we beached our boat at the Kemano fishing camp, the weather had turned. Mick said he was going to do some jigging, and Mom sat me down at the kitchen table and told me it was time to do some homework. I could hear his speedboat starting and then fading away. Uncle Geordie and Aunt Edith had gone to the Alcan site to refill some gas tanks. While everyone else was going around having fun, I had to sit at the front table and do math. I glared at my books.

"Your homework's not going to do itself," Mom said. She scrubbed the dishes and ignored the looks I sent her way. The morning was bright and cold. Watery sunshine turned the front room mildly warm. She refused to waste wood heating the front room during the day, and she was even using cold water for

the dishes. When I knew she wasn't going to relent, I zipped through my problems, not bothering to check if they were right or wrong.

Before I could go outside, I had to help dry dishes. "Sooner we finish," she said, "sooner you can go."

"I thought this was supposed to be fun," I grumbled.

"Aw, poor baby."

As soon as I'd wiped the last spoon, I tossed off my apron and was out the door before she could catch me.

"Lisa! Come put your coat on! Now!"

I booted it down the path to the beach. I headed towards the point, then swerved into the trees and waited at the edge of the graveyard. Mom yelled some more, then went back inside. She hated being undignified, and chasing me through the bushes would definitely qualify as humiliating. If I caught heck tonight, so be it. As long as I got a day to just fart around with no one hovering over me.

The first headstone I came across was carved in the shape of an eagle and covered in moss. It was already half-eaten through by bugs and looked ready to collapse. I looked down and realized that I was standing on the grave. I jumped back. The silence was the solemn silence of churches, hushed. Only the rain dripping off the trees broke the stillness. I wandered through the graveyard, hunting headstones.

As the afternoon wore on, I began to wish I'd put on a coat. Shivering and wet, I knew Mom was going to keep me inside if I went back to the house, and that would be the end of exploring. I snuck down along the beach, crept past the clearing in front of the house and headed for the spring. There was sand on the upper

part of the shore, where the trees met the beach. Near the spring I saw wolf footprints on the track of deer footprints. Excited, I went hunting through the bushes for the wolf and came across some decrepit houses. The roofs had fallen in, the doors were leaning drunkenly against their frames or were flat on the ground. Some of the rooms still had old cups and dishes in them, half-hidden in dead leaves and moss.

When I heard Mick's speedboat coming in, I walked back to the house. Mom never lit into me as badly when Mick was there. I steeled myself for the big lecture, but when I got inside, she didn't even turn to look at me. She was frying corned beef. Mick was sneaking up on her, and I stepped back onto the porch so I wouldn't ruin the surprise. He came up behind her, encircled her waist with his arms and gave her a gentle kiss on the neck. She pulled his arms off, slowly, then pushed him away, eyes downcast.

I stayed in the shadows of the porch as Mick retreated into the front room. She continued frying as if nothing had happened. I backed slowly down the steps, careful to go on the edges, where the steps creaked the least.

Time passed, I don't know how much, everything blurred and slid together, and I shook and felt like I was going to throw up.

"Hey, short stuff," Mick said as he walked along the beach. "We're waiting for you. Dinner's getting cold."

I walked past him, saying nothing. I stopped in the doorway and waited. Mom handed me a plate.

"If you get a cold," she said, "I'm not going to feel sorry for you."

"Sorry," I said.

"Just go change, Lisa."

Dinner that night was quiet. Uncle Geordie started coughing. Aunt Edith was knitting

"You in the doghouse too?" Mick whispered when Mom went into the kitchen.

Uncle Geordie was going back early to Kitamaat in the speedboat to see about an engine part. I told Mom I was sick and wanted to go with him back to the village. She frowned at me, placed her hand against my forehead and agreed with me, telling me how it was my own fault for running around in the cold without a coat.

Later, Aunt Edith told me about the accident they had on the way back from Kemano. They were towing the punt. Since it was empty, it was rolling in the waves. She was watching it, so when a wave hit it the wrong way and it slid under the water, she called out a warning. The troller tilted, stern pulled down, as the punt sank. Mom tried to work the knot free, but it had tightened as the punt pulled at it. Mick slid beside Aunt Edith, brought out his knife and cut them free, but Mom said that during those few seconds that she was thinking they were goners, she saw porpoises playing around the punt and knew they were going to be all right. But for a moment, she said, the porpoises looked like people, and she screamed.

≋

The greengage tree was covered with a fishing net. The greengages were almost ripe, so Dad had put the net on

to keep the crows from raiding our tree. Crows are clever, though, and find the holes or simply go under the net. I don't like ripe greengages, anyway. I like them tart and green, hard enough to scrape the roof of my mouth.

White feathers tumbled down from the half-eaten chickens caught near the top of the tree, where the hawks had dropped them. The chickens were still alive. They flapped wings, kicked feet, struggled against the net. Their heads had fallen to the ground like ripe fruit. Their beaks opened and closed soundlessly, and their eyes blinked rapidly, puzzled and frightened.

≋

I can't find my cigarettes. I've ripped my room apart and nothing. I had a full carton. I couldn't have gone through it so fast. I had a full pack right there in the bottom of my purse. I have more, I know I have more. I can't have just three cigarettes to my name. Damn. I'm going to have to make a trip into town. I light the first one. Eyes are closing again. I collapse into my bed. Never fall asleep with a cigarette in your mouth. No, no, no. I regretfully stub it out, saving the rest of it for later. Funny how you never appreciate a cigarette fully until you know it's one of your last.

Morbid thoughts. Try to avoid morbid thoughts. Staring at my ceiling. Flat expanse of white. Easy to space out. Tired. My clock says 2:47 a.m. Rain blowing against my window. More than a half-kilometre under the surface, the ocean is perpetually dark, and even artificial light is obscured by the blizzard of

falling particles from decaying animals and plants. They fall like snow against the unending darkness. At a depth of one kilometre, the temperature is only a few degrees above freezing. Less than one hundredth of a per cent of the deep sea has been glimpsed; astronauts have flown 384,000 kilometres to walk on the moon, but no one has actually set foot on the deepest ocean floor.

The crows are squawking in the greengage tree. Ma-ma-oo told Jimmy that feeding crows brought you good luck, so he tried it before a swim meet. It was the first time he won. He also likes to leave them things to steal. Before he went out fishing on the *Queen of the North*, he left an old run-down pocket watch on our porch. It was snatched up by one of his favourites, Spotty, who looks like she's been splashed by bleach. Spotty pecked at it for a long time before bringing it to the road and leaving it there.

"Watch this," Jimmy said to me. "She's going to haul it up in the air, then drop it until it busts open. They do that with clams too."

Spotty did no such thing. She waited patiently by the side of the road, preening in the early-morning sunlight and occasionally screeching. Jimmy tried not to look disappointed. I was about to go inside when a car drove by, missing the pocket watch completely. Spotty hopped over and moved it two feet to the left, so that when the next car came along, it ran right over the watch. Jimmy and I looked at each other, then back at Spotty, who picked at the exposed innards of the pocket watch. She gathered up some of the pieces and flew away.

"If I hadn't seen it with my own eyes," I said, "I'd never have believed it."

Jimmy looked so pleased, you'd have thought Spotty had joined Mensa.

Some swimmers spat in their goggles, some shaved their bodies, but Jimmy used to feed the crows. Every morning, early, he'd be on the back porch. He would wait a moment before he began to rock in his chair. The porch would creak like an old ship. The crows were attracted to the creaking, they knew it meant food. He'd break the bread into small pieces while the crows settled into place, squawking, flapping and pecking each other. The crows covered our porch in a shifting black mass. He'd toss the bread languidly, as if he were a king granting favours. The crows are so used to this ritual that they keep coming back to the porch, arguing over the best place to wait.

≋

For our first sex-education class, the girls and boys were split up and sent to different rooms. Tab picked a spot at the back, and we wrote notes back and forth while our teacher explained the mysteries of a uterus. As she moved on to menstruation, she passed around some pads and tampons for us to look at. She said that our bodies would start to go through many changes, and that we would become women. "If you see blood on your panties, don't be afraid to tell your teacher or your parents. Let them know, and they will help you get the right equipment."

She started to explain birth control. Whenever she

said "sex," a wave of nervous giggles washed through
the class. She started to say "intercourse" instead, but
we all knew what she meant, and the giggles continued.

I couldn't really imagine having sex with a boy.
From the look on Tab's face, I could tell she felt the
same way. According to every *True Story* I'd ever read, sex
led to misfortune. Girls in our class had become very
silly, standing around the playground and whispering
about this boy or that. I was glad I didn't have to be a
part of it.

After school, we went to Tab's house and snuck
into her room. It was hard to concentrate on playing
cards, because Aunt Trudy had her stereo blasting. Tab
could ignore the blaring Creedence Clearwater
Revival and Aunt Trudy's sing-along drinking bud-
dies, but I played with one hand against my ear. When
we went upstairs to get chips, Aunt Trudy invited us to
sit with her. Josh had his arm around Trudy's shoul-
ders and was rambling on about his fishing season.
The other two men were singing and waving their beer
cans to the beat of the music. When we didn't join
them, she called us stuck-up snobs and asked Tab over
and over if she thought she was better than her
mother. The cigarette smoke made the ceiling a blue
haze, and the yeasty smell of beer on everyone's breath
combined with the noise to make me sick. Aunt Trudy
started asking Tab if she was fucking around, who she
was fucking around with and if she thought she could
get away with it.

"Don't think I don't know," she said. "I'm on to
you. I know what you're doing. You can't get anything
past me, girly-girl."

Tab just looked at her mother. My eyes bugged out. I expected Tab to break down and cry. The longer Aunt Trudy went on, the madder I got. Tab stomped on my foot each time I was about to open my mouth, but I finally spoke up.

"You're being really mean," I said. Tab kicked my ankle under the table, but I kept going. "She doesn't even like boys."

Aunt Trudy's glazed eyes switched from Tab to me. She blinked, and stared at me as if I'd just appeared. "Miss High-and-Mighty, aren't we? Miss High-and-Mighty."

"Let's go," I said to Tab.

"You think you're so good. You think you're so special. Don't you? Don't you have a special friend, girly-girl?"

"Mom," Tab said. "Stop it."

"Shut up, you whore," Aunt Trudy said to Tab.

I stood up. "Shut up, you drunk."

Tab gave an exasperated sigh. "Lisa . . ."

I couldn't believe she was taking her side. "She can't talk to you like that."

"You think I'm a drunk," Aunt Trudy said. "I'm not half the drunk your precious uncle Mick was."

I stood in Aunt Trudy's kitchen and couldn't make my mouth work. Aunt Trudy grinned. "All dried up now, is he? All sober and clean. Oh, he was a horny dog when he was a drunk."

"He was not!"

"Mom, we've got homework," Tab said. "Come on, Lisa."

"Panting after your mother."

"You're a liar!"

Aunt Trudy laughed, which woke up Josh, who'd passed out on his chair. He blinked at us, then asked Aunt Trudy for a beer.

"Fridge's right there," Aunt Trudy said.

"Some fucking host you are," he said.

While they were arguing, Tab tugged on my sleeve. When we were back in her room, she told me to ignore her mom.

"How can you let her talk to you like that?" I said, still furious.

"She's just drunk. She won't remember a thing tomorrow," she said.

I sat on her bed and hugged a pillow. "I can't believe she says things like that. What a liar."

Tab gave me a pitying look. "Why do you listen to her?"

≈

The next day, I went back over to Tab's house.

"Come in, come in." A shakily sober Aunt Trudy led me into the kitchen and offered me juice, then laughed and said she'd just sent Tab to the store to get some. "You can have coffee or water. I don't think you drink coffee yet, do you?"

I shook my head. I watched her for any hidden resentment, any clue that she was still mad at me for calling her a drunk, but she seemed genuinely glad to see me. She cupped her mug of coffee, squinting when the sun poked through the clouds and lit the kitchen.

"How're your mom and dad these days?" she said.

"Okay," I said, racking my brains for a clever way to bring up Uncle Mick that would make her tell the truth.

"What grade are you in now?"

"Five."

"Five! Oh." She laughed again and hit her own head. "Same as my Tab. Don't have a brain till I've had my coffee."

"Aunt Trudy?" I gave up. I wanted to know too badly to be clever.

"Hmm?"

"Did Mick and my mother have an affair?"

She almost dropped her cup, then spent a long time pretending to mop up coffee that hadn't spilled. "What? What?"

"Did they?"

"Who on earth have you been talking to?"

Until that moment, I hadn't really believed that she couldn't remember the night before. "People."

"People?" She adjusted her bathrobe, ran a hand through her hair. "People, hey?" Her eyes narrowed. "Erica people?"

I didn't answer. For a moment, I was going to tell her that she'd told me herself, but knowing Aunt Trudy's dislike of anything involving her sister Kate, Erica's mother, I just watched her.

"Thought so," Aunt Trudy said. "You don't listen to anything that little witch says. Your mom and Mick went on a few dates, but he left before they . . . um, before they . . . did anything. She was brokenhearted, your dad was there to comfort her, and they fell in love. What did Erica say to you?"

"She just hinted." Which was, more or less, the truth.

"Jealous, I bet." She raised her eyebrows signifi-
cantly. "Just like her mother."

What Erica could possibly be jealous of escaped
me. She had everything.

"Here," Aunt Trudy said. She pushed herself out
of the chair and patted my shoulder. "I think there
might be a cookie or two left in my cupboards."

When Tab came back, she found us sitting at the
kitchen table. She paused, startled. Aunt Trudy called
Tab a dear and made us a Kraft pizza. Tab watched me.
Aunt Trudy said her tummy was upset, probably
because of a darn flu bug. When her mother wasn't
looking, Tab rolled her eyes upward.

≋

A sea otter dives. Long streams of sunlight wash
through kelp trees, undulating like lazy belly dancers.
A purple sea urchin creeps towards a kelp trunk. The
otter dips, snatches up the urchin, carries it to the sur-
face, where the sound of the waves breaking on the
nearby shore is a bitter grumble. Devouring the
urchin's soft underbelly in neat nibbles, the otter
twirls in the surf, then dives again. The urchin's shell
parachutes to the ocean bottom, landing in the dark,
drifting hair of a corpse.

≋

The little man woke me near dawn, his eyes glittering
and black. The Winnie the Pooh stories end with
Christopher Robin saying he's too old to play with

Pooh Bear. Little Jackie Piper leaves Puff the Magic
Dragon. Childhood ends and you grow up and all your
imaginary friends disappear. I'd convinced myself that
the little man was a dream brought on by eating dinner
too late—Mom had told me she always dreamed of
earthquakes if she ate too much lasagna. Sometimes he
came dressed like a leprechaun, but that night he had
on his strange cedar tunic with little amulets dangling
around his neck and waist. His hair was standing up
like a troll doll's, a wild, electric red. He did a tap
dance on my dresser. Then he slipped, fell into my
laundry basket and pulled my sweaters and T-shirts
over his head. The basket tipped over and rolled
beneath my window. I watched it warily, my chest
aching so hard I couldn't catch my breath.

"You little bastard," I whispered.

He popped into the air behind me. I didn't know
he was there until he touched my shoulder with a cold,
wet hand. When I spun around to smack him, he
stared at me with wide, sad eyes. Even after he disap-
peared, I could feel where his hand had touched me,
and I knew he'd been trying to comfort me.

≈

I put my head in my hands, nursing a headache on the
front steps. Mick came and plopped himself down
beside me. "Hey, how's my favourite monster?"

"Okay," I said.

"Yeah? You've been pretty quiet lately."

I shrugged. "I'm thinking."

"Your mom says some things are simple, and thinking just make them complicated."

"Like what?"

"Oh, life. Apparently we're here to have babies and everything else is just icing on the cake."

"Are you going to have babies?"

"If I can find someone who'll put up with me."

"Are you leaving?"

"Someday. Tomorrow. Three years from now. Who knows?"

It wasn't the answer I wanted. I sat up, pulling myself right beside him. "Can I come with you?"

He ruffled my hair. "You know you can't."

"It's not fair."

"You can come check the net with me."

I pressed my temples together. "I got a headache." He laughed. "I do. I had awful dreams last night."

He kissed the top of my head and stood, stretching. "I don't feel like checking the net either. Been skunked for the last few days anyway." He saluted me. "But duty calls, I'm off."

I waved, then turned away and went inside to have breakfast. My eyes were gritty. It felt like I hadn't slept for weeks. Dad's car pulled into the driveway and he emerged carrying a waist-high shrub. I watched through the kitchen window as Mom stomped across the lawn and put her hands on her head and pulled at her hair as Dad placed his new greenery in front of the rose trellis.

My cereal had no taste. I couldn't eat. The dream still crowded around me. Jimmy watched TV in the

living room and the cheerful pops and endless, bubbly music of his cartoon show faded for a moment. Sunlight broke through the clouds, brightening up the kitchen so much that I felt dizzy, like I was falling. I jerked upright, disoriented, staring into my Rice Krispies.

Uncle Geordie phoned later that morning to say that the seals were getting at the nets, and that if we wanted any of our coho, we should go out and check them.

"Mick's truck is here," Dad said as we drove into the bay.

"Maybe he's having coffee somewhere," I said.

Dad frowned, parking the car at a distracted angle to Uncle Mick's truck. "Flirting away with someone, I bet, when he said he'd check the net." Dad honked the car horn impatiently, but Uncle Mick didn't appear. "Dammit, the seals will get everything."

I hadn't slept since the little man left me. I kept thinking, Nothing's wrong. Nothing's wrong. Mick's just goofing off. He's fine.

The rest blurs like a shaky homemade movie. My feet, heavy as we walked down the dock. The speedboat's outboard motor, cranky and refusing to start for five endless minutes of Dad yanking on the cord. The choppy ocean. The net, all the corks along the middle sunk under the water. Mick's speedboat pushing itself against the shore, nudging it and scraping slowly along the rocks. Seals bobbing their dark heads between the whitecaps as Dad picked up his shotgun and fired and fired at them, then reloaded, saying, "Don't look."

Morning light slanted over the mountains. The sky was faded denim blue. Grumbling, a raven hopped between the branches of the tightly packed trees. Water sparkled as a seal bobbed its dark head in the shallows. A deer paused at the shoreline, alert. It flicked its tail up, showing white, then bounded up the beach and into the forest. In the distance, the sound of a speedboat.

≋

Spotty wakes me from a dream about Monkey Beach. She is in the greengage tree when I wake up. She screeches, hops, and I hear her hit our roof, then trundle back and forth, her claws clicking against the shingles. *La'sda*, she says. Go into the water. *La'sda, la'sda.*

The house has grown a thick scum of quiet. An unhealthy hush reserved for terminal wards. The living-room light is on. I make myself a hot chocolate. I vividly remember the first time I got a hollow chocolate Easter bunny. Marvelling at how big it was and how much chocolate I had, and then biting into the ear too hard, expecting resistance and meeting nothing.

The phone rings and I close my eyes. Anyone calling this early has either very good or very bad news. I pick up on the third ring.

"Lisa?" Dad says. His voice is shaking. I can hear Mom crying in the background.

"Yes," I say.

"We—" He takes a breath. And another. "They found a life raft."

"A life raft. Are they sure it's from the *Queen*?"

"No," Dad say. "But no one else is missing."

"Was anyone in it?"

"No."

"Dad, I'm coming down as fast as I can. Is Mom okay?"

He doesn't answer. I ask where he is, where the life raft was found, then say goodbye and hang up. I should have gone with them. I should have gone. I call the twenty-four-hour line for Air Canada, but the travel agent says it is a busy week and now the people from a soccer tournament, a Health Canada conference and nine wedding parties are returning to Vancouver. She says I could try standby, but there are already fourteen people at the airport trying to get on the same flights. The next available seat is in four days. Canadian and Coastal Mountain are the same. The charters out of Prince Rupert are booked solid because it's the height of the sports fishing season. I phone the airlines again, thinking that if I explain about Jimmy, I might get on a flight if someone is willing to get bumped, but all the lines are busy.

It takes twenty hours to drive to Vancouver—sixteen if you ignore the speed limit. You have to go inland all the way to Prince George and then down and back to the coast. Add the hours to get to the island, and maybe you'll get a spot on the ferry up to Bella Bella and you've wasted almost two days. The bus is a twenty-four-hour ride. The ferry out of Rupert won't leave for two days. The train takes three days. Most of the boats are out fishing right now—

Why didn't I think of it before? God, I have no brain in the morning. Of course, I have a speedboat. Damn thing is only 35 horsepower so that's three

hours to Butedale, then three hours to Klemtu, then three or four hours to Namu. Add an hour for bathroom breaks and rest stops. I could be in Namu early this afternoon. On the night Jimmy disappeared, I dreamed he was at Monkey Beach. His seiner went down so much farther south, so I don't hold much hope of that dream being anything but a dream, but I can stop there for a few minutes, since it's on the way, just to be sure.

I want to get out of the house before Aunt Edith wakes up, so I don't pack much. If she finds out I'm going, she'll make me wait for Uncle Geordie to take me down and we'll waste valuable time getting a hold of him, waking him up, breakfast, blah, blah, blah. I leave her a note telling her about the life raft and saying that I'm going to meet up with Mom and Dad. Then I steal the keys to Dad's speedboat. He used to have a gillnetter, but he sold it because it used too much fuel. He kept the speedboat, though, so he could set the net. Jimmy is the big salmon eater in our family. He'll go through two jars a day if we let him. Dad jokes that he's going to grow gills.

It isn't even light out yet, but I walk all the way to the docks. The speedboat hasn't been used in months. When I pull off the tarp, I have to bail the stupid boat because of the rain water collected on the bottom. I haul my stuff on, then cast off. With a deep breath, I go to the stern, then yank the motor cord. It takes three tries before the motor kicks in. The sound is so loud that I'm sure someone's going to run down and stop me. I drive to MK Bay Marina and wait for the gas station to open.

Gordo comes down first. "Playing hooky from school?"

"Oh, yeah," I say. "A little day off won't hurt anybody."

He laughs. "Tell that to my boss."

I fill up four gas cans on Dad's credit card. I store them in the back while Gordo disappears into the store.

"Wear your life jacket!" he yells to me as he casts me off.

I wave to him. As I drive by the village, I watch our house for signs of life. No lights are on. Daylight makes the sky dark grey. Clouds hang low and flat across the entire sky. The air's nippy, the engine's noisy, and the whole day stretches ahead of me. Since it's early in the morning, I'm going out with the tide and there's no wind. Rain splatters me. I blink, water creeping down through my collar, plastering my hair flat and stinging my face. I'm cold and can't see much, but I don't mind. There is nothing like being on the ocean to clear the head.

The Song of Your Breath

Contacting the dead, lesson one. Sleep is an altered state of consciousness. To fall asleep is to fall into a deep, healing trance. In the spectrum of realities, being awake is on one side and being asleep is way, way on the other. To be absorbed in a movie, a game or work is to enter a light trance. Daydreams, prayers or obsessing are heavier trances. Most people enter trances reflexively. To contact the spirit world, you must control the way you enter this state of being that is somewhere between waking and sleeping.

≋

The tide is wicked. When I go against it, my speedboat does a crazy, sideways slither. The sky, one sheet of pissing greyness, stretches low across the horizon. A sea gull squalls overhead as it flies towards Kitamaat. This early in the morning, the beacon in the distance is still blinking, a forlorn warning against rocks. Ever since I was a little kid, I've spent hours watching it flash. Sitting on top of a short metal tower painted red and white, the beacon is about fifteen klicks from the village. When I see that lone flash of white light against a vast stretch of darkness, I feel deliciously alone.

I'm passing the old graveyard. It's about a twenty-minute walk from the village, but barely a five-minute ride on my boat. Mick took me there for the first time when I was little. I remember staring at the graves, thinking how messy they looked, with ragged clothes and pots and junk around them. The next time I went, I was a little older and with my summer day-care group. We had to take rubbings of the headstones and bring them back to class and describe to the others what we had seen. Most of the kids went for the carved totems, the fancy writing, but I saw this plain headstone with nothing on it but the number 100 and a backwards F. Since it was simple to copy, I put my paper against it and rubbed my pencil across the surface. As I was standing in front of the class, I held up the paper and the light shone through it. 100F was really "Fool" backwards. No one in class knew what it meant, so I brought the rubbing to Ma-ma-oo after school, and she told me that everything in the land of the dead is backwards. When you are in the next world, our day is your night; our left is your

right; what is burnt and decayed in our world is whole in yours.

At Mick's funeral, the casket was closed. The picture on his coffin was a blurry black-and-white from his basketball days, when he was sixteen or seventeen, trophy in one hand, smiling into the camera, confident, young and clean-cut. He had never talked about his glory days as a most valuable player. The picture wasn't the Mick I knew. I sat in the front row of folding chairs and stared at the picture, thinking: that was the person Mom had dated.

When I glanced over, I saw one of Mick's friends from his A.I.M.'ster days—a group of about seven men and women had traveled up to Kitamaat. The man seemed familiar, and then I realized he smelled of Sagos, the same brand Mick smoked. Barry, I thought, remembering his name. Barry sang an honour song for Mick as we walked in the funeral procession. His voice was high and I didn't understand anything they were singing, but it covered the squeaking sounds of the coffin being lowered into the ground, Aunt Trudy's wailing, and finally, the dirt hitting the top of the coffin. Mom took my hand and squeezed it. Aunt Kate put a hand on Aunt Trudy's shoulder, whispering to her. Dad put our wreath on his grave. When he walked back, Mom put her hand around his waist. Jimmy stood beside Dad, staring at the ground.

The crush of people left to give the family time with Mick. We stood in a circle around the fresh and the plastic flowers. I concentrated on the trees. They creaked and swayed in the wind. The sun was out and I was hot in my black dress. Mom's hand was sweaty. She

led me past his grave and I knew I was supposed to say goodbye but I stood there until she tugged on my hand and led me away.

We went to Ma-ma-oo's for cake and drinks. Mom brought Dad coffee and they stood with Aunt Edith and Uncle George.

"Don't tell me to take it easy!" Aunt Trudy yelled at Aunt Kate by the kitchen. "He's fucking dead! If I want to cry, I will fucking well cry! I don't care if you're embarrassed."

Kate bit her lip and stepped away from Trudy. "I didn't mean—"

"I have feelings! Unlike the rest of you bastards!"

Someone came and sat beside me. Jimmy nudged my arm and offered me spice cake on a foam plate. I shook my head. "I'll leave it here," he said, putting it on the chair between us before he left. I looked down at my hands. When I looked up, Aunt Trudy was sobbing on Josh's shoulder. He stroked her hair, talking in soothing tones. Aunt Kate picked up her jacket and left. Erica followed. Tab slid away from her mother and asked me if I wanted some pop.

"Tabitha," Aunt Trudy turned to us, "we're leaving. Now."

"My mother," Tab muttered. "The drama queen."

"What did you say?" Aunt Trudy said.

"I said okay." She gave me a hug, then whispered. "Excuse us while we make a dramatic exit."

Aunt Trudy came up and gave me a hug too. "You take care of yourself."

"Back at you," I said and she smiled.

"You come and see me later, okay?"

"Okay."

Josh shook my hand and gave me an envelope. "Just because."

I nodded at him. When I opened it later, there was a sympathy card and two pictures, one of Mick holding up a basketball trophy and one of him and Mick on his seiner. They were grinning like crazy as they lifted a giant halibut between them. Josh had also included a crisp hundred-dollar bill.

As the afternoon wore on, people came and went. Some of them sat with me, and gave me food. I had a plate overflowing with food by the time Barry came up to me.

"I gotta smoke," he said. "You want to keep me company?"

I shrugged. "Sure."

We went to the front steps, but there were people there, so we walked down the beach and sat on a log. The tide was low but coming up. Near the old wharf, two little kids were horsing around in the water, squealing and splashing each other. A couple of months earlier, a boy had ridden his bike off the end of the wharf. People wanted to pull it down because the wood was rotting and everyone agreed it was an accident waiting to happen. Barry finished rolling his cigarette and lit it. He reached into his front shirt pocket and pulled out a battered picture. He handed it to me. A man with a really bad Elvis hairstyle and an Indian woman with a mile-high bouffant were kissing. I squinted, bringing the picture closer. God, I thought, that's Mick.

"That's my sister, Cathy," Barry said. "But we all called her Cookie. That's their wedding picture. See

the guy in the corner?" There was only half a dark
brown face and it was painted with flowers. His mouth
was wide open, showing missing front teeth. "Crazy
old bastard is my uncle. He's the medicine man that
married them. They made him sing some fuc—I mean,
some damn Elvis song. We were all kind of nuts back
then, but Mick and Cookie . . . " He shook his head.

"Were you there?"

"Oh, yeah. Never saw anything like it. They broke
up couple of days later. Got together again, made up.
Remarried. Fought. Broke up. After a while, none of
the medicine men would marry them no matter how
much they tried to bribe them, so Cookie told every-
one they were living in sin even by Indian standards."

"What did they fight over?"

He grinned. "Faster to say what they didn't fight
over."

A woman started yelling at the little kids to quit
swimming and come in for dinner. They yelled back
that they just wanted five more minutes. She waded in
and pulled one of them out of the water and he let out
a despairing howl. Barry was watching me. I stared
right at him.

"Mick wasn't in the water long, but the seals got
him."

He sucked in a breath. "Bad way for him to go. Bad
thing for you to see."

I held up the picture. "When he had nightmares,
he'd call out her name. I used to think he was having
bad dreams about cookies."

"Yeah," he said. "He took it hard when she died."

"She died? How did she die?"

He stubbed out his cigarette. He looked out over the water. "Cookie got kicked out of three residential schools. At the last one—guess she was fourteen then—this nun kept picking on her, trying to make her act like a lady. Cookie finally got sick of it and started shouting, 'You honkies want women to be like cookies, all sweet and dainty and easy to eat. But I'm fry bread, you bitch, and I'm proud of it.'" He laughed and shook his head. "She always had to be right. When I was losing an argument and wanted to piss her off, I'd call her Cookie and it stuck."

"How'd she meet Mick?"

He hooted. "Oh boy. Well, she joined A.I.M. right after me and we were going around to all these rallies. We stopped over in Vancouver and we were protesting something, jeez, what was that, the block—"

"You were at a rally," I interrupted.

He looked at me, raising an eyebrow. "You talk to all your elders like this?"

"Only the ones I like."

"Uh-huh. We were at a rally. Some of the guys were going off to a sweat and she wasn't allowed to go because she had her period. She was pissed off and telling everyone how wrong it was and the guy that was making a speech had to tell her to shut up and she started yelling at him. Mick piped up that tradition was tradition and if they wanted to get back to the old ways, they should follow them. Then they were off! They stood in the middle of a crowd and shouted at each other until they were hoarse."

"So it was love at first sight?"

"Nah. Worse. She finally met her match. She was

never going to be happy until she argued him into the ground. Did Mick tell you about Washington and the Trail of Broken Treaties?"

"When A.I.M. occupied the Bureau of Indian Affairs building?"

"Yeah." He started to tell me about it, then said he'd explain it to me when I was older. I leaned my head against his shoulder. I closed my eyes, suddenly glad I didn't know how she died. I didn't want to hear anything else that ended badly. He gave me a piece of paper. "You did him a lot of good. You ever want to talk, you give me a call, okay?" We went back inside and he left with his friends a few minutes later.

I kept the paper with his address and phone number in my jewellery box. He wrote me once, a short letter with bad handwriting, the words packed tightly together and jittery on the page. He was proud to know Mick. When things got screwy, he wrote, Mick stayed on the path of true human being. I always wanted to know what he meant by screwy. I still have his address kicking around somewhere.

At a family meeting a few days later at our house, Aunt Trudy and Aunt Kate got into a scrap over Mick's basketball trophies, medals and awards. Dad didn't want them. Ma-ma-oo wanted them put over his grave, but everyone said they'd just get stolen. Trudy claimed she was closer to Mick than anyone in the family—they had suffered through residential school together, they had the same friends—but Aunt Kate loudly told everyone she was worried Trudy would use some of them as ashtrays or break them in one of her parties. Trudy shouted that she would fucking well

appreciate the trophies better than Kate, who would only put them in a box somewhere and forget them. Dad divided the trophies into two piles for his sisters. They glared venomously at each other.

I knew Mick wouldn't care as long as he got his cigarettes. I wished he was with us, because he'd make some stupid joke and everyone would forget what they were arguing about and laugh.

That night, we heard an ambulance wailing through the village. I ran downstairs and overheard Mom talking to someone about a fight going on at Aunt Trudy's. I later learned from Tab that Josh had tried to claim some of Mick's medals, and Trudy had broken a beer bottle over his head. Josh's fishing crew fought with Aunt Trudy's drinking buddies until Josh was thrown down the front steps and broke his leg.

"Holy," I said.

Tab smiled, looking smug. "I'd say the honeymoon is over."

Aunt Trudy was evicted. Tab came over the night before she and her mother left, saying they were going to live in Vancouver. I couldn't imagine school without her. As a going-away present, I gave her my teddy bear, Mr. Booboo. Tab held him by one frayed ear and examined him. He was mostly patches by then.

"He gives good hugs," I explained.

≋

On Mick's birthday, Jimmy followed me down to the Octopus Beds. I didn't want him with me, but he came anyway, even when I told him to go jump off the dock.

I brought a tin of Sago tobacco, a portable stereo and an Elvis tape. I picked up all the dry driftwood that I could carry, and made a fire. I turned on the tape recorder, and Elvis sang "Such a Night."

The waves surged against the rocks. Down the Douglas Channel, I could see fat, lumbering clouds inching south.

"For Mick," I said, throwing loose tobacco on the fire.

"What are you doing?" Jimmy said.

"Just shut up," I said, staring out at the place where Mick used to set the net. My father had pulled Mick's corpse from the net and wrapped him in a tarp. Mick's face, right arm and part of his left leg had been eaten off by seals and crabs.

"What did he look like?" Jimmy asked me, greedy for details.

"An ugly fish," I told him. "A bad catch."

≈

Two weeks later, Uncle Geordie got eighty-two sock-eye. He gave Ma-ma-oo twenty, his wife's parents twenty and twenty to us. Mom took me over to Ma-ma-oo's, who insisted that she didn't need any help, that she wanted to do the smoking herself. Mom said they'd help each other.

Dad set up two sawhorses and put some planks on them to make a table behind Ma-ma-oo's house. Mom let me chop the heads off the fish. Sockeye are heavy. The easiest way for me to decapitate them was to stick my fingers in their eye sockets to hold them in place

while I cut off their heads. As I got better, Mom let me cut off the tails and fins too. She did the cleaning and deboning, and Ma-ma-oo did the *datla*, carefully slicing the salmon for smoking. Crows flapped in the trees around us, eying the pailful of fish guts. Mom didn't like to give them food because, she said, what with Jimmy's feeding them, they'd just keep hanging around the house, lazy buggers, and wait for handouts, shitting on everything in sight.

The sky was cloudy and threatening to rain. Ma-ma-oo was silent, working so fast that she would have to stop and wait for Mom and me. My hands got tired, but I liked having something to do. "Oh, you learn fast," Mom said to me as I handed her another fish. We went through half the fish, and I helped them put the long slices of red flesh on sticks. I wasn't tall enough to reach the rafters of the smokehouse, so Mom and Ma-ma-oo put up the racks of fish. Mom went inside to start canning the other half of the sockeye and left me out in the smokehouse to keep Ma-ma-oo company. The smoke was sharp and hurt my eyes. The shack was warm and dim. I instantly started to sweat. I removed my jacket and took it outside so it wouldn't smell smoky.

Ma-ma-oo was sitting on a block of wood, staring at nothing. Now that she didn't have anything to do, she sagged. I sat down on the ground beside her, yawning. She covered her eyes with her hand. Her shoulders started to shake. She never made a sound when she cried.

I rested my head against her knee. She put her other hand on my neck. The skin on her fingers was rough; her hand was warm and smelled of fish.

≋

Ma-ma-oo and I were driving down a narrow logging road that went through the bushes on the Kitimat River tidal flats. She stopped the truck when the road was too overgrown to see the gravel. She handed me a shovel then slung her rifle over her shoulder and walked into the bush. From inside the truck, the trees were very pretty. As I followed her, fending off branches and crunching through dry leaves that hid mud puddles, I was less impressed with the brilliant green colours of late summer. Rain soaked through my jeans, my jacket. I was covered in mud up to my ankles and Lord only knew what Mom was going to say about my new running shoes. A long time ago, there had been an old fishing camp here, and before then it had been a winter camp. Some of the houseposts still stood, giant, grey logs leaning heavily into the wild tangle of undergrowth, but now the old camp was being washed away by the river. The people had made nets out of *du'qua*, stinging nettle, and it was growing wild everywhere. The tall, skinny plants with fuzzy leaves stung worse than jellyfish.

We came across bear scat. It was still moist. Ma-ma-oo kicked it around then bent over and stared into it as if she could see her future in the heavy brown shit. She paused, getting her bearings, then wiped the rain off her face.

"Look," she said. "See the fish bones? It's really fattening up for winter."

"Gross," I said.

"You can tell where the bear's going to be by its

scat. Berry seeds, it's up the bush. Fish bones, it's down by the river."

"It's still gross."

"You kids these days."

After another half hour of slogging, she stopped in front of a plant as tall as her, with broad, smooth leaves that branched off the stalk like a tulip's leaves. It was topped with tiny, white flowers.

"Just watch," she said, handing me the rifle.

She took the shovel and started digging a big hole around the plant. When she hit the root, she started digging with her hands. The root had a small dark bulb, but then it went stringy like a creamy yellow mop. When she'd exposed enough of the root, she began tugging until it came loose. She brushed off the dirt and motioned me to come closer.

"*Oxasuli*," she said. "Powerful medicine. Very dangerous. It can kill you, do you understand? You have to respect it." She handed me the root and I put it in the bucket. There were some more oxasuli bushes around, but she said to let them be. We slogged some more, found two suitable plants, then Ma-ma-oo declared we had enough. "You put these on your windowsill, and it keeps ghosts away."

"How?"

"Ghosts hate the smell. It protects you from ghosts, spirits, bad medicine. Here, you break off this much and you burn it on your stove—"

"Like incense?

"What's incense?"

"Like cedar and sweetgrass bundles."

"Oh. Yes, yes like that. Smoke your house. Smoke

your corners. When someone dies, you have to be careful."

"Why?"

She paused again, frowning. "Hard to explain. But don't eat it, hear? You eat it, and you go to sleep and you don't wake up. Good for arthritis. Joints. Hard to use, though. You have to do it right or your heart stops. Bad, slow painful way to go."

"Cool."

She shook her head. "You kids." She pulled out a pack of cigarettes and unwrapped the cellophane.

"Holy. When did you start smoking?"

"Not for me. I'm getting some cedar branches. You leave tobacco here, see?" She broke one of the cigarettes and left the tobacco scattered at the bottom of the cedar trunk. She said some words in Haisla, then she broke off one of the branches. "We'll get four for you, and four for me."

"You're giving tobacco to a tree?"

"The tobacco is for the tree spirits. You take something, you give something. I'm asking for protection. Going to go up in the corners of my house. Put these in your bedroom. Hang them up like this."

"What do the spirits look like?"

She paused, looking up into the top of the cedar tree. "I don't know. Never seen one. The chief trees—the biggest, strongest, oldest ones—had a spirit, a little man with red hair. Olden days, they'd lead medicine men to the best trees to make canoes with."

"Oh," I said, shaking. All the air left my lungs for a moment and it felt like I couldn't catch my next breath. "Oh."

Ma-ma-oo glanced at me curiously, then began walking again. She picked another tree and offered tobacco.

I made my voice very casual. "What would it mean if you saw a little man?"

"Guess you're going to make canoes."

I laughed. "I don't think so."

"No one makes them any more," she said. "Easier to go out and buy a boat. Old ways don't matter much now. Just hold you back."

"What else would it mean if you saw one?"

She touched my hair. "You seen one?"

I nodded.

"Ah, you have the gift, then. Just like your mother. Didn't she tell you about it?"

"What gift?"

"Your mother's side of the family has it strong. Do you know the future sometimes? Do you get hunches?"

"Predictions? From the little man. He comes, then something bad happens."

She eased herself down onto a stump, then patted the space beside her. "Here, sit." She frowned. "Your mother never said anything?"

"She just said he was a dream."

"Hmmph," she grunted. "He's a guide, but not a reliable one. Never trust the spirit world too much. They think different from the living."

"What about Mom?"

"When Gladys was very young, lots of death going on. T.B. Flu. Drinking. Diseases. She used to know who was going to die next. But that kind of gift, she makes people nervous, hey?" She smiled.

"Mom doesn't see anything," I protested.

Ma-ma-oo grunted again. "She doesn't tell you when she sees things. Or she's forgotten how. Or she ignores it. You'll have to ask her. Her grandmother, now she was a real medicine woman. Oh, people were scared of her. If you wanted to talk to your dead, she was the one people went to. She could really dance, and she made beautiful songs—that no one sings any more. And I was too young back then to put them in here." She tapped her temple.

I was only half-listening to her. As soon as she said you could communicate with your dead, I wondered if I could talk with Mick. "How do you do medicine?"

"All the people knew the old ways are gone. Anyone else is doing it in secret these days. But there's good medicine and bad. Best not to deal with it at all if you don't know what you're doing. It's like oxasuli. Tricky stuff."

"Oh," I said, disappointed.

We hung the cedar in her house first and put oxasuli on the windowsills. When we put the cedar up in my room, Dad came in and raised an eyebrow when he saw what we were doing, but he didn't say anything.

≋

The raven flying near the shore catches my eye. It croaks, then disappears into the trees. I loved Ma-ma-oo's stories about the cheeky, shape-changing raven named Weegit. I try to remember a story she told me, but I am distracted. My hands are chapped and tingling from holding the throttle. I wish I'd thought to

bring gloves. I hadn't thought it would be so cold in the middle of August. I think it was grade seven when I learned that wind starts as a difference in temperature between the air and the ground. Whatever the reason, the waves hitting the bow send constant shudders through the speedboat. Worse, the spray sent up by the bow keeps putting out my cigarette.

≋

School started four weeks after Mick's funeral. Mom and Dad came into my bedroom and asked me if I was feeling up to going. I was tired of them hovering over me so I said it was fine.

God, I thought as he walked into my math class, don't do this. Please don't do this. As if it wasn't bad enough that Tab had moved to Vancouver, Frank had been kicked out of his school in the first week and transferred to mine. He'd been kicked out of most of the elementary schools in Kitimat because he kept beating up other kids. He sat in the seat directly behind me, grinning. As the teacher did roll call, Frank began throwing spitballs into my hair. She called out his name, and he said, "That's my name, don't wear it out."

In her first and last letter to me, Tab commiserated with my bad luck. Meanwhile, across the playground from us, Frank was taking charge of his cousins, Pooch and Cheese, two of the meanest boys in school. They raced each other to the top of the hill near the swings, then pushed each other down.

Frank always sat behind me in class and as the weeks

wore on, he began pinching and jabbing my arms. He'd reach forward and poke hard enough to bruise. He began to kick my chair. Telling the teacher would make him and his thugs gang up on me at recess—I'd seen him do it to other kids. Complaining about him would be an unending hell of getting picked on in the village and at school. As far as I was concerned, someone else could have that privilege.

Some days, it was hard to do anything. Even eating seemed like too much trouble. I'd lie in bed and stare at nothing, and hours would pass in a flash. Then the next thing I knew, Mom would be calling me for dinner. It wasn't even painful. I felt nothing. Blank.

Other days I wanted to run. Really run, push myself until I fell down. I ran up and down the highway, up the power lines, around and around the village. When taking a breath hurt, when sweat soaked me right down to the tips of my hair, when my muscles spasmed and ticked, I stopped. After the first snowfall, Mom made me stop running because she said the last thing I needed was a broken leg.

After supper one evening, I was listlessly doing homework at the kitchen table. Dad had walked over to Uncle Geordie's house to watch a hockey game. Which meant that he and Uncle Geordie were going to get tipsy and annoy Aunt Edith by smoking inside, drinking beer without using her coasters, spilling chips on the carpet and shouting wildly whenever their favoured team scored. Mom was out visiting. Jimmy went into Dad's pockets and filched his car keys. "You wanna go for a ride?" He spun the key ring. "It'll be fun."

I felt my eyes stretch wide in disbelief. "Are you feeling all right?"

"No guts," he said. "No glory."

"Have you been drinking?"

"We'll be back before anyone even knows we're gone."

"What's got into you?"

Jimmy shrugged. I'd never seen him like this before, and wondered if he would actually go through with it.

We grabbed some things we thought we'd need, then strolled out to the car. He put on a baseball cap and clicked in his seat belt. I tucked my hair under one of Mom's old wigs and put on a pair of her huge sunglasses, which kept sliding down my nose.

"One of these pedals is the brake and one is the gas," he said, scowling in concentration. He fumbled with the keys for a while. The engine kicked in. I peeked out the window. No one was watching us. As he sat in the driver's seat adjusting the pillows we'd stolen from the living room, it occurred to me that we knew squat about driving.

"It would make sense that the pedal nearest my right foot is the gas, because you have to step on it more. I think Dad used this one—" He moved the top stick to R and pressed down hard on the pedal. The car shot out of the driveway, right across the street and up our neighbour's driveway. We were almost to their door before he stomped on the brakes, jerking so hard that I bumped my head on the dashboard.

"Maybe now," he said, "would be a good time to put on your seat belt."

He drove to town, slowly and cautiously at first, and then with more speed. I liked the sudden freedom, being away from everyone and everything, able to go wherever we pleased. Jimmy's face was flushed, his eyes sparkled and he couldn't stop smiling. "You want to try?"

I grinned. "You betcha."

The wig was hot and itchy, but I didn't want to take the chance of someone seeing me without it. Jimmy tensed and lowered his head whenever a car heading towards the village passed us, but I casually lifted my hand and waved and got a jolt of pleasure when people waved back, not at all suspicious.

Jimmy turned on the radio and cranked it. "Funky Town" was playing, and we started singing along. He tilted his seat back and laughed, then said, "I always wanted to tell you something."

"What?" I said. We were nearly to Hirsh Creek when I saw the police car in the rearview mirror. I lost track of the road for a minute and almost steered us into a ditch.

"What's wrong?" Jimmy said, his voice rising. "What's happening?"

"It's okay, it's cool. Don't panic—"

"Panic?" Jimmy spotted the police car in the side mirror. "Holy fuck," he said breathlessly. "Holy fuck. It's the cops."

The lights flashed in my rearview mirror. My throat went dry. I pulled over and rolled my window down. I looked up innocently at the officer, who frowned down at me in my overlarge wig.

"Evening," he said.

"Hi," I said.

"I'd ask you for your driver's licence," he said, "but I'd be wasting my time, wouldn't I?"

I felt my face flushing deep red. "Would you believe I'm pregnant?"

He raised an eyebrow.

"I mean, my brother's got a bad stomach ache. He really has to go to the hospital—"

Jimmy punched me hard in the arm.

"Let's call your parents," the officer said.

There is nothing like a police escort to attract attention. The police officer lectured me and Jimmy all the way home, while his partner followed us in my dad's car. When we got home, Dad started shouting and didn't stop until Mom started and they drowned each other out. I sat meekly in my chair and went to bed, grounded until kingdom come, which turned out to be four weeks later. They didn't yell at Jimmy—and if he wasn't going to tell them it was his idea, I wasn't going to bother to explain something they'd never believe anyway.

≋

The weather was still good so Ma-ma-oo grabbed her berry pails, took me out to the Terrace highway and we drove up a logging road. She'd inherited Mick's truck, and sometimes I'd look over and expect to see him.

"Look," she said, coming up to a bush. "See these ones? *Pipxs'm.*"

"That's what you call blueberries in Haisla?"

"No, no, just these blueberries. See, they have white stuff on them. *Pipxs'm* means 'berries with mould on them.'"

"Mmm, tasty."

"They are." As if to prove it, she popped a few in her mouth and chewed with her eyes closed. I tried one, and it was so sweet it was almost piercing. I had never noticed that there were different types of blueberry bushes. If it was blue and on a bush, you picked it. Ma-ma-oo pointed out the contrast in the leaves and stems, but it was easier to see the distinctions in the berries themselves. We found the other kind, *sya'kᵒnalh*, "the real blueberry," shiny bluish-black berries, prettier, but not as sweet as *pipxs'm*. We drove around, going higher up the mountains until we found the third type, pear-shaped and plump and sweet. Their Haisla name is *mimayus*, which, loosely translated, means "pain in the ass," because although they taste wonderful, they're hard to find and to pick.

"We used to call my sister Mimayus," she said, smiling fondly at the berries in her hand.

"You have a sister?" I said.

"Oh, yes. She died long ago."

"Was she older or younger?"

"Older."

"And she was a pain in the ass?"

"Her real name was Eunice."

"How'd she die? Is it okay to ask?"

"Yes. Do you ever run out of questions?"

"No. But I can shut up if you want."

She chuckled. "I think that would kill you."

We spent the last of the good weather tromping through bushes, picking berries and watching "Dynasty," with Ma-ma-oo shouting advice to the wayward Alexis.

Namu, Ma-ma-oo explained later, means whirlwind. The area is famous for whirlwinds. Usually, they're only the small ones; they play on the water, go in the bay and dance out. She found this out after Mimayus fell in love with a Bella Bella boy. To be closer to her handsome Heiltsuk, Mimayus went to work in the cannery in Namu where her Bella Bella boy had a job as a fisherman.

But one Halloween, Mimayus hitched a ride with a man who was on his way to Bella Bella in his gillnetter. Her Bella Bella boy's birthday was the next day, and his family was throwing him a huge party. Mimayus wanted to surprise him, so she had told him she couldn't make it. The weather had been iffy all week, sometimes hot and summery, sometimes blistering cold. But that day it had been especially bad. Towards evening, when the sky cleared, the man said they should make a run for it now or they wouldn't make it at all.

A troller also going to Bella Bella had agreed to follow behind the gillnetter so they could help each other out if anything went wrong. The skipper of the troller was bringing his pregnant wife to the hospital. Both the boats were old.

One of Mimayus' friends was supposed to go to Bella Bella with her, but she chickened out. Mimayus waved as the gillnetter left the dock and promised to bring her friend some chocolates if she could find any.

Mimayus' friend watched the two sets of boat lights getting farther away. As she was about to turn around and go back inside, she saw the lights in front blink out. Shivers ran down her back; she said she knew right then that Mimayus was gone.

Out on the water, hail came down. The couple in the troller were arguing. The wife wanted to turn back, but the husband said the hail wouldn't last. It battered their boat for a few minutes, then stopped suddenly as a strong wind started. The wife looked up in time to see a funnel descending from the clouds like a black finger. The sound, the wife said, was like a thousand people screaming. Her husband immediately turned their boat around.

The wife looked back and saw the gillnetter struggling to turn, bobbing and dipping like a toy in the rough water. As the funnel touched down in front of Mimayus' boat, the wife wanted to close her eyes but couldn't. She watched in horror as the gillnetter was sucked into the air.

The couple made it back to Namu, but Mimayus and the gillnetter's skipper were never found. Neither was the gillnetter, but its engine was discovered a week later, washed up on a nearby beach.

≋

The rain is easing. Sea gulls circle and land on something between the logs on the rocky shore. A flock of sea gulls is called a squabble, and they are doing that right now, fighting for a place on whatever has washed up on shore. As my speedboat buzzes by, some of the

sea gulls hop away, revealing something dark, but then they cover it again. It must be big to have attracted so many. On the other side of the channel from me is a tanker on its way to Alcan's dock. It moves with the ponderous weight of a loaded ship, is low in the water and oblivious to me. When we were kids, Jimmy and I used to watch the tankers through binoculars and try to decipher the names. Some were Russian or Japanese, or rusted beyond reading.

The crows wait at the outskirts of the squabble. They are little black dots that flutter and edge nearer to the corpse until the sea gulls drive them away. A flock of crows is called a murder.

≈

Make your hand into a fist. This is roughly the size of your heart. If you could open up your own chest, you would find your heart behind your breastbone, nestled between your lungs. Each lung has a notch, the cardiac impression, that the heart fits into. Your heart sits on a slant, leaning into your left lung so that it is slightly smaller than your right lung. Reach into your chest cavity and pull your lungs away from your heart to fully appreciate the complexity of this organ.

The bottom of your heart rests on your diaphragm. The top of your heart sprouts a thick tangle of large tubes. Your heart is shrouded at the moment by a sac of tissue, a membrane called the pericardium, which acts like bubble wrap by both protecting your heart and holding it in place. Peel away this sac. Inside

is a watery lubricant that minimizes friction when your heart beats. Shooting down from the aorta—the large tube arching on top of your heart—are two large arteries that branch out like lightning forks over the heart muscle.

Behold, your heart. Touch it. Run your fingers across this strong, pulsating organ. Your brain does not completely control your heart. In the embryo, the heart starts beating even before it is supplied by nerves. The electrical currents that ripple across your heart causing it to contract are created by a small bundle of specialized muscle tissue on the upper right-hand corner of your heart.

≈

The good thing about having a thirty-five-horsepower outboard motor is that it doesn't need a whole lot of gas. You can go days on a couple of tanks. The bad thing is the putt-putt factor. It takes forever to get anywhere. Also, I travel by sightlines, aiming for one point, holding the boat steady until we get there and then picking another landmark.

Nic-fit. I'm dying for the extremely satisfying ritual of shaking a cigarette out of a pack, placing it between my lips and sucking in that first hot puff. Mmm. One lousy smoke left, but I'm saving it. Should have waited at the village and done a cigarette run. A bit too late now. I try to concentrate on other things. Technical terms I learned in biology. "*Atrium*," from the Latin, meaning the central courtyard of a Roman house. "*Ventricle*," Latin also, meaning belly or stomach.

"*Septum*," a partition; in the cardiovascular system, a partition between the right and left sides of the heart. "*Ischemia.*" *Isch-*, to hold back; *-emia*, a blood condition. "*Infarction*," the death of cells.

The weather is inspiring my gloomy turn of thoughts. Or maybe it's knowing that Mom and Dad will be in Namu today, hunting for Jimmy. Ah, irony. We're all out on the water. The whole family is together.

I should have gone. I should be with them. They didn't want me to go. It would be too much, they said, to have me there. They didn't say "if something goes wrong," but from the way they looked at me, they didn't have to. I don't know what I would have said when they found the life raft. But Jimmy isn't stupid. Josh isn't stupid. They are two smart men. Nonetheless, I want to be there right now. I ease off the throttle when the boat skitters. Since I'm riding with the tide, I'm not doing too badly. I tuck the throttle under one arm as I reach for my thermos and pour myself a cup of coffee. It steams and swishes in the thermos cap. I've put too much sugar in it, though, and the taste, burnt onto my tongue and tickling the back of my throat, is acidly sweet.

≋

The first report cards came in. My grades hovered dangerously at a C–. Most of the comments read, "Doesn't participate in class. Not working to full potential. Not concentrating, please set up an appointment to discuss study habits, etc." Frank began

to hit me with snowballs at recess. Jimmy, on the other hand, made the honour roll every time. He'd even made it into the *Northern Sentinel*, holding up a swim medal with one hand, the other arm over a teammate's shoulder. The caption read, "Future Olympic Hopeful Jimmy Hill Wins Regionals."

Jimmy hadn't really known Mick and he was so immersed in his swimming that an alien invasion couldn't have distracted him from perfecting his stroke rate. Having no ambitions beyond getting through school, I had no way of understanding Jimmy. When the Olympics came on, he glued himself to the set, watching every single swimming event. Sometimes he went over to his teammates' houses and watched with them, but he seemed to like it better by himself, absorbed. He would pore through the times set by little countries and announce that if he lived in Yukatuka-too, he'd have qualified for the one-hundred-metre butterfly. His games all ended with him getting a medal and placing it around his own neck.

Jimmy's grades slipped a bit as he put everything into his swimming, but he tried, and that seemed to count for something. At school, we ignored each other. In his teammates, he had a ready-made circle of friends who had nothing to do with me. Most teachers were surprised we were siblings.

Nothing they taught me meant anything. None of the stories I read in English had anything to do with my life. As long as I could add and subtract, I didn't feel a need to have any great math skills.

While browsing through some albums, I found what used to be my favourite ABBA collection. Disco

was officially dead, but just for old times' sake, I put it on the record player and was boogying away in my bedroom when I noticed Jimmy and a bunch of his swimming friends goggling at me from the doorway like I was a loonie. The moment I noticed them, they smirked at each other. Jimmy stood stiffly in front of them, arms up as if he was trying to shield them from something hideous.

"She's adopted," Jimmy said to his snickering friends.

"Come on, Jimmy!" I said. "Do the hustle!"

"And brain-damaged."

"Don't be shy," I said. I went over and grabbed his arm, but he jerked back like I had the plague. "Jimmy used to be a big ABBA fan, didn't you? Remember that Frida poster you used—"

"I did not!" Jimmy said, face turning red.

" . . . to have up over your bed?"

"I didn't," he said to his friends. "She's a big liar."

"Wow, was he in love!"

"Shut up!"

"Of course, now he likes Boy George."

"Let's go," Jimmy said, reaching around and slamming the door in my face.

I sang "Karma Chameleon" at the top of my voice.

That Friday at the breakfast table, Jimmy took his Walkman off long enough to say, "My friends are coming over this weekend."

"Whoop-dee-doodle."

"So don't be a freak."

I glared at him. "Like you're not one."

"Lisa—" He stopped, sighed and put his earphones

back on. He hunched over his cereal and chewed furiously. I stuck my tongue out at him. "Grow up," he said.

He was too wiry to throw down on the floor and tickle like I used to do when we were younger. As I looked at him, an idea formed. Finding the copy of the monkey mask Dad had bought was hard. He kept it in a box stuffed away in the attic, which had never been organized. I had to clamber around for an hour before I found the right box. I shook out the dust, brought it downstairs and hid in Jimmy's closet.

While I was waiting, it occurred to me that I might be making a mistake. But as I was reconsidering my plan, Jimmy and his friends came into the bedroom. I slowly lowered the mask over my face. It was heavy and the fur was itchy. Jimmy and his friends lay on his bed and pulled out their books.

Oh, man, I thought. This is going to take forever.

After what felt like hours, but was probably only fifteen minutes, Jimmy stood up and walked over to the closet. As he opened the door, I hopped out, roaring and waving my arms. Jimmy's expression of horror, his complete and utter terror, was beyond anything I'd expected. His friends leaped off the bed and screamed like sissies. I raced out of the room with Jimmy and his friends in hot pursuit. I tossed the mask on the living-room chair, laughing as I headed outside, zipped down the steps and took off towards the rec centre.

"You'd better run!" Jimmy yelled after me from the porch.

I gave him the finger.

"You're gonna get it!" Jimmy said. "You hear me, you freak? You're gonna get it!"

The next day, Frank left a dead frog in my desk. It was dark green and tiny, barely out of its tadpole stage. I stared at it, then slowly turned to face him. He smiled at me. I hated his smug expression, the cocky way he lounged in his chair. But what made my blood boil was that he'd killed the frog just to make me scared. I grabbed his chair and yanked. He landed with a thud, yelled and held his head where he'd hit the floor. I reached into my desk, grabbed the frog and tried to stuff it up his nose.

Unfortunately, the teacher pulled me off. We both had to write "I will not fight in class" a hundred times on the chalkboard. She wrote notes for our parents to sign. Mom was going to be pissed, but I was sick of taking it. From now on, if he was going to try anything, I was going to give as good as I got.

At lunch, I sat with Erica and her friends in our usual spot near the seesaws. They gossiped and giggled, talking in high, excited voices about how to get bigger hair, what they were going to wear to the Christmas dance, and which boys were the cutest. Anger flashed through me—they seemed so young and stupid. I must have been making a face because Erica turned to me and asked me why I was looking so crabby.

"We talk about the same stuff every day. Aren't you bored of it?" I said.

"If you think we're so boring," Erica said in an aggrieved tone, "why don't you go sit somewhere else?"

"And miss your fascinating debate on hair spray?" The second it came out of my mouth, I knew I'd have to start apologizing or I'd be socially dead. But I couldn't bring myself to care. It was my voice saying

these things, but it felt like I was watching some mildly interesting program on TV.

Erica snapped her eyes at me, then turned back to her friends, who spent the rest of the day pointedly ignoring me. When the last bell rang, they shadowed me to the bus stop. They hadn't got up the courage to start name-calling yet, so they were just whispering. I stood apart from them and glared at my hands, trying to think of a convincing way to tell Mom I wanted to change schools. I looked up to find Erica's gang forming a circle around me, giggling and giving me sly looks.

"She looks like a boy," one of Erica's friends said with the greatest contempt as they took the bus seats directly behind me.

"She is a boy."

"No," Erica said. "She's an animal."

"Hey," one of Erica's friends said, pushing at my shoulder. "Hey, Miss Piggy." More giggling. They began oinking.

"Well," I said. "At least I didn't have an accident on the Zipper, did I? I'm not scared of a baby ride."

Total silence. I turned to look Erica right in her face, which was flushing the deepest, darkest, most satisfying shade of red. Tab had told me that when they were on the carnival ride and their car got stuck upside down at the very top, Erica had panicked. If I kept my mouth shut, it would end right there. They would pretend I didn't exist and I could live my life in peace. But when I looked into Erica's furious face, I couldn't stop. "Isn't that right, Pissy Missy?"

She lunged. I'd never seen her move so fast. She grabbed fistfuls of my hair and yanked for all she was

worth. It hurt like hell, but I just pushed her away and laughed, which made her slap my face.

"You're an animal!" Erica screamed. "You're nothing but a lying animal!"

"Miss Piggy, Miss Piggy, Miss Piggy," her friends began to chant.

"Pissssssssssss," I said, still gasping with laughter.

Erica's arms were pinwheeling so fast she looked like a cartoon, but she was so mad that most of her hits missed me.

Then, from the back of the bus, Frank and his friends started their own chant: "Pis-sy Mis-sy, Pis-sy Mis-sy, pisssssss."

"If you don't knock it off," the bus driver yelled, "I'm stopping the bus right here!"

Erica's eyes were shiny with tears. Her face was scrunched up and beet red. She blinked quickly then looked out the window, and her friends turned away and started whispering again. Making her mad had been fun, but making her cry made me feel like crap. It wouldn't do any good to say sorry. Erica would be more embarrassed and probably wouldn't believe it, coming from me. She shouldn't dish it out, I thought piously, if she couldn't take it. Erica got off at the stop before mine, punching my shoulder as she went by. I sighed.

My fall from grace was spectacular. If I'd had head lice, scabies, worms and measles, I couldn't have been more unpopular. Rather than sit with me on the bus, kids would sit on the floor. Rather than be my lab partner in science class, kids would claim to be sick and have to go to the nurse's office. Rather than eat with me, kids would throw their lunch bags in the

garbage and claim they weren't hungry. All I had to do
to be back in Erica's good graces was grovel and kiss ass,
but I'd die before I did that.

After school, when I walked into Ma-ma-oo's
house, the smell of spice cake floated through the
room. Ma-ma-oo had a cake pan as large as her oven.
Ba-ba-oo had made it especially for her. It was older
than me and deep brown with encrusted oil. It made
enough cake to feed sixty people. At funerals, when so
many people visit and the family members are not sup-
posed to cook for themselves, huge amounts of food
have to be prepared. She used to have two pans, she
told me, but the other one wore out. In the past, she'd
used it for weddings and showers, but lately I'd begun
to think of it as her death pan.

"The next time I bake with this," she said as I
strolled into the kitchen, "you'll be getting married."

"Yeah? To who?" I said.

"Someone rich." Then she said it was time to go
and that she wanted to show me something. She
brought the cake out to the car and I thought we were
going to a funeral, but we went to the docks instead.
We climbed into her boat, she cast us off and we left the
village. I held the cake in my lap as we bumped along.
She beached the boat just below the old graveyard. We
struggled through the snow and bare branches to
arrive at the first graves.

"Lots of family here," she said. She pointed out
long-dead cousins, great-aunts and uncles, great-
grandparents. "This is your great-grandfather. He was
a good hunter. Never missed a shot. He was a sniper in
the first war."

"Oh," I said, staring at the plain white headstone. Hector Hill, it read, 1902–1943.

"He loved my baking," she said.

"Is it his birthday?"

"No," she said. "Just visiting."

We built a small fire and she fed it her cake. "You been in a lot of trouble these days."

I stared at my feet and waited for the lecture.

"Your ba-ba-oo was a fighter too. Second war. I was so proud of him. He was very handsome in his uniform. All the girls were jealous of me." When I looked up, she was smiling at me. The graveyard was filled with creaking trees and skittering things. The woods were shadowed and eerie.

"You scared?"

I shook my head.

"Good. Don't be scared. Only ghosts here are relations."

I shivered, staring around, feeling the silence as a tangible thing, heavy and smothering. Imagining eyes staring at us and judging me.

"Do you know where Mick is?"

"Rotting in the ground," I said bitterly.

"I bet you anything he's arguing away with your ba-ba-oo. Never got along for more than five minutes, those two. He's meeting Hector. And Eleanor. And Phillip. Lots of singing, dancing. Good place, where he is. Good people with him."

"So you don't miss him?"

"All the time. So does your dad. He hides it. You hide it."

"I don't see you crying."

"I cut my hair when he died. I talk to him every day."

"What do you say?

She sang a low, sad song, first in Haisla, then in English:

Food is dust in my mouth without you.
I see you in my dreams and all I want to do is sleep.
If my house was filled with gold, it would still be empty.
If I was king of the world, I'd still be alone.
If breath was all that was between us, I would stop breathing to be with you again.
The memory of you is my shadow and all my days are dark, but I hold on to these memories until I can be with you again.
Only your laughter will make them light; only your smile will make them shine.
We are apart so that I will know the joy of being with you again.
Take care of yourself, wherever you are.
Take care of yourself, wherever you are.

She touched my hair. I put an arm around her waist. "Your great-grandfather Hector made that song when his wife, Eleanor, died. Oh, he had a beautiful voice." She looked at the sky. "Getting dark. Kick the fire out."

When I got home, I went into Mom's sewing room and hunted for a pair of scissors. Mom caught me in the middle of cutting my hair. She let out a horrified

shriek and ran into the room to grab the scissors away from me. We wrestled for them. She won after smacking me on the side of the head and saying, "What the hell do you think you're doing?"

"I'm mourning," I said.

"God," she said, touching the side that I'd cut down to the scalp. "God."

"It's just hair, Mom."

"It was beautiful hair. Oh, sweetie." She sat down on the bed, reluctantly handing me back the scissors and letting me continue to cut my hair, pressing her hand against her mouth and making squeaking noises as I chopped the rest of it off. Then she marched me down to the kitchen, threw a garbage bag over my shoulders and stared at my head for a long time, her eyes squinting in concentration.

"Yes," she said, starting her barber's razor. "Yes, I think we can save this."

She carefully shaved the sides and the back and spiked the top, leaving the left side long so it all fell over in a prickly arch. She touched the ends with gel and sighed. She handed me a mirror. "It's the best I could do."

"You are so cool," I said, massively impressed with my new do.

I wasn't sure if there was a ceremony that went along with the hair burning, but just the cutting alone had made me feel better. Mom said she'd heard we were supposed to burn it. I didn't know how to start a fire, though, and Mom said that if she tried to chop wood for the basement stove, she'd probably hack off a leg. I stood on the back porch and tried to use a lighter

to set handfuls of hair on fire over a metal garbage can. But my hair had been long and thick, so it took forever and burnt my fingers. In the end, we fired up the hibachi and threw my hair on the coals.

"I can't believe we're barbecuing your hair," Mom said.

"I like mourning," I said.

As I was drifting off to sleep, I thought of Mick. I wanted him back. I whispered his name. For a moment, I felt light, free, as if a warm wind blew through me, making my skin tingle. I was filled with a sense of calm, peace, and I saw Kitlope Lake, flat and grey in the early-morning light, mirroring the mountains.

≋

At school the next morning, Erica's goon Lou Ann came up to me five minutes before the first buzzer rang and told me she was going to kick my butt good later. She was a head taller than me and about twice my weight. Since she told me just before classes, I knew she was trying to psych me out so I'd worry about it all day.

Ironically, for the first time in months, I didn't want to fight. But I didn't want to get my butt kicked either and Lou Ann never backed down. No matter what I did or said, it was going to happen. I'd hurt Erica too much to be left alone. I resigned myself to getting creamed. So instead of waiting for Lou Ann to come get me, I went up to her at lunch and without preamble punched her in the nose. To my surprise,

she collapsed to the pavement and began wailing so loud I thought I'd broken it. The teacher on playground patrol came running. I spent the afternoon in detention and was warned that the next time I was caught fighting, I'd be suspended for three days. The principal phoned my house and Mom yelled at me, telling me I was a disgrace. On the bus ride home, there was a circle of empty seats around me.

Thoroughly depressed, I didn't notice that Frank and his friends had followed me off the bus. They blocked my way as I tried to go around them. I frowned at him, secretly glad that we were going to have it out. Hitting someone who wouldn't burst into tears would be a relief.

"You're okay," Frank said.

If he had ripped off all his clothes and set his hair on fire, he couldn't have surprised me more. It must have showed, because he started grinning.

"Big Lou had it coming," he said.

"Yeah," I said, more to say something than because I agreed with him.

"We're going up to the old hall." He watched me. I realized this was an invitation.

"Yeah?"

"Yeah."

It was a trap. It had to be. They were going to kick the shit out of me. That's what was going to happen. But even knowing that, I wanted to go. I hadn't played with anyone in months.

We ran. The other guys didn't say anything. I thought they were being snobby, but I didn't mind. Council Hill was slippery. We scooted up, around the

hairpin turn and right to the top, where the old hall had stood before they tore it down so kids wouldn't play in it and get hurt. We were all out of breath.

"She's on my side," Frank said.

We split up. Three guys went one way and I followed Frank and his friend Pooch down the path that led to the graveyard. We dumped our books behind a waist-high snow fort. Frank and Pooch started making snowballs. Not knowing what else to do, I copied them. When we had a big pile, they crouched behind the wall and waited.

The attack came a few minutes later. Two guys came straight at us, yelling and hooting, while the other snuck around the back and rained snowballs at us from the trees. I chucked a few polite snowballs in their general direction until I got hit in the chest so hard the wind went out of me. Then I started belting them, and to my surprise, none of the guys got mad at me when I hit them—in my experience, if you hit too hard the game stopped and everyone glared at you and called you a mean poor sport. The attack ended, and Frank and Pooch charged after them. We attacked their fort, then they attacked our fort again, and it went on until the sun set.

By some unspoken rule, I'd never played with boys before. When I was friends with my cousin Erica, we'd agreed that they were icky and stupid. We'd even made a pact that if we ever kissed one, we'd cut our lips off. These days, I heard Erica whispering about this boy or that on the bus, and her friends would all agree that so-and-so was cute. I couldn't understand it and didn't want to.

The day after the snowball fight in the graveyard, I was a part of Frank's gang and, as such, untouchable. At recess, while the other girls stayed in the under-cover areas, out of the snow and wind, I went off and had a smoke with the guys. Frank brought out the pack. He handed it around and everyone took one. He lit his with a practised ease that the other boys tried to mimic. I had never been so grateful to Tab in my entire life. If she hadn't shown me how to smoke before she left, I would have looked wussy. When Frank threw me the matchbook, I made a decent go of it. I didn't even cough. Frank was impressed, and I was officially cool.

In PE class that afternoon, we had dodge ball. Those of us in Frank's gang formed our own circle. We agreed that you got out only if you were hit in the head. The game was fast, hard and dirty. After one of the guys got a bleeding nose, the teacher broke us up and made us join the other circles, and I was put in with all girls. I won every time because none of the girls would even breathe my way. Apparently, it was all right to want to date a boy, but not to go out and play with one, let alone join a guy gang. Intensely bored, I looked wistfully over at Frank and Pooch, who were hurling balls at the ceil-ing. In the change room, I got a lot of looks. But when I stared back, the girls turned away. A part of me still wanted to be like them; but somehow it didn't matter.

≈≈≈

Contacting the dead, lesson two. You are in a large mall near closing time. It's Christmas Eve. You turn away for just a moment, look back and your toddler is

gone. Even through the noise, even through the con-
fusion of bodies bumping and swearing as you push
through the crowd, even as you yell your child's name,
you are listening for that one voice to call for you.

Names have power. This is the fundamental prin-
ciple of magic everywhere. Call out the name of a
supernatural being, and you will have its instant and
undivided attention in the same way that your lost tod-
dler will have yours the second it calls your name.

≋

Passing Clio Bay, and the squall has just ended. I can
see the next one coming, the sleek curtain of rain
angled by the wind. Clio Bay has an appropriately pic-
turesque mountain in the background, with the kind
of peak kids draw when they think of mountains, sharp
and pointed. The bay itself is small but deep. I forget
which family used to live here—Ma-ma-oo told me on
one of our fishing trips.

The coming squall is near *Ga-bas'wa*, the mountain
in the middle, which divides the channel in half: the
English name is Hawkesbury Island. Going north
around *Ga-bas'wa* will take you right to Hartley Bay and
the ocean. But going south is faster even though the
channel twists and turns, because I'm aiming for the
inside passage, a stretch of water sheltered by islands
from the extreme surf and chancy weather of the open
Pacific Ocean. To get there, I'll be traveling down the
Verney Passage. I'm going by Ursula Channel so I'll
pass Monkey Beach first, then the ghost town of
Butedale, then Bella Bella and finally Namu.

I wonder where Mom and Dad are now. They probably didn't sleep much either. Dad hates boats. He gets seasick. I hope he remembered to get Gravol. He likes his boats big, ferry-sized, heavy and steady. Boats are second nature to Mom, who spent a summer as a cook on her cousin's seiner. It toughened her up, she said, made her realize what she wanted out of life, decide what was important, and gave her enough money to rent a nice apartment when she went to beauty school. She was thrilled when Jimmy decided to go fishing. "It's just what he needs," she'd said as we waved goodbye to him barely three weeks ago.

Jimmy phoned us when he and Josh stopped over in Bella Bella before going on to their fishing point in Area 8. I wasn't there when he called, but Mom said he was sore and tired and didn't want to talk long. As she gushed about how mature he sounded, I felt an intense surge of relief. If he was chatting to her about his aches and pains, he could hardly be planning anything stupid.

≋

Jimmy was in awe of Frank and his buddies, but the awe didn't transfer to me. I avoided breakfast with him because it always ended with him lecturing me on the evils of smoking. I would be stirring my cereal, trying to pry my eyes open, and he would sit across from me, yapping about how black my lungs were getting and how I was going to die of cancer. One day, I flicked a spoonful of Cheerios at him. He sat with a deer-in-headlights expression and a Cheerio stuck to his cheek

while the milk dripped down to his chin. I hocked another spoonful to see what he would do.

"That's mature," he snapped. He wiped his face with his napkin and glared at me. "That's very mature." When he rolled his eyes and looked disgusted, I grinned.

"I thought it was funny."

"See me laughing?"

"Yeah, you're a riot too."

If Jimmy had no sense of humour, it didn't seem to bother the girls in the preteen set. Gaggles of girls left notes in his locker, phoned our house after school then hung up when I answered, knocked on the door and stood there giggling, trying to peer over my shoulder to see if Jimmy was home. He could have had his choice of girlfriends, but he wasn't interested. It would, he said solemnly, interfere with his practice schedule. His aloofness didn't discourage any of them, and even seemed to add to his mystique. On his tenth birthday, so many girls gave him teddy bears and chocolate boxes that his dresser was covered in gifts.

I dreaded my birthday. Mom wanted to send invitations to all my cousins, which was actually my fault, because I'd been telling her that I was playing with Erica and her gang when in fact I was horsing around with Frank. I told her I was too old to have a birthday party.

"Don't be silly," she said, washing a plate and handing it to me. "You're only turning twelve."

"I don't want a party."

"Why?"

"Parties are for babies, Mom."

She stopped washing dishes and stared at me with a wistful expression. "Sweetie, don't try to grow up too fast. You're only young once—"

"I just want a cake," I said, trying to compromise.

In the past, I'd always wanted a birthday party on my birthday, but Mom thought it was disrespectful because it happened on Remembrance Day. When I was ten, I'd told her that if Ba-ba-oo had fought for freedom, why weren't we free to have a party? Mom wasn't impressed. This year, with the party safely moved to the weekend, I could honestly say that Erica had gone to Terrace, which she did every weekend to see an orthodontist.

All that was left to do was invite one or two friends. At recess, I brought out a bag of Mom's homemade candy and handed it around. After everyone agreed it was pretty good, I decided it was now or never. "My mom wants to throw me this birthday party," I said as casually as I could manage. "She's gonna have candy and stuff. Any of you wanna come?"

Frank looked around at the guys and shrugged. "Sure."

They came trooping up the steps five minutes early. They were quiet and most of them had combed their hair, which was unusual. Mom had forced me into a dress. Frank's eyes went wide when he saw me. I invited them in, and we stood in the hallway in an awkward silence.

"Come in," I said to them. "Take a load off."

When I asked Mom if I could invite boys, she must have thought I meant one or two in addition to the girls, because when we came into the kitchen she goggled.

I remembered then that she hadn't seen Frank since the time in Emergency. She had been planning to have some party games, but after seeing the guests, she went straight to the video, which was *The Terminator*. We all cheered Arnold, and Mom gave us hot dogs and cake, hurrying the party along nervously.

At the end of the movie, I opened presents. The guys mostly got me socks and stuff, but Pooch got me a Crazy Carpet. Mom and Dad got me a pink dress that I stared at and couldn't quite picture wearing. Then Frank went to his jacket and came back with a small box. When I opened it, I gasped in delight.

It was the most beautiful slingshot I'd ever seen. I was close to tears as I pulled it out of its box. I wanted to give Frank a big hug, but I slugged his shoulder instead and said it was cool. Mom looked appalled as she handed out the grab bags, and we sat on the front steps and ate the candy. The guys laughed their heads off at the presents, which she'd chosen, expecting only girls to show up. Pooch got a Smurfette figurine, Frank got a mood ring, but best of all, Cheese got a candy neck-lace with little hearts saying things like "Wuv U 4ever."

Dad brought home a kitten that night. Mom didn't even bawl him out for not asking her. It was orange and mewly, with wide, frightened green eyes. I sat with it on the porch and scratched beneath its chin and behind its ears. I'd never named anything before. I didn't want something cutesy, like Fluffy or Pumpkin. I decided to wait a few days and see what my kitten did.

This was also the time Mom started cutting hair to make a few extra bucks. Women would phone her and ask for trims and colourings, but mostly for perms.

They had to pay for the perm kit, and she charged ten bucks to do the work.

"How old were you when you went to beauty school?" I said when Mom mentioned it to one of her customers.

"Before you were born," she said.

Dad helped her adapt the bathroom downstairs so that the sink was lower. They set up a swivel chair and put our old TV in front of it so the women could have something to watch while Mom put in their rollers. While the perms were setting, Mom and her customers would sip coffee and gossip. Their laughter and the smell of perm solution wafted through the house.

You can't really hide things in the village. Everyone knew Dad had been going through some rough times since he quit working for the council and went on pogey. Mick's death had hit him hard. Mom's hair salon was helping to pay for Jimmy's swimming lessons, but the swim meets were a strain. Most of the women who came to her knew this, and at first came more as a show of support than because they needed their hair done. I mean, when Aunt Edith asked for a perm, I knew the rumours of our pending financial doom must be flying through the village.

When my kitten heard doors open, her ears would perk up. She'd stir and stretch from her place on my pillow. Once she smelled the perm solution, she was out my door and downstairs, putting on her act.

I've always heard that cats eat only until they're full and then they stop. But we fed my kitten the amount of food that was posted on the Tender Vittles packaging. She'd hork it down, then smack her lips and meow for

more. She ate three times as much as kittens are sup-
posed to, she ate anything, and she would keep eating
until she vomited.

She would slowly make her way past Mom's cus-
tomers, pushing her bowl in front of her, mewling
piteously. She'd rub herself frantically against the
customers' legs, then purr when Mom finally gave in
and fed her. The only time it didn't work was when
Mom was doing five customers in a row for a wedding.
She had done her act for the first four women and was
mewling at the fifth when she let out this enormous
belch, quickly followed by a fragrant fart. Mom threw
rollers at her until she left the basement, but the dam-
age had been done. It was so stinky that Mom had to
finish the woman's perm in the kitchen. My kitten
slunk off into my room and sulked all night.

"You are definitely an Alexis," I said, naming her
after my favourite "Dynasty" character.

For my birthday, Ma-ma-oo opened a jar of $ci'x^0a$.
Wild crabapples grow in sandy places. There is a big
grove in the Kitlope and the trees used to be pruned
and healthy, Ma-ma-oo told me. But they are wild
now, with tangled grey branches choking the green.
$Ci'x^0a$ grow in bunches like cherries, but are smaller
and sour. When ripe, they're sweet but mushy. She
liked them a little hard, for canning. Mick had done
most of the picking. Ma-ma-oo picked for a while, but
said she was too old to be climbing trees.

"I'll do it this year," I said.

"Good," she said. She wasn't hungry, but she
poured a little in a bowl for me, and then sat down,
practically falling asleep at the table.

"Are you okay?" I said, watching her blink slowly.

"Tired. Just tired."

"From what?"

She waved an annoyed hand in my direction. "*Na'*."

Ma-ma-oo looked pale. I brought her a glass of water. We went into the living room and she collapsed on her couch as if the effort of moving from the kitchen to the living room had been a climb up Mount Everest. I sat cross-legged beside her.

"Open her, I'm hot," she said, and I realized she meant a window.

The sky was clear but the full moon hid the stars. Shimmering, mercury-coloured light shone off the large, lazy rolls of waves that crawled up the beach and flattened themselves against the rocks and logs before sliding back towards the ocean.

"Lisa."

I hadn't realized I was drifting off, and I became confused, thinking I'd heard Ma-ma-oo call my name. But it was only the soft, sibilant whisper of the waves rolling against the shore. Ma-ma-oo had slumped onto her side and had begun to snore.

The porch groaned under the weight of something that sounded like it was dragging itself across the wood. The TV flickered, and beneath "Dynasty"'s music, I could hear laughter and singing. I wondered if it was the truckers on their CBs that sometimes came through the TV's radio. I sat down and snuggled in beside Ma-ma-oo. She muttered something, thrashed away from me. The strange sounds on the porch stopped.

The phone rang, making us both jump. Ma-ma-oo groggily reached over and grabbed the receiver,

answering with her usual "What?" Ma-ma-oo nod-
ded, then held the phone out for me.

"Lisa," Dad said. "Are you noticing what time it
is?"

I looked at the clock. "But—"

"Do you have homework? Is it done?"

"I didn't get any homework today," I lied.

"Oh really."

"Well, not that much. I can do it in the morning."

"Don't make me come over there."

"I'm coming, I'm coming."

I went over and kissed Ma-ma-oo's cheek. "Bye."

She patted my hand. "*Wah*," she said, not looking
away from the TV, where Alexis was trying to kiss
Crystal's husband.

As I was walking home, I saw a silhouetted figure
coming towards me. All the kids knew Screwy Ruby.
If you rolled quarters down the street, she'd run after
them. If you poked her, she'd rear up and hiss like
a cat. She walked around the village every night, her
head swinging from side to side as she scanned the
ground for change. I heard whispers that she was
a witch. As she came nearer, she loomed over me, a
creature out of Grimm's fairy tales. Tilting her head
like a crow, her eyes rolled, the edges of her brown
irises pearl white with cataracts. Her long, white hair
crinkled over her shoulders, controlled by a loose
braid.

"Hi," I said, standing tense, ready to run. I
searched my pockets, pulled up three nickels and took
a deep breath. I held them out. Ruby's wrinkles
rearranged themselves into a smile, and she showed

two gold teeth as she took the change from my hand. Her fingers were dusty and warm.

I leaned close to her and whispered, "Are you really a witch?"

She kept smiling as if she hadn't heard me.

Taking this to mean yes, I plunged in, afraid she'd stop me. "Do you ever see things? I saw this man, he was this high—" I held my hand up to my waist. "And his face was all wrinkly, and he comes into my room and I think it means I've got, you know, the gift, and I was wondering if you could teach me to be a witch, too." I waited hopefully as she tucked the change in her sweater pocket.

Ruby bobbed her head, frowning at her feet. "You're a bad girl."

Indignant, I pulled back and spat, "Dad says you're an evil witch and you eat people."

Her smile came back. She chuckled, deep in her throat. "Pot calls me black."

I turned sharply on my heel and marched home.

"Blackie!" she shouted after me. "Blackie!"

My kitten greeted me at the door when I came home. She mewled desperately, rubbed her head against my leg and drooped her tail. When I followed her to her bowl, Mom looked up from scrubbing a bloody stain on the kitchen floor.

"Believe me," she said, her voice dry with suppressed annoyance, "she's already eaten."

I have never met a cat who loved hunting as much as Alexis. As a kitten, she made our house a mouse-free zone. She could bring down four to five a day. First, we'd hear her skittering across the linoleum.

Sometimes this would last for hours. Eventually, we'd hear the terrified squeal of her prey. She'd carry it back to the living room, where, in front of the TV, she'd play with her victim until it flopped on the floor in exhaustion. Then, in delicate, tiny bites, she'd devour it, picking the bones clean. This did not endear her to Mom, who hated the bloodstains, the messy spectacle of Alexis eating and her habit of coughing up mouse fur anywhere she wanted.

"Wow," Dad said on one of her busier nights. He watched in awe as she chomped her way through her sixth victim. He kept a chart on the wall, putting up a skull and crossbones for every successful kill. "Good girl! Good girl, Alexis."

She licked her gory mouth. She loved an audience and Dad was her most enthusiastic supporter. He said it was like watching the nature channel, only in 3-D.

"Think of the money we're saving on mousetraps!" he said to Mom, who was looking slightly ill as Alexis ripped into the mouse's belly.

"And on cat food," I added.

Mom did not look consoled.

The mouse population in our house plummeted, so Alexis had to go outside to find prey. She never got over her need to show off her hunting skills, and no matter how far away she caught something, she had to bring it home. With her mouse in mouth, she would scratch at the door until Mom let her in.

One morning, Jimmy was eating Cheerios and reading an assignment. He'd grown used to Alexis bringing mice and rats into the house and didn't look up when he heard her playing with something. Then

he heard a desperate cheep and froze. When he looked up, Alexis was stalking a wounded sparrow, which frantically fluttered towards the kitchen table. It tried to hop onto a chair, but Alexis smacked it against the wall, smearing blood and guts as she dragged it all the way to the floor. She prodded it, and when it didn't move, picked it up and laid it at his feet.

After that, Jimmy insisted she be brought in every night. He'd seen her sitting on the windowsill, tail twitching in anticipation as she watched him feed the crows. I pointed out that crows were bigger than Alexis, and were also quicker and a lot smarter than sparrows. Jimmy set his mouth. Mom was on his side. Dad reluctantly agreed.

So every morning when she heard the crows gathering on our porch, she'd hop off my chest, mewl pathetically as she ran back and forth, and bump her head against my bedroom door. After five or ten minutes of this, she'd hop on the windowsill and stare at Jimmy's crows with such longing that sometimes I was tempted to let her out.

≋

Pull your heart out of your chest. Cut away the tubes that sprout from the top. Place your heart on a table. Take a knife and divide it in half, lengthwise. Your heart is hollow. Each side has two chambers. The top chambers receive blood and the bottom chambers pump it out. This requires great strength, so the bottom chambers are larger and more muscular than the top chambers. The right side takes oxygen-poor blood

from your body and pumps it into your lungs. The left side takes oxygen-rich blood from your lungs and pumps it back into the body. The pulse you feel at your wrists and neck is actually the shock wave emanating from the epicentre of your beating heart and vibrating through your arteries.

Look closer. Notice that each of the four chambers has a valve, a flap that controls the direction of the pumping blood. Put your heart back in your chest. Plug your ears with your fingers and listen carefully. You should be able to hear a rhythmic lub, dub, lub, dub. The sound you are hearing is not the heart muscle itself, but the four valves in your heart closing. At the beginning of systole, your heart goes lub. This is the sound of the two valves that let blood into the lower part of your heart slamming shut. At the end of systole, your heart goes dub. The two valves that let blood out of your heart have shut. If your valves don't close properly, your heart murmurs.

≋

I steer through the oncoming rain, but this squall is mild, and the waves bumping my speedboat are smaller than what I went through about fifteen minutes ago. I'm passing Costi Island on my right. The Kildala arm is to my left. When Ma-ma-oo and I hiked around here, she showed me where the winter and summer camps used to be, where people picked berries or had traplines. Because of all the clear cutting, bears from the Kildala area have migrated closer to Kitamaat for food, and they're territorial about their blueberry

bushes. One black bear made her den near the road, and in the spring the cubs played there. Tourists would usually stop and get out of their cars to get closeup shots of the cubs.

"Never go near cubs," Ma-ma-oo used to say. "That's a good way to get dead."

Bears thrive in this area. The entire coast of British Columbia is made of drowned mountains. The water beneath my boat was once dry land. But as the last Ice Age ended, the water rose, covering the shortest of the young, jagged mountains until they appeared as they are today: islands and mainland joined by a complex system of twisting inlets, canals, passages, rivers, streams, waterfalls and lakes.

Early explorers traveling through the Douglas Channel were probably daunted by both the terrain and the new languages they encountered. Haisla has many sounds that don't exist in English, so it is not possible to spell the words using English conventions. The language of the people in Kitamaat Village is commonly called Haisla. The actual word for the Haisla language is Xa'islak'ala, to talk in the manner of Xa'isla. To say Xa'isla, touch your throat. Say the German "ach" or Scottish "loch." When you say the first part, the "Xa," say it from far back in your throat. The apostrophe between the syllables signals both an emphasis and a pause. Say "uh-uh," the way you'd say it if you were telling a child not to touch a stove. Put that same pause between the first and last syllables of Xa'isla. Haisla is difficult for English speakers to learn partly because most English sounds are formed using the front of the mouth, while Haisla uses mainly the back.

In much the same way that Spanish is similar to French, Haisla is similar to the languages spoken by the people in Bella Bella and the people in River's Inlet. If you know one language, the other is fairly easy to pick up because the grammar and sounds and vocabulary are comparable. Haisla, however, is as different from English as English is from Arabic or Irish.

The name Haisla first appeared in print in 1848 as Hyshallain. It has alternately been spelled Haishilla in 1884, Qaila in 1890 and Ha-isla in the early 1900s. Xa'isla is actually a word for the village or the people of the village who lived at the mouth of the Kitimat River. Originally, there were also two other Haisla groups; the Nalibila, those living upriver; and the Gilda'lidox, those living in the Kildala Arm, which is a few minutes ahead of me. Some time before the first white settlement, the three branches began to winter together at the village of the Xa'isla.

We stayed in this village at the bottom of the Kitimat River until about 1893, when the Methodist missionary George Raley established a rival village on an old settlement site in present-day Kitamaat Village. Converts moved there when they became Christianized. By the early 1900s, most of the Haisla had moved to Kitamaat Mission, as the village was called.

Ma-ma-oo told me that my mother's grandmother would not move to the mission. She lived in the different summer and winter camps until she died. When I tried to ask Mom why her grandmother didn't move, Mom told me not to listen to any of Ma-ma-oo's stories.

Despite, or because of, Mom's disapproval, I would sit with her on the couch and flip through her box of unsorted photos. I liked the ancient, crispy yellow pictures of Mimayus in her sweetheart necklines and Rita Hayworth hairdos and with her easygoing smile that reminded me of Mick's. I found a photo of Mom standing between Mick and Dad, who were both wearing basketball uniforms. Mom was perfectly groomed, of course, and looking very ladylike. I said I must have been adopted. Ma-ma-oo laughed and said that when Mom was a little girl, she was always doing things like tying two cookie sheets to her shoes and attempting to ski because she'd seen one of her movie star idols in a magazine, elegantly poised on the slopes of Switzerland. Mom flew down the hill, hit a bump and crashed into a bush. She broke her leg and earned the nickname "Crash."

"Did Dad have a nickname?" I asked.

Ma-ma-oo frowned thoughtfully. "Some people, they called him Mick's Shadow because he does everything Mick does. But," she grimaced, "I never did like that name. Albert, he loved the heels of bread. I baked twelve loaves one day. They were on the table to cool. I went to the bathroom, and when I came back, all the loaves had no ends! He cut them off and hid down the beach and ate them."

He was hard to get mad at, she explained, because he would do things like ruin her favourite pinking shears cutting wildflowers and branches to fill the living room because it was her birthday and he wanted her to wake up to something special.

"Do you know what we called Mick? 'Monster.' Oh,

he was a terror. He'd jump out at you from closets, grab your feet from under the bed or sneak up behind you and tickle you. He loved to scare people, especially his sisters. Poor Albert was either being scared by Mick, or Trudy and Kate were putting makeup on him or practising new hairstyles. He had lovely hair."

"Why is Aunt Trudy mad at you now?" I said.

Her smile became sad. "We had a fight a long time ago. Very angry fight."

"About what?"

She touched my hair. "Old-people things. You'll learn about them, but not now."

"How come?"

"Look!" she said, pointing to the TV. "I think they're going to fight!"

I knew she was changing the subject, but decided to let it go.

Alexis and Crystal circled each other. We stopped and waited, but they just poked fun at each other and Alexis left, reappearing after the commercial in a sparkling white dress, trying to seduce some woman's husband at a cocktail party.

"*Na'*," Ma-ma-oo said. "He'll never make you happy."

"Ma-ma-oo, it's just TV."

"Yes, yes. I know," she said, absorbed in Alexis's unsubtle flirting.

There were only two channels, but there were rumours that we were going to get a satellite dish in the village. Dad said it wasn't likely, because it was so expensive. Ma-ma-oo's TV was on its last legs— everyone looked green and the top of the picture

leaned to the left, so Alexis's and Crystal's big hair looked very windblown. Meanwhile, Ma-ma-oo liked it when they got into mud fights. Now Alexis waltzed with a man she was trying to seduce. The man played it cool, but when he thought she wasn't looking, he'd give her big cow eyes.

"*Na'*, dummy!" Ma-ma-oo yelled at Alexis. "Don't go with him! Are you blind? He's after your money!"

Frank stared at me sometimes. When I caught him, he'd roll his eyes all the way back so only the whites showed, or he'd flip his eyelids up so they were red, or he'd do something equally silly and distracting. But the times he didn't know I knew he was watching me, he had this mopey, strained look, like he really needed to pee but had to hold it.

I caught him again when we were hanging out at the rec centre. We were horsing around in the bleachers, waiting for the junior boys basketball practice to start. They were all on the team. Pooch was trying to bounce a basketball off my head. I whacked his arm and the basketball went flying. I smacked the back of his head.

"Ow!" he said indignantly.

"You goof," I said.

"Now look what you did," Pooch said, rubbing his neck. One of the little kids had grabbed the ball and was running across the gym with it. Pooch took off after him. Cheese lifted one cheek off the bleachers and blew a big, juicy fart.

"Earthquake!" Frank shouted.

Cheese followed it up with a reverberating burp. He turned around and smiled at us like he was waiting for compliments.

"Holy shit," I said, scooting three seats back as pungent waves wafted up towards me and Frank.

"Like yours smell like roses," Cheese said.

"Mine," I informed him, "don't smell like something crawled up my butt and died."

"You're fucking gross," Cheese said.

I turned to Frank to back me up and caught him giving me one of those I-need-to-pee looks. It weirded me out enough that I couldn't speak. Frank pretended to fall off his seat and grabbed his throat like he was choking. Cheese kicked Frank's foot. Pooch came bounding back and stopped dead when he reached Cheese's odour zone.

"You gotta start wearing deodorant," Pooch said.

None of the guys liked to hang around my house, because Mom made them nervous. Pooch's house was like Ma-ma-oo's, old and drafty. Frank's house was a party palace, so we usually ended up in Cheese's house, which meant long sessions of listening to his guitar-playing. Cheese was a huge Van Halen fan and wanted to be the Native David Lee Roth, but he couldn't sing a note, so he settled for the electric guitar. He'd bought the guitar at a garage sale, and then sent away for an Easy-Play Van Halen fingering book, and went at it nonstop, his brothers told me, rolling their eyes. On the last day of classes at the beginning of the Christmas break, Pooch, Frank and me sprawled across Cheese's bed reading his *Mad* magazine collection.

"You're killing me," said Frank after one really long session, in which Cheese played along with every song on the album *Women and Children First*.

"Up yours," Cheese said.

"You should play punk," Pooch said helpfully. "You just have to be loud to play in a punk band."

"Punk sucks," Cheese said.

"So do you," Frank said.

"You're gonna be laughing out the other side of your mouth when I'm famous. I'm gonna have a big house, six cars, shitloads of money and marry a model. Not one of the dogs in the village."

I snorted. "Models'll be dying to marry you, Mr. America."

Frank laughed. "Yeah, Cheese, you'd be lucky to screw a poodle."

"At least I got plans."

"I got plans. I'm getting the hell out of here," Frank said.

"Wow," Cheese said, practising one of his rock poses, legs apart, one hand on the neck of the guitar, the other hand pumped in the air. "That's an impressive plan."

"You must have spent years thinking that one up," Pooch said.

"Yeah, about as much time as you and your 'I'm gonna work in the potlines and buy a truck' plan."

"It's gonna be a big truck," Pooch said. "And you're gonna be knocking around the village till you're a hundred."

"Excu-use me. A big truck."

While they argued, I folded the back of the *Mad* magazine. Unfolded, it showed a guy getting his diploma. Folded, he was chugging a huge beer glass in a frat house.

As I was walking home, I realized that I hadn't given the future much thought. It would be easy to go along

with Mom and Dad's plans, since they were assuming I'd go off to university. Then again, I couldn't see myself going in for another four years of school after I graduated. The only thing more painful than that would be getting all my teeth extracted without anaesthetic.

Absorbed in thoughts, I didn't notice the girl until I bumped into her. She grinned at me, her arms crossed. I didn't recognize her for a moment until she said, "Lisa? Jeez. I thought you were a guy."

"Tab?"

"In the flesh."

I gawked at her. The thrown-together look she'd usually sported had been replaced by biker-chick black and studs. She had silver earrings looped all the way up one ear and a single gold hoop in the other.

"I didn't know you were coming up for Christmas. How long are you here?"

She shrugged. "As long as I want."

She pulled her jacket open and showed me her tattoo. Not a homemade job, either. She had actually gone to a tattoo parlour in Vancouver. A snarling black tiger gripped her muscle on her upper arm, its claws drawing tattoo blood.

"My boyfriend has exactly the same one in the same place," she said.

"You have a boyfriend?"

"You don't?"

"Boy," I said. "You must love him a lot."

"Nope," she said. "I just wanted him to pay for the tattoo."

"You want to come over for dinner?"

"Sure."

Mom was attempting to hold a gingerbread house wall up when we walked into the kitchen. The gingerbread house looked burnt and the roof was lopsided and she'd slathered it in red and green Smarties that bled all over the icing. Alexis swished her tail back and forth as she sat on one of the kitchen chairs and watched Mom's progress with attentive bobs of her head.

"Come hold this," she said, then did a double take when she saw Tab. "Oh! My goodness, how . . . grown-up you look, Tabitha. Merry Christmas! How long are you here?"

Tab shrugged.

I eagerly eyed the candies. "What do you want me to hold?"

"This stupid wall won't stay up."

"You need toothpicks," Tab said, kicking off her boots. "That's what I saw on TV. And you get some tall glasses and put the walls between them until they dry, then you put the roof on."

"Now you tell me," Mom said.

We managed to get the walls up, but Mom had made the roof too steep, so no matter how long we held the pieces in place, they slid off and eventually broke. The icing hardened that night to the consistency of steel and Dad chipped a molar when he tried to sneak one of her roof slabs. Mom planned on using the remaining gingerbread house as a cookie bowl until Alexis left a mouse in it.

"A comment on my baking?" Mom said to Alexis. She picked up a pair of tongs she'd set aside especially for the purpose of disposing of my cat's victims. Then

she gingerly lifted the mouse by the tail and chucked it in a plastic bag.

"Her contribution to the Christmas spirit," Dad said.

"Let's put your stuff upstairs," I said to Tab.

Tab hauled her duffel bag over her shoulder and followed me to my room. She opened my window and lit a cigarette.

"Put it out!" I hissed. "You're gonna get us in trouble."

Mom came into my room to see if we were settling in all right. Tab dropped the cigarette out the window, but you could still smell it in the room. I thought Mom would throw a hairy, but she just asked if we needed more blankets.

"I'm fine," Tab said.

"We should phone your mother and tell her where you are."

"She knows."

"Oh," Mom said, closing the door as she left. "Well, you know where the towels are. Help yourself."

"Thanks." Tab took off her jacket. She stretched her arms over her head.

"I'm glad you're here," I said.

She glanced at me warily. "Me too." She reached into her bag and pulled out a book. "Do you want me to do your horoscope?"

"Cool."

Later than night, Tab pinched my arm until I woke up. "Ow, quit it."

"There's someone in the room," she whispered, eyes bugged out with fear.

I sat up, instantly awake. Please, I thought, don't be the little man. Tab leaned over and I heard a metallic rasp, then saw the silver flash of a long knife. She turned her head, making a slow sweep of the room.

Alexis leaped on the bed with a mouse skull in her mouth. She dropped it in my lap. "Mrrr."

"Oh, Jesus," Tab said. She slipped the knife back in her bag. She pushed Alexis off the bed. "You fucking freaky little bitch, you scared the shit out of me."

"Mrrr."

"Same to you." Tab started to laugh. She flopped back against the bed.

"Where'd you get the knife?"

"Christmas present. You're lucky," she said just as I was closing my eyes, so quietly I barely heard her. "Mom's been hammered since Mick died. At least your parents just pretend it didn't happen."

≋

Dad made French toast for breakfast. Jimmy eyed Tab then nodded when she sat beside him. Her mouth quirked.

"Hey, Jimmy."

"Hi," he said.

"Are you kids going up to the rec centre for Santa—"

"Aw, Dad," Jimmy said. "We're not babies any more."

"We're going," Tab said.

"We are?" I said.

She smiled. "We can't miss free candy."

We hung around the house until it was time to go.

Santa Night is usually the choir singing a few carols, the little kids doing skits, while other kids run around like crazy until the finale, when Santa arrives and gives out bags of candy. As we walked into the gym, we saw Erica already entrenched in the back bleachers with her gang. They stopped talking when we came into the gym, stared at us, and then started snickering.

"Wow," Erica said just loud enough for us to hear. "It's the queens of the Kmart set."

"You want a doobie?" Tab said. "I could sure use one."

I nervously followed Tab outside to the back of the rec centre and across a ditch to the elementary school. We sat in the swings. Tab pulled out two joints and handed me one. Tab put her joint to her mouth and hunched over to hide it. "Wanesica," she said, lighting up.

I copied her, hunched so far over that my head almost touched my knees. The stuff tasted as good as skunk cabbage smelled, was harsh and scratchy on my throat, and I ended up coughing most of it out. Tab grinned at me and hit my back. "Don't fucking waste it, man. That's five bucks a pop."

"This tastes like shit."

"You're welcome."

I managed half a joint then coughed so hard I got a headache. My fingers were numb from the cold by the time Tab finished hers. Tension eased out of my body. I started to smile. Tab watched me, smug. Her eyes were bright red. I giggled. "Tabby the red-eyed reindeer had a very shiny eeeeeeye, and if you ever saw it, saw it, you would even laugh and dieeee."

"Jeez, you're a cheap date," she said, leaning back.

"Then one foggy Christmas Eve, Santa came to say, Tabby, with your eyes so bright, won't you light my doobie tonight?"

I went on until she smacked me on the side of the head. I could feel the hit ripple through my brain. I closed my eyes to feel it better, swaying. When I opened them, Tab was biting her lip in worry. "You okay?" She shook her head sadly. "I think you should stick to sugar rushes."

"Ah, relax." Swaying hard, I felt like I was moving through water, moving in slow motion, like I was Jamie Summers, the Bionic Woman, getting ready to kick some bad-guy butt.

"Cut it out." Tab looked around nervously. "You are embarrassing."

"Hey," I said. "That's what family's for."

"Jesus." She handed me her bottle of eye drops. "You really are nuts."

I kicked the ground with the toe of my runner. It squeaked. "I missed you too."

"Lean back and put this in your eye. Yeah, like that. Now the other. Come on, hurry up or your parents will skin me alive."

I handed the bottle back to her. "We don't have to go home. We could go over to Frank's. Pooch and Cheese—"

"You're hanging out with them?" she said incredulously.

"Yeah," I said. "So?"

"Jeez, you've got more guts than brains, that's for sure."

"They're my friends."

She shook her head. "Frank's okay. Pooch is weird. Cheese is a pervert."

"He is not!"

"You remember when all those panties went missing from the clotheslines? That was Cheese and his retarded brother."

"Yeah? Who said?"

"People."

"I don't listen to gossip," I said piously.

She snorted. "Mm-hmm. And I just say no to drugs."

We ended up going home because it got cold enough for the channel to steam. When the ocean temperature is higher than the air, steam swirls above the waves. The colder it is, the higher the steam rises. I stopped to watch the pale, twisting forms strain to reach the darkening sky. They were so tall, they looked like the ghosts of trees.

I had watched a video in geography class about Siberia. In this one place, it drops so far below freezing, the rubber on the soles of your running shoes cracks when you step outside. As soon as a breath leaves your body, the vapour in it crystallizes, then tinkles as it drifts to the ground. The people there call that sound the music of your soul. Tab tugged on my arm and said if we stayed outside any longer, her tits were going to fall off.

Dad was too busy talking on the phone to hear us coming in, but when we closed the door he looked over, his face red.

"Tab, it's your mother." He said. He held out the phone for her.

As her mother screamed into the phone, Tab gave me a cynical smile, then ducked her head and played with the fringes on her jacket.

"What's the matter?" I said.

"Oh, besides the fact that Tab hitchhiked up here without telling her mother where she was going, nothing," Dad said.

After five minutes, Tab laid the phone on the table. She left the kitchen and went upstairs without looking at either of us. Dad picked up the receiver, listened for a while, then softly told Aunt Trudy to phone back when she calmed down.

Tab was packing her things when I came into the bedroom.

"What're you doing?"

"Brain surgery," she said.

I sat on the bed and watched her, not knowing what to say. Dad came into the bedroom and watched Tab too. "Lisa, could you leave us alone for a minute?"

I hesitated until he raised his eyebrow and gave me a look.

Mom came home and asked me how Santa Night had gone. I told her about Tab running away from her mother. She sighed and went upstairs. They talked to Tab for about an hour. I made myself a sandwich and gobbled it down. I had some cookies, chips and a banana and was still hungry when my parents brought Tab into the kitchen and told me she would be going home for Christmas. Aunt Trudy had told them that Josh offered to drive her down to make up for "the incident."

"I'd rather hitch," Tab said.

"Do you know how dangerous that is?" Mom said. "Do you know what can happen to you?"

Tab laughed bitterly.

"Seriously, Tabitha," Dad said.

Her lips pulled back into a sneer, but she didn't say anything else as she turned and went upstairs. I brought her cookies and a banana—peanut butter sandwich. She was curled into herself on my bed. I sat beside her and shook her leg until she sat up and took some cookies.

"I don't want to talk about it," she said.

"Okay. You want me to go?"

She managed a smile. "Only if you bring me more cookies."

"Man, I'm starved too."

"They're called the munchies. Haven't you ever done pot before?"

"Are you kidding? They'd kill me."

"Yeah. They would."

She turned to face the wall and wouldn't respond to my poking except to snap, "Stop it."

I woke early in the morning. I heard voices drifting up through the register. Josh and Dad were having coffee. Jimmy was feeding the crows and they were squawking excitedly on the porch. In the winter, his flock almost doubled. I flinched from the brightness of the kitchen lights and drowsily poured myself some cereal.

"When you leaving?" I said to Josh.

"Soon as Sleeping Beauty gets out of bed," he said.

"Oh. Can she stay for a few days, or—"

"Lisa," Dad said in a warning tone.

"It's not fair."

"Yeah, life's a bitch," Josh said. "The roads are icy from Prince Rupert to Williams Lake. It'll take us days to get down."

"You got chains?" Dad asked.

I stirred my cereal around the bowl and listened to them gripe about winter driving. Later, Tab came downstairs with her duffel bag slung over her shoulder. Josh took her bag and walked out to his truck. Tab gave me a hug, then followed him. He opened the car door for her. She got inside and stared straight ahead.

≋

For Christmas I made Ma-ma-oo a coiled pot in art class. When I saw the four gifts under her tree, I wished I'd made her something bigger. Mom and Dad had sat me and Jimmy down at the beginning of December and told us that Christmas was going to be tight. I assumed that everyone was going to have a tight holiday and didn't think any more about it. I could stay the night because Mom and Dad were going to a Christmas dance.

"Do you go to dances yet?"

"No."

Ma-ma-oo laughed. "Why not? Don't you like boys?"

"What was Mimayus like?" I said, hoping to steer her away from this topic.

"Mimayus? My crazy sister," Ma-ma-oo said. "Oh, she loved to jitterbug. She danced all night long. All the boys wanted to dance with her. She bought the

fanciest underwear. The boys lifted her up and spun her just to see her underwear. That's why she loved to jitterbug. All the women hated her, she was so pretty. You look just like her. You have her eyes."

I was left speechless at this declaration. I started to blush, not used to having people call me pretty. "Do you still know how to jitterbug?"

She smiled. "Yes. Want me to teach you?"

"How come you don't go to dances?"

Her face cracked wide open as she laughed. "Been a long time since I did anything worth gossiping about."

"Who gossiped about you?"

"Oh, everyone."

"Really?"

"I wasn't always old."

"What did you do?"

"Cookie?" She handed me an Oreo. "Did I ever tell you about shape-shifters?"

I knew it was a distraction, but I said, "No."

In a time distant and vague from the one we know now, she told me, flesh was less rigid. Animals and humans could switch shapes simply by putting on each other's skins. Animals could talk, and often shared their knowledge with the newcomers that humans were then. When this age ended, flesh solidified. People were people, and animals lost their ability to speak in words. Except for medicine men, who could become animals, and sea otters and seals, who had medicine men too. They loved to play tricks on people. Once, a woman was walking along the shore and she met a handsome man. She fell in love and went walking with him every night. Eventually, they made love

and she found out what he really was when she gave birth to an otter.

The old stories, she explained, were less raunchy than they used to be. There was a beautiful woman who was having an affair with her husband's brother. She and her husband were paddling back to the village after trading their oolichan grease for seaweed. Just off Monkey Beach, they stopped and he pissed over the side of the canoe. She lifted her paddle and clubbed him. While he was in the water, she used the paddle to hold his head under until he was still. Thinking he was dead, she paddled back to the village and told everyone he drowned. But the next day, when the wife and the husband's brother went back to hide the body, they found large footprints in the sand. Worried he might be alive, they followed the trail into the woods. They discovered the man—transformed into a b'gwus—who then killed his adulterous wife and brother.

But to really understand the old stories, she said, you had to speak Haisla. She would tell me a new Haisla word a day, and I'd memorize it. But, I thought dejectedly, even at one word a day, that was only 365 words a year, so I'd be an old woman by the time I could put sentences together.

≋

Two days before Christmas, we finally got around to getting the tree. Dad asked me if I wanted to come and help him pick one up from Overwaitea. I was almost going to say no. When we stood in the parking lot, he looked bewildered at the selection of bundled trees

leaning against the wall. I wanted to be out of there as soon as possible, so I grabbed a small spruce. We set it up in the living room in the opposite corner from where it normally sat. Mom took out the decorations and threw them on in five minutes. Then we all ignored it.

≋

Contacting the dead, lesson three. Seeing ghosts is a trick of concentration. You must be able to concentrate on nothing and everything at the same time. You must be both asleep and awake. It should be the only thing on your mind, but you can't want it or expect it to happen. It's very Zen.

Lie down. Wear loose clothing. Don't play any music. Especially don't play any of that New Age, sounds-of-the-humpback-whale music. Be still. Close your eyes. Keep your arms flat by your side, your legs uncrossed and relaxed. Begin by becoming aware of your breathing. Then your heartbeat. Then the blood moving through your body. Expand. Hear the traffic outside, or the wind in the trees, or your neighbour taking a shower. Then concentrate on both your body and the outside world. If you have not contacted the dead after several tries, examine your willingness to speak with them. Any fear, doubt or disbelief will hinder your efforts.

≋

I really need to pee. I wanted to make it to Bell's Bay before I took a break, but Blind Pass is closer.

THE SONG OF YOUR BREATH 213

Unfortunately, three other boats are anchored in the harbour, which nixes my idea of leaning over the side. The speedboat is too small for that anyway, and I don't feel like pissing into a pail.

I pull up to the north shore of Blind Pass and cut the motor. The boat glides up to the beach, and I take out the oar and pole in when the water is shallow enough until the bow grinds against the gravel. I tie up on a log and stretch. My back has a crick from all the bouncing around. Digging through my knapsack, I discover that the Ziploc bag came open and the toilet paper is soggy and mushed together. I put it in my pocket—I hate using leaves. Ma-ma-oo thought I was spoiled. She hated taking tp on our walks and thought it was a waste of space. The first time we took off together was one quiet afternoon in early spring. Ma-ma-oo was as antsy as I was.

"Let's go pick *kolu'n*," she said. "Too good out to stay inside."

I put on my hiking shoes, and Ma-ma-oo got her machete, which would perform the double duty of protector against bears and *kolu'n* chopper. Ma-ma-oo liked to mix the *kolu'n* with pussy willows and put them in Mason jars. I bought her a vase once, but she put it in her storeroom, where it collected dust, saying it was too pretty to use.

Kolu'n, sapling cottonwood, has oily, nutmeg-smelling leaves with such a strong scent that just a few branches can fill a whole room. Our walks to find the saplings were never short. We wandered through the brush, leisurely looking through the clearings where *kolu'n* liked to grow, on the alluvial flats and sandbars

just outside the service centre in town. We'd park near one of the garages or the Chinese restaurant where Ma-ma-oo liked to get her dried spare ribs. If I chattered and bounced around her, she didn't lose her temper or tell me to calm down. She watched me with a solemn expression, taking everything I said seriously.

Ma-ma-oo would let me carry her machete if I promised not to swing it around. She was the only grandmother I knew who regularly needed a machete, and I was very proud of this. When I told Ma-ma-oo how cool she was, she just grunted. "Look over there. Get those flowers," she said as we came to a small meadow with long, yellow grass that had been flattened by the snow and was wilted, half-raised. In the shade of the trees, you could still see sullen grey lumps of stubborn snow refusing to believe that spring had come.

My favourite walk was up the power lines. Running through the village were huge electrical towers with fat black wires that sizzled and hummed. The tower line ran along Walth creek for a while, then zigged up the mountain behind the village. Eventually, if you followed the power lines, they would lead you right to Alcan's Kemano hydro dam.

The first time we went up there, Ma-ma-oo put her jacket down and we sat on it. We could see the village below, hugging the shore. I put my thumb out and could blot out a quarter of the village. Tiny cars winked brightly in the sunshine and people were dark grains moving along the roads. The ocean glared yellow light, bounced it back at the sun, which had reached its peak and would set behind the mountains in about five hours. Swallows swooped and darted over our heads.

Ma-ma-oo handed me a thermos cap filled with iced tea. I picked out the bits of lemon she had put in and sipped. Her iced tea was always bitter because she hated using sugar. I'd greedily gulped my juice long ago, so it was tea or nothing. We sat in the sunlight until we were rested, before heading back down the mountain.

≋

Blind Pass is relatively calm. It's a favourite spot for spring salmon to rest and mill around. Ma-ma-oo wintered here a couple of times when she was a little girl. I look over to see if any of the boats are fishing, but they all seem to be waiting out the squall. One of the people sitting on top of a forty-foot pleasure cruiser lifts an arm and waves lazily. I wave back. Something glints and I realize they have binoculars. No pissing near the beach, then.

The good thing about the rain is that my trip into the bushes is bug-free. My Deep Woods Off is pretty useless right now, but I'm glad I brought it, just in case the weather clears up. The sound of rain on leaves is broken by the dull roaring of a plane overhead, hidden by the clouds. It's most likely one of the jets that lands at the Terrace-Kitimat airport. I find it ironic that if you're flying in from Vancouver, you can look down and see Kitamaat Village, but you have to land fifty kilometres north and make an hour-long car trip to get back there, when the airplane took only five minutes to travel the same distance. Maybe someday they'll have a service where you and your luggage are booted out of the plane and you skydive to your destination.

"Hello! Hello!" a voice calls out when I emerge from the woods. A young white guy, probably eighteen at most, is paddling a kayak to shore.

I stop, putting my Ziploc bag behind my back.

He grins and pushes his blond hair out of his sunburned face. "Are you from around here?"

Oh my God. The last thing I expected was to have some guy try to pick me up. I shove the Ziploc bag with the toilet paper into my coat pocket. "Yes." My brain is having trouble switching gears, and I do small talk with him on autopilot. He tells me how glad he is to see someone his own age and how he hadn't realized it would be so empty in the wilderness. He goes on to say how beautiful it is, how spiritual it is getting back to nature, and then asks if I want some coffee.

"I've got some, thanks. You don't smoke, do you?"

"Like a chimney!" he says, reaching into his front pocket. "But it's raining pretty hard. Why don't you come back to our boat? We just finished lunch, but if you're hungry we can warm up some soup."

At the best of times, I can't imagine anything I'd want to do less. I shake my head. "That's okay."

"Sorry," he says. "I know I'm being pushy. But it's been just me and my folks for the last four weeks, and to tell you the truth, they're driving me nuts. Big time." He tosses me his pack of cigarettes. Marlboro. "Four weeks of nonstop nagging. Why don't you go to law school? Ninety-nine per cent of all bands never make it to the big time. You should go to law school. You need a back-up career, don't you?"

"Why'd you come?"

"Blackmail. Sheer blackmail." He clambers out of

his kayak and splashes to shore, soaking his jeans to his waist. "If I had to do it all over again . . . " He holds up his lighter for me. "By the way, I'm Greg."

"Lisa," I say. I cover the cigarette with one hand as I smoke. Ah, tobacco, whose sacred smoke carries wishes to the spirit world. Please let me find Jimmy. After the way I was sucking the smokes back yesterday, you'd think the spirits would throw him in my lap just to shut me up. Greg lights his own and smiles down at me. I hold the pack out, but he says, "Keep it. I've got three cartons back on the boat."

"Thanks," I say. "You're a lifesaver."

"Bad place to run out. So. What're you doing out here?"

Lie, think of something fast. Leave out the missing brother. "Meeting some friends." Yeah, good one: you came out here to get together over a coffee. "Over in Bishop's Bay."

"The hot springs?"

"They're doing some fishing. We said we'd meet today, but I didn't expect this much rain." Don't babble, keep it short.

"Is it a party?" he says, desperately hopeful.

Make it sound boring. "No, just a bunch of us hanging out."

"Oh," he says. I can tell he wants me to invite him, and he's on the verge of inviting himself, so I look at my watch.

"God, I'm late. Thanks for the smokes."

"What's a few minutes?" he says. "Say you got held up in traffic."

If I was thinking more clearly, I would have made a

graceful exit instead of mumbling apologies, hopping in my boat and shoving off like he had the plague. He waved forlornly as I ripped around the point.

Jimmy picked up a lot of self-affirmation tapes when he was training and would repeat them out loud at breakfast. One of them said: only commit yourself to something, and the universe will move to help you get it. "Thank you, universe," I say, firing up a second Marlboro. I inhale deeply. Ten lonely little cigarettes roll around the half-empty pack. If I ration them, they'll last until Namu. I didn't become a real smoker until I started hanging around with Pooch. Frank and Cheese would go to wild parties that Pooch wasn't allowed to go near. His brothers went to them but always booted him out. After I got back from a long day at school, we would commiserate with each other over the unfairness of it all, and almost without fail, end up sitting on the church steps. I filched cigarettes from Dad and he filched them from his grandmother and we'd smoke furtively behind our hands, hiding what we were doing from passing cars and pedestrians. Once, while we were sitting there, a blue BMW slowly drove past us, with three little blonde kids pressing their faces against the windows, their eyes round as they stared at us as if we were dangerous animals in a zoo. The adults excitedly pointed at us.

"You wanna moon them?" Pooch said.

"Naw," I said. "Our asses might end up on a post-card."

Pooch flipped them the bird instead. The woman in the passenger seat snapped a picture.

"See?" I said. "You're gonna be famous now. Your

postcard will read, 'Indian boy gives ancient Haisla greeting.'"

He laughed and flicked the butt of his cigarette down the steps.

Pooch's father had committed suicide. His mother was missing in action. He and his two brothers lived with his grandmother in an old house. When I first went to his house, Cheese was with us and was hungover and grumpy, avoiding his parents' wrath. Pooch's gran was about eighty and always looked tired. When we came in, she offered us homemade candy. It looked like a humbug but was white, and after a few minutes in my mouth, it became chewy and soft.

Pooch was a tad odd. As he led us to his bedroom, I noticed just above the entrance to his bedroom, someone had hung a deer skull, yellow with age, horns curving up like cupped fingers. It stared at me through hollow black sockets as I followed him down to the basement. I paused at the top of the steps. He had painted his bedroom black, even the tiny windows. The darkness reminded me of a cave. He had a dozen black candles as wide as my wrist set in waist-high brass candle holders, that formed a circle around his bed. His headboard was filled with dolls that, when I looked closer, were hand-stitched. Each had a name printed on it. I was shocked silent, but Cheese didn't seem the least bit bothered by it.

"What's all this?" I said, looking around Pooch's spooky room.

"A psych. A head game." Cheese picked up a doll and sat down on the bed. He held it out for me. "Give it a try."

I shook my head.

"Don't fool around with that," Pooch said.

"You two are sooooo gullible," Cheese said. He picked up a pen and drew pimples over the doll's face. Raising an eyebrow at Pooch, he said, "Wanna give our favourite uncle a missing limb? Think it'll work?" He picked up a pair of scissors and snipped off a toe. The candle flared. Pooch jumped. Cheese rolled his eyes. "Gullible. It's in the dictionary. Beside your picture."

Pooch opened a black bag and poured a tiny amount of fine black powder into a saucer. "This is a pretty good hex." He lit the incense, and as he took the doll from Cheese's hands he said:

> Powerful demons of the deep
> Harm my enemies as I sleep
> I command thee, I command thee
> Go forth and destroy.

"You believe this stuff? Cheese said.

He shrugged. "My gran says—"

"Your gran says. You believe everything she says?" Cheese threw a book, *Voodoo for Beginners*, at me. "It's just a game. Call it the power of negative thinking. Works for Pooch. If he didn't have all this crap down here, his brothers would steal everything. But they think he's a big freak, so they stay away."

"Shut up!" Pooch said, shoving him.

"Well, it's true, isn't it?"

Pooch grumbled and said something under his breath. Cheese asked him to go get us something to eat. Pooch glared at him. "Don't touch anything."

I tossed the doll on the floor. "This is stupid. What else do you guys do around here?"

Cheese grinned. "We're famous for that, you know."

"For what?"

"The Haisla. We were masters of the psych-out. When the Haida or the Tsimshians paddled down the channel, they knew they were coming into the territory of some of the greatest shamen who ever lived. That's how we survived."

"Oh, bullshit."

"Think about it. Here we are, this little group stuck in the middle of all our mortal enemies. They didn't cream us because they were spooked, man. It's just like voodoo. You've got to put on a good show. That's all witchcraft ever was."

I hit him with a pillow, but later I flipped through the voodoo book. Some of the helpful chapters included "To Overcome Legal Problems"; "Proper Use and Care of Voodoo Dolls"; and, my favourite, "To Keep a Place Rented." In the chapter "To Communicate with the Restless Dead," I found a spell. I didn't have any of the ingredients and thought I'd probably skip the recommended orgy. But the rest of it seemed easy enough, and it was worth a try.

The first time I tried it, nothing happened. I fell asleep. Jimmy woke me for breakfast. The second time I did it, I saw neon-coloured geometric patterns swirling and merging until I was so dizzy that I had to open my eyes or puke. The third time, I felt like the bed was on water and it was rocking in the waves. I drifted upward, floating, watching spinning lights

swirl in front of me, and then I didn't feel my body. When I tried to open my eyes, I snapped awake. I sat up, yawning and stretching. It had been relaxing, I was thinking, until I heard the creaking. It was the little man. But this time his red hair was stringy red and he was hanging by his neck from a yellow rope, smiling at me as he swung back and forth.

I heard crows cawing and screeching. I went to the window and saw they were gathered in a circle. They lifted off the lawn, and I could see a dead crow with a missing wing. It lay at an odd angle. It was small and young, in the process of molting into its adult feathers when something had caught it and chewed it almost raw. Alexis crept out to it and sniffed the body. She was dive-bombed a few times before she ran off, meowing. Jimmy ran onto the back lawn and carefully cradled it against his arm. He stood in the predawn greyness and flung it upward. I watched the transformed baby crow soar upward, shrink to a tiny dot, then disappear behind the clouds. When I looked back down, the lawn was empty and the crows shifted silently on the back porch, waiting.

I stood at the window, trembling. Then I went into Jimmy's room and saw him sprawled over his bed. I pinched myself to make sure I was awake. I understood I had just had a vision, but I was afraid to think about what it meant. I went downstairs and waited until Jimmy woke an hour later. I followed him onto the porch as he took a bag of stale bread out to feed the crows for good luck. The crows fluttered around his feet. He seemed puzzled that I was watching him do what he'd done for years. I asked him if he'd been up

earlier and he said no. I touched him, to make sure he was the real Jimmy, and he smacked my hand away, then asked if I was feeling okay.

"Are you?" I said. "Do you feel all right? Do you have a cold? Is anything sore?"

"I'm fine."

"Have you had a checkup lately? We should make an appointment with the doctor—"

"What is wrong with you?"

I spent the morning in a state of anxiety. Something bad was going to happen to Jimmy. If I stayed with him, I might be able to stop it. I checked his breakfast cereal for anything he might choke on. I followed him up to his room, behind him, in case he slipped on the steps. I waited outside his room, ear pressed against the door, trying to hear if he was crying out for help.

"Stop it," he said when I followed him to his swim practice. He drew the line at the change rooms. "Just stop it. This is embarrassing."

I stood over him and shook my head. "I'm not leaving you."

"Dad—"

"Humour her," Dad said, grabbing my arm and towing me away to the bleachers. As we sat waiting for Jimmy to come out, I scanned the pool. There were so many ways he could be hurt.

"Don't run!" I screamed at him when he finally jogged out of the change room. His jerked to a stop, glowered at me and was elbowed by his teammates.

When he went into the water, I had never felt so helpless. If he drowned, I couldn't save him. I could

barely dog-paddle. Dad put an arm around my shoulder and I jumped.

"Easy," he said. "He's okay." The butterfly stroke, Dad explained, is the last to be learned, because it requires a high degree of mobility, strength and coordination. "See how he does it? He's a natural," Dad said with quiet pride. Although the reaction of the arms and legs produces some undulations, the general line of the body is horizontal. The legs move upward and downward, simultaneously and continuously. The propulsive pathway of the arms resembles that of the front crawl, with a recovery requiring a sideways and forward "fling" over the water surface. Usually, there are two beats of the legs to one complete cycle of the arms. "The first time he tried it, he just flew. His coach said he never saw anything like it."

All I saw was Jimmy putting his face in and out of the water.

He managed to elude me at school. I had to go to my classes, but I was so spacey, the teacher asked if I wanted to see the school nurse. At recess, I ran around and around the schoolyard looking, but I couldn't find him. I sat down on the front steps and burst into tears.

Frank, Pooch and Cheese came up to me.

"What's wrong?" Frank said, sitting beside me. I couldn't stop crying. "Is it Big Lou? Is it Erica?"

I shook my head.

"Did someone beat you up?"

"J-J-J-Jimmy . . . "

"Jimmy beat you up?"

"No. No." I tried to catch my breath to speak. "He's. Going. To. Die. Jimmy." They watched me uneasily.

Frank touched my shoulder. "Does he have cancer or something?"

I started giggling. It was weird stupid giggling, and the more I tried to stop, the louder and weirder it became. Pooch lit a cigarette and handed it to me. I nodded thanks and went through three before I stopped shaking. "You're not going to believe me. No one's going to believe me."

"Try us," Frank said.

I gulped, sucking in deep breaths. "I have these dreams. This man comes. He's a little man. Bad things happen. After he comes. I saw him. Before Uncle Mick died. He came to me. I didn't listen. I should have gone. To check the net. I should have been there. I could have stopped. It. I. Wasn't. There." I looked up, and they were listening, but didn't seem to think I was crazy yet. "I saw the man. This morning. I saw Jimmy. In my dream. He thinks. I'm nuts. I don't know what to do."

After a lengthy silence, Frank said, "Well, he's got three more bodyguards now."

Frank caught Jimmy at lunch. He cornered him in one of the undercover areas and kept him there until we found him. Jimmy was trying to push Frank away, but he had a solid hold on my brother's arm.

"Get lost," I said to some boys Jimmy had been playing with.

"We're telling," one of them said.

"You do and tomorrow you won't have any front teeth," Pooch said, coming up behind me.

"I think you'd look real pretty without teeth," Frank added, flashing a nasty smile.

"Lisa," Jimmy said as his friends slunk away. "What are you doing?"

"Think of it as baby-sitting," Pooch said.

"I don't have any money, if that's what you want," Jimmy said uneasily. "I didn't do anything to you. Did I? Just tell me what I did."

"You hungry? Let's eat," Frank said.

Cheese joined us as we sat in a circle around Jimmy at the front steps.

After school, Jimmy was supposed to go to his friend's house to study, but I said he'd have to cancel.

"But Dad's picking me up," he said.

I made him call Dad and tell him he had a ride home. Pooch thought we should hang out at the arcade until the late bus came. Nothing, he said, could happen to us there. I nixed that, imagining fights. We ended up catching the bus home and dragging Jimmy with us to the pumphouse by the river. We sat at a picnic table. He took out his homework. Pooch brought out some smokes and handed me one. Jimmy gave me a look, but didn't say anything. He bent his head down and stared firmly at his papers. I hadn't spent this much time with him since we were little. I knew as soon as we got home, he would complain to Mom and Dad.

"How long are we supposed to watch him?" Frank said.

I sighed. "I don't know."

Pooch and Cheese got into an armpit-farting contest. Pooch's were louder, but Cheese could make his last longer and do tunes. We threw pine cones at him when he started playing Van Halen.

"Hey, Frankie!" a girl yelled.

We all turned to see Frank's cousins Adelaine and Ronny strolling toward us. Adelaine waved, swinging her waist-length hair behind her. Since the first time I'd seen her at the docks, I'd wished my hair would grow like hers, smooth and shiny and black. Erica still glowered whenever Adelaine walked by, and I wished she went to the same school as us, but even though she had switched schools as many times as Frank, she never came to ours. Ronny followed her wherever she went and usually wore the same clothes. Everyone called them Double Trouble. Today, they both had on ripped sweatshirts over miniskirts, and leggings, frilled socks and Peter Pan boots. Adelaine made it look sexy, and I had a moment of height-envy. Ronny, on the other hand, looked like she'd just graduated from kindergarten.

"My name is Frank, and don't you forget it, Adelaine!"

"I'm shaking," Adelaine said. The style these days was spiral perms and big hair, but I couldn't imagine her in it. Ronny snapped her Hubba Bubba, then chewed it furiously as she asked, "Hey, Frankie, you got any stuff?"

Frank pulled himself straight. "You got me mixed up with Bib."

"Sor-ry. Doesn't he give you free stuff?"

"If he did, I wouldn't give it to you."

"Ex-cuse me for living."

"Knock it off," Adelaine said. She hopped up on the picnic table beside Jimmy, who'd put his homework away when I wasn't watching. Adelaine looked him over. "You're that swimming guy."

"Yowtz," he said, deepening his voice.

She tilted her head. "What's your name, Mr. Fish?"

"Jim."

"So?" Ronny said. "Are we going to find Bib or what?"

Adelaine grinned at Frank. "Does he rise before the sun sets?"

They laughed. She turned to Frank. "I read somewhere that holding your farts in is dangerous. They did this, like, study, and rectal cancer rates were higher in office workers because they always hold them in."

We all stared at her, then everybody howled except Jimmy. He watched her with so much awe, you'd think she was announcing the second coming of Christ.

"Where the hell did you read that?" Frank said.

"It's true," Adelaine insisted.

"It's the toxic waste products from digestion," Jimmy said. "They probably cause cell mutations."

"Hey, Cheese," I said. "You won't have to worry about that, will you?"

"Eat shit and die," he said.

"Don't fart and mutate," I said.

We hung out until the streetlights flickered on, then Adelaine and Ronny left. Frank escorted me and Jimmy home while Pooch and Cheese headed up to the rec centre to see if anything was happening.

"You okay now?" Frank said.

"I think so," I said. "Thanks."

"No problem." He slugged Jimmy in the shoulder and told him to do everything I said. Jimmy and I stood in the driveway and watched him leave.

"You're acting really weird," he said. "Even for you. Did I do something wrong?"

"No," I said.

"What the hell is going on then?"

I gave him a quick, awkward hug and said we should go inside.

He didn't say anything to Mom and Dad. He finished his homework and went to bed. I couldn't sleep, so I snuck over to his room to see if he was smothering to death or something. He lay on his side, frowning, curled around a pillow. When I was sure he was still breathing, I tiptoed away.

By the end of three days, Jimmy was reduced to throwing foot-stomping temper tantrums to get me to leave him alone. The next week I learned that the friend he was supposed to study with had come down with the mumps. His little sister had brought home a friend and she'd given it to half the swim team. The sick swimmers had to miss a meet, and there Jimmy caught the eye of a coach from Vancouver who said he'd be glad to have Jimmy train with him at a summer camp. But I was disgusted. All that fuss and I'd saved my brother from the mumps. The little man, I thought, was losing his touch.

I was watching TV with Dad when a sense of wrongness struck me. Something was missing. I checked around the couch, but couldn't put my finger on the source of my unease. Dad handed me the remote and said that if I was bored of "Wild America," I could change the channel. It hit me then.

"Have you seen Alexis?" I said.

He paused. "Come to think of it, no. Not for a while."

She didn't come home that night or the next. I
made posters and put them up all over the village. Dad
and I checked the pound. I offered a reward in the
newspaper. I walked around the village every night call-
ing her name. As a last resort, Pooch brought his Ouija
board over to Cheese's house and we all sat on the rug
near his bed. I felt kind of silly as we sat across from
each other and put our fingers lightly on the heart-
shaped pointer. One person would ask a question. A
spirit would work to answer your questions by moving
the pointer to the letters or to the numbers or to the
"yes" or the "no" which were printed on the Ouija
board. Cheese said we were wasting our time. Frank
took a drag from his cigarette then told him to shut up.

"Ouija board," Pooch said in a loud ringing voice,
"are you listening to me?"

The pointer moved to "No."

"Very funny," Pooch said, looking at Cheese, then
Frank.

"I didn't move it," Cheese said.

"Me neither," Frank said.

"Who's there? Who's with us?" Pooch said.

The pointer didn't move for a long time. Someone
touched my shoulder. When I looked up, no one was
there. Pooch repeated the question four times before
the board spelled out G-u-e-s-s.

Cheese started laughing.

"Stop screwing around!" Pooch yelled at him.

"It's not me!" he said, trying to be serious, but
spoiling the effect by snickering.

"Spirit," Pooch said, "who are you?"

"D-e-a-d."

Pooch punched Cheese in the arm. "Stop it."

Cheese took his hand off the pointer. "Go ahead. Try it. It's not me!"

Pooch looked exasperated. "Name yourself, spirit. I demand that you reveal your true name!"

Oh, brother, I thought. I'd seen this on one of *The Exorcist* rip-off B-movies on the late show about a week earlier. Cheese rolled his eyes. Frank narrowed his eyes and mouthed something at him and Cheese put his hands back on.

The pointer started to move, and Pooch loudly sucked in his breath.

"J-o-s-h."

"What?" he said, jerking her fingers off the board.

I felt the pointer quiver and stop.

We all looked at each other. Frank dropped his cigarette and hopped up to brush it off when it landed on his pants.

"Josh?" Pooch said, putting her hands back on. "He took her cat?"

The pointer went to "No."

"He killed her cat?"

"No."

"What about Josh?" Frank said.

"B-e-d."

"This is fucked," Cheese said, taking his fingers off the pointer again. He stood beside Frank. Pooch looked confused.

I stared at the board. "Do you know where Alexis is?" I touched the pointer and it moved to the W, O. I thought it was going to stop again, but it moved back to the R, then M.

"'Worm?' What are you trying to say?"

The pointer didn't move for so long that I thought the spirit had left. Then it trembled and spelled out, "Meat."

The room was still. I watched the pointer, mesmerized. As long as I kept my hands on the pointer, it spelled out "M-e-a-t" over and over again. In the distance, I could hear kids shrieking. I lifted my hands and the pointer squeaked to a stop.

Sunlight hit the windows, lighting up the room like spotlights.

"That's the problem with the dead," Pooch said. "They have such a fucked-up sense of humour."

≋

On Valentine's Day, I got three cards. One from the teacher, one from this white girl who gave cards to everyone, and another one that wasn't signed, but had written on the back, "To Lisa, the girl who don't take shit from no one."

Frank's handwriting was unmistakable. No one else had his big, loopy scrawl. I stared at the card. I wanted to stare at Frank, but couldn't bring my eyes up. I could feel him watching me. I put the card with the others then tucked them in my lunch box.

Mom had made me buy a box of chirpy Valentine cards but I'd tossed them in the garbage: I hadn't thought Frank or Cheese or Pooch would take a Valentine the right way. The best way to deal with this, I decided, was to ignore it completely. After all, if Frank had sent it, then he would have signed it. But I

couldn't imagine who else would write that note—if I had a secret admirer, he was doing a damn good job of hiding it. I glanced around the room. Erica sniggered when I looked in her direction. Another possibility was that the card was a joke, purposefully sent to make me think Frank liked me so I'd do something lame and embarrassing. This made sense. I felt a profound sense of relief at having the world settle around me again.

The first real sign of my impending womanhood was that the hair on my legs became thicker. It was so gross, I had to shave it. I snuck one of Dad's razors and hid in my bedroom. I was enthusiastic at first, but dry shaving burnt like heck and the nicks stung worse than paper cuts. I asked Mom how she could stand it, and she clucked over my bandaged legs and gave me quick shaving instructions. Hair appeared a few weeks later in more sensitive spots that I wasn't letting a razor anywhere near.

Most of the girls my age already had their periods. It got them out of gym, especially swimming. Sometimes they even got the day off and just stayed home. I felt cheated that mine was so late, and that I was missing out on skipping school.

Frank became quiet for a while when his voice changed over because Cheese and Pooch would kid him about sounding like Michael Jackson when his voice cracked. He'd nod or shake his head in response and use short sentences. He was immensely proud of his emerging mustache though, and I'd catch him staring at it in window reflections and mirrors. If he saw me watching him, he'd look sheepish. A girl named Julie, who blinked too much and giggled at anything,

began to hang around us at the playground, watching Frank with wide, earnest eyes. He ignored her.

I didn't understand the games the girls played with boys. Watching them disappear behind bushes or chase each other and pretend to give hickeys, or spin bottles at birthdays just didn't make sense. I liked smoking. I liked hanging out and goofing around. The rest of it seemed a waste of time.

≈

Early in the morning, the little man woke me by touching my shoulder. It was just a tiny shock, the kind of thing you get from rubbing your feet across a carpet, but it was a nasty way to wake up. When I stopped swearing, the little man hopped onto my dresser and grinned at me. He hadn't changed, still wore his hair like a troll, sticking up in jagged red tufts. When he did his jig, the bells on his shirt jingled. I threw my pillow at him and screamed, "Get out! Get out of here, you goddamned little bastard!" and kept on screaming until Dad burst into the room holding a bat. By the time he flipped on the light, the little man was gone—blink. Dad was still bleary-eyed from being jolted out of his sleep, and Mom followed, with one of Dad's golf clubs. They were annoyed to no end when I told them it was just a nightmare. But Mom came and patted my knee, then kissed me good night. I lay in bed, afraid to sleep, waiting for disasters.

Without thinking, I went downstairs and put on my coat. I didn't know where I was going. I ended up on the beach. I tucked my knees up and hugged them. I

closed my eyes and listened to the waves as the tide came in.

Dad touched my shoulder, I don't know how much later. He told me Ma-ma-oo had just had a heart attack. I pictured it happening like it was on TV: she clutched her chest, keeled over, and someone gave her mouth-to-mouth and then pounded her chest. In the operating room, a doctor yelled, "Clear!" then applied a defibrillator to her chest. Then the heart monitor beeped and everything was A-OK.

Later, Ma-ma-oo told me she had hopped into her car and driven herself to Emergency. She thought she was having a really bad gas attack and just wanted to get some prescription stomach soothers. Even when they were wheeling her around on a gurney, she said she was more worried about whether or not she'd left the oven on.

Dad had answered the phone. Jimmy said he had talked calmly to the person on the phone, then hung up and phoned Aunt Edith to come baby-sit us while Mom drove them to the hospital. Ma-ma-oo was flown down to Vancouver for further examination. As soon as I heard that, I thought she was going to die. The doctors only flew you down as a last, desperate resort. All the people I'd known who were flown to Vancouver were on their last legs.

Most people only learn about their body when something goes wrong with it. Mom could tell you anything about skin when she got her first deep wrinkle. Dad could talk for hours about the stomach after he got a hiatus hernia. After she had her first attack, Ma-ma-oo read everything she could about the human heart.

The doctors gave her pamphlets, a slew of nurses sat patiently by her bed and drew her pictures of what had gone wrong, and Mom tried to translate the jargon into something that made sense. Ma-ma-oo stared up from her hospital bed, annoyed. She pored over the pamphlets and pictures, listened carefully, but she still looked lost. When she came back to the Kitimat hospital, I would visit her after school, catching the late bus home after we had looked at my picture books describing the heart. Even in the kids' books, the technical words were confusing. We kept having to open up the dictionary, puzzling our way through the multisyllabic words. For a while, I thought we were just gruesomely curious. But when your body is falling apart, and you can't do anything to stop it, there is a grim satisfaction that comes with knowing exactly what is going wrong.

Ma-ma-oo annoyed the doctors. When she stopped feeling dizzy, tired and nauseated, she assumed she was better. She'd casually rip off the monitoring wires and take off for a walk down the hallway. When the nurses ran in, ready to resuscitate her, they'd find her in the TV room, or chatting with other patients. She couldn't endure lying in bed. She insisted on feeding herself the day after her heart attack. She insisted on the nurses leaving the room when she peed. She told them what soap she liked and when she liked to bathe. She woke up at her regular hour of 5 a.m. and did her cross-word puzzles until the nurses came in at 7 a.m. to give her pills, which she would only drink with orange juice. She never yelled or lost her temper, but was unmovable. When lectured, she watched the nurses

with a disdainful expression, and then told them to bugger off.

"She's so Type A," one of them said to me, "it's not funny."

Aunt Kate stayed at Ma-ma-oo's house for the first two weeks she was home. After that, they were yelling at each other so much that Aunt Kate declared that if Ma-ma-oo didn't drop dead of another heart attack, she was going to strangle her.

"Good riddance!" Ma-ma-oo called as Aunt Kate stormed out of her house.

Dad spent that entire night worrying. He drove to her house first thing in the morning, but Ma-ma-oo had locked the doors and pulled all the curtains closed. He sat on the steps until Ma-ma-oo opened the door and invited him in for tea. They agreed that Aunt Kate would come over once a day, and that Ma-ma-oo would call her if she had any pain at all.

I knew she hated people hovering, but it was hard not to twitch whenever her expression changed. Mom had made me memorize all the emergency numbers and we went to a CPR class together. Knowing that I'd have to pound Ma-ma-oo's chest and force air down her throat if she collapsed in front of me was unnerving. She lifted a case of canned salmon once and I watched her with my eyes bugging out. She wasn't supposed to exert herself at all. She wasn't supposed to lift anything. I sat at the edge of my chair, waiting for her to clutch her chest and keel over.

"*Na'*," she said, when she saw me ready to run for the phone. "You and your aunt."

Ma-ma-oo's breath smelled like oolichan grease.

She had two tablespoons of oolichan grease every morning. The doctors had told her that fish oil would be good, and had tried to get her on cod liver and halibut, but she insisted on oolichan. One tablespoon she spread over her toast and the other she simply tipped into her mouth and swallowed. She also took one Aspirin a day, and was told she was very lucky she didn't have to continue taking anything else. She had to carry nitroglycerin just in case, but the medicine cabinet collection of bottles slowly diminished as she recovered.

But of all the things that had changed, Ma-ma-oo mourned her salt the longest. Mom bought her a salt substitute but Ma-ma-oo spat it out as soon as it went in her mouth. I tried it to see if it was really that disgusting and the taste lingered in my mouth for a whole hour, even after I scraped my tongue. When she came back from the grocery store, she had a whole bunch of spices she didn't know how to use. Pepper she knew; thyme and sage were familiar from Thanksgiving turkeys. We spent an hour sniffing and sampling the contents of the spice jars and bags that spent their remaining days in a shoe box in the bottom cupboard beside her potatoes and onions.

After two months of positive results on her tests, Ma-ma-oo was confident she had her health back. Other than the salt, she hadn't had to give much up. One of the dietitians had told her to eat only white meat and fish, but she found chicken and turkey tasteless without gravy. Egg whites she made once, bounced around her plate, then nibbled. "It's like eating rubber," she said. She was supposed to eat more vegetables, and did for a while, but fell back on potatoes,

onions, turnips, carrots and celery. Once, she baked a
squash. But when it came out of the oven, she declared
that it looked like worms, ate a bite, then chucked it.
When she made herself salads, she usually put them in
the fridge until they rotted.

Eating fish was something she did understand,
even though she couldn't fry fish any more. Her fa-
vourite way of baking fish was to use big, thick steaks
covered in onions, which were now also on her forbid-
den list. But whenever I went to her house, I could count
on fish stew, fish casserole, fish cakes, steamed fish,
canned fish and dried fish. If it wasn't salmon, it was
halibut, rock cod, lingcod or the occasional trout.

On one of his visits, Jimmy had decided to intro-
duce Ma-ma-oo to Run DMC. Ma-ma-oo had lis-
tened politely, then told him to shut it off because it
was giving her a headache. "When I was young, every-
one goes listening to cowboy music. Everyone's
singing away about horses and shootouts, and there's
not even a cow for miles around. Now they're all
singing about gangs, all these people shooting each
other, and there's not a city around. You explain
that." We sat at her kitchen table, drinking mint tea
from her chipped mugs.

"I don't like country music either," I said.

Ma-ma-oo offered me a plate of Oreos. I took
three. The fridge rumbled to life, gurgling and chok-
ing. The avocado green clock ticked irregularly. Dad
had given Ma-ma-oo the latest in digital clocks to
replace it, but she hadn't taken it out of the box, saying
that if she had to read a book to make it work, it was too
much trouble—and besides, it was ugly. Ma-ma-oo

slurped her tea. Sometimes her hands would tremble and she'd stare at them.

On good days, we went tromping around the bushes. She said she really wanted to bump around on her boat, get away from the noisy village, but the bouncing made her nauseated now. On bad days like today, we sat in her kitchen and drank tea. At first, I used to fill the silences with chatter. She'd listen and nod. But after a few visits, I realized she was just happy to have me there and I didn't have to entertain her. The silences grew comfortable.

≋

At the end of the school year my marks were horrible, but most of my teachers bumped my marks up to passing, citing extenuating circumstances. I was going to high school. I tried to be excited—only five years left in my sentence.

Jimmy crushed his competition and earned his first swimming scholarship late that spring. It covered all his travel expenses and extra swimming lessons. Mom and Dad threw a surprise party for him and invited his teammates and all the family. Halfway through, Dad proudly read out a letter of commendation that basically said my brother was Canada's brightest hundred-metre butterfly hopeful.

At the end of the year, Frank came up to me at lunchtime. He didn't look at me. He kicked the toe of his boot against the ground. We both watched his boot get scuffed.

"Anyone ask you to grad?" he said.

What a dumb question. "Why? You asking?"

For a moment, I thought he was going to say yes. He opened his mouth, then paused. We stared at each other, and I noticed the scar that cut his left eyebrow in half, how his nose was sunburned, how he was exactly my height and I ended up looking right into his eyes, which were dark, dark brown.

"No way José," he ended up saying. "I'm skipping it."

"Hmm," I said. Hands clammy, mouth dry, I stared off at the playground, unable to say anything. Disappointment hit, then confusion about the disappointment, then I started to sweat.

"See ya," he said.

"Mm-hmm," I said.

He took off running. I sagged against the wall, wiping my hands against my jeans. Jeez, I thought, that was weird.

Frank went to grad, but he walked up with giggling Julie. I walked up with Pooch and Cheese on either arm. Pooch was bored, but Cheese was nervous and sweaty. He held himself slightly away from me, like I was the one who had smelly pits. When it came time to get our pictures done, Cheese snapped my bra strap. So when we posed under the arch made of balloons, in my grad picture, I was hitting Cheese while Pooch stuck his fingers behind my head in a V sign.

We met up a few days later. Frank was wearing a turtleneck even though it was sunny and warm. He said he was meeting Cheese at Sunrise and asked if I wanted to come. I shrugged and said sure. While we waited for the pool table, Cheese said, "Oh, come on. Show us."

I didn't know what he meant until Cheese grabbed

the turtleneck and exposed three large hickeys. Frank flushed dark red.

"Screw off," he said, pushing Cheese away.

"Did you do it?"

"No, we didn't. We just messed around." He glanced at me, then at the floor, then at his hands.

Cheese guffawed. "Oh, yeah, that's all you did."

"Shut up."

"You did it!"

"Cheese," Frank said. "You are such a virgin."

Cheese punched his arm and Frank punched him back and they started wrestling.

"Table's open," I said.

We played pool twice and then I said I had to go help with dinner. Frank said he'd walk with me but Cheese said he wanted to find Pooch.

"You want to split a Popsicle?" Frank said when Cheese was gone.

"Sure."

He didn't say anything on the way and I didn't know what to say. We stopped at the bottom of the front steps. Frank casually leaned against the railing and said, "We're biking across tomorrow."

"For what?"

"Change of scenery."

"When you leaving?"

"Probably noon. You coming?"

"Well, I have to see the queen of England for tea in the morning, but after that I'm free."

He slugged my shoulder and laughed. "See you then."

I slugged his shoulder back. "See you then."

Frank and the guys decided to celebrate the end of school by drinking some beer Frank had stolen from his brother Bib. When I went over to Cheese's, Pooch had fallen asleep on the bed. He was sleeping so hard that the guys thought we should throw water on him to wake him up.

"Jeez," I said. "How much did you guys drink?"

"He only had one can," Frank said.

"Can't handle his drinks," Cheese said, smirking.

I found a bottle of bright red nail polish in the bathroom, took off Pooch's socks and shoes and started colouring his toenails. Frank and Cheese laughed their heads off. It was very relaxing; I realized why Mom liked doing my nails. Pooch, of course, was not impressed. He didn't have any nail polish remover, so spent his spare time over the next few weeks scraping it off with a nail clipper.

≋

Dusk lingers nearly to midnight in the summer. Pooch and I were lying on a patch of grass in the middle of the darkening soccer field. We watched the sky and shared a smoke. Frank and Julie were making out on the bleachers. Her giggles and squeals drifted across the field.

"You ever talk to your dad?" I asked Pooch, handing him the cigarette.

"Lots. He was—"

"No, I mean now."

Pooch sighed. "I tried. It never really worked. Wouldn't know what to say to him anyway. Sorry you offed yourself?"

"Yeah," I said. "I guess I wouldn't know what to say to my uncle either."

"You ever wonder what it's like to die?" he asked, handing the butt back to me.

I sucked in the last bit before the tobacco met the filter. "Ma-ma-oo says you go to the land of the dead." She'd also added that the people who committed suicide were doomed to walk forever between the worlds of the spirits and the living, but I didn't think Pooch needed to hear that.

"I wonder what it's really like." He sat up and shook the empty pack as if that might dislodge a hidden cigarette. "Maybe Frank has some more smokes."

"I think he's busy."

"Hey, Frank! You got any smokes!"

"Shut up!" I hissed.

"No!" Frank yelled back.

"I do!" Julie said. She walked over to us, the top three buttons on her blouse undone and her hair tousled. Frank followed her, scowling. She smiled brightly as she handed Pooch her pack. "What are you guys talking about?"

Pooch looked at me and I looked at him and we said, together, "Nothing."

She giggled. "Or should I say *who* are you talking about?"

"Where's Cheese?" Frank said.

Pooch shrugged.

They went back to the bleachers and Pooch handed me a cigarette. They were icky mentholated ones, but beggars can't be choosers.

Later, Frank asked us why we didn't like Julie.

"She's okay," Pooch said.

"She thinks you hate her."

"Why does she want us to like her?" I said.

"I dunno. Girl stuff, I guess. Just pretend you like her, okay?"

"Man, you are so whipped," Pooch said.

≋

Pooch and I were sitting behind the Sunrise when I was busted. There were a bunch of other kids, too, but they were older and pretended that we weren't there. Pooch bummed a smoke off his cousin and we were sharing it when suddenly Mom said, "Lisamarie Michelle Hill, what the hell do you think you're doing?"

The first thing that popped out of my mouth was, "What the hell does it look like I'm doing?"

Her mouth dropped open. Oops, I thought, just before she grabbed my ear and dragged me to the car. She was too mad to speak. She hauled me to my room, shoved me in and slammed the door. She waited until Dad came home before she came into my room. Her face was pale, her lips thin and bloodless, and she motioned Dad to speak instead of lighting into me first.

"I hear you've started smoking," Dad said.

"A couple of times," I admitted.

"You're way too young."

"Too young?" Mom shouted at Dad. "This is all Mick's fault. I told him not to smoke in front of her. I told him."

"Like Dad's never had a puff."

He glared at me.

"What?" I said.

"You are not smoking again." She then listed off all the reasons smoking was bad. I watched her mouth moving. She finished shouting and wound down with, "Young lady, you are not leaving this room until you promise me you are never smoking again."

"So you want me to lie to you?"

"Lisa!" Dad said.

Over the next few days, she brought home pictures of diseased lungs, people with holes in their necks, statistics on death rates. Every time she did, I wanted to pull out a cigarette and smoke it in front of her.

Finally, at the dinner table, she announced that Dad was going to quit with me. He looked startled and said if he was going off cigarettes, she was damn well going to give up coffee. After that, Jimmy uneasily babbled about swimming until Dad finally said that mouths could also be used for eating. Just before bedtime, Mom caught Dad sneaking a puff, ironically enough, in the smokehouse. After she stomped on his favourite lighter, he went into the house and threw out her favourite coffeepot.

Jimmy took off first thing the next morning and stayed out all day, lingering at his friend's house until well past curfew. Dad savoured his breakfast coffee. He took the longest, slowest sips, letting out little satisfied sighs that Mom grimly ignored as she whipped her milk into the strongest tea she could brew.

Mom drank so many pots of tea, the kettle was never off the stove. Dad took to sucking lollipops, chewing gum and munching candy bars and licorice whips. By the end of the week, he'd gained five pounds

and grumbled that at this rate, in a month he was going to be twice the man he was. Mom cheerfully suggested he take a long walk off the docks.

I was stuck inside during the most beautiful days of August. The sun was gloriously bright and warm, but the wind took the scorch out of the day, and the waves looked so inviting, I wanted to walk right down to the beach and bask in them like an otter. Cheese came by to say hi. We sat on the front porch. Pooch, he said, was unnerved by the way Mom had glared at him and was too chicken to visit. Frank was busy with Julie. Cheese told me about the soccer tournament he'd watched in Terrace and his brother's baby girl puking all over the front seat of his mother's new car. I would have enjoyed his visit more if my head wasn't pounding.

Ma-ma-oo dropped in to take me blueberry picking and Mom explained why I was grounded. Ma-ma-oo looked down at me. I steeled myself for another lecture. "Tobacco was sacred, long time ago. The smoke, it lifted prayers to the gods. These days, it's nothing. It's like candy, hey?"

I said nothing.

She patted my hand. "You come over later. Help me jar blueberries."

I spent an afternoon in my room. Then I went down and told Mom I was going to stop smoking.

"Fine," she said. "Take off. Go."

While I was over at Ma-ma-oo's, Dad came home and caught Mom slurping down a large mug of coffee. He sprinted out to the porch and sucked down half a pack. They both told me separately about the

moment when they looked at each other and started laughing.

"I wanted to marry her all over again," Dad said.

≈

Cheese taught me a couple of chords and I practised them on his bed while we waited for Pooch and Frank to show up. "You want a smoke?" Cheese said. "I got Export A."

After a tempted pause, I said, "No, thanks. I'm trying to quit."

"Want a beer?"

I shook my head, flubbing the fingering again.

"You want some pot?"

I looked up. "I'm fine. You smoke if you want."

"Nah, I'm cool."

"Okay," I said. He sat on the edge of the bed and watched me while I attempted some scales.

"You want to go out with me?" he said.

"Where?"

"Nowhere. You know, going out. Steady. Together."

I burst out laughing, but stopped when he didn't join in. "Are you serious?"

"Why not?"

"Cheese," I stopped, not knowing what to say.

"We could make out in front of Frank and Julie. You could get back at him that way, make him jealous."

I put the guitar down. "Why would I want to do that?"

"Everyone knows you like him."

"Oh, do they?"

"When I asked him if I could go out with you, he got real quiet."

"You asked him before you asked me?"

"Well," Cheese said, finally realizing I was pissed off. "Yeah. He's my friend. But he said I could go out with you if I wanted."

"Oh, how generous of him."

"Look, I can get you anything you want. You just have to ask and I'll—"

"How about shoving your head up your ass? Can you do that?"

"What's your problem?"

"You, fuckwad," I said, then marched out.

Although I wasn't grounded any more, I stayed in my room, not wanting to see anybody. Cheese tried to come over and I slammed the door in his face. Mom raised a questioning eyebrow but didn't say a word. After a few days, she suggested Dad take me with him to Terrace to watch Jimmy compete. I stared out the window of the backseat the whole trip. At the pool, Dad said I could go window-shopping, but that I had to be back at 4:30 on the dot.

Terrace is larger than the Kitimat townsite, and has two malls. Over the years, it has evolved into a crossroads and most people from the area go there to shop, so on weekends the parking lots are plugged and cars circle endlessly in search of a good spot. I considered going to a matinee, but the theatre was only showing some lame kiddie movie. I didn't have any money, and I had no interest in window-shopping. I wandered around the strip between the

malls, wondering what I should do when I saw Erica. I froze, then decided it might be good to have a spat and get it out of my system. But she was walking with her head down and didn't see me as she went by. I noticed a car following her. A young white guy stuck his head out of the passenger's side of the car and invited her in, they'd show her a good time. All three guys in the car were wearing black baseball caps and sunglasses even though it was cloudy. I couldn't tell what colour their hair was, and there was mud all over their licence plates. One of them had a black mustache, but it was obviously fake. Erica turned on her heel and walked back towards me. They pulled a U-turn and the driver called out that he'd teach her how to fuck a white man.

"Yeah?" I yelled out. "With what, you dickless wonder?"

The car stopped ten feet away from me.

"Hey, looky, looky, we got a feisty little squaw on our hands," the driver said.

"Looky, looky" I said. "The dickless wonder can speak. I thought guys like you just grunted."

"You fucking watch your mouth, cunt."

"Yeah, you're so brave with a girl, aren't you, ass-wipe? Can't stand up to someone your own size, can you? Cowards like you gotta pick on girls to feel like men."

"Bitch," he said. "You're begging for it." He opened his door and got out. It was about that time that I realized Erica had buggered off. Everyone else on the street was ignoring us. He came up to me and stared down.

"Yeah, show me what a man you are, dickless. Come on. We'll see how much of a man you are when they stick you in prison for assault and battery. You remember this when you're getting it up your flat ass. We'll see who's the bitch then, won't we?"

I heard the click of the car doors as the other guys got out of the car.

"Now we're going to teach you a lesson," the driver said.

"Just grab her!" the other guy said.

He reached down, but stopped and stared at something behind me. I skipped back. He ignored me.

"Son," a deep voice boomed. "You get in your car and you drive away."

The driver hesitated, then they all scrambled back in and squealed off. I watched them until they burned rubber around a corner and were gone. I turned and a hulking white guy with a long grizzled beard and tattoos up his bare, crossed arms shook his head at me.

"Babydoll," he said. "Take it from someone who knows—that temper of yours is gonna get you killed one day."

He turned and strolled into a tackle store. I started shaking. Erica's older brother, J.J., came tearing around the corner then, followed by six other Haisla guys carrying crowbars and broken bottles.

"You okay?" J.J. panted.

I nodded.

"That was pretty stupid."

I shrugged.

They escorted me back to the pool and J.J. told Dad what had happened.

"Oh my God," Dad said. "Lisa—Lisa, did it occur to you to run into a store? Did it occur to you to call the police? Did you even think about running away? Do you know what they could have done to you?"

"I don't know why you're mad at me." I said. "I'm not the one who was following Erica."

He sat down on the bleacher and put his head in his hands. "We should have never named you after Mick."

≈

It was a bump-around day with our direction depending on the weather and Ma-ma-oo's whim. She had a hankering for halibut so away we went. There were nothing but babies splashing around the dock that early in the morning. The older kids like Erica were too cool to show up until later. The tide was low and you could see all the old tires, cans and discarded clamshells resting on the bottom. The tar-covered poles that held the docks in place were bristling with mussels and barnacles and I scraped a few off as Ma-ma-oo got the speedboat ready to leave. I was standing beside the tow ropes, ready to push off. Ma-ma-oo let me tie up when we docked. I had learned a few knots but I was slow. Since we weren't in any rush, Ma-ma-oo didn't mind.

"Jacket," Ma-ma-oo said, throwing me my orange life preserver.

"You're not wearing one," I pointed out.

"I'm old," she said.

"Does that make you float better?"

"Put it on."

That's what I liked about Ma-ma-oo. Cheeky remarks didn't bother her one bit. Her eyebrow would quirk a little, and sometimes she'd even smile, but she never got mad and sulked at you or told you to stop being a brat.

Ma-ma-oo didn't gun the motor so we puttered along. The day promised to be a scorcher, but out on the ocean with the spray cooling my face and the wind drying it away, the heat was bearable. I wished summer would never end. I wished I could do this all year and never have to go back to school. I wished I could pick berries and go fishing with Ma-ma-oo and spend all my days wandering.

≋

I saw a new black truck when I walked up our driveway. When I stepped into the living room, Josh had his arm around Trudy's shoulders. Apparently, the honeymoon was back on. My parents were laughing and Josh was smiling but Trudy looked mildly annoyed.

"Hey," Josh said. "How's our little Mick?"

"Hi. Where's Tab?"

"Upstairs," Mom said.

Tab was only going to be in Kitamaat for a week, but she didn't seem to mind. She didn't complain about anything. She mostly stayed in my room and snuck cigarettes out my window until Mom discovered she was smoking and asked her to smoke outside. Tab nodded, said sorry and went out to the back porch afterward.

"How come she didn't get the lecture?" I said.

"She's a guest. I'm not about to tell her how to live her life."

"Lucky bum," I said to Tab back in my room.

"I wish I had your mom," Tab said. "She's cool."

"Great. Take her."

"You're lucky. You're really lucky that your dad was too young to go to rez school. And Aunt Kate too, because she was married. Just Mick and my mom went and it fucked them up," Tab said.

"Why?" I said. "What happened?"

"When Ba-ba-oo was kicking Ma-ma-oo around, she sent Uncle Mick and Aunt Trudy away. Mom's mad 'cause she thinks she picked Ba-ba-oo over them. Aunt Kate thinks Ma-ma-oo might have killed Ba-ba-oo after he got carried away."

The whole idea was ludicrous. I couldn't picture Ma-ma-oo letting anyone kick her around and I certainly couldn't see her hurting anyone.

When I awoke early the next morning, the little man darted into my closet and stared at me until I put my bathrobe on and went downstairs to get away from him.

Aunt Trudy was up, even though it was about four-thirty. She sat on the couch and was watching the TV with the volume turned down low. She smiled when she saw me and I went to sit beside her.

"Morning. I heard you never wake up before noon in the summers," she said. "What's wrong?"

"I had a bad dream. What about you?"

"Insomnia. Never been good at sleeping."

We watched TV for about a half-hour. I drowsed, leaning against the arm of the couch.

"Lisa," Aunt Trudy said, "you got to be more careful."

"About what?"

"Those guys would have killed you."

"It was broad daylight," I said. "And there were tons of witnesses. They wouldn't have done anything."

"Honey," she said, "if you were some little white girl, that would be true. But you're a mouthy Indian, and everyone thinks we're born sluts. Those guys would have said you were asking for it and got off scot-free."

"No, they wouldn't."

"Facts of life, girly. There were tons of priests in the residential schools, tons of fucking matrons and helpers that 'helped' themselves to little kids just like you. You look at me and tell me how many of them got away scot-free."

I didn't understand why she was mad at me. I didn't understand why I was the one getting blamed for some assholes acting like assholes.

"Lisa," she said, "no one would have cared. You would have been hurt or dead, and no one would have given a flying fuck." She touched my shoulder. "Except your crazy old aunt, who just about made you cry, didn't I? I'm sorry, honey. I'm sorry. I gotta mouth on me too. Never know when to keep it shut."

≋

I went over to Pooch's house and his gran answered the door. She smiled when she saw me and her gold tooth glittered when she asked if I had eaten. I said yes, but she gave me cookies anyway and sat me at the table

while she went to get Pooch. His oldest brother was sleeping on the couch in front of the TV. He'd been caught doing another B & E in town and was going to be shipped down to Vancouver to go to an experimental camp for young offenders. Pooch was pretty happy about it because his brother always took his allowance. The floors were old wooden planks that squeaked when Pooch came upstairs. He sat opposite me and rubbed his eyes. "God," he said. "What time is it?"

"Almost four."

"You want to go to Cheese's?"

I was still mad at Cheese, but he'd already said he was sorry a couple of times and he hadn't brought up the subject of either Frank or our dating. As Pooch and I walked over to his place, the weather was a mix of muggy sunshine and rain, as if it couldn't decide what it wanted to do so it kept switching back and forth.

"Jesus fucking Christ," Cheese said, pushing me back outside when I knocked on the door. "You're dripping all over the rug. Mom's gonna throw a hairy."

Cheese's mom didn't want us at her house either, so after a short stay in the porch, we were left to wandering. The sun came out, and the wind picked up. As it was a Saturday afternoon, Frank said there was going to be a party at one of the deserted houses up the hill. Until they tore it down, it was a party palace.

"Fucking cool," Cheese said.

The clouds began to break apart. The tilt of the sunlight showed me it was getting late.

Julie was already at the party and she and Frank started making out in a corner. Someone had a tinny little boom box going that squeaked if the singing

got too loud. The rooms of the house were lit with flashlights and candles. I squinted to see if there was anyone I knew around. It was mostly older kids, who were busy gabbing.

"Shit," Pooch said, ducking behind me.

His brother had already spotted him. He casually walked up to us and said, "Hey, little bro. You know the drill. You can walk out or get tossed out."

"Come on," Pooch whined. "I'm fourteen fucking years old."

"Out. Now." His brother grinned at me and lifted his hands. "You, I ain't even touching. I heard you took on some Neo-Nazis."

I snorted. "Nah. Bunch of weenie assholes acting tough."

"That's not fair!" Pooch said as his brother caught him by the collar. Pooch gave a halfhearted kick and then went quietly.

I hung around, but was starting to get bored and was thinking of going home to talk to Tab. I'd been avoiding Aunt Trudy all day, but I missed Tab.

"Hey," Cheese said, emerging from the shadows, holding out a beer to me. "No hard feelings?"

I didn't really like beer, but I took a sip to show I wasn't mad any more.

He started complaining about his mother taking away his guitar. She'd found some pot in his room and he was supposed to be grounded, but he'd snuck out. Then he looked around and said, "Kind of a boring party."

"Yeah."

"You staying?" he said.

"For a bit. Where . . . " I stopped, dizzy for a
moment. I lost what I was going to say.

"How you doing?"

"Tired. Woke up too early, I guess."

"See you tomorrow?"

"Yeah. See you."

He went back the way he'd come, chatting to some
other people. I headed for the front door, walked
down the slanted steps, holding on to the rail. I'd had
a bad ear infection once, and every time I had stood
up, I felt the way I was feeling right now.

The long blank spots start then. Chunks of mem-
ory are gone. I have a piece of it where I'm halfway
down a hill, but I can't figure out if I wanted to go up
the hill or down it. The bushes moved, and I was
fuzzily alarmed. The next piece I have, I'm lying on the
ground and I can't see the sky because of the tree
branches. I'm cold and someone is breathing over me.
The last piece is pain between my legs, and a body on
top of me, panting. We're moving together as if we
were lovers, and the rocks and twigs are digging into
my back. I open my mouth and a hand covers it. I can't
see the face. It has the feeling of a dream, as if it didn't
happen to me. I remember fighting sleep, thinking I
had to stay awake, but I couldn't.

≈

"Lisa?" Tab whispered as I tried to sneak into my room.

"Shh," I said. "What time is it?"

"Two-thirty. Don't worry. I covered for you. Your
parents think you've been here all night."

I felt my way to the bed and sat down. I heard the blankets rustle. Tab leaned in close and I flinched.

"What happened?" she said.

I couldn't think of anything. I didn't want to talk about it. I wanted to crawl into bed and sleep, but now that I was awake I felt like throwing up. My temples throbbed and my mouth was dry. I ached.

"You got your period?" Tab said. "I'll get you a hot-water bottle. That always helps me."

While she was downstairs, the little man appeared on my dresser like he used to. Tab had left the door open and by the hallway light, I could see him clearly. He dropped to the floor and stared at me. His eyes were red-brown. His eyebrows were mossy green. His face was different this time, was grey-brown and dry like cedar bark. Ants skittered between the cracks in his skin.

"If you couldn't stop it," I said, "what good are you?"

His eyes glittered as he watched me.

"Don't bother coming again," I said.

He reached out to touch my hair, just for a second, and then he was gone.

≋

"Lisa."

I couldn't tell where the voice was coming from. It bounced off the mountains and echoed. The rain started again, drops that bent the leaves and needles in the trees around me. Hairs prickled my arms. I gripped my plastic bag that was filled with the clothes I'd been wearing that night.

"Lisa." It was fainter, and I wondered if Dad was calling me from the house, and that was what I was hearing.

Something came slithering in my direction, a heavy weight being dragged through the undergrowth somewhere close. In the distance, I heard a crow. It was joined by another crow, and another until it sounded like there were hundreds of crows cawing. Then, as I was near the trail, I heard the same slither. There aren't many snakes around Kitamaat, just the little green-and-brown garden snakes. They're shy, though, and you rarely see them, except on the road if a car runs them over. I breathed through my mouth, curious, not moving in case I frightened it.

I waited like that for maybe a minute before it moved again. Soft, clicking sounds came from a bush not more than two metres away from me. I thought, No, it must be a grouse, and I waited for it to thump its chest. The slither came closer, the sound low to the ground. Could be a porcupine, I told myself. Porcupines can move fast, and they do click, but this click was different. I moved slowly towards the bush and pushed them aside.

There was nothing weird about the crab, except that it was up in a bush. It raised its claws, turning around to face me. It was a good-sized Dungess.

I backed away. The crab turned, skittered sideways into a clearing, past a stump towards the trees in the centre. I wasn't sure if I should follow it or not. The wind shifted and I had to cover my mouth because I smelled the fermented aroma of old meat left in the garbage, of something gone bad in the fridge. On the

other side of the trees, I saw a rusty oil barrel. The crab had stopped beside it, barely ten feet away. I could almost see inside. Six crows sitting on the lip of the barrel lifted into the air as I walked towards them. The smell was strongest there, and normally I would have puked. Instead, I took the lighter fluid out of my jacket pocket and just as I was going to toss my clothes in the barrel, I saw one tiny grey corpse of what was once a kitten, or maybe a puppy, shriveled against the scratched-up side of the barrel.

"Lisa!" a voice said from somewhere inside the forest.

I turned my head. I expected to see a person but there was nothing but trees. The crows launched themselves upward in a flurry of wings. I became aware of whistles, high and piercing. They were in the trees. Some were musical, like flutes. Others played long, continuous shrieks.

"Who are you?" I yelled.

"Guess."

"Quit screwing around! Who are you?"

A different voice, barely a whisper, said, "We can hurt him for you."

"Yes," a chorus of other voices said, "Yes, yes, let us, yes."

When I said nothing, there was giggling from the trees.

I looked down at my plastic bag. I didn't want any witnesses. I didn't want any reminders. For a moment, I thought I saw Cheese at the edge of the clearing, but when I turned my head, it was only a piece of cloth caught in some tree branches.

"Bring us meat," the first voice whispered. "And we'll hurt him."

It's your overactive imagination, I told myself. No one's in the trees. You are alone. The voices hissed into silence. I turned the barrel over and the bugs underneath skittered and squirmed away from the rain. The tiny corpse rolled out of the barrel and landed with a thump in the wet grass. I righted the barrel, put my clothes in, squirted them with lighter fluid, then set them on fire. I watched them writhe and shrivel. I wished he would burn. I wished him pain and unending agony. Then I dug a little grave for the dead animal, wiped my hands on my jeans and left.

≈

I tilted my head and my reflection in the bathroom mirror stared back at me quizzically. I couldn't put my finger on what had changed. Maybe it was because I had bed head. I combed my hair out until the spikes stood straight up again. Maybe it was just fatigue. I'd had strange dreams all night.

"Lisa!" Mom called out from downstairs. "You have company."

She was at the door, standing between me and Frank. "We're taking Trudy and Tab to the farmer's market today, Lisa," she reminded. "You have five minutes, then I want you to get ready. No dawdling."

"Okay," I said. I smiled at Frank. "Hi."

"Hi," he said.

"Five minutes," Mom said as she walked into the kitchen.

"I heard you," I said. I stepped onto the porch.

Frank studied me as I stood beside him. He walked down the steps and I followed him and we sat on the bottom one. He held out a cigarette for me. I took it. He lit it, then shook out his match. "Cheese told me last night you guys are going out. He said you guys did it."

"Yeah?" I said. I put my cigarette against my lips and I slowly inhaled. "Did you believe him?"

"I don't see why he'd lie."

"Cheese said you told him to go ahead and fuck me."

"What?"

"Did you?"

His mouth opened and closed as if he was a goldfish.

"Cheese lies, Frank. He lies and he's mean. Tell him if he comes near me again, I'm going to kill him."

"Lisa," Mom yelled. "We have to get ready."

"Bye, Frank," I said.

≋

On the first anniversary of Mick's death, Ma-ma-oo took me to the Kitlope to pick $ci'x^{o}a$. The first night of our trip, we stayed in the Kemano fishing village. The yellow light of the fire shone through the crack in the wood stove's door. I was glad we were sleeping beside it.

When I awoke, Ma-ma-oo was gone. I sat up quickly, wondering if she was all right. I had visions of her tumbling down the steps, unconscious in the outhouse, slumped over the boat. But when I stood at the porch, I saw her sitting farther down the beach. She

turned and motioned me to come sit beside her. "Over there," she called. "Look."

A single black dot broke the surface of the water and a curious head watched us. The seal ducked under, sending ripples through the flat water. We watched to see where it would come up. A raven made a trilling, bubbling sound somewhere in the trees behind us.

"You hear that?" Ma-ma-oo said as I came to sit beside her. "That's a good sign. Good day today. Any other call but that one would be a bad sign."

I was still watching the water, but the seal never resurfaced.

Near noon, we stopped at an old logjam near the beach. I finished my sandwich in four gulps, then flopped on the ground and stared up at the trees. Ma-ma-oo forced down half her sandwich, then asked if I wanted the rest.

The wild crabapples grow on trees at the bend in the river there. I reached up into the tangled grey branches for the hard little apples. She pointed out thick patches. I dropped them down and she put them in a bucket.

The second night, we set up camp on the same sandy beach where I'd seen the great blue heron. Ma-ma-oo made corned beef hash but rubbed her stomach, saying she'd had too many $ci'x^0a$ and gave me more than my share.

This time, I curled into her before she fell asleep. Her hands were cold. I shivered when she touched me, and she pulled the blankets over us. It reminded me of the last time, when we set out the tent and Mick was on one side of me and Mom on the other.

I was startled awake by the sound of footsteps crunching across the sand towards us.

"Ma-ma-oo," I whispered.

The footsteps stopped a few feet away from me. I shook Ma-ma-oo's shoulder and she grunted, unwilling to wake up. I turned my head slowly, but nothing and no one was there. As I was pulling the sleeping bag over my head, something bright streaked across the sky. I paused. The clouds had cleared, the moon was down, and the stars shone hard and unwinking white against the late-night sky. Another frantic streak seared its afterimage against the darkness. I closed my eyes and made a wish. When I opened my eyes, three falling stars, one after another, raced each other across the tops of the mountains. The frequency built until the sky was lit by silent fireworks.

When we got back to Kitamaat, I told Ma-ma-oo about the footsteps on the beach. She raised an eyebrow at me. "You don't have to be scared of things you don't understand. They're just ghosts."

≋

When I dreamed, I could see things in double exposure—the real world, and beyond it, the same world, but whole, with no clear-cuts, no pollution, no boats, no cars, no planes. Whales rolled in and out of the water, and not just orcas either. Some of them were large, dark grey whales. Some of them were smaller and black. Hundreds of birds I'd never seen before squawked and chirped in the air, on the beaches, in the trees. Later, in the spring, the beaches were white

with herring eggs. Oolichans came next, filling the rivers so full with their shiny, shimmering bodies that I was sure I could cross it and not get my feet wet.

I began sleepwalking and, Mom and Dad told me, I sometimes picked things up, stared at them, put them down or walked in circles. I awoke from one of my wanderings to find Erica and Aunt Kate leading me home.

"Oh," I said. "Hi."

"Hi," Erica said. "Are you okay?"

"Yes. Yes, I'm fine. Hello, Aunt Kate."

She put an arm around my shoulder. "Hello yourself. We almost hit you, you know. You walked right in front of our car."

"Did you?" I looked around but couldn't see their car. "Where did you park?"

"Near the bay. Does your mom know where you are?"

I blinked, dizzy and cold and still not focusing on them. "I think so."

"Let's get you home anyway."

"Oh, look. Is there a party going on?"

"What?" Erica said.

"All those people are going into that house. I don't recognize any of them."

"I think she's still sleeping," Aunt Kate said.

"No," I said, realizing that the people were ghosts. "They must be an escort. Someone in that house is going to die."

"She's sleeping," Erica said.

Mom and Dad brought me to the hospital to find out what was wrong. The doctors did test after test, but

couldn't find anything. I was watching a nurse line up bottles that I realized would have to be filled with my blood, and as soon as the nurse picked out the needle, I left. There was no way I was staying around for that. The hallways were filled with ghosts. They stood watch over their families. Some of them watched me with strange, sad eyes. When I came back to my body, the nurse had called the doctor and they were watching me curiously. They said I had been walking around and around the bed.

The doctor took Mom and Dad into a separate room and they talked for a long time. I stayed in my body while the nurse took my spinal fluid. I squeezed my eyes closed and thought about going out on the boat with Ma-ma-oo.

Pooch knocked on the door when the nurse left. "Hey, heard you were in for some tests."

"Hi," I said. "What are you doing here?"

"My gran's getting some tests too. She's just down the hall."

"Is she all right?"

He nodded. "Are you?"

"Yup. Healthy as a horse."

He sat beside me on the bed. "I was talking to Frank the other night."

"Oh."

"Did you guys get in a fight or something?"

I frowned. "I guess."

"He's pretty mad at Cheese. I couldn't get him to say why. Gave him a black eye and a fat lip. Isn't talking to him. Won't talk about you. What happened?"

I picked at a loose thread on my jacket. "Nothing."

Pooch rolled his eyes. "God. That's exactly what he said. Is it something Cheese said?"

"Yeah."

"Well," Pooch said. "He can be an asshole. Just ignore it. Frank and me are going to a party tomorrow. You want to come?"

I shook my head. "Can't."

He patted my shoulder. "I gotta get back to Gran. See you."

When we got home, Mom gave me cookies and a blanket and let me watch TV until I fell asleep. Dad woke me up later and said I should get to bed. He tucked me in, kissed my forehead.

"No sleepwalking," he said.

"No sleepwalking," I agreed.

≋

Look closely at the skin on your wrist. The blue lines are arteries. They are blue because they carry oxygen. If you pinch off one of these arteries, your hand will tingle. You have blocked the artery and your muscles are starving for oxygen, giving you pins and needles. If you climbed Mount Everest and got frostbite on your hands, they would turn black and die. Among other things, the arteries to your hands could no longer supply blood to the muscles because they would be blocked. The amount of damage would depend on the severity of the freezing or blockage.

When oxygen-rich blood is pumped out of the heart to the body, it travels up through a large tube called the aorta. The heart feeds itself through two

large arteries that come off the aorta and fork down like lightning over the heart muscle. If the arteries are narrowed with plaque deposits, your heart will tingle. These unpleasant pins and needles in your chest are episodes of *angina pectoris*, often shortened to angina. If the plaque breaks off and blocks the arteries that send blood to your heart muscle, your heart will starve. This is a heart attack.

All heart attacks cause damage to your heart muscle. The severity of the attack depends on where your artery is blocked. If one of the smaller branches is blocked, you will have a tiny heart attack. If a main branch is blocked, you will have a severe heart attack.

≋

Skinny Point is one and a half kilometres north of Monkey Beach. The tides are strong, and mix everything up, so the five families that used to winter here could fish just in the bay and get both halibut and cod. If I was going to stay the night, I'd go to the house near the beach, a triangular building set back in the trees. The beach is rocky, and sea gulls squall over resting spots. A brown seal barks, lifts its head and wriggles, arguing with its neighbour. I move away from the shore so my propellers won't get caught in the kelp.

The creek to the left of the house leads up to a lake, where there was the last official sighting of a sasquatch. Or, at least, trappers had found a footprint in the mud, as long as the stock of their rifle. Ma-ma-oo said the two men who saw it are still alive. I'm sure she said they saw it.

≋

On a typical morning, Jimmy and Dad would sit up front and talk basketball, and I'd try to sleep in the backseat but would end up listening to the radio. Dad was lucky enough to get on the morning shift, so Jimmy's swimming practice fit right in with his work schedule. At the pool, he would stay for a while and watch Jimmy do laps and exercises. I hated the smell of chlorine, the moist heat of the change rooms and the eerie way sound echoed off the ceilings and walls. The whole place made me claustrophobic. But Jimmy's long brown arms would lift and fall as smooth and fast as a waterwheel. When Jimmy went to meets, my ears would ring with Dad's shouts for hours. But on those early mornings, he would sit with his coffee between his hands, not moving at all, just watching Jimmy. Sometimes I would sit beside him. Most times, I would wait in the car for him to drive me to school. He would be quiet afterward, as if he'd just got out of church.

He never talked about it. I think he was afraid to jinx it. Jimmy in the Olympics. He grinned sideways when anyone mentioned it.

On the second day of grade eight at lunchtime, I saw Frank for the first time since we'd talked on the bottom steps. He didn't look at me. He was hanging around with a group of older boys and none of them would deign to look me. I told myself it didn't matter.

Erica was completely unsympathetic. "I can't believe you were friends with him. He's a psycho hosebag."

It was hard not to feel dumb for having liked him. I kept walking and pretended not to see him either.

THE SONG OF YOUR BREATH

≋

Soapberries don't grow around Kitimat. If you want them, you have to trade for them. They look like cranberries, but can be squashed and whipped into a foam—Indian ice cream, *uh's* in Haisla—which is mildly sweet but with a bitter, bitter aftertaste that takes some getting used to. Ma-ma-oo added a banana to hers to take some of the bitterness away, but the taste still made my eyes water. She'd brought back from Vancouver a case of soapberries that she'd traded for her oolichan grease, but otherwise she refused to talk about her trip. She had new medication, but as far as she was concerned, it had been a waste of time, she was healed.

I wasn't a big fan of *uh's*. But Ma-ma-oo had whipped up a big bowl the night she came back, and I hated to insult her when she was already grouchy. She spooned a generous helping of *uh's* into my bowl. The texture was slippery and oily. I shoveled them down to be done as quickly as possible. I'd never actually finished a whole bowl before.

"Good, hey?" she said, pleased with the way I'd demolished her dish.

I nodded. She picked up my bowl, but instead of putting it in the sink, added some more *uh's*. I kept smiling. I had no idea how I was going to finish it. Ma-ma-oo practically licked her bowl clean. She waited for me to finish, sipping her tea. I hoped she would go to the bathroom, so I could pour it down the sink, but she sat and looked mildly into the distance. I made my way through the second bowl. I ate slower. Ma-ma-oo

patted my hand. "We have enough for the whole win-
ter," she said.

"Oh, good," I said.

By the end of the week, I had become used to the
taste. I didn't even notice the bitterness any more. It
was like whipped cream, but not as nauseatingly sweet
as the canned stuff Mom bought.

"What was Ba-ba-oo like?" I asked, sitting beside
Ma-ma-oo on the couch.

She shrugged. "Sherman was a good man."

"When did you fall in love with him?"

She brushed the hair from my face. "He was thir-
teen, maybe fourteen. Your age."

"You don't remember?"

"It was a long time ago."

Mom phoned and said it was time to come home.
As I walked in the front door, she was in the hallway,
smiling. She sat me down at the kitchen table where
Dad was waiting. In cautious, practised calm, they told
me I had an appointment at the hospital. Everything I
told the shrink, they assured me, would be in complete
confidence.

Mom picked me up after school, and we went to the
hospital and waited in a bare, green room. Ms. Jenkins
came out and shook Mom's hand, then introduced
herself to me. She looked more frazzled than I did,
although I suppose I got that impression mostly from
her hair, which frizzed free of the two gold barrettes
on either side of her head. What I tried not to focus on
was the thing that was beside her, whispering in her
ear. It had no flesh, just tight, thin skin over bones. Its
fingers sank into her arms, its legs wrapped around

her waist as it clung to her like a baby. When Ms. Jenkins shook my hand, I caught a bit of what it was saying to her. " . . . screws her? Do you think he thinks of you? When he puts his hand on your thigh, does he imagine hers? Is he—"

"Mom?" I said.

"It's okay, Lisa," Mom said. "You don't have to be nervous. Go on."

"Please," Ms. Jenkins said, closing the door behind her as she gestured for me to sit. "Call me Doris."

I lowered myself slowly into a chair, and Ms. Jenkins sat across from me, so close that I could see the thing's tongue sliding over her neck. I answered her questions quickly, wanting the hour to be over, wanting to stick my fingers in my ears and not listen to its whisperings.

"Do you think," she asked me halfway through our first and last session, "that maybe these ghosts you dream about aren't really ghosts, but are your attempt to deal with death?"

"No," I said.

Her wide, blue eyes fixed on me. "Then you believe ghosts exist?"

"Yes," I said.

It turned its bony head to study me. The room was still and warm. The air conditioning in the hospital wasn't working very well. Sunlight glinted in Ms. Jenkins's hair, the colour of the highlights fascinating— a tawny-gold, a light red, deep eggplant. "Are you sure?"

The thing unwrapped its arms from Ms. Jenkins and drifted across the room, hovering over me. It hummed like a high-tension wire.

"Yes," my mouth moving by itself, my body not moving at all. I couldn't take my eyes from it.

"Why?"

The thing bent its head, its lips near my ear. "For attention, I guess."

"Good, this is good, Lisa."

Its touch was like a breeze on wet skin. The air changed, became the way air is before a thunderstorm. While the thing was feeding, I kept seeing Mick's body as Dad pulled it into the boat, Mick's empty eye sockets in his lipless face, the fishing net embedded in his skin. Words came out of my mouth, ones the thing knew Ms. Jenkins wanted to hear, but I was drowning. I yanked myself away, and the thing fled back to Ms. Jenkins. My heart trip-hammered. I felt glued to the chair, heavy, lethargic.

"Lisa," Ms. Jenkins said quietly, "I think this was a very good session. I'm sure that with a little work, you'll be back to normal in no time. I'm glad we had this talk."

My lips smiled. "Thank you. I feel a hundred times better."

While Mom and Ms. Jenkins talked in the other room, I touched my face where the thing had touched me. It was numb, like I'd had a shot of Novocaine.

Snow stopped falling after midnight and I was doing English homework when the numbness wore off. Only me and a couple of yappy dogs were awake. I could hear them fighting over garbage cans in the street outside. I stood, went to the window and rubbed my temples where a headache was arching all the way back to my neck. A full moon poked out from behind

the clouds. The brighter stars shone in the blue-black sky. The ocean glistened like crumpled aluminum. I leaned my forehead against the window, and my breath steamed the glass. I knew it was wrong to want the thing to feed on me again, I knew it was bad. But without it, the night was long and empty and endless.

≋

Heartbreak happens when less than 40 per cent of the heart is damaged. Blood pressure may be preserved, but the left ventricle cannot cope with all the blood returning to it and the lungs become congested. Medical treatment can usually correct the situation. If the muscle of the heart becomes too weak, blood forces its way through the wall into the pericardium or through the septum between the two ventricles. Both these forms of cardiac rupture are usually fatal very quickly, but occasionally can be repaired surgically.

If too much of the heart is damaged, there is usually not enough pumping power left to maintain the circulation. Shock sets in: the patient becomes pale, cold and sometimes blue, and is mentally confused. Death often follows within the next few hours.

≋

The motor sputters. I snap back to attention and stop the boat. I've almost let the tank run dry. I shake it and hear dribbles swishing around the bottom. Stupid thing to do, I tell myself. I'm near Monkey Beach, but still too far to get there by paddling, especially against

the tide. I pour gas into the tank, crossing my fingers against any air bubbles.

With the first three yanks, nothing happens.

"Shit," I say. "Shit, shit, shit."

On the fourth yank, the motor grumbles, then it surges to life on the fifth and I start off slowly, waiting for a telltale sign that I've screwed up. Going slowly keeps me in the same spot. I gun the motor and crawl forward. In moments like this I wish I had a thirty-footer with two 115-horsepower engines ripping me through the water. A cover would be nice too. Then I wouldn't have to stop and bail. The waves are less high, but the rain is still coming down in slightly less than biblical proportions.

Rounding the point, I check my watch. Almost time for lunch. Aunt Edith will be cooking something. She'll put it in the fridge, ready to frown at me when I get back for wasting a good meal. I pull out some crackers and cram a handful into my mouth to settle my stomach.

On my side of the channel, coming up, is *Gee Quans*, which means "pushed-out point." Lazy, shape-changing Weegit, the raven, was tired of paddling around the mountain on his way to Kitamaat and in a fit of energy, he tried to push the mountain down to create a shortcut. Halfway through, he took a break and never finished the job. *Na-ka-too* is on the opposite side of the channel. The two Haisla families who lived there used to play a game, *na-ka-too*, in which they would challenge each other to see who could bend a sapling the farthest. If I had more time, I would stop there. The beach still has sections of gravel ramps

among the rocks that were used as canoe launches, and are perfect for pushing a speedboat up when you land.

≋

Grade eight had been a less than stellar academic year for me. Grade nine was worse. When I was going in to grade ten, Mom and Dad got the note from school suggesting I'd be better suited to the pace of modified classes. They sat me down in the living room, both wearing the same grim expression. They were sitting on the sofa. I hunched into the armchair, waiting for the lecture to start.

"It may seem fun now," Dad said, "but believe you me, it'll be a different story when you're trying to get into university."

"Look, it's not like I flunked. I'm still going to school. Pooch has to repeat grade nine and no one is—"

"I don't care what Pooch is doing or is not doing," Dad said.

"This is about you," Mom added. "Don't try to wriggle your way out of this one. You have to think about your future. This is important, Lisa."

"I have been thinking about it. I'm going to work in the cannery with Tab," I said. "You don't even need a high school diploma to do that."

That made them pause. Dad's face went ashen, then blood rose up from his neck straight to his fore-head. "Have you completely lost your mind?"

"Over my dead body," Mom said.

"What?" I said. "It's good money."

Mom snapped, "That's not the point—"

"I want to work in the cannery. You said you'll be happy if I just get a job I like. I'm doing it."

They exchanged frustrated looks.

"Lisa," Mom started, but she was gritting her teeth so hard that she had to stop. Then she added, "You could be anything you wanted, if you just try—"

"I am trying!"

"You're goofing off!"

I dropped my head and stared at my feet. It didn't matter what I said. I didn't think it was such a big deal. It wasn't like I was going to sponge off them, I was going to pull my own weight. In fact, I was going to be giving them a break. With me gone, they could devote everything to Jimmy's swimming. I'd go my way and they'd go theirs.

" . . . listening? Lisamarie Michelle Hill, you look at me," Dad said. "Look at me."

They went on for another half-hour about how I could be a doctor or lawyer or whatever I wanted, then they sent me to my room to think about it.

Erica threw her head back and laughed when I told her I was going to work in the cannery. "You'd last an hour," she said.

"I would not," I said. "I'm tough."

"You've never even been near a cannery."

"Have too."

"When?"

"Last year."

"That doesn't count, that was a museum."

"It does too count."

"You can't even stand the smell of outhouses." She shook her head. "I'll believe it when I see it."

Ma-ma-oo wasn't much help either. "I remember your mom's first day. She put on her fanciest boots and her best lipstick and curled her hair. She was just supposed to be a washer, but she looked like a movie star. All the other girls had on gumboots and old jeans. Then Dan Thompson said, 'Hey, Gladys, are you going to kiss the fish?' and she was so mad that she didn't talk to him for years."

"Mom worked in the cannery?"

"Mmm," Ma-ma-oo said, pouring herself some more tea. She poured it into a saucer, then used the saucer as a bowl, tilting it into her mouth and sipping tea like soup. "For a week, I think." Mick worked there too, she said. He had a boat from the company that Ba-ba-oo helped him rent. Mick hated working for the company because he wasn't making any money—it was all going to the boat and fees—and he wanted to quit but Ba-ba-oo wouldn't let him. In the end, Mick took off, leaving for his career as an A.I.M. activist.

The more I thought about it, the more I was certain that it was what I wanted to do. Sure, when I first said it I was just talking, but the idea of being free appealed to me. I knew I could do it. I'd be sixteen in six months and could do what I damn well pleased, and no one could tell me otherwise.

I met up with Erica at the rec centre. We went to the official party at Toodley's house, her sweet sixteen, with all the balloons and sappy cards and fluffy-looking cakes a mother could want. It mellowed out after eight. The real party was by the pumphouse at Walth Creek. I'd heard it was going to be rocking and frantic because there were a couple of soccer teams in

the village, but most of the players ended up in town and there were only ten of us. I was stuck on one of the picnic tables with Erica. She was dating this guy named Chuck, had heard he was seeing some other girl on the side and she was getting weepy. I wanted to tell her to go bust Chuck's ass, but she was welling up and I knew she was going to have a crying jag. She stopped mid-sentence, eyes blinking the tears back, staring at something behind me.

Everyone knew Adelaine Jones, if only by reputation. She was gorgeous. She still wore her hair down to her waist, but she'd filled out since the start of summer and looked years older than fourteen. Wow, I thought, staring enviously, it was as if she'd had expensive plastic surgery to look like a Playboy bunny. Pooch, who was her cousin, told me she'd got the nickname Karaoke last year after she hijacked the machine at the bar and his older brother had to stop her from killing the bouncer who tried to throw her out. Now she walked around the picnic area with biker-wannabe Ronny, all attitude and sneers, and stared around like she was daring you to say something. This seemed to have an energizing effect on the guys, who flocked to her and argued over who was going to get her drinks or something to eat.

As the night wore on, Toodley took offence at being ignored by her boyfriend, who was trying to give Karaoke his phone number. Toodley was a heavy girl with a big mane of spiral-permed hair. She called Karaoke a slut, pushing herself against the taller girl until they were almost nose to nose. Instead of trading insults, Karaoke lifted two fingers and casually poked

Toodley's eyes. She squealed and clutched her face and fell to the ground. Her boyfriend slapped Karaoke, who slapped him back. He was about to shout at her, when she punched him in the kidneys. While he was bent over, she grabbed a fistful of his hair, forced his head farther down and kneed him in the face. His nose snapped with a delicate crunching sound.

"Holy shit," someone said.

"Let's go," one of Karaoke's friends said.

Karaoke paused, gave us a sweeping glance. She watched the couple rolling around on the ground for a moment, then turned and left.

"And she's the quiet one in our family," Pooch said, coming up behind me and Erica.

"I heard she was in juvie for kicking the shit out of some girl in the Tamitik," Erica said.

"They couldn't make it stick," Pooch said. "The girl wouldn't testify."

"Then where's she been for the last couple of months?"

"Vancouver, I think, with some guy," Pooch said.

I sipped my beer and watched Karaoke's victims haul themselves up and stagger to the road.

A few weeks earlier, Jimmy had had his fourteenth birthday party early so he could go to a meet. He'd invited his first girlfriend, Annabella, an Italian girl with large blue eyes and curly black hair who was the twin sister of one of Jimmy's teammates. She'd been chasing him through all of grade eight. Not once at the party, even while Jimmy was blowing out his birthday candles, did she let go of his hand. She couldn't stop staring at him, as if he was the only boy

who existed. Some of the girls had muttered among themselves—when they thought no one was listening—that Jimmy should be dating someone from the village, sneering at Annabella when my brother wasn't looking, but adopting dewy, helpless expressions when he was. Jimmy had worn a glazed, mildly overwhelmed expression until he'd opened his presents. The problems of the beautiful and the popular, I thought, rolling my eyes.

Erica and I were partners in home ec, and she took this opportunity to regale me with sob stories about being in love with two guys at once, not knowing which of her friends to take to Prince Rupert for the All-Native basketball tournament, and—my favourite—hairdo horror stories. While describing the worst perm she'd ever had, she put one cup of baking soda in the blueberry muffins instead of flour. She reached the part where she was hissy-fitting at the hairdresser, who'd refused to give her a refund, when we both heard a loud banging. Each of the twelve muffins had exploded and the batter caught fire, setting off the fire alarm.

The day after the party at the pumphouse, home ec had soufflé on the menu. Lue Ann yelled out that we should call the bomb squad.

"Oh, ha ha," Erica said.

One of the secretaries' voices came over the P.A. system, "Could Lisamarie Hill please report to the principal's office. Lisa Hill." There were giggles and fake concern that I was in trouble. I ran through a list of all the things I might be in trouble for, but I hadn't done anything that week.

Mom was waiting for me in the principal's office. She blinked too fast, nervously moving her clutch purse back and forth.

"Ma-ma-oo had a stroke," Mom said. "Do you want to get anything before we go to the hospital?"

Until that moment, I had never appreciated the little man. This is, I thought, what it's like for everybody else. Hello, it's bad news. Bam. I couldn't grasp it; my head wouldn't wrap around it. "Are you sure?"

"Yes," Mom said. "The doctors say it was a small one. We caught it early. Everything's going to be fine, Lisa."

The hallways were empty and my footsteps against the linoleum were strangely slow. It was hard to catch my breath. Opening the office door was like moving through water, so slow and odd to see my hand in front of me, pushing against the handle, and to notice the nails bitten down to the quick, the three scars on my left hand from fighting with Alexis, the way the knuckles looked huge and too big for my fingers.

Knowing what to expect helped, but not much. We didn't see Ma-ma-oo until the next day, and then only for a few minutes. She waved a disgusted hand at all the tubes and needles and said she wanted them to take a few out so she'd feel less like a pincushion.

My teachers waived my tests and based my marks on the schoolwork I'd done over the year. Erica and I flunked home ec. My teacher offered us a chance to bake a lasagna or a dessert to make up for the sections we'd bombed on. We chose the lasagna and still flunked. I told Ma-ma-oo this, and she said I'd better find a rich husband. She was spunky that day, had

bounced back in record time, much to the relief of the nurses, who said she hadn't changed.

She was allowed back home eight days before Christmas. I packed my things and slept on her couch while Aunt Kate slept upstairs.

For Christmas dinner, we had a skinless turkey. On Boxing Day, Ma-ma-oo insisted on two large Ziploc bags of frozen *uh-unt*, herring roe. It was laid on branches, not on kelp, which was Ma-ma-oo's favourite type of *uh-unt*, but she said that eating *uh-unt* would make it worth putting her teeth in and had me go the bathroom to get her partial. She didn't put them in that much these days, because she said they grated against her gums.

Ma-ma-oo wanted bacon in her *uh-unt*, but Dad rolled his eyes and said oolichan grease was enough. Ma-ma-oo wanted soy sauce and Dad handed her the light soy sauce, which made her grimace. When Dad wasn't looking, Ma-ma-oo snuck the salt shaker and dumped at least two teaspoons in her bowl. She gave me a look that meant "Don't say anything," and seemed so happy at outsmarting Dad that I didn't want to tell her Aunt Kate had filled the shaker with half sodium substitute. Ma-ma-oo and Dad sounded like rabbits as they chewed. I didn't like herring eggs much. The flavour was too strong. I liked how tiny the eggs were, though, and how loud they crunched when you ate them.

When she was done, Ma-ma-oo sat back and held her stomach. "Ice cream next."

"Mmm," Dad said.

While Dad and Aunt Kate were doing dishes, she said to me, "You watch out for your brother. No sense.

Just like Mick. Nothing in his head but swimming. How's he going to give me great-grandchildren flapping around the water like that?"

"I don't want you to leave," I said.

She raised an eyebrow. "When it's time to go, you go."

I sat on the floor and put my head on her knees. "Don't."

"The place I'm going," she said. "Nobody's hungry and nobody's in pain. Sunny all day. People I love everywhere, waiting for me."

"No," I said.

She touched my hair. "Everybody's singing. Everybody's dancing and laughing." The kettle whistled. She patted my shoulder. "Go get us tea. Go on. Hurry. You want to miss 'Dynasty'?"

Ma-ma-oo fell asleep on the couch. I picked up her mug of half-finished tea and brought it in the kitchen where Aunt Kate and Dad were having tea and biscuits.

"Ma-ma-oo's getting worse," I said. "We should call Aunt Trudy. She should be here."

"Good luck," Aunt Kate said.

"We've already called her," Dad said. "She's not coming."

"Oh," I said.

"She always has to have someone to blame," Aunt Kate said. "Nothing's ever her fault."

"Kate," Dad said.

"Well, she does. She thinks Mother's dirt, while she goes out and parties and treats Tab worse than what she blames Mother for."

"Let's put Mother to bed," Dad said. After they did that, Kate said she could handle it, and that Dad should take me home because I didn't look well.

When we were alone, Dad said, "Don't listen to her. Just be there for Mother. That's all she needs now."

"Okay," I said.

"Good girl."

≋

Wind coming up the channel from the south is warm, soft. Wind going down the channel from the north is bitter. When the wind is strong enough, trees fall on the power lines. Some of the power lines are already leaning over the cliffs like old men peering into the water. After a storm, the road is littered with branches, and the whining, teeth-grinding sound of the power saws is in the air. Big storms usually happen after Christmas. February is the worst month. Which also happens to be when the All-Native basketball tournament in Prince Rupert is on.

During the All-Native, the village is deserted. Everything grinds to a halt. Radio stations tune in to the Northern Native Broadcast. Excitement mounts. Basketball teams with no hope of winning get themselves knocked out quick so they can spend the rest of the week partying. The teams with a real chance of winning live like monks during Mardi Gras. They are in bed before ten, don't drink, don't smoke, aren't even supposed to have sex. Any player who deviates from this is soundly lectured, and then, if the team is serious is penalized by being taken out of a game.

The Haisla Braves were knocked out by Thursday. I escaped Jimmy and Dad, who were on a break from training. If I had known I was going to be having sex that night, I would have worn something special, instead of jeans and a white shirt, though I don't know why people make such a big deal about doing it. In all the movies I've ever seen, it is this huge, life-changing event. With me, I met Pooch at a party, we went up to a room, took off our clothes, kissed, got on with business and that was it. He was sort of drunk, I was sort of drunk, but by the end of it we were both sober.

"You want to get married?" Pooch said.

We both laughed.

"Gran's in the hospital," he said.

"Sorry," I said.

"You know what the worst part is? She's dying and all I can think is how much I don't want to live in a group home."

"You staying in town?"

He shook his head. "Going to Van."

"Harsh," I said.

"Harsh," he agreed.

We were quiet and I didn't know what to say next. I hadn't talked to Pooch in ages. I picked my clothes off the floor, Pooch stayed on the bed, all sudden modesty, blankets pulled up to his chin. I lay back beside him and he put one arm under my head.

He wasn't in love with me and I wasn't in love with him, but it was nice to be held and to have someone there. It does make a difference when you're feeling alone. It takes the feeling away for a few minutes, a few hours. Then it's over and nothing's really changed.

The next day, me and Jimmy were sitting in the bleachers for one of the playoff games. The Haisla Braves weren't playing so we weren't as excited as the rest of the fans who jumped out of their seats, cheering or booing, screaming at the refs over each call, and shouting encouragement to their boys. Jimmy froze, then ducked his head. I looked over to see what he was hiding from and saw Karaoke standing in the entrance with Pooch. They were talking with their heads close together. Karaoke gave him a hug. He looked miserable. I guessed he was telling her he was leaving.

I looked back at Jimmy. "Why don't you go over there?"

He glared at me, and hunched farther into himself.

"Want me to call her over?"

"Don't," he said.

"Do you like her?"

He didn't say anything, but he blushed and looked down. He would dart I-have-to-pee glances in her direction. It was the first time I'd seen him painfully shy. I was going to call her over but saw Josh approach them. He put a hand on Pooch's shoulder. Pooch shrugged it off. Josh handed him an envelope. He threw it in Josh's face and tried to push past him. His uncle grabbed his arm and held him while Karaoke picked up the envelope and handed it to Pooch. Josh put his hand on Pooch's neck, then steered him out of the gym. Karaoke watched this for a while, then turned her head and concentrated on the game.

"She's alone now," I said to Jimmy.

"She's so pretty," he said.

"You aren't dog food yourself," I said. "Look, this is silly. Go over to her. Say hi. Ask her if she wants a pop or something. Life is short, Jim."

"You think she'd go out with me?"

"You'll never know until you try."

He stayed beside me, taking deep breaths. He stood, gave me a nervous smile, made it to the bottom of the bleachers, paused and turned around, annoying the anxious fans who hissed at him as he pushed his way through them back to me. Maybe it was better this way, I thought as he sheepishly sat beside me. If you never fall in love, you never get your heart broken.

≈

When I arrived at Ma-ma-oo's house that afternoon, the house was filled with the sound of ghosts murmuring. Ma-ma-oo rested on the couch by the window.

"There's Mimayus," Ma-ma-oo said to me, pointing her teaspoon at the corner of the room. "And Solomon, and Bertha, and Hector, and Vern—oh, I had eyes for him when he was young."

"You see them?" I said. I could catch movement from the corner of my eyes and caught the whiff of cigarettes, but I couldn't see them clearly and didn't want to.

"They came this morning," she said.

Aunt Kate was in the kitchen boiling water for tea. The phone rang and she went to get it. Ma-ma-oo poked her spoon at my arm. "You'll never get a boyfriend if you look like a stick."

"Ma-ma-oo," I said.

She reached under the chair and lifted an unwrapped brown box and offered it to me. Inside was a silver locket engraved with curling vines and leaves. I clicked it open and inside was a picture of Mick. She watched my face carefully.

"Thank you," I said.

"I think about him too," she said. She put her hand on my cheek. "Some days you give up. That's the way it is when you're mourning."

"I'm not mourning any more."

"No, you're still mad."

I pushed her hand away from me.

I touch my throat where the locket bounces against my neck. I hate to get it wet, but the rain is starting again.

Aunt Kate sent me home later that evening, saying I wasn't doing Ma-ma-oo any good looking so glum. Aunt Kate's son J.J. called Ma-ma-oo's later that evening and asked Aunt Kate to drive her grand-daughter to Emergency. She'd fallen and chipped a tooth. Ma-ma-oo waved her off and said, "Go, go. I'm sick of you hanging over me like a vulture."

Aunt Kate tried to call me, but I'd gone over to Pooch's goodbye party. I stayed at Pooch's until Frank came. It was awkward, and neither of us looked at the other. I went out to the back porch. I leaned against the railing and noticed the northern lights, barely vis-ible above the trees, smudgy green ribbons flapping slowly as if underwater.

I could feel the cold coming up through the rubber in my running shoes, cold seeping in the holes in my leggings and the wrists and neck of my jacket. The

scum of ice covering the snow cracked and complained as I tucked my hands under my arms and followed a path that led to a clearing where I used to pick blueberries at the base of the mountain. The clearing was a lot in a new subsection, the farthest out, and slightly on a tilt.

The night was moonless. The party rocked on without me, and I was filled with sadness that no one even noticed I was gone. The soulful wailing of Led Zeppelin, muffled by distance and the trees, came to me almost like a memory. In the clearing, the only sounds were my rattling breath and the creak of the trees that formed a disapproving circle. The air was so still that the stars stared down unblinking.

I heard something crunching on the hardened snow. In the distance, I could hear whistles. Something was coming towards me. I kept watching the sky. No one's here, I told myself. I'm not letting my imagination get away from me. I am alone, and I don't see anything but the auroras, low on the horizon, undulating to their own music. I sat on a log until my butt went numb, and then I went home.

≈

The fire alarm in Kitamaat Village is loud enough to be heard from Suicide Hill, some two to three kilometres away. I've never heard it go off in the daytime, except as practice.

I remember arriving at the door just as it went off, then the phone began to ring. I couldn't get the door open and listened to it ring, over and over again as I

struggled with the keys. No one answered it. Jimmy was staying over at his friend's place. I realized that Mom and Dad weren't home.

I went to every window in the house, looking out for the fire. House lights went on and people waited in their doorways to hear who the unlucky ones were. I didn't bother phoning the fire hall because everyone else would be doing the same thing. There was nothing to do but wait. I went back and made myself a cup of hot chocolate, wondering who had been careless. Wondering if anyone was dead. I went back to the doorway and heard someone shouting that it was old Agnes Hill's place.

Ma-ma-oo. Ma-ma-oo's place.

By the time I got there, her house was a black shell and lights were flashing over it, fire-engine lights, ambulance lights, camera lights and the constant murmur of the people waiting, shifting.

Sometimes I dream about it, how Ma-ma-oo decided to make herself some forbidden food, fried bacon. The frying pan caught fire. I see Ma-ma-oo as she takes a lid to cover the pan and it burns her arm. She collapses as her heart speeds up, she falls to the floor, gasping for breath as her heart labours. She makes no move to leave her house, even when she hears the fire, when she smells it. She stays on the kitchen floor, curled over, hugging her chest. As fire crawls over her ceiling and the pink insulation in the attic shrivels in the heat and the gyproc walls crack, she doesn't move, even as the fire sizzles down her walls and the sound of engines approaches.

I stood there, my mouth and throat frozen. There

were arms around me, people held me and waited for me to cry. I stared at her house, at the ambulance, at my mother. I walked towards Ma-ma-oo's house and no one stopped me. It felt as if no one could see me.

Two volunteer firemen carried her body up out of the rubble. She had no hair, no skin. She was charred and smelled like bacon. My mother and my aunt shrieked. I remember that the clearest, my aunt's voice cutting through all the other sounds.

Dad grabbed me then and covered my eyes. He led me towards Mom saying, "It's all right. It's going to be all right."

≋

Ma-ma-oo always said that she was leaving everything to me. I thought she meant the house. Since she didn't own anything, I had assumed she had no money. What I hadn't thought of was how long she'd worked and how frugally she'd lived.

"I bought my coffin today," she'd told me. "Everything is arranged."

"Yeah?" I said. "What kind did you get?"

"A plain one," she said. "You know how much they cost? They were trying to make me buy a big, fancy one." She snorted.

Mom upgraded a bit when Ma-ma-oo died. The handles were nicer and the mouldings were more intricate, but as Ma-ma-oo had pointed out, when you're dead, you're dead. I imagined her in the other world, shaking her head at our waste of money. After

settling her estate, she'd left me more than $219,800, so I told Mom to do what she thought best with it.

Some of the money went towards Jimmy's swimming. Some went to pay off bills. Most of it, Dad invested. I had a trust fund and got so much in interest a month. Dad tried to tell me what he was doing with the money, but it went in one ear and out the other. I didn't care. I tried to get excited, but whenever I touched it, I remembered that I could have saved her. If I had listened to my gift instead of ignoring it, I could have saved her.

≋

The tide rocks the kelp beds, the long dark leaves trail gently in the cloudy green water. I hear squeaking and chirping. Dark bodies twirl in the water, pause, still for a moment as I'm examined. I dip my hands in the water and the sea otters dart away, then back, timid as fish.

Well, I'm here, I think. At Monkey Beach.

In Search of the Elusive Sasquatch

Weegit the raven has mellowed in his old age. He's still a confirmed bachelor, but he's not the womanizer he once was. Plying the stock market—instead of spending his time being a trickster—has paid off and he has a comfortable condo downtown. He plays up the angle about creating the world and humans, conveniently forgetting that he did it out of boredom. Yes, he admits, he did steal the sun and the moon, but he insists he did it to bring light to humankind even though he did it so it would be easier for him to find food. After doing some spin control on the crazy pranks of his youth, he's become respectable. As he

sips his low-fat mocha and reads yet another sanitized version of his earlier exploits, only his small, sly smile reveals how much he enjoys pulling the wool over everyone else's eyes.

≋

I can hear them in the trees. They whistle—some high and musical, others just muted one-note shrieks—as my speedboat glides towards the shore of Monkey Beach. The hull grinds against the sand. I leap out and splash to shore. Once the boat is tied up, I pull my hood over my face and settle into a smoke. A raindrop splashes the cigarette tip, hissing.

They begin to giggle.

I was here last year with Jimmy. 1988. Another banner year. A catalogue of the parties I remember, the amount I drank, the drugs I did would be pointless. It's a blur. A smudge. Two years erased, down the toilet, blotto. The first year, I managed to slog through grade ten, but I gave up on grade eleven altogether and took off to Vancouver with people I thought were friends but, it turned out, were not. Some of it was fun.

For the first time in my life, I felt like I was cool, if only because I bought the booze. What had started out as a way to escape turned out to be a ticket to popularity. Temporary, yes, but popularity nonetheless. My favourite bootlegger charged me only 10 per cent to go into the liquor store and get me what I wanted. I didn't look old enough to get by the cashier without showing my fake ID, which I'd paid a lot of money for

but was a useless piece of shit that didn't stand up to scrutiny. Sometimes I'd go to the pusher who lived two buildings away and get coke or hash or pot without a hassle. And since I was such a loyal customer, he usually gave me a discount. Or so he said. He had the same line for everyone. The longer he stayed in business, the more careless he got. He was busted a few days after he bought a new Corvette with cash. The same week, the trust fund allowance for that month ran out, and I was strapped and so were my friends. Without a party, we went our separate ways.

I would have stayed that way for years if it wasn't for Tab. She came to me when I woke up lying facedown on cool, sticky tiles. My mouth was dry. My head ached like a bugger. I wanted to stay where I was, but I wanted a cigarette worse, so I put my hands under me and pushed myself up. I stopped when I was on my knees and put both hands against my temples, but that didn't stop my head from throbbing. I searched through my front pocket and I found my pack and lighter. I became aware of someone staring at me and opened my eyes. The light was burning a hole right through my skull, so I could only squint.

Sitting on the edge of the bathtub, Tab said, "You sober now?" She was scrawnier than ever, had dyed her hair red and was wearing a black, skin-hugging lace mini and bikini top.

"Mostly," I said. I raised the cigarette to my mouth and lit up.

"You remember where we are?"

"East Van," I said. "I'm awake, I'm awake. What happened?"

"You tell me."

From her tone I could tell she was really pissed, so I must have been especially stupid the night before. Or the day before. Whenever. I didn't feel up to one of her lectures. I flicked my cigarette into the toilet.

"Want some coffee?" she said. She stood up and waited for me to haul my ass up. I felt shaky and stiff from sleeping on the floor. I scrubbed my face with cold water and saw myself in the mirror. My hair was flat on one side and bar-hair high on the other. It was shoulder-length and tangled, oily—yet dry to the point of feeling like straw. My mascara had migrated down my face and smudged where I'd wiped it. I finally noticed my surroundings. The orange-and-brown sixties' decor, the crackling silver on the mirror's corners, the smell of mould and smothering Old Dutch cleanser all screamed cheap motel.

"What a night, hey?" I said. I unlocked the door and pushed it open. I used my sleeve to wipe off my scummy makeup and tamed my bar-hair with a liberal dose of water. She watched me with a curiously unmoved expression, like I was someone she didn't know.

Six guys and three girls were passed out in the next room. I couldn't remember any of them. None of their faces was familiar. Beer cans were piled on the tables, and the lingering cloud of cigarette haze spoke of a long, drawn-out party. Tab picked her way through their bodies like they had the plague. I followed her down the hallway and outside into a sullen rain squall. I patted down my jacket, then my jeans and was surprised that I still had my wallet.

"Hey," I said. The sky was black with shifting clouds, then underlit with orange from Vancouver's light pollution. Fresh rain had cleaned the skids of its normal bouquet of *eau de piss*. I was dizzy so I sat on a cracked seat at a bus stop and pulled out my cigarettes. I ran a hand through my hair. My reflection in the bus shelter's glass blew smoke at me. I thought I could probably be a poster child for something, but I wasn't sure what. Yes, I could be in a movie, maybe some cheesy TV special: *Poster Child Without a Cause*. I laughed, and people passing by steered a wide course around me. Tab watched me.

"Diner up ahead," she said, walking away.

We went into a scuzzy diner with a sign saying Open, You Come In. The booth we sat at had a picture hanging over it of a mama duck and three ducklings in yellow sou'westers crossing a puddle. Inexplicably, this cheered me up. I expected Tab to light into me. Give me the standard how-could-you-be-so-stupid and look-how-you're-ruining-your-life talks that she always gave me. Instead, she watched while I ordered a coffee. The waitress ignored her. I sat back and drew circles on the table with my spilled Cream-o. The coffee was flat and stale, but it was hot. The diner was overheated and I started to sweat after being out in the cold.

"What's up?" I said, to break the silence.

She glanced at me, then back at the table. No smart-alecky comment. "Did I say something last night?" I said. "I'm sorry. Whatever it was, I'm sorry."

She pulled her jacket in closer. "Who's sitting here with you?"

"What?" I said fuzzily, wishing I was in bed.

"How many people are at this table, Lisa?"

"I'm sorry already."

"No, you're not."

"Jesus, you're in a mood."

"It's me and you. Just me. You. Your asshole friends buggered off last night and left you with a bunch of strangers."

She was gearing up for a rant, and I prepped myself to tune out, turning to watch the rain hit the windows and stream down. The streets were empty. A traffic light blinked frantically as it swayed in the wind.

In the diner, there was just us and two guys at the counter, who were absorbed in eating a nauseatingly large breakfast. The waitress sat near the till, flipping through a *Cosmo*. She had her hair tied back in a no-nonsense bun and would check her watch every other minute as if she could speed time along by glaring at it. Tab's fingernails clicked against the table. "Let's call a cab," I said, taking out money for the coffees and plunking it on the table. "I don't feel like walking back to the motel."

"I'm walking," she said.

"What's your problem?"

"Lisa, some people have lives. Some people are moving on. Some people aren't wallowing in misery like they're the only ones on earth who've ever had someone die on them."

"Screw you," I said, stubbing out another cigarette.

"You almost got killed last night, you know that?"

I shrugged, too mad to speak.

"I'm not going to be able to help you any more,

Lisa. I just can't." She stood up. "Don't depend on me to bail you out next time you get in trouble."

After she left, the waitress came over again, nervous until she saw the money on the table. She refilled my coffee while I watched Tab pull her jacket over her head. I sighed, then put a tip on the table and followed my cousin.

The section of abandoned warehouses, boarded-up stores and closed industrial shops was my favourite walking route. No one went there except people who were more interested in shooting up or shooting off. I could meander in peace, in a silence punctuated only by the occasional wail of sirens. I pulled the hood of my jacket far over my face and paid attention to where my feet were going.

When I caught up with her, I shook out a cigarette and sucked in three hasty puffs. She scowled at me. "Help yourself," I said, tossing the pack to her. It went right through her body. Startled, I watched as it hit the ground and bounced.

"You moron," she said.

"But you can't be dead. I just saw you last week . . . " I touched my temple where a hangover headache was intensifying. "I must be dreaming."

"Wake up and smell the piss, dearie. I just got bumped off by a couple of boozehound rednecks and I'm pretty fucking angry at you right now."

"At me?"

"Don't look at me like that. You and your fucking problems. Get your act together and go home."

She disappeared. It was as if she had never been there. I waited, wondering if I was hallucinating.

Maybe I had alcohol poisoning. Then I shook my head, smoked another cigarette and went home.

I had a hotel room, just a dinky hole above a bar, but I had four prepaid days of relative safety to ponder the peeling walls and the cracked ceiling, and to listen to the throb of the cheap stereo system and incoherent arguments of the drunks and the shoptalk of the strippers entering and leaving their rooms. After three days, I had a Pepsi from the vending machine and realized I'd spent three days alone for the first time in months. My hands were shaky. The Pepsi went down in gulps. I bought a Five Alive for the vitamin C. The hallway light spazzed. I felt my way along the wall for the stairwell, then walked down, and out onto the street.

I would have money tomorrow. My party pals knew my payment schedule and would casually begin to feel me out, see how much I was willing to blow. Each time, I said to myself, Hey, let's go somewhere nice this time. Disneyland. Las Vegas. Cancún. Let's try being broke in some other country. But each time, I succumbed to the spurious pleasure of being Queen Bee. Friendship on my terms, with me pulling the strings, in control as long as I gave honey.

I went to a cheap hairdresser the next day and got a slightly crooked chin-length bob. Mom would be appalled. She hated shoddy work. I bought a small mirror, makeup, and went for a manicure. When I made my way back to the hotel, the desk clerk did a satisfying double take and said I looked good enough to be a call girl. This, I decided magnanimously, I would take as a compliment.

I commandeered the bathroom at the end of the hallway. I bathed for an hour, causing one of the other tenants to urinate on the door as a protest.

"Soak in that, ya bitch!" he yelled, hammering the door one last time.

I dropped underwater, scrubbing my scalp. I had asked the clerk to upgrade me to the luxury suite. He gave me a room three doors down from my previous residence. It was exactly the same, except it had an electric burner and a kettle. As I lay on the squeaky bed sipping tea, I could hear two of my friends frantically knocking on my old door, telling me to stop fucking around. Other friends came and went. The same tenant who had pissed on the bathroom door became disgruntled at the stream of people disturbing his sleep and took to hurling empty beer bottles at anyone who knocked too long.

"Fucking take a Valium, man," I heard one of my party pals yell.

"Fucking learn some manners, you inconsiderate prick! I gotta work tomorrow!"

"I hope you're fired," party pal muttered.

"I heard that!" the man yelled.

They traded insults, with other tenants joining in, telling everybody to shut up. My party pal finally left and the man slammed his door.

The next day, my stomach was up to broth. I snuck out of my room, made a dash for the nearest corner store, bought a stash of bouillon cubes, smokes and a box of tea, then headed back, hoping not to bump into anyone. I knew that if they talked to me I'd give in and go party because the room was small and empty and bare and cold.

No matter which way I looked at it, I'd either pick-
led my brain or my brain was finally clear. There was
no way to avoid it any more: I decided to check out the
next morning and go see Aunt Trudy. If what I'd seen
was just my overactive imagination, fine. But if Tab
really was dead, Aunt Trudy would need someone to be
there for her.

I put my stuff in a plastic shopping bag and took
the bus across town to her house. From the blasting
music and the lineup of cars parked on her street, I
knew the moment I walked up her steps that Aunt
Trudy was in full party mode. I knocked on the door,
but no one answered. I rang the doorbell and waited.
After a couple of minutes, I opened the door and
went inside.

"Yowtz!" I said. When there was still no answer, I
stepped inside. The hallway was bare of its usual clut-
ter. I had expected to see people everywhere, but the
living room was full of boxes, all the pictures were
off the walls and the furniture was pushed into one
corner. No one was in the kitchen, or in the down-
stairs bedrooms. I shut off the stereo. "Yowtz! It's
me, Lisa!"

"Lisa?" her voice said. It sounded like it was com-
ing from upstairs. I started to go up, but she met me
on the steps, throwing her arms open and giving me a
fierce, crushing hug. "Hi, baby," she said. "I haven't
seen you for ages, just ages! We were all worried about
you."

"I'm okay," I said. "Ow, ow, you're hurting me."

"Whoops! Here, come on, I'll make you some cof-
fee. How the hell are you?"

I followed her as she wobbled into the kitchen. She swayed so much, I told her I'd make the coffee but she waved me off, saying I was a guest. I sat down at the table and watched her root through the boxes piled on the counter to find the coffeepot.

"Looks like you're moving," I said.

"Yeah, Josh got me into Native housing. Good old Josh. He always looks out for me. It's a two-bedroom. Big. New. Where'd I put those filters?"

"It's okay, I'm not—"

"No, no. I'll find them. Tab's room is really big. Ungrateful twit. You know what she said to me?"

"You talked to her?"

"She phoned two days ago. Yap, yap, yap. You know how she is."

"Oh," I said, and the relief flooded through me. Well, there you go, I thought. It was just a dream. I felt dizzy so I put my head on the kitchen table.

"You don't look so good," Aunt Trudy said. "You want a fixer-upper instead?"

I laughed and pushed myself upright as Aunt Trudy pulled a bottle of whisky out of her fridge. "No. No, I'm just—" Relieved? Insane? "Hungover."

"Ah," she said. "Here. Have one on me."

"I'm kind of cutting back."

"Yeah? Me, too," she said, pouring herself a glass. She held it up. "Wanesica."

The pot beeped. The kitchen was filled with the smell of coffee and stale cigarettes. She found a cup for me and dug around for the sugar. When she sat down at the table she said, "Guess who's going into treatment."

"You?" I said.

She grinned. "That's what everyone says. After I move my stuff into my new place, I'm off to Alberni!"

"Bullshit."

"Gonna have one last blowout! You up for it?"

I shook my head. She sipped her whisky.

"So Tab's okay?" I said.

"Tab's Tab. That one can take care of herself. You know what she said when I told her? She said it's about time, don't screw it up."

I chuckled. "Yeah, that's Tab."

"You going home?"

I shrugged.

"You better. You're giving your parents kittens."

"Are they really mad?"

She reached over and patted my shoulder. "My floor is your floor. You can stay at my place as long as you want. I'll be gone for eight weeks, but Josh'll be there until fishing season starts so you'll have some company."

"Do you mind?" I said, pulling out my smokes.

She waved her consent and asked me for one, then wrinkled her nose when I handed her a menthol. "You smoke this crap? Why don't you get some real smokes?"

"It's easier on your throat."

"Yech," she said, but smoked it anyway.

"Yowtz!" We both turned as someone knocked on the door.

"Josh!" Aunt Trudy yelled. "We're in the kitchen!"

"You ready to roll, Tru—" He stopped at the door and grinned when he saw me. He was bigger than he

was the last time I'd seen him. He'd cut his hair so short, he almost looked bald. "Look what the cat dragged in!"

"Thanks," I said, then yelped as he lifted me off the chair and twirled me around.

"Little Lisamarie," he said, setting me down. "All grown up." He tousled my hair. "How's my favourite troublemaker?"

"Fine," I said, annoyed.

"The cab's waiting," he said to Trudy. She grabbed her purse and asked me again if I was coming. She wouldn't take no for an answer and I didn't really want to stay in her place by myself.

We caught the cab to a booze can in Surrey. I knew the house and cringed when I thought of meeting up with my party pals. The Dobermans on chains at the entrance snarled and hurled themselves at us as we walked down the stairs leading to the basement. The walls were covered in soft, grey soundproofing material and the floor was covered in classic green shag. Josh excused himself. I tucked myself into a corner beside the pool table, sipping a four-buck glass of orange juice. When you were sober, the place was grungy and seedy. The normal buzz of excitement I felt when I came here was muted. But, I thought, the party hadn't even started yet. The booze can would get hopping when the bars closed.

"Frank?" Josh yelled. I looked up to see Frank pausing at the den door that led to the hallway. He was almost as tall as Josh now, nearly six feet, but he was all bones and angles. They stared at each other then Frank looked down and away.

"Hey, where the hell have you been?" Josh said.

Frank brushed past him as if they didn't know each other. Josh watched him go, a puzzled, hurt expression on his face. He came and sat on the arm of the sofa. "Did you see that?"

"Yeah," I said.

"You know what he's mad about? I wouldn't cosign a car lease for him. But I ask you, is that any reason to treat me like that?"

I shrugged. "Family."

"Family," he said. "Where's Trudy?"

"Getting a refill," I said.

He shook his head. "She's never going to last eight weeks. I told her, old boozehounds like us can't change. You'd never catch me going back there," he said. "You want a refill?"

"No, thanks. Aunt Trudy's getting me one."

"You ever need anything, just ask," he said. "I mean it, I really do."

"I'm fine."

"Mick was always there for me. Anytime I needed help, I never even had to ask. He was the most generous guy I ever knew. He had the biggest heart. He was like a brother."

I swished the orange juice in my cup. "Do you have any extra copies of those pictures of Mick?"

"Done," he said. "I've got a box of pictures at Trudy's. When we go back, help yourself."

"Thanks. It would mean a lot."

"No problem. He talked about you all the time. Monster this and Monster that."

"Did he ever mention Cookie?"

"Cookie? His wife? What about her?"

"Do you know what happened to her?

His face lost all expression. "Someone tied her up and put her in her car. Then they set it on fire. It was way the hell in the middle of nowhere. The police said it was a suicide and the FBI—"

"What's all the glum faces about?" Aunt Trudy asked as she sat down beside me.

"She asked about Cookie," he said.

"Oh, God," Aunt Trudy said, grimacing. "This is my last night of freedom and you two wanna bring me down." She shook her head. "That's enough of this. Who wants to dance!" She grabbed Josh's wrist and towed him to the centre of the room. Josh did a two-step back and forth while Aunt Trudy bounced around him.

I didn't want to venture out of the den, but I needed to pee. The lineup for the bathroom was long. I sighed and leaned against the wall. This had been a mistake. I wished I'd stayed at home.

"Lisa?" Frank peered at me. He was wearing cologne, something woodsy. "What are you doing here?"

"That's my line," I said, forcing my mouth into a smile, then letting it fall away, knowing it probably looked dumb. "How you doing?"

"Good. Good."

"How long you down?"

"Until tomorrow. I'm driving Adelaine back to Kitamaat."

"Oh. Good."

"It was good seeing you."

"You too." He was turning away, retreating into

the crowd. I wanted to call him back, but I didn't know what to say to him. What could I say? Sorry for dumping on you when I had a problem with Cheese? Then I heard, over the pounding bass, a high, familiar whistling. I turned my head slowly but it was just a kettle going off somewhere.

"Hey!" Karaoke said, pushing herself beside Frank. She said something to him and he shook his head. She thumped his chest, and took off.

Someone had puked in the sink and mostly missed. I held my breath, but couldn't get out of there fast enough. Josh was surrounded by a cluster of women. The only ones I knew were Aunt Trudy and Karaoke, who was trying to get money from him.

"Alberni? Really? There's a treatment centre where the residential school used to be?" one of the women said to Aunt Trudy.

Another woman laughed, then said, "Hey, how many priests does it take to change a lightbulb?"

"How many?"

"Three. One to screw it, one to beat it for being screwed and one to tell the lawyers that no screwing took place."

"That's not funny," Josh said.

"That's the point," the woman said.

"Come on," Karaoke said. "Just a couple of bucks."

"Lisa," Josh said. "Have you met Adelaine?"

"Yeah. We met a couple of times. Hi," I said to her.

"Do I know you?" Aunt Trudy slurred. "You seem familiar. Who's your mother?"

"This is my niece Adelaine," Josh said. "Who should be home by now."

Karaoke took her beer and downed it in one gulp. "Come on—"

"Adelaine," he said, "let's go home."

"Screw you," she said, turning on one heel and stomping out.

Josh shook his head. "You gotta love family."

I stayed with Aunt Trudy another half-hour then called a cab. When I told her I had a headache, she gave me the keys to her place. Josh tried to give me money but I said I had my own. I stood on the sidewalk and willed the cab to arrive faster as the dogs barked and strained against their chains. I was about to give up and go back inside when someone stopped beside me and touched my shoulder. I turned around and was looking up at Frank. He stepped back. "You need a ride somewhere?"

"Sure," I said.

"My car's down the block." At the car, he went to the passenger's side and held the door open for me.

"Do you know where Aunt Trudy lives?" I said as he started the engine.

"Oh, yeah," he said. "Been there many times." He stared straight ahead. I asked if the radio worked. He said no. Fifteen minutes later, he asked if I'd been to any good movies. I said no.

"So. How you been doing?" I said.

"It's been kind of tough since Pooch."

"What about Pooch?"

"Didn't you hear?" Frank said. "He shot himself. He's in the hospital. They're taking his organs tomorrow. I'm going to the funeral with Adelaine. No one told you?"

"No." The cars and the street began to blur, everything was out of focus.

"You want me to stop the car?"

"Oh. No. When?"

"He shot himself about three weeks ago."

"Oh." and we drove in silence the rest of the way. At Aunt Trudy's he asked, "You going up for the funeral? You can ride up with us if you want. I mean, with me and Adelaine. The two of us. She'll be sleeping most of the way. I wouldn't mind an extra driver. If you want to come."

I opened the door. Ride up. Pooch dead. Funeral. "Oh."

"It was good seeing you," Frank said.

"I wouldn't mind."

"We're leaving pretty early. Or the bus leaves at eight. If you want to get some more sleep."

"What time are you picking me up?"

"Lisa?"

"Pooch." I was going to say something, but it left my head before I could get it out. It seemed important to say something.

"You're looking kind of spacey. Are you okay?"

"I'll be ready. I have everything packed."

"We'll be here at five. Do you want me to phone?"

"No, Ma-ma-oo will wake me up. She always gets up early."

Frank ducked his head, then looked away. "Um, isn't she dead?" he asked. When I didn't answer, he touched my arm, and gently steered me to the door. He took the keys from my hands and opened the door. His mouth moved and I realized he was talking.

"—you didn't know. I didn't mean to spring it on you like that."

God, I'm rude, I thought. I didn't even thank him for the ride home. "Do you want some coffee?"

He must have said yes because we went into the kitchen and he made coffee. He stayed, then left. Aunt Trudy and Josh came back, but went upstairs.

Someone honked outside, and I picked up my plastic grocery bag and went to the window. It was Frank's car so I went outside. He raised an eyebrow at my bag but put it in the trunk without saying anything. Karaoke was asleep in the backseat, her hair sticking out from under a blanket. Frank asked if I wanted breakfast and I said I wasn't hungry. We drove and came into Williams Lake. Frank looked tired so I said we should stop and have something to eat. He said there was a twenty-four-hour place that had just opened up. The place had a ruffled, country kitchen-type decor. A group of noisy truckers was sitting in the back, where the smoking section was. Frank settled into a table by the window. "Do you still see ghosts?"

I sat opposite him. "Yeah. Sometimes. When I'm sober. Did you see something?"

He nodded. "Pooch. I saw Pooch."

"The day he shot himself?"

He nodded again.

"That's a death sending," I said. "It's nothing to worry about. He probably just wanted to say goodbye."

"Mm-hmm," Frank said, obviously only half-listening, distressed. "I saw that. He said . . . he . . . "

"Hey, hey, hey," I said when he started to hyper-ventilate. "You don't even have to tell me, okay?"

He nodded.

"You know," I said, to change the subject, "I like the chocolate ones with sprinkles."

"What?" he said, looking alarmed.

"Donuts. Do you want one?"

"Yeah. I like those ones too. I was in prison once."

"What for?"

"Small stuff. Nothing major. Just a B & E. Failure to appear. Disturbing the peace."

"Disturbing the peace?"

"Got into a fight with a drinking buddy. We broke some windows." Frank leaned forward. In a hushed voice, he said, "Listen . . ." He stopped again. He seemed to want to say something important, but I wasn't up to any big revelations.

"I'm going to get you a donut."

When I came back, he was smoking and a woman at the table next to us pointed to the no-smoking sign so he butted it out.

"I can take over now," I said. "I'll get us to Prince George."

He frowned, then looked outside to the car. "I dunno. My car's a standard."

"That's okay. Pooch taught me."

He broke his donut into pieces and dunked it. "Everyone always said, that Frank, he's never going to amount to anything. Guess they were right." He examined his fingernails. "I always wanted to ask you out. But I figured you deserved better. Then you went out with Pooch."

"He was a good guy," I said.

"To Pooch," he said, raising his coffee cup.

"To Pooch," I said.

I drove us to Prince George. We woke Karaoke up for dinner. When we got back in the car, she promptly fell asleep again. Frank said he was ready to take over, but halfway to Smithers, he started to drift and I said I was fine. The sun was getting low. I turned the headlights on. The road had started to curve and the hills were getting steeper so I slowed down. A squall hit, and the wipers squealed against the glass. As I was driving around a curve, a man came out of the bushes and crossed the road ten metres ahead of me. As I slammed on the brakes, he paused in the headlights, his head turning sharply in surprise, then he broke into a jog and disappeared into the trees. The memory of him is imprinted on my brain—the dark brown fur on his back, the lighter fur on his chest, the long hairy arms, the sharply tilted forehead and the row of pointed teeth he flashed at me when he snarled.

Frank woke when I opened the car door and the lights inside went on. He came out and stood beside me as I peered into the trees, listening to the bushes snap as the sasquatch made his getaway.

"What's wrong?" Frank muttered, rubbing his eyes.

For a moment, I considered sharing my b'gwus sighting with him. But then I decided that I didn't want to sound cracked. "I saw a moose. Almost hit it."

"Oh," he said before he went back into the car, dropped his head against the seat and closed his eyes.

I got soaked standing in the rain. I stood there until I couldn't hear the bushes breaking. The highway was dark and silent. As I drove away, I felt deeply

comforted knowing that magical things were still living in the world.

≋

The shore is a brown sliver between the vast expanse of choppy ocean and the patchwork green of un- touched forest. Mountains slope into the water, where the waves foam against the barnacle- and seaweed- encrusted rocks. A bear—a hazy, dark brown figure in the distance down the shore—paws at the seaweed. It raises its head, stands on its hind legs, and for a moment, as it swivels around and does a rambling, awkward walk into the woods, it looks human.

≋

"Lisa." They call to me from the trees. "Lisa."

My arm hurts from holding the throttle. Haven't been out on the water for weeks. I still have six or seven hours of riding ahead of me before I hit Namu. I want to stay here on Monkey Beach. Some places are full of power, you can feel it, like a warmth, a tin- gle. No sasquatches are wandering around the beach today, chased by ambitious, camera-happy boys. Just an otter lounging in the kelp bobbing in the surf and the things in the trees, which may or may not be my imagination.

"Lisa," the first voice whispers. "We can help you."

The tide is going down and my speedboat is halfway out of the water. I should hurry, if I want to get to Namu before dark. As I walk across the beach, my feet

crunch against the shells. Cockles are a favourite food
of B'gwus, the wild man of the woods. He uses sticks to
dig cockles out of the sand. Clams are his second
favourite food. Monkey Beach is popular with B'gwus
because it has so many cockles and clams. In clams, the
sexes are usually separate, but cockles are hermaphro-
dites. Clams and cockles spawn at different times of
the year. At this moment, the cockles are spawning.
The eggs and sperm are squirted into the water, mak-
ing it cloudy. Baby clams and cockles are called larvae.
They swim around until they get big enough to drop to
the bottom and grow shells. Muscles attached to the
shells open and close the clams and cockles to let in
food or to let out the foot to burrow. Clams have black
tongues because a long time ago the world was on fire
and the clams tried to put it out by spitting.

B'gwus is famous because of his wide range of
homes. In some places, he's called Bigfoot. In other
places, he's Yeti, or the Abominable Snowman, or Sas-
quatch. To most people, he is the equivalent of the Loch
Ness monster, something silly to bring the tourists in.
His image is even used to sell beer, and he is portrayed
as a laid-back kind of guy, lounging on mountaintops in
patio chairs, cracking open a frosty one.

B'gwus is the focus of countless papers, debates
and conferences. His Web site is at www.sasquatch.com.
Grainy pictures, embarrassed witnesses and the
muddy impressions of very large feet keep B'gwus on
the front page of tabloids and the cover of books which
are dismissed as the results of overactive imaginations
or imbibing too much alcohol or ingesting funky
mushrooms.

Most sightings of this shy creature are of single males, but B'gwus is part of a larger social complex, complete with its own clans, stories and wars. There are rumours that they killed themselves off, fighting over some unfathomable cause. Other reports say they starved to death near the turn of the century, after a decade of horrific winters. A variation of this rumour says that they were infected with TB and smallpox, but managed to survive by leaving the victims to die in the woods. They are no longer sighted, no longer make dashes into villages to carry off women and children, because they avoid disease-ridden humans.

At night, very late and in remote parts of British Columbia, if you listen long enough, you sometimes hear him. His howl is not like a wolf's and not like a human's, but is something in between. It rings and echoes off the mountains, and you can convince yourself it is a wolf or maybe a pack of inebriated teenagers 4x4ing it up some logging road, but if your body reacts by tensing, if your skin tightens into goose bumps, your instincts are warning you that he is still around.

I shake my muscles out then pull my jacket close. I grab my bail and start shoveling the bilge out of the bottom of my speedboat. The wild man has been spotted several times digging in the sand of Monkey Beach. Some people claimed he was a bear, but I doubt that the bears around here need clams and cockles when the salmon are so much easier to get at.

I sat between Frank and Karaoke during Pooch's funeral, not looking to see if Mom and Dad had come. Frank drove us to the graveyard. We stayed at the back of the crowd and didn't talk to anyone. After the service,

we went back to Frank's apartment. While some old Van Halen tunes played on the radio, we sat around not saying anything.

"Did he say anything to you guys?" Frank said.

I shook my head. "Not to me. But we didn't talk much."

"We all know why he did it," Karaoke said.

"Shut up," Frank said. "Just shut up."

"Yes, let's not talk about it. Josh didn't—"

"Shut. Up."

They were both quiet. Frank started telling me about his new satellite dish.

A cousin knocked on the door around midnight and invited us to a party. Frank said he wasn't interested, but Karaoke said she was good to go. We went to an apartment that turned out to be two apartments down from where Uncle Mick stayed when he was in Kitimat. I shivered. Karaoke knocked on the door and then opened it and let us in. Half the people were rank, and the other half were getting there. I breathed in all the familiar smells, then stopped cold at the sight of Cheese and a girl in the corner, sharing a Silent Sam forty-ouncer.

Cheese, pissed out of his gourd, saw me and said, "Freaky's here! Talking to fucking ghosts. Right! You're so fucking special."

"Ease off, Cheese," Karaoke said as he sang the theme song to *Ghostbusters*. She gave me an apologetic look. "He's tanked. Won't remember this in the morning, will you, Cheese? Come on, help me get him to the car."

The girl on his arm said, "He's with me."

"I'm his cousin. You want a ride home too?"

"I'm going where Cheese goes."

"Fine. You want to meet his parents now? Hmm? Didn't think so," she said as the other girl glowered at her.

"You're such a freak," Cheese muttered. "You're super-freaky."

"I'll . . ." Karaoke paused, her eyes caught by something behind me. I turned in time to see Jimmy come through the front door. He'd grown his hair so that it was shoulder length and I guessed chlorine in the pool had highlighted parts of his hair to light brown. He wore jeans, a blue T-shirt and a brown leather jacket. I didn't recognize any of the guys he was with because they weren't from his swim team. I ducked behind Cheese before my brother could spot me, and was trying to figure out a way to leave inconspicuously when Cheese started shouting for more beer and Jimmy looked towards us. His eyes met Karaoke's. His smile was instantaneous, warm and shy. She breathed in hard, then ducked her head and said to Cheese, "You think you can walk by yourself to the car?"

"Screw you," he said, pushing her away. "I am having a gooooood time!"

I thought, this apartment was exactly like Mick's, there'd be a back door out of the kitchen. I turned to leave but found Jimmy standing in front of me.

"Where the hell have you been?" he said.

"Here and there," I said.

"That's all you have to say? You've been gone for—"

"All right, all right. I'm inconsiderate. Good to see you, too. Karaoke's over there."

He put down the beers he was carrying on a side table and wiped his hands on his jeans. "Are you going home? They'd really like to see you."

"Jeez, you've gotten tall. How's swimming?"

He flinched. "I quit."

"You quit?"

"Yeah. I quit."

Cheese and another guy started pounding each other in the living room. Karaoke threw her hands in the air and stomped away. Jimmy watched her go. I couldn't imagine him out of the water.

"Are you staying or going back to Vancouver?" he said.

"Going back."

"When?"

"Tomorrow."

"Where are you staying tonight?"

"City Centre Motel."

He nodded. "You mind if I walk you back?"

We walked up to the fountain instead. The hospital rose behind it, electric pink. Every Remembrance Day, the flame near the fountain gets lighted. In the summer, the tourists get their pictures taken by the totem pole but it wasn't the right time of year for the fountain. Hospital Hill, the road that leads from the City Centre Mall to the highway, was empty, and the two sets of lights in Kitimat blinked at the deserted roads. Jimmy sat on a bench and smoked, offering me one.

I grinned. "This is unreal. I can't believe you, Jimmy Hill, are having a cigarette."

He gave me a sideways look, then bent forward and

rested his elbows on his knees, staring at the fountain. "You're not taking me seriously at all, are you?"

I shrugged. He sighed. We stared at each other—his eyes dark brown, gold-flecked eyes. "You should at least say goodbye."

As we drove to the village, he explained that he had to go pick Dad up at work, but he'd drop me off at the house first. "I can take you back to the motel when I get back."

We pulled into the driveway. The porch light flicked on and Mom opened the door. I don't know which one of us was more surprised. Her hair was flat and her clothes weren't ironed. She didn't even have any makeup or jewellery on. Her hand reached out and touched my hair. "Who did the butcher job?"

"You should have seen it before I got this cut."

She touched my cheek. "You're so thin."

"It's the new look. Very chic."

"We had barbecue fish for dinner," Jimmy said, pushing me in the door. "I can reheat it if you want."

"That sounds good," I said.

Jimmy pulled some plastic bowls out of the fridge and put them in the microwave. Mom poured three coffees and handed me a mug.

"Did you fly up?" Jimmy said as I sat down.

"No. I drove up with Frank. For the funeral."

"How are Bill's brothers taking it?" Mom asked.

Bill. I couldn't think of him as anything but Pooch. "They're doing okay."

"She's at City Centre Motel." Jimmy said just before the microwave beeped.

Mom frowned, sipped her coffee. "Waste of money."

I wasn't sure if that was an invitation or a general comment. "It's okay."

"If you don't want to stay here, I could call Erica. I'm sure she'd be glad to see you."

"She's got a kid, a little girl," Jimmy said. "Tell her the name, Mom."

Mom rolled her eyes. "Chinook Agnes Jakobs."

"Ouch."

"You should stay the night," Jimmy said. "Do you want your old room?"

I watched Mom's face. "Are you sure? I mean, that I . . . "

She waved her hand in dismissal, "It's done. Let's forget it now. Do you want another cup?" She held up the pot.

"No, thanks. I'll be up all night."

Jimmy surprised me with a peck on the cheek as he left. Without him there, we couldn't seem to find anything to talk about. The fridge hummed to life. Some dogs barked outside. She said my hair was driving her crazy and asked if she could straighten the line. I grinned and said we could do it tomorrow. The last week of sleepless nights was catching up with me and I had trouble keeping my eyes open. Mom asked me if I had a nightgown, and when I said no, gave me one of hers.

My bedroom had been tidied. I pulled up the desk chair and spun a few times. Mom brought me blankets and sheets and started to fix my bed.

"I can do that," I said.

"No, no, it's okay. How long are you staying?"

"Probably go after they have the thank-you supper."

"Good. Good." When she finished making the bed, she rolled the covers back, then paused, looked sheepish, as if she'd been caught doing something silly. I didn't know how to bring up the subject gracefully. "How's Jimmy? He said he quit swimming."

She sat on the bed. "He had an accident. A stupid one. He was helping a friend change a tire. He was carrying the flat tire to the trunk, the gravel was loose and he slid down the embankment. He landed at just the right angle to dislocate his shoulder. The Olympics are in a few months. He got bumped." She asked if I needed anything else, and I said no.

Dad knocked on my room later that evening. "Lisa?"

"I'm still awake."

Dad wasn't thin, he was emaciated. He hadn't ever been chubby, but now he was gaunt. He sat on the edge of my bed as I leaned against the headboard and hugged my knees.

"You look good," he said.

"So do you."

"You can stay as long as you want."

I gave him a hug. "Thanks."

He patted my back then left.

≈

Erica brought her baby over to visit on the fourth day I was back. Her baby was chubby and constantly turning around to see what was going on. She had deep blue eyes and black hair. Erica had graduated on time, had her baby, and her boyfriend was trying to convince her

to move to Esquimalt, where he would be stationed while he was training to be a naval officer.

"You're going back to school?" she said when I told her. We were sitting in the living room as she bounced her girl in her lap.

"Starting January," I said.

She sang the theme song to "The Twilight Zone" and we laughed. She asked for a smoke and I shook one out. It was a gorgeous day. I had forgotten how the ocean steamed when the temperature dropped. I wondered how Tab was doing. I considered calling her, to tell her about my plan to get my life back together. I couldn't believe I was actually going to try grade eleven again.

"No shit," Dad had said when I told him. He was sitting at the kitchen table with Mom.

"No shit," I said.

Dad gave me three weeks. Mom said a month, just to be stubborn. Erica said I wouldn't even make it past the first week. They shook hands on a ten-dollar bet and I glared at them all.

"If you take summer classes," Jimmy said, grinning, "you can graduate with me. Want to walk up together?"

For my birthday that year, Mom bought a Safeway cake with one big candle and put up balloons. Dad took the day off and said we were going to have dinner anywhere I wanted.

"McDonald's!" I said, laughing at their expressions, and then I declared I wanted dry spareribs from the Chinese restaurant in town. Jimmy met us as we were going in. After dinner, we read our fortune cookies, then they brought out presents. Mom said

that if I didn't like hers, I could return it. The wind chimes were long and silver and had a solemn, mellow tone when I hit them with my fingernail. I grinned. "I love them."

"Thank God," she said. "I have no idea what to get you now that you've grown out of slingshots."

Dad gave me the copy of the monkey mask that Mick had carved. I almost started crying and he patted my shoulder, saying he always meant to give it to me.

"Thanks a lot, Dad," Jimmy said, nudging him. "I'd have to give her my kidney to top that. When you look at this, remember me and smile."

I looked at him quizzically, reached into the gift bag and pulled out the ugliest clock I'd ever seen.

"Now you'll get to class on time," he said.

Frank had a job on the Kemano II project. He came in every other weekend and took me to Rosario's. When I asked him if he wanted to come back to school with me, he snorted. "Lisa, I'm making union wages. I got benefits. I'm saving up for a truck—"

"A big truck?"

His grin faded.

"Sorry," I said. "I don't know why I said it. It's—"

"Pooch's dream," he said. He sat back and was quiet for the rest of the meal.

It's amazing what a goal will do. Mine was simple, but not very admirable. I didn't want to graduate after Jimmy did. I plowed through my assignments with an enthusiasm I usually reserved for partying. To say that my teachers were surprised would be like saying Mount Everest is high. When I felt bogged down and

overwhelmed, I pictured myself walking up to get my diploma with Jimmy in front of me.

My head was spinning from all the things I had to memorize. I'd never pushed myself in school before, so I'd never known how distracting it can be. It's hard to philosophize about how crappy life is when you're trying to finish a zillion things at once. Sometimes, late, late in the night when I paused for my smoke and coffee break, I would sit on the patio chairs and stare at the stars. When I started to feel sad, I'd head back inside and hit the books.

I caught up with English easily, but algebra was an absolute bitch. I struggled up to the quadratic formula, then admitted defeat. I skipped two classes before Jimmy found out and asked me what I was doing. I explained that I wasn't interested in school any more; he pulled out my books and perused my homework.

"Are you going to give up?"

I glowered at him. "No."

"Good," he said. "Let's get to it."

He would break down problems until they were little pieces all over the page. He'd explain each piece, and when I grasped it, we'd move on until the problem was solved. I hated it the first night, found it completely galling, but admitted secretly that the mysteries of math were unfolding.

Not that Jimmy had given up partying. His date of the week would arrive at the door, pick him up and he'd be gone. He would stumble home, late at night, fall into bed and wake up grouchy. Mom and I liked to guess how long it would take him to go through all

the girls and have to start dating in Terrace. But he wouldn't call Karaoke.

≈

On one of my smoke runs to the mall, Frank strolled towards me, his clothes a little too tight from the weight he'd gained. We chatted, and he said he was taking off for Vancouver soon to look for a truck. I wished him luck and he wished me luck with mid-terms, then he asked if I wanted to go to a party. "Karaoke's birthday. We're going to try to have a quiet one this year."

"Sure," I said. "Can I invite Jimmy?"

"Go ahead. The more the merrier."

After dinner, I asked Jimmy if he wanted to come, and he ran for the shower, then frantically blow-dried his hair and then spent a half-hour picking out his clothes and another half-hour dithering over which pair of running shoes to wear.

"You're worse than Erica," I said.

"God, God," he said, suddenly grabbing the car keys. "Got to get a present, got to get a card."

"Jimmy! We don't have time!" I yelled from the front porch as he sprinted to the car. "We're late al-ready! And nothing's open! Are you going to make me walk?"

He waved as he drove away.

"Thanks a lot!" I yelled.

The party was at Frank's brother's house in one of the new subdivisions. Bib greeted me at the door and gave me a beer. Karaoke was in the living room with her

cousin Ronny, who was resplendent in a tight leather
micromini, and enough earrings and bracelets to set
off a metal detector. Bib shook his head and said
Ronny's parents were freaking because she was now
going through a biker-chick phase. Karaoke and
Ronny were making tequila-puff shooters on the coffee
table and slugging them back as if they were Kool-Aid.

"Kids," Bib said, shaking his head.

"Ah, wise one. How old are you now? Twenty-
three? Twenty-four?"

"I'm a hundred compared to them."

I laughed, turned around and caught Frank watch-
ing me. He came and stood beside his brother, smiling
at me. "I didn't see you come in."

"That's not surprising," Bib said. "You need
glasses like—"

"Like you need a beer," Frank said, handing him
a can. "There's some pot in the kitchen. Karaoke
doesn't want it."

"Hey, thanks, bro," Bib said, winking at me before
he made his way through the crowd. Frank's chin sank
to his neck and his eyebrows crunched together as he
studied me.

"What? Why are you staring at me like that?" I said.

"Like what?"

"Like I did something wrong."

"I'm not."

"Then stop it."

He turned and glared at Karaoke instead. She was
using the empty tequila bottle as a microphone and
belting out a Janis Joplin song. Ronny told him to
crank the tunes or Karaoke would sing again. He

brought out the cake instead and we all sang "Happy Birthday." Karaoke blew out her sixteen candles then grabbed a handful of cake and smeared it into Ronny's face.

"Watch the couch!" Bib roared as they threw cake at each other. "That's real leather! Stop it!"

Frank leaned against the wall, not saying anything.

"I'm going to get another beer," I said.

"I'll do it."

"You stay here and sulk. You seem to be enjoying it." I walked away. I saw some people I knew from school on the back porch and went out to say hi. When I went back inside, Frank was gone. Karaoke was opening her presents, which were mostly booze. She opened every bottle she got and passed it around. I was too irritated to enjoy myself.

The party wound down about midnight. I wondered if Jimmy had chickened out. It would be just as well if he did, I thought, since Karaoke was by now mostly toasted. She leaned against me at one point and said, "Pooch thought you were rea—rea—really special."

"Thanks," I said, turning my head to avoid the fumes.

"Josh-u-wa, wa-wa does too. He says you remind him of Mick, Michael, Michelle, elle."

"Okay," I said, trying to push her off. "That's great. Thanks."

"You know," she said. "I'm gonna kick his ass one of these days."

"Good," I said, not caring who she was talking about. "I think he's over there. Go get him."

Jimmy came through the door a few minutes later.

He had two dozen long-stemmed red roses. He made a quick survey of the room, spotted me and casually strolled over.

"Where on earth did you get those?" I said.

"Rupert."

"You're kidding."

"Is she still here?" he said, peering around.

"Technically." I looked into his very earnest face and pointed in the direction I'd last seen her go. I silently wished him luck. A few minutes later, I heard an unholy chorus of shrieks from the backyard. When I looked out the window, Karaoke and Ronny were pouring him tequila shots. Bib started kicking people out at one-thirty. I waited around for Jimmy to give me a ride home, but had to walk when I couldn't find him.

I had the worst headache. I took three aspirin and waited for the throbbing in my temples to ease. I drifted off when the sky started to lighten to grey. In my dream, Ma-ma-oo and I were driving in Mick's truck down a logging road. She had her berry bucket on the seat beside her. We drove farther up the mountain until the trees started scratching the roof and sides. She pulled the truck to a stop and said, "Find mimayus."

He didn't come home that night. Mom was pissed because he was supposed to take her to Terrace. Her mood wasn't going to improve when she found out he'd ditched her to boogie with Adelaine, a girl who got her nickname from drunkenly monopolizing a karaoke machine with a switchblade. I wondered what Karaoke would do when Jimmy broke up with her. He said most of the girls knew when they met him that he

wasn't in it for anything serious. I wasn't sure if he understood his effect on women. Still, she didn't seem to be the kind of girl who would mourn for too long.

Jimmy still hadn't come home by evening, and Mom began to worry. She sat at the kitchen table until Dad came home, and then they sat together. I went over to Uncle Geordie's and asked to borrow his car.

The road turned off the Terrace highway near the municipal dump and snaked into the mountains. At first, the road was wide enough to turn around on, but then the trees crowded close and bushes sprouted along the centre. It was much more overgrown than when Ma-ma-oo had brought me there. The sun set. As I went farther up, I wondered if the dream had just been a dream, when I saw the sparkle from a fire up ahead. Jimmy stood in the centre of the road and waved. Behind him, Karaoke sat on the trunk of the car, wrapped in an aluminum emergency blanket, and rubbed sleep-encrusted eyes.

"Jesus," Jimmy said. "How the hell did you find us?"

"Mom's going nuts. Come on, get in."

"Hey," Karaoke said.

"Evening," I said.

Jimmy was in a gentle, silly mood, and that was out of character for him these days. He opened the back door for Karaoke and she clambered in, still wrapped in the blanket. He slammed the door shut and got in the other side. I backed the car up to a spot where the logging road widened. Jimmy put an arm over Karaoke's shoulders. She rested her head against him and slept for the whole ride back. Jimmy brushed a stray lock of hair off her face.

Mm-hmm, I thought as the car came to the turn-around place. I maneuvered the beast slowly around and we bumped down the mountain. Every few minutes, I'd peer into the rearview mirror and watch Jimmy watching Karaoke.

≋

The day I sketched my last art assignment, I decided to make dinner. Since I hadn't cooked anything in years, I decided to stick to rice, canned fish and seaweed. I bought a cake at Safeway and stuck a Congratulations! candle on top. Jimmy asked if he could bring Karaoke. Still high from surviving the first half of grade eleven, I said enthusiastically, "Sure!"

Mom and Dad exchanged a glance when Jimmy told them Karaoke was coming over. They sat beside each other at the table. We waited for her to show up. Jimmy stood by the window. I picked the skin off the salmon. Dad liked all of the salmon mushed together, but the rest of us could handle only the smaller bones and the dark flesh. As I was mixing in the mayonnaise and fancying the salmon up with pickles and carrots, Jimmy snapped to attention and I knew he'd seen her. He had that flushed, nervous look. When he opened the door for her, his smile was so bright that it could have powered a solar car.

Karaoke herself was looking pale. She came in quietly, nodded to everyone and sat down, staring at her plate as if she expected to be chopped up and eaten herself. Jimmy made loud small talk about the weather.

"Well, it's ready!" I said, bringing the rice and fish to the table.

"I don't believe it," Dad said, sitting back. "You cooked."

"Three years of home ec and I think I still burned the rice," I said.

"Mmm," Jimmy said. "It's crunchy too."

Mom and Karaoke were quiet through the whole meal. I think this was probably the smartest thing Karaoke ever did. Mom warmed up to her enough to ask if Karaoke's mother was okay. Karaoke nodded. She excused herself from dessert, saying she had to watch her weight.

I lit my candle and blew it out, glad that Mom hadn't insulted Jimmy's new girlfriend. If she had, Jimmy would've spent the summer not talking to her. Karaoke wandered out onto the back porch for a smoke. I went up and stood beside her. She stared out at the grass. "We used to live here. Our old house was a few feet away from your smokehouse. All this was marsh. In the summer, you could hear the frogs."

"I remember that," I said. We smoked. Jimmy came and leaned over Karaoke. They began kissing, so I went back into the kitchen and helped Mom load the dishwasher. She pursed her lips.

"Looks like you're going to get grandkids after all," I said.

"Bite your tongue."

"Love is blind," Dad said, pouring himself a cup of coffee. "I married you, didn't I?"

She gave him a withering look. "Men."

"You weren't exactly an angel yourself," Dad said.

"Maybe a snow angel," I said.

They looked at me, startled. Dad grinned.

"Who've you been talking to now?" Mom said, irritated.

"Mick told me. He said you got toasted and made snow angels on—"

"*Na'*," she said. "Mick and his big mouth."

"How long ago was that? Thirty years?" Dad said, kissing her.

Mom decided to scrub the stove. Recognizing the signs, I left the kitchen and headed back to my room. As I sat at my desk, I wondered how serious Jimmy was about Karaoke. With all the other girls, they did the phoning, they did the picking up and dropping off, they arranged the places to meet. Jimmy simply went along with them. Karaoke hadn't called once. He called her every night. He went over to her house and drove her around. The weeks turned into their one-month anniversary. Mom's expression went sour when he mentioned her name, which was every five minutes when he was home.

≋

Spring came and went and as summer loomed, I wanted to get back out onto the water. I'd missed my bump-around days and had a hankering for crab fresh from the pot and halibut straight out of the ocean. Uncle Geordie helped me fix up the speedboat. It hadn't been used for years and needed a new paint job. We pulled it out of the water to scrape the gunk off the bottom. He shook his head when he saw the motor. "I

don't like it. This is an old boat. You should have a twenty-five-horsepower outboard at the most. Thirty-five is too powerful for this old girl."

"Oh, we've used this motor for years," I said. "It'll be fine."

He showed me the engine, gave me an oar and a lifejacket and said, "Be careful."

On our first test drive, he drove us around the bay. The first of the little kids were bouncing off the docks. One of them dived into the water and I watched until his head popped out of the water and he screamed at his friends to wait for him.

≋

Frogs croak to potential mates as darkness settles over the village. Their love songs grow loud enough to drown out the distant hum of Alcan. The frogs hide in the tidal flat grass that hisses and bends in the early-evening breeze. The water laps the shore, hesitating before the tide turns. In the distance, the sound of a seiner.

≋

Crows land on the beach, down the way from me. They peck at the empty shells. They are not alarmed by the whispering from the trees. I stand by my boat, my forgotten bailer in my hands. I'm soaked. I don't know what time it is, and don't want to lift my arms to check.

"We can help you," a voice says. "Give us meat."

≋

T'sonoqua is not as famous as B'gwus. She covers her-self in a cloak and pretends to be an old woman. She will ask for your help, feigning a helpless shake in her hands as she leans on her cane. If you are moved to go close enough for her to see you with her poor vision, she will straighten to her true height, and the hands that grip you will be as strong as a man's. She is an ogress, and she won't let go because, to her, human flesh is the ultimate delicacy and young flesh is espe-cially sweet. But discredited scientists and amateur sleuths aren't hunting her. There are no conferences debating her existence. She doesn't have her own beer commercials. She has a few amusing notes in some anthropology books. She is remembered in scattered campfire tales. But she is, by and large, a dim memory.

I pieced together three of her stories for the final English essay of the year. It was due in two weeks, but it was supposed to be ten pages long and I had only two. I wanted to get it out of the way so I could concentrate on math. I had to modernize a myth by analyzing it then comparing it with someone real, and had got as far as comparing her with Screwy Ruby.

Jimmy was pretty mad when I brought him here. He was a busy guy, things to do, people to see. I didn't know Karaoke had left Kitamaat until he started smashing up his room, throwing things off the walls.

"Don't," Mom said when I started up the stairs. "He was like this after . . . the accident. It doesn't help, Lisa. Just leave him alone and he'll settle down."

I didn't believe her. I had no doubt about going into his room, even when I saw his strained, red face as he hurled a lamp against the wall. "Get out!"

"Hey, hey, hey, back up. What's wrong?"

"She left. She left. She left."

No need to ask who. "What did she say?"

"She didn't say anything. She packed her things and took off and she didn't even say—"

"Did you have a fight?"

"No." He wiped his nose on the sleeve of his shirt. "No fight. Nothing. She just left."

"Do you know where?"

He shook his head miserably.

"Maybe she's in Terrace."

"She's gone. She hitched to Prince George. She left me."

"Look, don't take it personally. She's got her own troubles. Did you think of that?"

"I thought she loved me. I really did. How stupid . . ."

"Give her some space, Jimmy. Maybe she needs to blow off a little steam. I'll bet you a hundred bucks she'll be back. Here's my hand. If you don't believe me, shake on it."

"What you looking at?" Jimmy said as I stared at him the next morning after we'd awkwardly said hello. He didn't look like much of a catch right now, with his bleary, puffy-eyed hangover.

"Is that a beard?" I said.

He scratched his chin. "Maybe."

"Good," I said. "I was afraid it was just blackheads."

"You're so funny."

"You're a laugh a minute yourself this morning," I said.

"Fuck off."

I punched his arm. "Tough guy. You ready to go a few rounds? Come on. Up and at 'em!"

He stormed out of the kitchen and I heard his bedroom door slam. I never thought I'd see Jimmy look that angry. I sat at the table and pushed my Cheerios around. I had no idea what I was supposed to do. I went and knocked on his door anyway.

"Piss off," he said.

"Come on," I said. "Open up."

"I said piss off."

"I'm going to sing. I'm serious."

He didn't answer. I took a deep breath and belted out, "A million bottles of beer on the wall, a million bottles of beer! Take one down, pass it around, nine hundred and ninety-nine thousand, nine hundred and ninety-nine bottles of—"

He ripped the door open and shouted right into my face, "Why the hell did you come back!"

"Good," I said, pushing past him into the room. "You're awake."

He grabbed my arm, pulled it up so I was standing on tiptoe then marched me out of his room and slammed the door in my face.

Well, I thought. There goes my counselling career.

Jimmy might have been partying his ass off, but he didn't look like he was having any fun. For the first week after she left, he moped around, his grim and unapproachable expression not deterring any girls from hanging off his arms. I'd never appreciated the merits of having a good-looking brother before. I was intensely popular at parties because girls were trying to get close to Jimmy through me. They went out of their

way to be friendly. I found it ironic that now that I'd decided to sober up, free drinks and invites to parties were practically being pushed into my hands.

The Olympics started. I watched the opening ceremonies. I found Jimmy at a party. Frank had got an arm under Jimmy and was steering him to the front door.

"Jimmy?" I said.

I had a flutter of nerves as I smoothed down my hair, caught Frank watching me, tried a smile. Frank cleared his throat. "He's getting heavy."

Jimmy thrashed around. He had the skanky smell of someone who's been partying too hard to worry about personal hygiene.

"Where do you want him?" Frank said, opening his car door. Jimmy rolled his head and swore at us.

"Jeez," I said, looking up at the house. Mom and Dad would freak when they saw him like this. Inspiration hit and I ran inside to get the boat keys. "Wait here."

I scribbled a hasty note saying Jimmy and I had gone fishing for a few days. I didn't really have a plan. I just wanted to get him alone and away from his party friends long enough for him to sober up. I grabbed some food, the extra tank, a couple of blankets and some matches.

"You're fucking nuts," Frank said when I told him to drive us to the docks. He carried Jimmy down to the boat for me. I was afraid Jimmy would wake up before I could get the boat going, but he was so passed out that he slumped over his seat and started snoring. "You sure you're gonna be okay?"

I gave him the thumbs-up and told him to cast us off. He grinned and shook his head, but untied the rope anyway.

At first, I was going to take Jimmy to Kemano, but after thinking about it a bit I knew that wouldn't work. If there were any people around, Jimmy could get a ride back. The whole point of this was to get him alone so he couldn't storm off. I'd heard about a camp of some kind being set up in Kitlope too, so that was out. Then I remembered the trip we took when we were kids, when Jimmy had wanted to take pictures of sasquatches, and I thought, hey, what a kick if he wakes up on Monkey Beach.

The water was flat all the way to the beach, but Jimmy woke up fifteen minutes away from it and I had to stop so he could vomit over the side. He stared around, head bobbing. He wiped his mouth, then tried to stand up.

"Hey!" I said. "Easy, easy, or you'll tip us over!"

He flopped back in his seat, eyes glazed. When he closed his eyes, I started the engine again. He didn't wake up as I dragged the boat up the sand and I unloaded the gear. As morning turned into afternoon and afternoon sank towards evening, he still sat in the boat, chin tucked into his chest, oblivious. I set up camp above the waterline and sat on the sand, waiting for him. The tide was coming up. Ravens argued in the trees. A plane broke the blue of the sky with its tiny white exhaust streak. After it passed overhead, I could hear the whine of its engine. I'd forgotten to bring any bug repellent, and as the sun began to set, the mosquitoes came out. Jimmy woke up with

a start, slapping his face. I reached down and lit the kindling.

"Where're we?" Jimmy said. At least, I think that's what he said. He wasn't quite sober yet, but fear was doing a good job of jolting him awake. He slowly made his way out of the beached boat and staggered up the sand to watch me get the fire going.

"Evening," I said.

Jimmy slapped his arm. He stared at it. The mosquito had left a smear of blood on his arm. "Jesus."

"You hungry?" I said. "I brought some marsh-mallows."

"Marshmallows."

"Little fluffy white things that you put on the end of sticks."

"Is this a joke?" Jimmy sat in the sand beside the fire. I handed him a stick I'd whittled, with a marsh-mallow stuck on the end. He shook his head and gave it back to me. "I need a drink."

"Coffee or water?"

He glared at me.

"That's all I got," I said. I roasted the marshmallow until it caught fire, then waited until it was practically hanging off the stick before I blew it out and ate it. Jimmy lay down and passed out again. I took a life jacket out of the boat and stuck it under his head, then put a blanket over him. He muttered thanks.

It was so quiet that I could hear the clams spitting. I hunted around in my bag for my cigarettes. I lay back against the sand and watched the stars and smoked. As the fire died down, I realized I'd forgotten how dark it got out here. The stars popped out of the

blackness. A falling star streaked down behind the mountains. I closed my eyes and hoped my brother would smarten up.

Jimmy shook me awake. "The engine won't start."

"What? What?" I said, sitting up. It wasn't even light yet. I shivered and wrapped the blanket around my shoulders.

"The engine," Jimmy said slowly. "Won't start. Get up. Get up and get us the fuck out of here."

"Go 'way," I said, pulling my blanket over my head and sinking back into the sand.

"Lisa!" Jimmy shouted. "Get up! Now!" He ripped the blanket off and yelled at me to get up. "Fine. I'll start it myself." He got in the speedboat and I listened to him cursing and yanking at the motor's cord. His swearing stopped suddenly. I raised my head and squinted at him. He was looking at his hand in disbelief. A string was dangling from it.

"Um, Lisa?" he said. "Do we have any tools?"

I sat up. He guiltily showed me the cord.

"Oh, that was smart," I said.

He threw the cord at me. It landed near my foot. He stomped off down the beach.

"God," I said, watching his shrinking back. He kept going until he reached the isthmus, then he went over the hill and disappeared. I looked down at the cord. Another one of my brilliant plans down the tubes. Get him away from everything and of course he'll spill his guts, and I'll come up with some answer and solve all his problems and mine, create world peace and still have time to get my shit together to start school.

I put the cord back in the boat. First things first. I opened the thermos of coffee. Cold. I'd used up all the wood last night and for the moment was too lazy to collect more. I sipped the coffee straight from the thermos and nibbled on crusty marshmallows. I'd left the bag open and they were a bit stale. When I shook the bag, there were no bugs in it that I could see, so I figured it was safe.

Jimmy came back while I was prying the motor open with a butter knife.

"Can you fix it?" he said.

I glared at him.

He hovered over me as I lifted the cover off the motor. There was a frayed piece of rope in what looked like the inside of a giant yo-yo. Jimmy handed me a Swiss army knife.

"Where'd you get this?" I said.

"Who cares? Just fix it!" he said.

I trimmed the cord and threaded it back where it looked like it had come from. Jimmy breathed on my shoulder and I gave him another look. He backed up two steps, still watching me hopefully.

"Where'd you learn to fix engines?" he said.

"Does it look fixed?" I said. "Jeez, you're going to jinx it."

The corner of his mouth quirked.

The mosquitoes from yesterday came back for refills and brought some of their friends along. I pulled a blanket over my head, leaving only my eyes and hands available. Some of the more determined buggers snuck up my pant leg or just bit through the blanket.

"Where you going?" Jimmy said when I stood up and started walking towards the bushes.

"None of your damn business."

"Aren't you going to fix—"

"I'm taking a piss, do you mind?"

He swatted the cloud of mosquitoes in front of his face. "Don't yell at me. You got us into this."

"Yeah, I forced you to wreck the motor."

"You brought us out here in the first place."

"So sue me." By the time I reached the bushes, I realized I hadn't brought any tissue paper. I picked some leaves, checked them for bugs and wished I had an ounce of sense.

"Is there any more food?" he asked when I came back.

"No," I said. "That's it."

"A can of Spam and bag of marshmallows."

"You don't like it, you don't have to eat it."

"That's all you brought?"

"We were supposed to stay only one night." I lit up a smoke and puffed at the mosquitoes.

"Can you get on with it?" he said, waving his hands at the motor.

"When I'm good and ready, buster."

"Some of us have lives, you know."

"I'm pretty sure there'll still be booze around when you get back."

"You're one to talk," he said.

We were both furiously silent for about five minutes. Jimmy paced back and forth, arms crossed over his chest, fingers tapping against his elbows. I finished the first cigarette and started another one. Jimmy saw me lighting up and said, "Get in the boat."

"And do what? Paddle back?"

"Yes. Yes, if that's what it takes, we're going to paddle back."

"There's only one oar," I said.

"Get in the boat!"

I blew smoke in his direction and deliberately sat down. He took off his shoes, his socks and rolled up his pants. He untied the towline, waded out to the boat, hopped in and searched around for the oar.

"Look on the side," I said.

He brought the oar up and poled the boat out to deeper water.

"Jimmy," I shouted as he started rowing towards Butedale. "You're going the wrong way."

"You are the biggest pain in the butt in the history of pains in the butt!" Jimmy shouted back.

"Fine! I've got nothing to say to you either!" I furiously power-sucked my cigarette.

Jimmy struggled with the boat until his arm gave out and the tide brought him back to shore. I peeled the label off the Spam tin, poked a hole in the side, stuck a stick in it and roasted it over the fire. Jimmy stomped down the beach to stand beside me, waving the mosquitoes and horseflies and no-see-ums away from his face as if it would help.

"You're not going to eat that, are you?" he said. "Do you know what's in there? Do you realize what it's made of?"

"Then you don't want any?"

"Ugh."

"More for me," I said.

I offered him half the tin when it was warm. He

stared at it, nibbled a corner, then dug his fingers right in and wolfed it down. Two days of nothing but marshmallows, berries and cold coffee were enough to make anything taste good, he said. Tomorrow we could get some crabs or a fish, some halibut maybe. There were jigging lines in the boat. We could be eating like kings if he hadn't farted around for so long, but I knew better than to say it out loud. Jimmy was mad enough as it was.

We were getting ready for bed when we heard a stick crack somewhere in the darkness under the trees. We stopped unrolling the blankets and looked at each other.

"Did you hear that?" Jimmy stage-whispered.

"Probably just a bear or a—"

"Just a bear. Oh. Is that all?" Jimmy said. "I feel better now."

"Relax. They're more afraid of—"

"Shh."

"If it's a bear," I said, "We should let it know we're here. Helloooo! I'm Lisa and this is my brother, Jimmy! He'd really appreciate it if you left—"

Jimmy grabbed me and clamped a hand over my mouth. "Shh."

I bit his hand and he howled. If any bears were around, they would have taken off running. I didn't really think there were any though, and when we went to find berries the next morning, the patches were picked over and I couldn't see any bear shit anywhere; since it was near the end of the summer, they were probably all salmon fishing right now.

Jimmy hopped around like I'd poured boiling oil

over his hand. I put my hands on my hips. "You big baby. I didn't even break the skin."

He showed me his hand, momentarily speechless. There was a bright red mark where my teeth had been.

"Well, that's what you get for being mean," I said.

"That's rich, coming from you." He turned his back to me and lay down. I was down to my last two cigarettes. He turned back and held his hand out. I took mine, then his and handed it to him.

After a while, he said "What was Vancouver like?"

"Sad," I said. "But I was pretty bummed."

He tilted his head. "I never understood why you missed them so much. Mick was a nut and Ma-ma-oo was a cold fish."

I punched his arm. "How can you say that?"

"It's true! Mick was always doing something crazy and I never saw her crack a smile."

"You didn't know them. You were too young. I don't know what you see in Karaoke. Have you ever seen her fight?"

He grinned. "Yeah. Wicked, huh?"

"Men," I said, mildly disgusted. There are limits to what you want to know about your brother.

"She's smart, too. She knows all about the stars. See that, right there? That's Cassiopeia. And that's Ursa Major, and over there, that's Ursa Minor and the North Star."

"Karaoke knows astronomy?" Disbelief did not even begin to cover what I felt.

His grin faded. "I don't know. We never talked about it."

I sighed. "Now I'm jealous of you all over again."

"Oh, yeah. I've got the perfect life."

"No, I mean it. You're in love. I've never been in love. Sure, it bites at the moment, but give it a few years and you'll be laughing about this."

"What about you and Frank?"

"We're just friends."

"Come on—"

"And if you marry her, we'll be in-laws."

"Well," he said, "you don't have to worry about that now."

I lay back against my blanket. I thought he was asleep but he said, very quietly. "I used to think you were weak. I mean, everyone has people die on them and they don't . . . give up. But all it took was my shoulder and I quit."

I didn't look at him. I kept staring straight up at the stars. "It was your dream. I think it's harder when they go."

"I dunno. Everyone tried so hard. Do you know how much money they spent on me?"

"Did you actually add it up?"

He sighed. "Yeah. Do you have any more smokes?"

"Sorry. Those were my last ones."

"That's okay." He shifted, putting the life jacket under his neck. "I was kind of relieved when it happened. It was like an out. I kept thinking, what if I fuck this up? I used to have nightmares where I was halfway through the pool and everyone was passing me and I kept getting slower and slower."

"Huh. All this time I thought you were having fun."

"I was. In the beginning. Then it stopped being fun and started being about not fucking up."

"Did you tell anyone?"

"Like who?"

"Mom. Dad. Anyone."

"Nope."

"Well," I said. "You're talking to the queen of fuckups and you'd have to do a lot more to take my crown away."

He reached over and kept giving me nudges until I looked at him. "You weren't that bad."

"You weren't the one that ran away."

"You're back now. You're dealing with things. I didn't understand what it was like to lose something. Now that I do, I think you're doing fine. I mean, Karaoke didn't die on me. She just dumped me and I flipped. I don't know what I'd do if someone actually died on me."

I laughed. "You call that flipping? That was a little spaz."

"Yeah, well . . . "

We drifted off in a comfortable silence.

We had visitors in the morning, two sea otters rummaging through the empty Spam tin. Jimmy opened one eye, then both, then hollered. The otters scampered down the beach and dived into the water, poking their heads up to watch us from a safe distance.

"Why don't you be useful and get us some crabs," I said.

"You want crabs, you get them."

"Fine. You can work on the motor."

He whipped his blankets off, shook them out with more energy than necessary and tidied up before he said, "Where are the crab pots?"

"Just run after them with a net. Or do some fishing. I don't care what you bring me as long as it's dead and cooked."

Jimmy heaved a great, put-upon sigh. He rolled up his pants and waded gingerly into the water. He took off his shirt and splashed himself, then scrubbed his face. I rolled off the sand, my back aching from sleeping at an awkward angle. I wanted to go home and have a nice hot soak in the tub. While eating a big slice of apple pie and ice cream. Instead, Jimmy triumphantly produced two smallish crabs. We stared at them.

"Well?" Jimmy said. "Now what?"

"Start a fire," I said.

"How?"

I thought he was just being lazy, but he really had no idea how to make a fire. I went through the basics, and he enthusiastically built one capable of keeping an entire village warm. I vaguely remembered that we could roast the crabs in a pit, but I suggested that we barbecue them instead. Jimmy squeamishly killed them, then skewered them with the marshmallow sticks. They were slightly singed, but still better than Spam.

I put the motor back together before sunset. Jimmy wanted to hop right in and take off. I said we could go only if he developed infrared vision in the next five minutes, because if we left now, we might as well kiss our asses goodbye.

"I don't care," Jimmy said.

"I like breathing," I said. "And I want to keep doing it. You want to go kill yourself, go ahead. I'm not stopping you."

"What the hell were you thinking?" Jimmy said for the hundredth time.

I lay awake with the stars revolving overhead, the fire dying and Jimmy snoring beside me. The moon, a sliver of white light, rose a hand above the horizon, then, tired, fell back. The purple blackness overhead faded into grey, the grey into pale blue; this was followed quickly by pastel reds and oranges, and finally, yellow rays streamed through the trees as the sun climbed. The water was a muddy green from the spawning clams. Sea otters chittered as they spun, playing in the kelp. At the end of the beach, I saw what I mistook at first for a large grey dog but realized was a wolf. It padded to the edge of the water, sniffed, swung its head to examine Jimmy and I, then loped back into the trees.

That morning, Jimmy woke with a groan. He sat up, and when he saw me grinning at him, he grumbled, "Sasquatches didn't carry you away in the night. I'm disappointed."

"Maybe they smelled your cooking," I said.

"My cooking? Point that finger at yourself, Spam Queen."

His sarcastic cheeriness lapsed back into grumpiness, and he began answering me in an unhappy monotone again as we pushed off and left Monkey Beach. I tried to point out the things Ma-ma-oo had pointed out to me, but he said we could skip the tour.

A pod of killer whales lived in the Douglas Channel at one time. They stayed there all year long. People thought of them as another family who lived in the area. I'm sure they had names for them. Sometime around the turn of the last century, however, some

whalers came and killed them all. Once in a while, a stray whale or two will still come poking around up the channel, turn around and leave.

On the way home, Jimmy saw the spout. He told me to shut the motor off, but I was afraid that if I did, we wouldn't be able to get it going again. Then I saw the dorsal fins.

"Orcas," Jimmy said.

They were coming straight towards us. I froze. They were so big. They slid alongside our boat, ignoring it, sleek black bodies with white spots shining in the water like glow-in-the-dark stars. One slid by the boat, its fin coming up to my waist as it broke surface and lifted the boat slightly, tilting it so that we rocked. It was longer than our boat, longer and almost as wide. Jimmy kicked off his shoes and jumped in.

"Are you crazy!" I shouted. "Jimmy!"

I thought they would eat him but they moved by him like they didn't see him. They passed us and Jimmy hit the surface of the water, trying to get their attention. He dived. When he came up, he shouted, "Come in! Come see this! You've got to come see this!"

I said, "Get back in the boat, Jimmy."

He wouldn't get in until the whales had passed, and then he wanted to follow them. He sat with his teeth chattering and his clothes dripping over everything. I wouldn't let him have the motor. The whales left the channel.

"You should have come in," Jimmy said. "You don't know what you missed."

I hold him there in my memory, smiling, excited, telling me how they moved like submarines, and how

the water looked so much more magical when they were swimming in it.

≋

I jumped when I heard a heavy crash coming from Jimmy's room. I went over to investigate and found him packing his trophies and medals into file boxes.

"What'cha doing?" I said.

"Clearing out the trash," Jimmy said.

Dad had beat me to the room and was trying to take the boxes from Jimmy. "You're going to throw them away? Are you sure you want to do that?"

"I'm moving on."

"Why don't you just put them away? Here, I'll help you put them in the attic."

"Yeah," I said. "You have to keep something to bore your grandkids with."

I was anxious for him to move on too, and hoped his next step would involve letting go of his noisy crows.

"If you aren't swimming any more," I groused over coffee, "you don't need their luck, do you? Why do you keep encouraging those stupid things?"

"Did you know that crows have the biggest brains for their body size of all the birds around?" As I watched him over the rim of my coffee cup, I carefully said nothing as he rambled on about the virtues of the biggest brained member of the Corvidae family. Instead, I pictured him with kids, and imagined that he would probably get beat up by other parents for bragging about his offspring.

"I'm going to set up a research centre to study them," Jimmy said.

I chuckled. "Yeah, right."

He started to pace. "I've already decided, this is what I want to do. I have a new direction. When my arm snapped, I thought that was my whole life ending, but it's just starting. Do you know how free I feel? I feel like everything's just opened up. Everything. The sky's the limit!"

I smiled uneasily. "Good."

"I wasted hours—no, days, days—in that pool going back and forth and back and forth. You have no idea how much time I put into that part of my life. It was like I was possessed."

"I remember."

"You don't know what it was like. No one who hasn't done it knows what it's like. I'm better off without it. You know it, I know it. I'm having fun now. I couldn't have fun before. Everything was so serious." He enthusiastically slapped my shoulder. "Now I'm letting loose!"

Ah, sweet denial, I thought.

≋

Two weeks before Karaoke came back, I had a dream about Ma-ma-oo. I saw her sitting at her kitchen table. She had a dark purple bruise covering her left cheek and smaller bruises on her arms. Ba-ba-oo was singing in the shower. A thud came from the bathroom and then there was silence. But instead of moving or asking if everything was all right, she sat and

gripped her mug of tea tightly between her hands. I heard the sound of water hitting the tub and the shower curtain. "Nothing's wrong," she whispered, even when the water seeped under the door. "Nothing's wrong."

I snapped awake. I reached for my smokes and went downstairs to the back porch. The crows were flapping around the railings, squawking when I shooed them away. I leaned against the railing and stared out at the channel. I was on my third cigarette when Jimmy's favourite crow, Spotty, landed beside me. I looked at her, then back at the ocean. I saw something small floating in the water, stuck in the long, half-submerged grass near the shore.

The water glistened like green silk as the morning light slanted over the mountains behind the reserve. It came then, a light touch on my shoulder. No one was near me. Out on the water, a dark head bobbed. The seal rolled twice, creating ripples that distorted the reflection of the mountains. Then it dived and the water smoothed. I was walking down to the beach. Something in the water was drifting out with the tide and I didn't want the seal to get it. I thought it might be a cat, but the closer I got, I knew it wasn't. For a moment, it looked like a baby in a christening outfit. But when I was a few feet from it, it was just a bucket.

"Lisa! Lisa, what the hell are you doing?"

I was standing waist deep in the ocean. I could feel the cold, was aware that I was cold, but it didn't bother me. The bucket sank slowly in front of me. I should catch it before it's lost, I thought. I couldn't remember wading in. My clothes were heavy with water.

"Lisa!" Jimmy said, running down the path. "What are you doing?"

He was alarmed by something I was doing. I could see this but couldn't understand it. I reached for the bucket, felt it bump against my legs. My arm went numb as I plunged it under the surface. I had trouble grasping the handle. Something caught my ankle then and yanked me under.

I remember looking at Jimmy from under the water. He grabbed me by the arm and pulled me up. When we were back at the house, he put a blanket over my shoulder. Mom made coffee. Dad asked if I wanted to go to the hospital.

"What were you doing?" Jimmy kept saying.

"I don't know," I said. "I really don't know."

≋

Jimmy didn't want me to be alone. If he couldn't get Mom and Dad to watch me, he baby-sat me, dragging me to some bad summer movies, giving me help with my finals or driving me everywhere, talking to fill the long silences. One night we ended up on Alcan beach, looking across the channel at the lights of Kitamaat Village twinkling against the blackness of the mountains. We sat on the hood of Dad's old car, leaning back against the windshield, smoking.

"You know what was weird?" he said.

"About what?"

"When you went into the water, Spotty woke me up. She was flapping against the window like she was trying to get in."

"Yeah?"

"Yeah."

Finals approached and I started to cram. Jimmy seemed to think I was okay, so he began to leave me alone. I didn't know Karaoke was back until I saw her with Jimmy; they were holding hands as they walked. I almost stopped the car and offered them a ride, but they were absorbed in talking and I didn't want to butt in. It looked like they had picked up right where they left off.

Someday, I thought, I want someone to look at me like that, like there's no one else in the world.

Erica told me Karaoke had stayed in Vancouver at her aunt's place, where she—depending on the rumour you listened to—had another boyfriend, or was selling drugs, or herself, or in court getting charged with murder, or getting an abortion, or joined a Hell's Angels gang, or—my personal favourite—had become a nude model.

Jimmy dragged me out of bed at five in the morning. While I was still half-asleep, he pushed a box into my hands.

"What's this?" I'd muttered.

"It's for Karaoke," he said.

"Oh my God," I sat up. I opened it. Inside was a slim, gold band with a diamond so small that I had to squint to make sure it was really there.

"Promise ring," Jimmy said.

"What kind of promise? That the next one will be bigger?"

"You're a big help," he said.

"Just kidding," I said. "So you're going to ask her to get hitched?"

"She makes me feel like . . . like," he stopped, frustrated.

"Like a king?"

"No. Yes. When I'm with her, I'm a better person. I'm not a fuckup with her. No, that's not right. I'm strong. I'm fast. I can leap tall buildings in a single bound."

"So you're asking her today?"

"No. It has to be right. I've got it all planned. I'm going to take her to this field. There's all this fireweed there where we had our first real—" He paused. "Date. Do you think she'll like it? Is it really too small?"

I pushed myself up and gave him a peck on the cheek. "She'll love it."

At breakfast, he asked Mom how much a wedding cost. Not a cheap one either, he insisted. A real one— the church, invitations, renting the rec centre and a live band, everything. After she choked on her toast, she said a minimum of five thousand dollars.

"Oh," he said. Then he rallied. "I don't care. That's what I want."

Dad piped in that he could probably get Jimmy into Alcan if they applied right away, and they started to work out how long it would take for him to save enough for a wedding.

"The bigger the wedding," Mom muttered as we did the breakfast dishes, "the faster the divorce."

"Don't get your hopes up," I said. "He's got it bad. Just think about the grandkids you'll be getting. Lots of bouncing little babies."

"Well, it's your turn now," she said. "When am I going to see you settle down?"

"Mom," I said.

"I know, I know. You're young now. But you're not getting any younger, you know."

I watched Jimmy and Dad at the table, working through the figures and I thought, Thank God at least one of us is getting a happy ending.

≈

The greengage tree is a shadow against the morning light. I shade my eyes with my hand as I walk down the steps of our front porch. A large flock of crows is perched in the branches, silent and shifting anxiously, but when I get close, it lifts like a dark cloud, blocking out the sunlight. The crows wait on the roof of our house.

≈

I can't move.

"Lisa," they say.

"Come closer," the first voice says.

"Just listen to us. Come over to the trees."

They've been calling to me, but I don't know for how long. I know I should get in my boat and ignore them. I know I should leave. If I stay any longer, I'll be at Namu tomorrow morning and Mom and Dad will worry. But if the things in the trees can help me, maybe Jimmy can keep his happy ending. Maybe it wouldn't be so bad, just this once. I reach into my bag and dig around until I find my knife. When I pull it out, the voices hiss into silence. A crow begins to caw.

It's a gutting knife, an old one that Uncle Geordie gave me to help carve up fish. He sharpened it himself. It has a wooden handle worn smooth with use, and a small spoon at the end, to scrape out the innards. The blade has been sharpened so many times, it's as thin as a razor.

I walk from my boat up the beach and into the trees. The rain is soft against my face. The grass at the edge of the shore shivers against my legs. Creaking in the light wind, the trees rise above me. The moment I step under the canopy, the world darkens.

I tilt my head upwards. "I don't have any meat. But I have blood."

I wait, but nothing answers.

≋

On the morning of my math final, Jimmy was sitting on the porch when I woke up. He was wearing the same clothes he'd had on the day before. I poked my head out the door. "You want a coffee?"

He shook his head.

Uh-oh, I thought. That was an I've-just-been-dumped look if I ever saw one. "What's up?"

"I'm going fishing," he said.

"Fishing?"

"Yeah," he said. "I've got a job."

"You don't look too happy about it," I said, flopping down in the chair beside him. "What are you going in?"

"What?"

"Seiner? Gillnetter? Troller?"

He shrugged.

I laughed. "Jimmy, you can't even start an out-board motor. What are you going to do?"

"Deckhand," he said.

"I'll believe it when I see it," I said. "You're not serious, are you?"

"Leaving tomorrow," he said.

"God, Jimmy." I was shaking my head. "It's a tough job. Do you know what you're getting into?"

He finally looked at me, mouth tightening, eyes completely black. "Yes."

Mom was thrilled. She told me that her stint on her uncle's boat had made her grow up, and that she was pleased to think Jimmy was following in her foot-steps, earning money. She didn't say this, but implied it—getting away from Karaoke. Dad didn't like the idea, but he went along with it reluctantly.

The day before Jimmy left, Karaoke came to our house. I was surprised to see her. Normally, she avoided our house unless Jimmy dragged her there. She didn't look like she'd been getting much sleep, and I felt sorry for her when she asked if Jimmy was home.

I said, trying to be cheerful, "He's across with Dad buying supplies. Didn't he tell you? He got the job," I said.

Her eyebrows went up. "A job."

"I know. It's hard to believe he's going fishing. He's so spoiled, I think he'll last a week. Thanks for putting in a good word with Josh, anyway."

Her eyes focused on something behind me, and I thought Mom might be coming up the stairs to check

on who was visiting, but Karaoke was just staring through me.

"Why don't you come in?" I said. "Coffee's hot and fresh. I made it strong. Nothing like a strong cup of coffee. I have to show Jimmy how to make it—I don't think Josh's a tea drinker, is he?"

Karaoke still looked stunned. "So he's going on *Queen of the North*?"

"Of course, silly," I said. "We know you pulled some strings. How else could Jimmy get on with your uncle?"

Instead of answering, she turned around and walked away.

≋

The morning Jimmy left, he gave me a hug and said he'd call Adelaine later. We went down to have breakfast. Mom had gone all out. She'd made two stacks of pancakes, a plate of bacon, another plate of scrambled eggs, muffins and toast. Jimmy whistled.

"Wow," I said. "We're going to have to roll you to the docks."

Josh honked his horn to collect Jimmy. He gave me a quick hug and whispered, "Tell her I love her."

"Tell her yourself," I said.

Dad carried Jimmy's gear. Mom had her arm around my waist. Jimmy didn't want us to see him off at the docks. It would make him look like a baby, he said.

The sky was light grey, no stars. We stood around the porch for about five minutes. Mom and Dad

hugged him again, and I wished I was in bed. He got in
the car and Mom started to cry. She kissed Jimmy like
she was never going to see him again. He looked
embarrassed but pleased. Jimmy and Dad shook
hands, then Dad slapped his shoulder.

"I'll be back before you know it," Jimmy said.

Dad nodded. "I know. Good luck."

Jimmy looked at me. "Be good."

"Don't fall overboard," I said.

"Jimmy . . . " Mom said.

As the car drove away, Jimmy rolled down his win-
dow and waved. We all waved back. The crows hopped
and cawed.

I saw Karaoke in the hallway at school. I went up to
her and told her Jimmy was going to call her. She
shrugged. The lunchtime buzzer rang. A bunch of
girls were standing by their lockers, laughing and jok-
ing. Karaoke pulled her fist back and smashed it into
the nearest girl's face. Her front teeth cracked. She
screamed, holding her mouth as blood spurted from
her split lips. Her friends jumped in and twisted
Karaoke's arms behind her back and held her while
another girl started whacking Karaoke's face. She
grinned as if she didn't even feel it.

"Chick fight! Chick fight!" a guy yelled, and a
crowd gathered to watch. I started to push my way to
the front, but the kids around us cheered enthusiasti-
cally. Karaoke went down, kicked and pummeled by
the girls until two teachers pulled them off her and
took her to the hospital. I tried to catch a ride to the
hospital and talk with her, but by the time I arrived,
she had already been released.

≋

I knew he'd never forgive himself if he screwed this up, so I went into his room and started hunting for the promise ring. I was going to show it to her and say he did leave her, but he didn't dump her—he was saving up for their wedding. I knew if she saw the ring, she'd forgive him.

In the pocket of Jimmy's brown leather jacket, I found an old photograph and a folded-up card. The picture was black-and-white. Josh's head was pasted over a priest's head and Karaoke's was pasted over a little boy's. I turned it over: *Dear Joshua*, it read. *I remember every day we spent together. How are you? I miss you terribly. Please write. Your friend in Christ, Archibald.*

I asked Karaoke about it later, and she uncomfortably said it was meant as a joke, Jimmy was never supposed to find it. But she wouldn't look at me, and she left a few minutes later. Jimmy'd picked it up the same way I had. The folded-up note card was a birth announcement. On the front, a stork carried a baby across a blue sky with fluffy white clouds. *It's a boy!* was on the bottom of the card. Inside, in neat, careful handwriting it said, "Dear, dear Joshua. It was yours so I killed it."

≋

The cut I make in my left hand is not deep. The skin separates and the blood wells up and spills down my palm. For a moment, there is no pain, and I wonder if I'm dreaming this, then the cut begins to burn, to

sear. I hold my hand up to the trees and the blood runs under my sleeve and down my forearm. I turn around in circles, offering this to the things in the trees, waiting. When I'm about to give up and go back to my speedboat, I hear a stealthy slither.

≋

Remove yourself from the next sound you hear, the breathing that isn't your own. It glides beneath the bushes like someone's shadow, a creature with no bones, no arms or legs, a rolling, shifting worm-shaped thing that hugs the darkness. It wraps its pale body around yours and feeds. Push yourself away when your vision dims. Ignore the confused, painful contractions in your chest as your heart trip-hammers to life, struggles to pump blood. Ignore the tingling sensations and weakness in your arms and legs, which make you want to lie down and never get up.

The Land of
the Dead

We were a half-hour's snowshoe tramp from the log-
ging road when Mick found the ugliest pine tree in
creation. Snowflakes, airy and dry, hissed across the
crusted, frozen ground. The tree was bent over like a
hunchback, brown for the top foot or so, and drip-
ping needles before even he touched it.

"I like it," Mick said.

"Son," Ba-ba-oo said, slapping a friendly hand on
Mick's shoulder, "I wouldn't even use it for kindling."

"What do you think?" Mick said to me.

"Why didn't you visit me?" I said. "Why did you
stay away?"

He kissed the top of my head. "I'm here now. And we have a tree to pick. I think this one is just dandy." He chopped it down and threw it over his shoulder. Ba-ba-oo held my hand as we walked through the nippy air back to the truck. He sang:

Asshole, asshole, a soldier I will be
To piss, to piss, two pistols on my knee
I will fight for my cunt, I will fight for my cunt,
I will fight for my country . . .

"Dad," Mick said, wincing. "Enough, please. There's a lady present."

"This from the man who taught you 'Fuck the Oppressors'" Ba-ba-oo said to me, rolling his eyes.

I laughed as Mick and Ba-ba-oo mock-wrestled, squashing the tree as they tried to pin each other to the ground. We had to start the Christmas-tree hunt all over again, but none of us minded. The sun glinted off the snow, the wind rubbed our faces red and, somewhere out there, was a tree hideous enough for Mick to bring home.

≈

I wake. The moss is soft and wet against my back. There is a dull, aching pain in my hand. I lift it, and the cut is raw, but has stopped bleeding, and all the blood has been licked away. Its tongue was scratchy, like a cat's.

"You said you would help me!" I yell, but my voice cracks, and I don't know if they heard me, so I yell it again.

They snigger.

I push myself up with my right hand, cradling my left hand against my chest. The bushes rustle.

"More," a voice says from the shadows.

I stand. "You tell me where Jimmy is first."

≋

The waves have washed the blood from the oar tip but he can see the dents in the wood where he hit Josh— first on the hand as Josh gripped the side and screamed, trying to put one leg in the seiner as Jimmy kicked him and hit him. For what he did to Karaoke, he knew that Josh deserved to die. But he couldn't bring himself to do anything more until the boat tilted, and finally Jimmy brought the oar down on his head. It hit Josh's left temple and his head snapped back and God, he killed him, he hoped he killed him because the waves let Jimmy see him for the longest time as the man he'd sworn to kill drifted away, held up by his floater jacket, a bright yellow dot against the white-tipped blackness of the waves.

As Jimmy slips off the deck and over the railing, what surprises him is how fast the seiner sinks. Something so large, he thinks, should not be able to disappear in mere minutes, but in its last moments, it rode almost level with the water, rolling sluggishly in waves. It tilts up as a wave hits it to reveal the gaping hole where Jimmy rammed the seiner into a log. Josh fought to save his *Queen*. And when he was distracted, Jimmy replays the moment when he pushed him, hoping to make it quick, but, God, failing.

The life raft that Josh threw over the side in the first moments of the crash is nowhere in sight. So Jimmy aims for the shore, lifts his arms in and out of the water, executing the strokes he's trained all his life to perfect.

≋

One crow caws. It is joined by another and another, until it sounds as if hundreds of crows are on the beach. My hand is numb. The thing waits in the shadows.

"No," I say. "No, you know what I want. That wasn't . . . wasn't what I . . . " Very tired. The moss looks comfortable. Rest for a few minutes. Sink to my knees. Eye level with the pale body as it rears up.

"More."

"No." Crawl through the bushes. Rocks hard on my palm. Forgot about it, until the cut begins to bleed again. Can hear it, pacing me. Eyelids so heavy.

Startled when I break from the trees. Crows, as far as the eye can see, waiting on the beach. Crows still, as if they were statues. Then they hop out of my way to give me a path to the speedboat.

Manage to stand. Wobble towards the speedboat. It bobs in the rising tide. Untie the rope, slow, hands are clumsy. Lose it for a moment. It's drifting away in the tide. Water is cold as I wade in up to my waist. Should have pulled the boat to shore, then pushed off. Not thinking. Catch the rope, pull the boat towards me, but can't quite manage to get in. Slip. Hand can't grasp the side. Speedboat does enough of a spin to gently knock my head and push me underwater.

≋

The rain is warm. This strikes me as very strange. I am, on some level, aware that this should alarm me. Mama-oo frowns at me. "Are you all right?"

"Peachy keen," I say, but it comes out as an unintelligible mumble because my mouth isn't working.

"Come on," she says.

She grabs my wrists and hauls me up. I sway. The trees blur, come back into focus, and I know something is wrong, but I can't put my finger on what. Trees so tall. Young trees. Narrow trunks. Rain coming down on my upturned face splashes into my eyes and goes up my nose, making me sneeze. I stop moving altogether, entranced with the sensation of raindrops hitting my skin.

"Listen," she says, trying to pull me along, yanking my wrist. "You have to listen."

"Am I dreaming?" I say.

She picks up a piece of oxasuli. "Look. Do you understand?"

"No," I say.

"You have a dangerous gift," she says. "It's like oxasuli. Unless you know how to use it, it will kill you."

"I still don't understand," I say.

Something cold touches my foot, making it so numb that I gasp. I keep catching flashes of green plaid between the trees. I want to stop and see who it is, but I know this isn't a smart thing to do when I don't have my head together. Her face is scrunched up in worry. "When it's time to go, you go," she says. "Nothing you can do or say will change it. We're

where we belong, but you have to go back. Do you hear me?"

"Jimmy?"

"Never mind about him now. Go back. You've come too far into this world. Go back."

The trees undulate. A dark, rectangular cloud descends. I can't catch my breath. We are floating. Her feet aren't touching the ground. Bubbles rush upward, glimmer silver against the darkness. The flash of red is a life jacket. My exhaled breath disappears against the light coming from the surface. Underwater, Dad's speedboat sinks in elegant slow motion. The keel scratching the bottom echoes oddly through the water. The surf rocks me, and I brush against slippery kelp leaves. I inhale. The salty taste is so strong that I gag, twist, as the water pulls me back down.

≋

The crows fly in circles above my head. They are silent as they swoop and dive and turn and, finally, I realize that they are dancing.

≋

The tide rocks the kelp beds and the long amber leaves trail gently in the jade green water. I hear the seals squeaking and chirping, but can't see them yet. Fragmented, shivering light from the surface streams down. Jimmy stands beside me and holds his hand out for me. The moment I touch it, warmth spreads down my arms.

He almost wrenches off my arm as he takes hold of my shoulders and shoves. As I drift upward, the seals twist around me as if they have no bones, swooping and darting through the water, coming close but not close enough to touch me. His upturned face glows in the water, pale white, then pale green, then a shrinking grey spot against the dark water, until he is swallowed.

When I reach the surface, I can't move my arms. I'm warm now, so it's hard to want to move. Want to sleep. Want to drift. Rain in my eyes. Waves capping and spraying, and I can't tell which way the shore is until I hear them singing. I spin myself around and see the bonfire.

I want to yell for help, but nothing comes out. The seal swims beside me, splashing water in my face. This annoys me enough to make me dog-paddle away from him.

When I get tired, a man on the beach puts one hand up to his face and his moose call pierces through the songs, the wind and the waves.

As my feet touch the sand, I see the people around the bonfire make their way to the shoreline and watch me struggle to stay upright against the waves. I am sucked back in the surf, pushed out with the fading tide.

Someone touches my face. "*Wah*," she says. "My crazy girl. Go home and make me some grandkids."

"Hiya, Monster," Mick's voice says. "Don't listen to her. You go out there and give 'em hell. Red power!"

I open my mouth, but nothing comes out. They are blurry, dark figures against the firelight. For a moment, the singing becomes clear. I can understand the words even though they are in Haisla and it's a

farewell song, they are singing about leaving and meet-
ing again, and they turn and lift their hands. Mick
breaks out of the circle and dances, squatting low,
showing off.

The beach is dark and empty. The voices are faint,
but when I close my eyes I can still see the pale after-
image of Jimmy shaking his head. "Tell her."

Aux'gwalas, the others are singing. Take care of her
yourself, wherever you're going.

≋

Early evening light slants over the mountains. The sky
is faded denim blue. Somewhere above my head, a
raven grumbles as it hops between the branches of the
tightly packed trees. The crows have disappeared.
Water splashes as a seal bobs its dark head in the shal-
lows, hunting crabs. I lie on the sand. The clamshells
are hard against my back. I am no longer cold. I am so
light I could just drift away. Close, very close, a b'gwus
howls—not quite human, not quite wolf, but some-
thing in between. The howl echoes off the mountains.
In the distance, I hear the sound of a speedboat.

Acknowledgments

The list of those who made *Monkey Beach* possible would fill another book. Here is the short version:

My strength has come from my family. Thank you for your support, encouragement, inspiration and enthusiasm. John, Winnie, Dale and Carla, you are my heart and everything I learned about courage, I learned from you. I would like to acknowledge Laura Robinson and Annie Hunt, the strongest women I've ever had the privilege of knowing. Their compassion, humour, intelligence and generosity make them powerful and loved. The descendants of Laura Robinson taught me to reach for my dreams, to never be afraid of hard work and to be proud to be Haisla. The descendants of Annie Hunt taught me to face my fears with laughter, to never be afraid of change and to be proud to be Heiltsuk. I will always remember and cherish my baby-sitters, protectors, and guides. My family in Comox and scattered throughout B.C. and Canada, you've given me warm welcomes and endless hospitality. You are all gifts from the Creator and I am honoured to be a part of your lives.

My agent, Denise Bukowski, deserves a medal for patience. This book would have been impossible without her support in the face of chronic writer's angst. Big thanks to Louise Dennys, my editor and midwife, whose gentle guidance brought this manuscript to life. Thank you to Diane Martin and Noelle

Zitzer for their patient suggestions. To the staff at Knopf Canada, thank you for your support. To my publishers, thank you for your faith.

For sharing their insights about Lisamarie, I'd like to thank Karen Nyce, Angie Starr, Lynn Williams, Karen Smith, Sherry Smith, Nancy Nyce and Terri Galligos. Special thanks to Zsuzsi "Title Queen" Gartner for her instrumental help in naming this book. Thanks to my friends, who never tired of listening to my writing saga. Thanks to my teachers, for their patience.

Some of the source material for this book came from *Eulachon: A Fish to Cure Humanity* by Allene Drake and Lyle Wilson; *Salmonberry Blossoms in the New Year* by Alison Davies with Beatrice Wilson; *Tales of Kitamaat* by Gordon Robinson; *A Haisla Book*, compiled and edited by Emmon Bach; *Shingwauk's Vision* by J.R. Miller; *Lakota Woman* by Mary Crow Dog with Richard Erdoes; *Forgotten Soldiers* by Fred Gaffen; *Forgotten Warriors*, a film directed by Loretta Todd. My technical advisors include John Robinson, who guided me through my settings, especially Monkey Beach; Bea and Johnny Wilson; Ian Green and John Kelson, who showed me the Kitlope; and Bruce Billy and Ted Hunt, who patiently explained boats, fishing and emergency rescues. My cultural advisors include Winnie Robinson, Patricia Wilson, Louise Barbetti and Pam Brown, who generously shared their knowledge of plants and ghosts; and the people of Kitamaat Village, who have always shared their stories.

Last, but not least, thanks to my guardian spirits.

Eden Robinson is a First Nations woman whose father grew up in Haisla territory near Kitamaat Village, B.C. Her first book, a collection of stories called *Traplines*, was awarded the 1996 Winifred Holtby Prize for the best work of fiction in the Commonwealth, and was selected as a *New York Times* Editor's Choice and Notable Book of the Year. Eden Robinson lives in North Vancouver. *Monkey Beach* is her first novel and is a 2000 Finalist for the Giller Prize.